NEW DEAL ART IN THE NORTHWEST

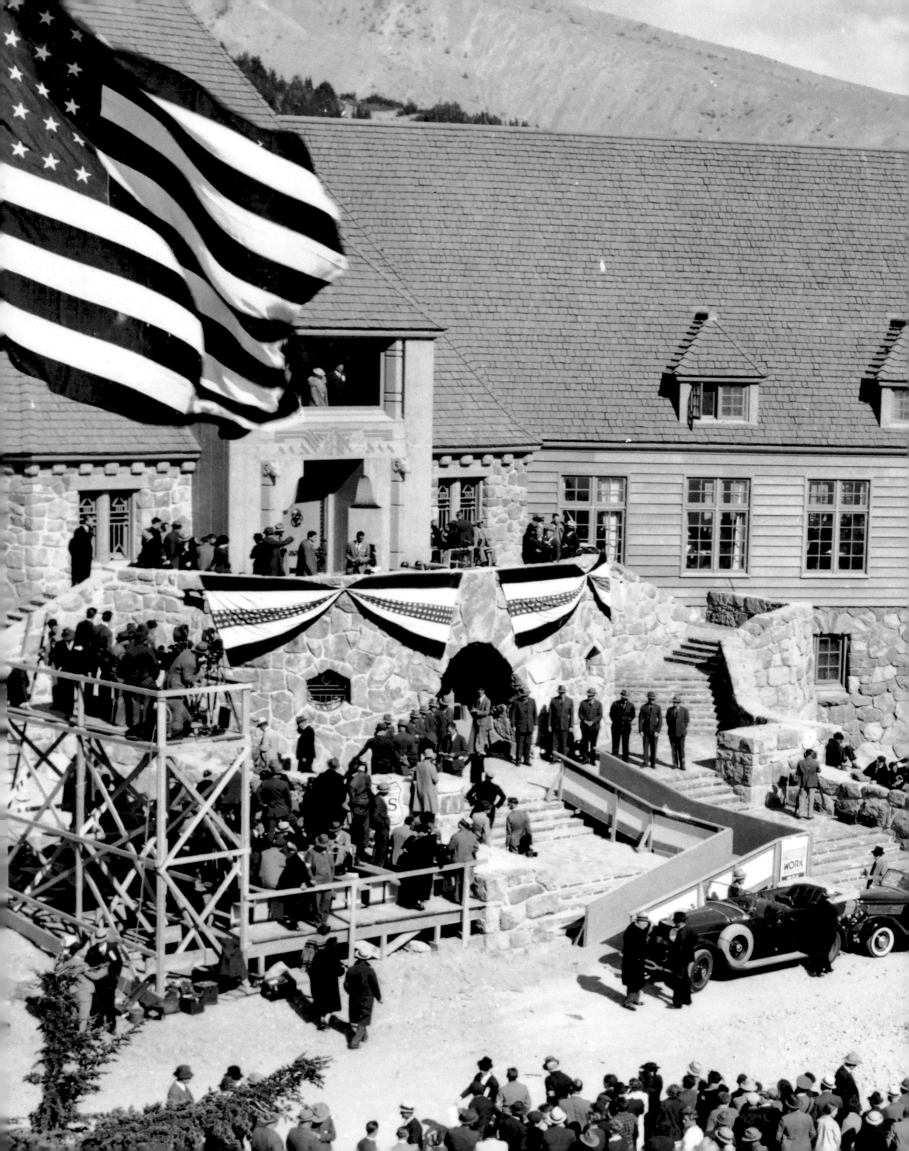

NEW DEAL ART IN THE NORTHWEST
THE WPA AND BEYOND

MARGARET E. BULLOCK

TACOMA ART MUSEUM

TACOMA, WASHINGTON

CONTENTS

CHAPTER 6: THE NEW DEAL ART PROJECTS: CONTEMPORARY ENCOUNTERS

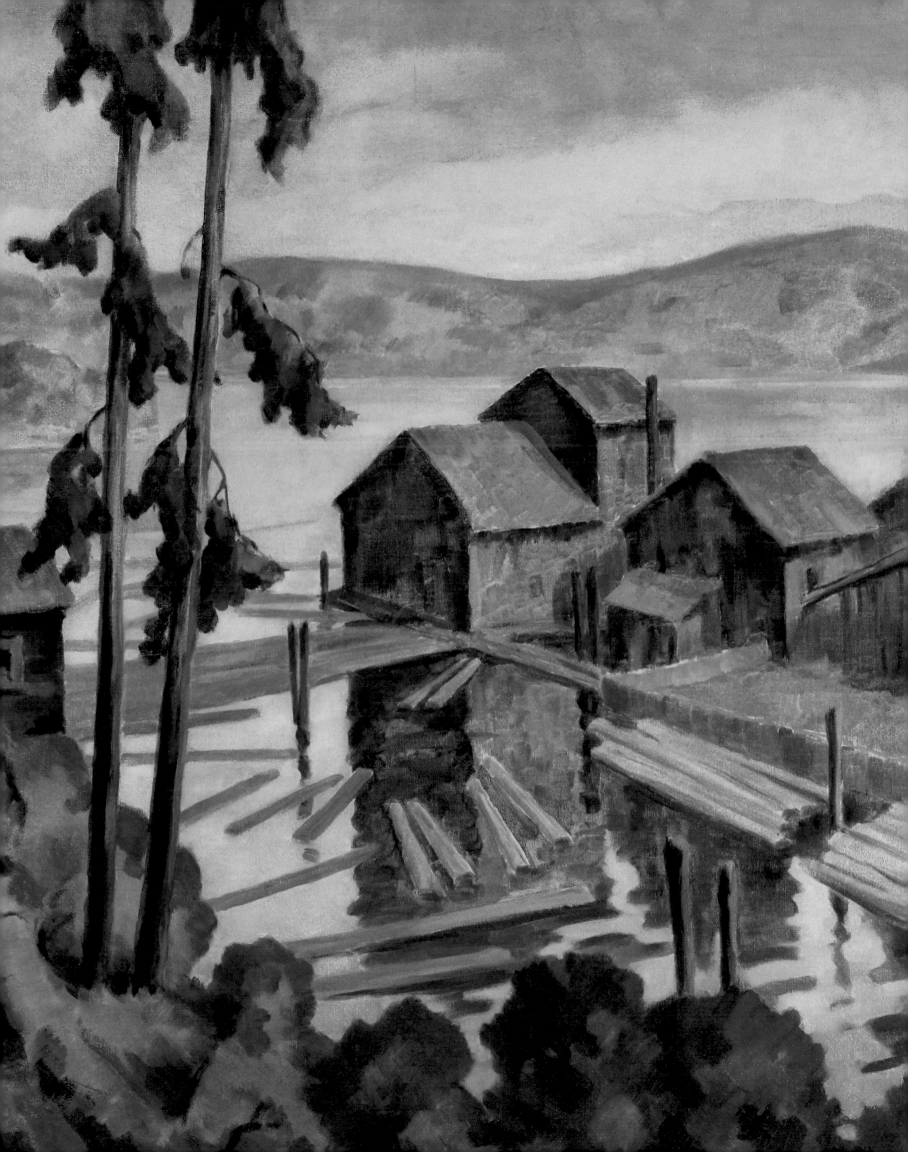

DIRECTOR'S FOREWORD

DAVID F. SETFORD

n 1993, long before my tenure here began, Tacoma Art Museum launched the Twelfth Street Series, celebrating the work of regional artists. It was a bold statement for the then-small museum, claiming a leading role in scholarship on the art and artists of the Pacific Northwest. Renamed the Northwest Perspective Series in 2003, these exhibitions and catalogues have focused on important contemporary and historical figures in Northwest art, honoring that early commitment, fulfilling a key component of the museum's mission, and spotlighting the depth of creativity and talent to be found in our own backyard. I am delighted to be marking the addition of another project to this long-standing succession.

This book is a unique variation on the series as it tells the story of not one, but hundreds of Northwest artists, and details a significant moment when the US federal government acted as their employer. The histories of the New Deal art projects of the 1930s are not well known outside of major metropolitan areas, but they had a significant impact in the Northwest. TAM's interim chief curator, Margaret Bullock, has been working on recovering this history since 2001, and we hope this book, and the accompanying exhibition, will be eye-opening and also inspire others to continue to explore this rich topic. As she notes in her acknowledgments, it has taken a legion of dedicated scholars and enthusiasts to unearth and gather this information, and we honor their contributions here.

This publication has been enhanced by the expertise of the nine coauthors, and I thank them for sharing their deep knowledge. At TAM, Zoe Donnell, exhibitions and publications manager, has applied her meticulous eye and many talents to the production of this substantial book, which was carefully edited by Michelle Piranio and brought to life by designer Phil Kovacevich. We are greatly pleased to once again partner with the University of Washington Press and director Nicole Mitchell on distribution of this book. I also want to acknowledge Rock Hushka, director of Northwest special projects at TAM, for his staunch support of this project since its inception.

In association with the book, Margaret Bullock has curated a wide-ranging exhibition revealing the scope and variety of artwork created on the New Deal art projects in the Northwest. We are deeply grateful to the many lenders, both institutions and individuals, who have entrusted us with works from their collections. Organizational details were spearheaded by Jessica Wilks, associate director of curatorial and head registrar, assisted by Ellen Ito, collections manager. The splendid installation was the brainchild of Ben Wildenhaus, head preparator and exhibition designer.

Publications of this size are significant financial undertakings. TAM is deeply grateful to the Henry Luce Foundation for making this publication possible through a generous grant from their American Art Program.

We also recognize the thoughtful contribution of Matthew and Kimberly Bergman, associate sponsors of both the publication and the exhibition. In addition, we recognize ArtsFund and Tacoma Arts Commission for their continued support. I also thank TAM's associate director of development Mary Brickle, grants and development communications manager Damara Jacobs-Morris, and former corporate and foundation relations manager Michelle Paulus for their efforts in obtaining funding for this project.

I would also like to acknowledge our partners at the Hallie Ford Museum of Art, Willamette University, notably John Olbrantz, The Maribeth Collins Director, and Roger Hull, professor emeritus of art history and senior faculty curator, who have shared an abiding interest in

and encouragement of this project. We are delighted the Hallie Ford Museum will be the second venue for this historic exhibition.

For the many other facets of this project, from compelling educational programs to delightful celebrations to safeguarding the artworks and paying the bills, I sincerely thank TAM's multitalented staff for their untiring dedication and hard work. It is truly a pleasure to come to work every day.

The artworks created under the New Deal art projects in the Northwest were a public treasure trove meant to delight and inspire. We hope this book can offer the same experiences not only for scholars and enthusiasts of this era but also for new eyes and minds.

Artists at work at the Washington FAP headquarters, Seattle
Robert Bruce Inverarity papers, circa 1840s–1997, Archives of American Art, Smithsonian Institution

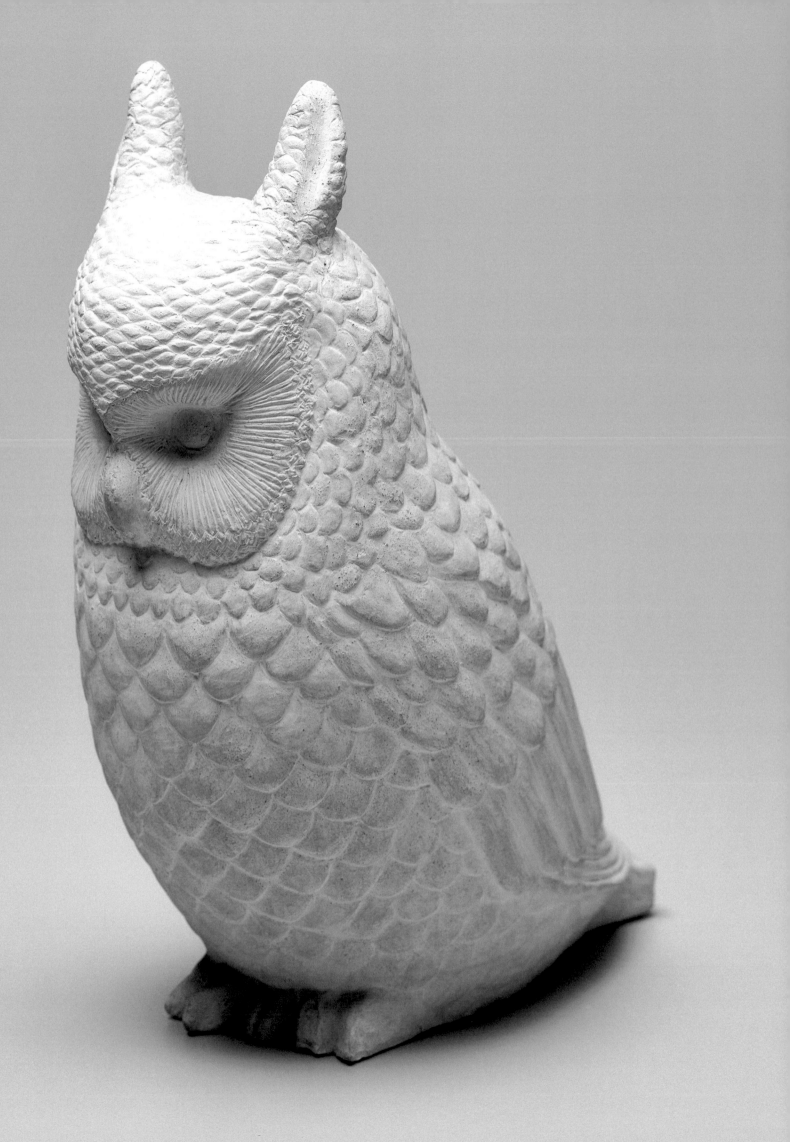

INTRODUCTION:
NEW DEAL ART IN THE NORTHWEST

MARGARET E. BULLOCK

From December 1933 to June 1943, framed by the staggering economic decline resulting from the Great Depression and the rising horrors of World War II, the United States government took on the unlikely role of patron of the arts. President Franklin Delano Roosevelt's signature achievement was the New Deal, a slate of government-funded programs to restore the economy. Employing workers of all types was a key component of his recovery strategy, and work relief was the original primary motive behind the four projects devised to offer jobs to visual artists: the Public Works of Art Project (PWAP), the Treasury Relief Art Project (TRAP), the Section of Painting and Sculpture (later the Section of Fine Arts), and the Federal Art Project (FAP). Together, they mushroomed from a small pilot project to a decade-long experiment in the creation of public art and discussion of the role and value of art and artists in American society.[1] Their impact was felt nationwide, from large urban areas to small rural communities, but was particularly outsized in certain areas of the country, including the Pacific Northwest.

Four Northwest states—Idaho, Montana, Oregon, and Washington—were grouped together into the

Bue Kee (1893–1985)
Owl, 1939
Clay
15⅛ × 6¼ × 14 inches
Portland Art Museum, Portland, Oregon, Courtesy of the Fine Arts Collection, US General Services Administration, New Deal Art Project, L42.28

government's Region 16, one of the largest geographical clusters in the nation. In 1972 Francis V. O'Connor, the pioneering scholar on the New Deal art projects, called out the Northwest as particularly worthy of further study in trying to understand what the art projects meant to the American art community and American culture as a whole during the 1930s.[2] Circumstances, however, have worked against this deeper study despite his call to action.

The New Deal art projects ended abruptly—sometimes literally overnight—with the United States' entry into World War II. Across the country, records and artworks were scattered or discarded rather than returned to the central offices in Washington, DC, as requested. The office records from the Pacific Northwest, including the Region 16 headquarters in Portland, mostly vanished. Some materials reached the National Archives and a few documents landed in regional archives or the hands of individuals, but there are few detailed sources among them.[3]

Large numbers of artworks suffered the same fate, though fortunately several caches of work were preserved. Many of the artworks created under the Northwest's PWAP were distributed to institutions when the program ended in 1934 and are still part of regional museum, university, and public school collections. In 1942 the director of the Portland Art Museum, Robert Tyler Davis, who had worked closely with local art project administrators, made a plea for a gift of artwork to the museum; two additional allocations

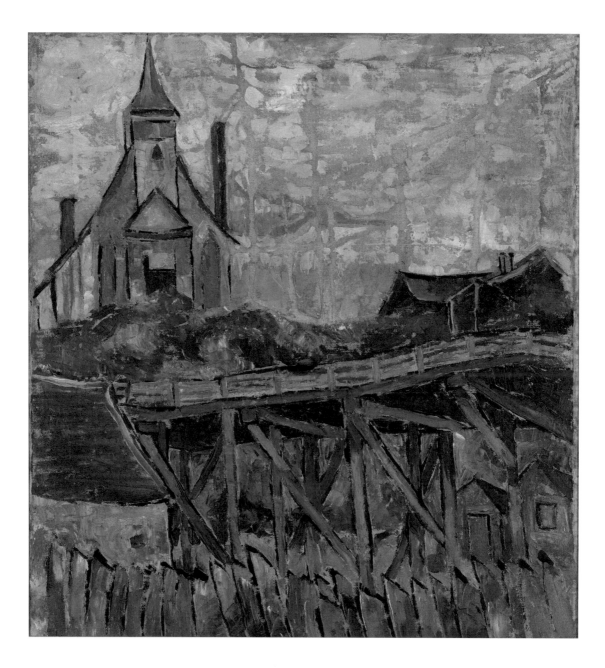

Morris Graves (1910–2001)
Church at Index, 1934
Oil on canvas
31 × 19 inches
Seattle Art Museum, Gift of the Marshall and Helen Hatch Collection, in honor
of the 75th Anniversary of the Seattle Art Museum, 2012.15.7

followed in 1943 and 1945, securing several hundred pieces by Northwest artists as well as works from other states. Together, these regional institutions today hold more than 500 works created under the auspices of the New Deal art projects in Region 16, but research now shows they represent only about 25 percent of the total number.

Because of the chaotic ending, lost records, and scattered artworks, it has long been believed that the New Deal art projects were of small scale and minimal impact in the Northwest and of no great importance to the national history. In 2000 the Henry Luce Foundation awarded a grant to Portland Art Museum for a series of three focused studies on aspects of their American art collection. The collection of PWAP and FAP works acquired by Davis in the early 1940s was chosen as one of the subjects in order to fill out spotty and conflicting records.[4] This small study was the genesis of an extensive research effort that focused originally on Oregon and later expanded to the other three states in Region 16. A dedicated group of New Deal enthusiasts began searching and researching, steadily turning up bits and pieces, including such treasures as the photo archives of the Oregon Works Progress Administration in a disused storage room, collections of artwork tucked away

in school closets, murals stashed behind walls, and other discoveries. Together, they have slowly revealed the surprising extent and lasting contributions of the New Deal art projects to the art history of the Pacific Northwest as well as some significant contributions to the national program. In Region 16, it is now known, at the time of this writing, that more than 600 artists were employed, over 2,000 artworks were created, and commissions were undertaken for hundreds of government and educational institutions across the Pacific Northwest.

Further, it has become evident that the region played a central role in the preservation and revival of a number of handicraft traditions and fostered their evolution as artistic media. The Northwest is known for its pivotal role in the mid-20th century as a center for innovation in ceramics, glass, textiles, and jewelry, but the contributions of the Northwest art projects to this renaissance are a new discovery. The often-cited isolation of the early 20th-century art world in the Northwest is also belied by the region's extensive participation in the national exhibitions, publications, and artistic exchanges of the New Deal art projects and the citation of several Northwest programs as national models. In addition, a number of important postwar artists had some of their first professional opportunities through these projects in the Northwest, and a number of artists from outside the region worked temporarily in or relocated permanently to the Northwest because of them.

This book brings together the fragments and discoveries into the first comprehensive resource on the New Deal art projects in the Northwest. The initial essay by Dr. Sharon Ann Musher, associate professor of history at Stockton University, provides the overarching social context in which the art projects developed and brings new viewpoints to bear on the forces that shaped, buffeted, and ultimately led to the demise of the federal government's great experiment in art patronage. Dr. Roger Hull, professor emeritus, Willamette University, then continues the story in the Pacific Northwest, discussing the region's art community and the impact of the government art programs on both artists and aesthetics.

These contextual essays are followed by chapters that detail the histories and scope of the four New Deal art projects in the Northwest. The final section looks back at particular aspects through a contemporary lens, echoing the original anthologies of memoirs by project participants assembled in the 1930s and 1970s.[5] The book concludes with appendices that list the artists and commissions in each state and a list of archival resources on the Northwest's New Deal art projects.

Artists' names, artworks, and other information are still emerging as this book goes to press and are expected to continue to surface. This gathering of resources is envisioned not as the definitive text but as a platform offering an easier entry into this complex and once-fractured history, thereby inspiring future study and appreciation. It is also a celebration of the varied and rich contributions of the New Deal art projects to the cultural life of the Pacific Northwest region both then and today.

NOTES

1 There is a wide variety of publications on the history and politics of the federal art projects, many of which are cited throughout this book. Some of the primary overview texts include William F. McDonald, *Federal Relief Administration and the Arts: The Origins and Administrative History of the Arts Projects of the Works Progress Administration* (Columbus: Ohio State University Press, 1969); Francis V. O'Connor, *Federal Support for the Visual Arts: The New Deal and Now* (Greenwich, CT: New York Graphic Society, 1969); Richard D. McKinzie, *The New Deal for Artists* (Princeton: Princeton University Press, 1973); Francis V. O'Connor, ed., *Art for the Millions: Essays from the 1930s by Artists and Administrators of the WPA Federal Art Project* (Greenwich, CT: New York Graphic Society, 1973); Roy Rosenzweig, ed., *Government and the Arts in Thirties America: A Guide to Oral Histories and Other Research Materials* (Fairfax, VA: George Mason University Press, 1986); and Bruce I. Bustard, *A New Deal for the Arts* (Washington, DC: National Archives and Records Administration in association with the University of Washington Press, 1997).

2 Francis V. O'Connor, ed., *The New Deal Art Projects: An Anthology of Memoirs* (Washington, DC: Smithsonian Institution Press, 1972), 2.

3 Because the PWAP ended in a more orderly way and the TRAP and Section projects were mostly administered from Washington, DC, there is more information at the National Archives on these projects in the Northwest. Notably, for the PWAP there are lists of almost all the artists employed, and for the Section there are many of the contracts for the post office murals.

4 Margaret Bullock, *Back to Work: Oregon and the New Deal Art Projects*, permanent collection brochure (Portland, OR: Portland Art Museum, 2001).

5 See, for example, O'Connor, *Art for the Millions*, and O'Connor, *New Deal Art Projects*.

ART IN A TIME OF NEED

SHARON ANN MUSHER

ard times came to the Pacific Northwest well before the stock market crash of 1929.[1] Following World War I, demand for wheat plummeted. Homesteaders, who had previously prospered in a boom of easy credit, federal incentives, and an unusual period of regular precipitation, found that drought, dust storms, and swarms of grasshoppers and Mormon crickets incapacitated much of their land.[2] The Great Depression's bank failures, bankruptcies, foreclosures, and influx of Dust Bowl migrants from the Great Plains only compounded the situation, shuttering timber mills, leading farmers to default on their mortgages, and causing homeless rates in cities to soar (fig. 1).

Struggling to survive, residents appealed to state and local authorities, the Red Cross, and communal charities, yet their needs quickly surpassed available resources. Local politicians were reluctant to acknowledge their quagmire. In June 1932 Oregon's governor, Julius L. Meier, promised

that the state had "practically everything necessary to meet the existing emergency." But eight days later, he privately sent a plea to President Herbert Hoover: "We must have help from the federal government," Meier insisted, "if we are to avert suffering . . . and possible uprisings."[3]

Oregon's governor was far from the only one turning to the president for help. Having directed food distribution in Europe after World War I and relief efforts following the Mississippi River's flooding in 1927, Hoover had substantial prior experience providing humanitarian assistance. Yet as president he encouraged businessmen-led voluntary associations, rather than the government, to address the crisis. His administration's policies, including the Reconstruction Finance Corporation, provided loans to banks and companies. The closest Hoover came to providing aid directly was through public works projects, but because of limited funding, they had little impact.[4] Mocking his meager response, homeless people across the country, such as those who built more than 300 shanties in northeast Portland, named their temporary abodes "Hoovervilles."[5]

Although Republicans had previously prevailed in the Pacific Northwest, people were desperate for change. When Franklin Delano Roosevelt ran for president in 1932, he swept the region. Indeed, he won every western state that year.[6] In his first 100 days in office, Roosevelt began a project of "bold, persistent experimentation" to restore

Figure 1
Arthur Rothstein (1915–1985)
Vernon Evans (with his family) of Lemmon, South Dakota, near Missoula, Montana on Highway 10. Leaving grasshopper-ridden and drought-stricken area for a new start in Oregon or Washington. Expects to arrive at Yakima in time for hop picking. Live in tent. Makes about two hundred miles a day in Model T Ford, July 1936
Nitrate negative
3¼ × 4¼ inches
Library of Congress, Prints and Photographs Division, Farm Security Administration/Office of War Information Collection, Washington, DC, LC-USF34-005008-D

the nation's confidence and bolster prices.[7] Roosevelt's administration tackled the nation's agricultural calamity with the Agricultural Adjustment Act (AAA) of 1933, which paid farmers to reduce surplus by fallowing or plowing under their land and selling corn hogs—and later other livestock—for slaughter. Trying to create scarcity in a time of want was, understandably, a controversial policy, even after the government pledged to redistribute the excess to the unemployed.[8] Less contentiously, the New Deal expanded the public works projects Hoover had begun. The Civilian Conservation Corps hired millions of unemployed young men into a "tree army" that promoted environmental conservation and transformed the national park system. Relief workers also developed the nation's infrastructure, building roads, schools, libraries, courthouses, post offices, airports, athletic fields, gyms, and even public pools.

Despite the skepticism expressed by many regional politicians, the New Deal invested more in public projects in the West than anywhere else in the country.[9] Indeed, the 14 states receiving the most money per capita were all in the West. Public investment in projects such as the Fort Peck and Grand Coulee Dams, Bonneville Power Administration, and Timberline Lodge illustrated the federal government's expansion throughout the American West.[10]

Beyond infrastructural development, the New Deal expanded into the cultural realm. From 1933 to 1943 it sponsored an array of art programs that put artists and intellectuals to work while democratizing creative experiences. At its height, the New Deal spent about $30 million to hire 40,000 dancers, actors, musicians, and visual artists who were selected based on financial need or merit.[11] Such artists decorated newly constructed public buildings, documented the country through photography, taught classes in community art centers, and produced hundreds of thousands of plays, travel guides, posters, dances, sculptures, and easel paintings enjoyed by millions of Americans. The New Deal's art projects made aesthetic experiences accessible to people across the country who had previously never encountered artists, art classes, and original works of art.

Such projects emerged from several impulses. Relief administrators wanted to expand aid to professionals and women, whose needs were not met by blue-collar projects.

As Harry Hopkins, the director of the Works Progress Administration (WPA), explained: "We decided to take the skills of these people wherever we found them and put them to work to save their skills when the public wanted them."[12] Hopkins was among a cohort of reformers, artists, and intellectuals who argued that the state needed to intercede to save the nation culturally in the face of the Great Depression.[13] Some administrators and artists believed that government-funded art might communicate New Deal ideology to a broad public. For example, the muralist George Biddle, who had been a classmate of Roosevelt's at Groton and Harvard, wrote the president two months after his inauguration suggesting that muralists in the United States, like those in Mexico, might be paid "plumbers' wages" to promote the New Deal on government buildings.[14] But other artists and intellectuals were inspired by the activism of laborers such as the longshoremen who shut down most of the West Coast in their maritime strike of 1934. Seeing themselves as art workers, they demanded that the government support them with public works projects.[15]

Historically, the US Treasury Department had long overseen public art. During the 19th and early 20th centuries, it had selected only a few European-trained artists to embellish public buildings and spaces using ancient Greek and Roman iconography. But in the 1930s the Treasury shifted its approach to host open competitions from largely anonymous artists, enlisting them to create images that drew on American scenes and regional styles. Beginning in December 1933, with the short-lived Public Works of Art Project and then continuing with the Section of Painting and Sculpture (later the Section of Fine Arts), the Treasury encouraged an iconography that ennobled the experiences of working people and drew on what the literary critic Van Wyck Brooks called a "usable past" intended to restore faith in common principles and values.[16]

Fletcher Martin's post office mural in the mining town of Kellogg, Idaho, exemplifies this approach. Initially, in 1939, he sketched two muscular miners rescuing a third, who had collapsed in some sort of accident (fig. 2). The Treasury's Section of Fine Arts selected the proposal as one of 48 winners out of almost 1,500 entries into a competition to decorate post offices across the country. The Treasury assigned the selected murals to post offices

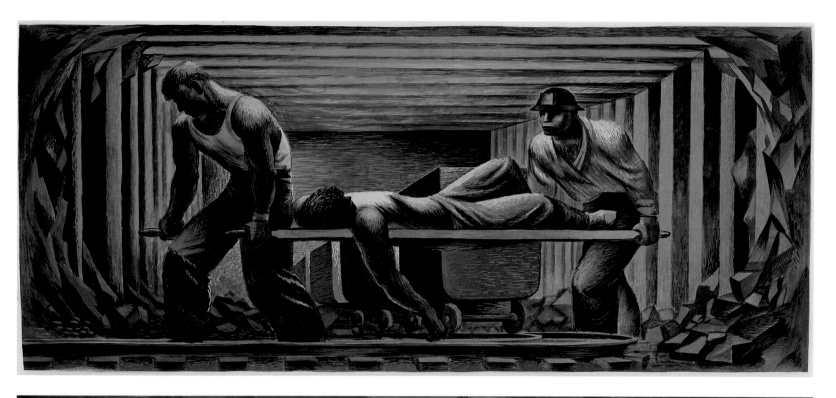

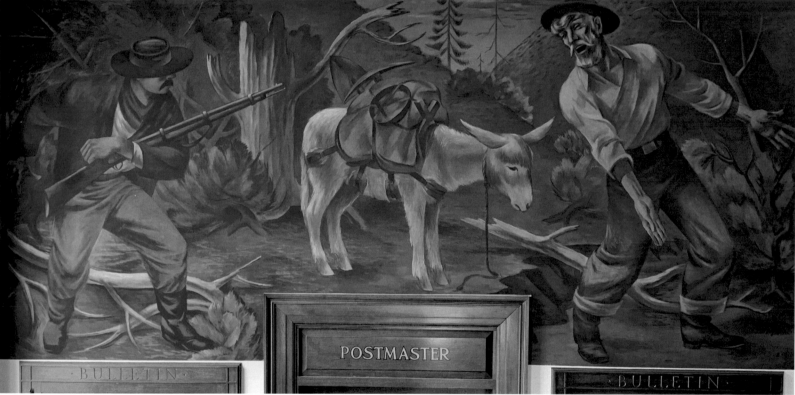

Figure 2
Fletcher Martin (1904–1979)
Mine Rescue (mural study for Kellogg, Idaho, Post Office), 1939
Tempera on panel
15¾ × 36½ inches
Smithsonian American Art Museum, Transfer from the General Services
Administration, 1974.28.315

Figure 3
Fletcher Martin
Discovery, 1940–41
Oil on canvas
5 feet 1 inch × 12 feet
Kellogg, Idaho, Post Office
Courtesy of United States Postal Service. © 2019 USPS

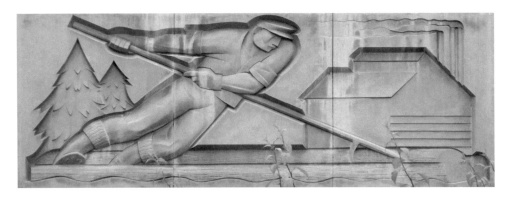

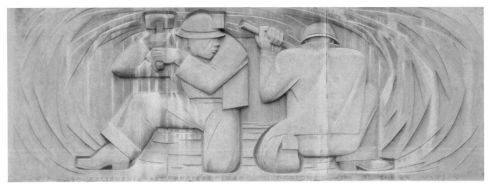

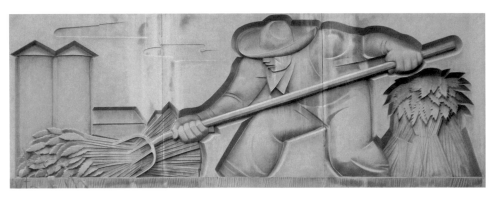

in each of the 48 states, with Martin's mural designated for Kellogg. Successful mural designs also traveled around the country in an exhibition and appeared in *Life* magazine.[17] Like the Treasury, the local unionized mining workers responded enthusiastically to the artist's sketch. But resident businessmen rejected it, and Martin subsequently revised his work to focus instead on a legendary scene of the town's origin. The new mural, titled *Discovery* (1940–41; fig. 3), illustrates a prospector named Kellogg finding gold.[18] When Martin created a frieze for the facade of the Boundary County Courthouse, his representations of Idaho's major industries— "Floating Logs" (timber/lumber), "Mining," and "Harvest" (agriculture)—assumed a similarly nonconfrontational style (fig. 4). His imagery ignored the extent to which such industries and their workers were suffering in the midst of the Great Depression,

Figure 4
Fletcher Martin
Symbols of Bonners Ferry, 1939–40
Limestone relief
4 feet 6½ inches × 12 feet (overall)
Boundary County Courthouse, Bonners Ferry, Idaho

when, for example, in 1930 a lumber company in Bonner County closed, laying off 1,500 employees.[19] While Martin romanticized the past, his peers in the photography unit of the Farm Security Administration Dorothea Lange and Russell Lee documented empty mills and the government's relocation of farmers from depleted land (fig. 5). As the historian Karal Ann Marling has explained, "'Now' is not to be found [in New Deal murals]. The center is missing. Around that missing center, imagery polarized sharply into wishful projections of a wondrous tomorrow and wishful reminiscences of a serene yesterday."[20]

Figure 5
Dorothea Lange (1895–1965)
Washington, Yakima Valley, near Wapato. One of Chris Adolph's younger children. Farm Security Administration Rehabilitation clients, August 1939, Yakima Valley, Washington
Nitrate negative
4 × 5 inches
Library of Congress, Prints and Photographs Division, Farm Security Administration/Office of War Information Collection, Washington, DC, LC-DIG-fsa-8b34383

Figure 6
J. K. Ralston (1896–1987)
Sully at the Yellowstone (detail), 1941–42
Oil on canvas
5 × 12 feet
Sidney, Montana, Post Office
Courtesy of United States Postal Service. © 2019 USPS

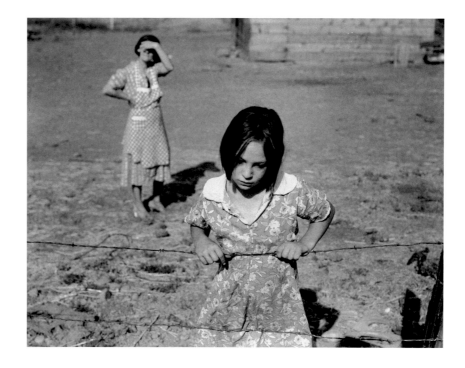

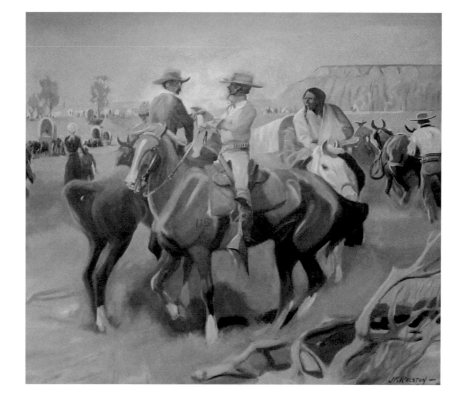

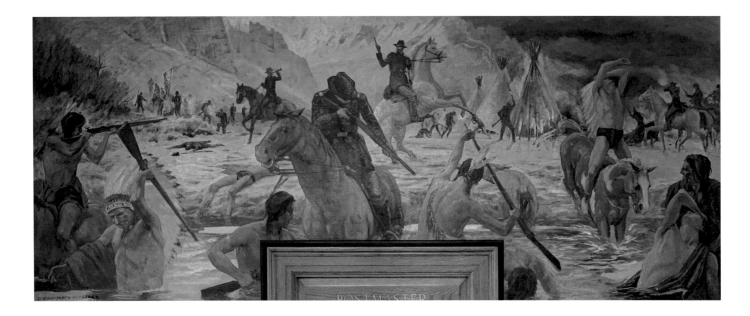

Figure 7
Edmond Fitzgerald (1912–1989)
The Battle of Bear River, 1941
Oil on canvas
5 × 12 feet
Preston, Idaho, Post Office
Courtesy of United States Postal Service. © 2019 USPS

The Treasury's approach at times silenced alternative voices. For instance, although 400 of the 1,600 murals the Treasury commissioned illustrated Native Americans, only 24 of them were created by Indigenous artists. In turn, many of them, including J. K. Ralston's 1941–42 *Sully at the Yellowstone* mural (fig. 6), represented westward expansion as an idyllic myth rather than showing the violence, food shortages, epidemics, and land sales that more accurately reflected such contact.[21] A poignant exception to this is the muralist Edmond Fitzgerald's *The Battle of Bear River* in the Preston, Idaho, Post Office (1941; fig. 7), which illustrates how Colonel Patrick Edward Connor and his California volunteers violently "cleared" the land for the Mormons who would later develop Preston by slaughtering more than 200 Shoshone Indians and burning their tipis.

Many artists during the 1930s objected to the control the Treasury and the public exerted over commissions and the works produced. Instead, they insisted that the government should fund all needy artists and leave them free to create what they wished. The WPA's Federal One, which included the Federal Art, Music, Theatre, and Writers' projects, significantly expanded government-sponsored art by hiring needy artists rather than commissioning works it considered meritorious.

Under Federal One in the Pacific Northwest, the director of Idaho's Federal Writers' Project, Vardis Fisher, produced the first of 48 state guides and the first state collection of folklore.[22] The Federal Music Project in Oregon saw the creation of a 48-piece band and a 27-person orchestra.[23]

Seattle's Federal Theatre Project included an all-black unit and also ran Living Newspapers, original presentational works intended to educate and mobilize audiences around contemporary concerns, such as public ownership of utilities; making accessible affordable, decent housing; and curbing the spread of venereal disease.[24] And a number of community art centers developed throughout the region, including three in Oregon, three in Montana, and one in Spokane, Washington. Testifying to the cultural importance of Spokane's art center, where, at one point, six teachers instructed a thousand students, the Junior League director Charlotte H. Upton explained: "Here at last was a chance that many of us had actively longed for and many others unconsciously desired—an outlet for jaded nerves, an opportunity for enrichment."[25]

But the survival of such opportunities was short-lived. From the New Deal's inception, detractors on the left and right had accused it of harboring communists, boondoggling (making superfluous work), nepotism, promoting political partisanship, undermining business through the creation of unfair competition, and disabling labor unions by creating a monopoly on cheap labor.[26] The turning point, however, was the political realignment of 1938, when

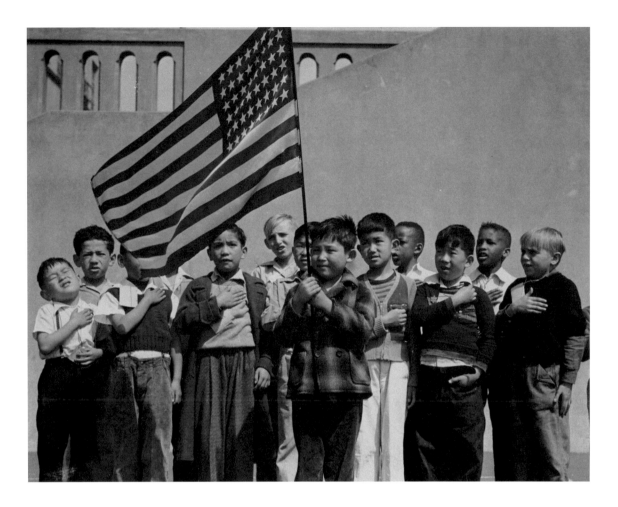

Figure 8
Dorothea Lange
Flag of allegiance pledge at Raphael Weill Public School, Geary and Buchanan Streets. Children in families of Japanese ancestry were evacuated with their parents and will be housed for the duration in War Relocation Authority centers where facilities will be provided for them to continue their education, April 1942
Gelatin silver print
5 × 7 inches
War Relocation Authority Photographs of Japanese-American Evacuation and Resettlement, 1942–1945, circa 1941–1947, BANC PIC 1967.014—PIC v.56 GA-78 [recto], The Bancroft Library, University of California, Berkeley

southern Democrats split from the New Deal coalition as part of a backlash against Roosevelt for his failed efforts to pack the Supreme Court and to purge conservative Democrats from Congress. Congressional investigations of the New Deal's so-called un-American activities and spending further undermined the projects. In 1939, as part of its restructuring of the executive branch, the Reorganization Act decentralized Federal One, limiting how long artists could work for the government, instituting loyalty oaths, and killing its most overtly political program, the Federal Theatre Project.[27] Although the other art programs continued until shortly after the United

States entered World War II, growing restrictions tempered enthusiasm for them. Just after the bombing of Pearl Harbor, the abstract artist and teacher Opal Fleckenstein recalled an official confiscating her sketchbook and threatening to arrest her when he saw that she had drawn two half circles—her representation of the Spokane River's Monroe Street Bridge. Fleckenstein viewed the scolding she received from her adviser at the Spokane Art Center for sketching what was deemed to be classified material as a sign of "the disintegration of the Art Center."[28] Those art projects that most successfully sustained themselves through the war, such as the Office of War Information's photography unit, did so by documenting small-town America to promote patriotism and support for the war.[29] More controversial work, such as Lange's documentation for the War Relocation Authority of Japanese internment (fig. 8), wound up confiscated, marked with the word "impounded," and then buried in the National Archives.[30]

In the decades following the closure of the New Deal's art programs, many government-sponsored works literally disappeared or fell into disparagement as critics

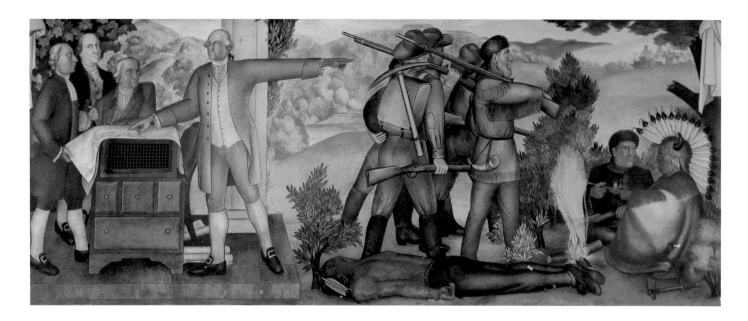

Figure 9
Victor Arnautoff (1896–1979)
Westward Vision from the *Life of Washington* mural, 1936
Tempera on plaster
1600 square feet (overall)
George Washington High School, San Francisco

labeled them kitsch and middlebrow. Beginning in the 1960s, opponents also objected to the New Deal's racial iconography. Student activists, for example, threw ink at the 13-panel mural *Life of Washington* by Victor Arnautoff, protesting its representations of African Americans and Native Americans (1936; fig. 9).[31] But according to the historian Robert W. Cherny, the Russian-born, left-leaning muralist challenged contemporary understandings of the first president by showing him as a slave owner and highlighting the consequences of Manifest Destiny for Native Americans in terms of death and betrayal.[32] San Francisco's Board of Education responded to protests by commissioning the African American muralist Dewey Crumpler to paint in the same school *Multi-Ethnic Heritage: Black, Asian, Native/Latin American* (1974), portraying minorities overcoming obstacles. A new wave of opposition to New Deal imagery emerged more recently. In the wake of national conversations about how to respond to public memorials of people who supported slavery or segregation, San Francisco's Board of Education voted in August 2019 to spend $825,000 to cover controversial sections of Arnautoff's mural with newly commissioned images of the "heroism of people of color in America."[33]

As the movement to destroy Arnautoff's mural illustrates, threats to dismantle New Deal art coexist with efforts to recover and reinterpret it. Since the 1960s scholars have looked to the art projects as a blueprint for the establishment of the National Endowment for the Humanities and the National Endowment for the Arts. In 2008 celebrations of the 75th anniversary of the New Deal at the onset of the Great Recession further revived interest in New Deal art.[34] And today, calls for a New—and a Green—New Deal continue to encourage rediscovery. Investigating New Deal culture on a regional level illustrates how artists and creative expression forge hope in hard times. New Deal art did this both by articulating comforting and wishful narratives and also, at times, by resisting them and, instead, drawing attention to inequalities and injustice.

NOTES

1 Neil Barker, "Portland's Works Progress Administration," *Oregon Historical Quarterly* 101, no. 4 (Winter 2000): 414.

2 Mary Murphy, *Hope in Hard Times: New Deal Photographs of Montana, 1936–1942* (Helena: Montana Historical Society Press, 2003): 38–41, 73–74.

3 Barker, "Portland's Works Progress Administration," 415.

4 Jason Scott Smith, *Building New Deal Liberalism: The Political Economy of Public Works, 1933–1956* (New York: Cambridge University Press, 2006), 27–28.

5 Barker, "Portland's Works Progress Administration," 415.

6 William G. Robbins, "Surviving the Great Depression: The New Deal in Oregon," *Oregon Historical Quarterly* 109, no. 2 (Summer 2008): 312.

7 William E. Leuchtenburg, *Franklin D. Roosevelt and the New Deal* (New York: Harper and Row, 1963), 5.

8 "Agricultural Adjustment Act," in Jyotsna Sreenivasan, *Poverty and the Government in America: A Historical Encyclopedia* (Santa Barbara, CA: ABC-CLIO, 2009), 117–19. In *United States v. Butler* (1936), the Supreme Court found the AAA's agricultural restrictions to be unconstitutional. But it later reversed its decision, in *Wickard v. Filburn* (1942), when it ruled that the consequences of farm trade crossed state lines even if farmers tended to buy and sell locally. For additional information, see Wayne D. Rasmussen, Gladys L. Baker, and James S. Ward, *A Short History of Agricultural Adjustment, 1933–75*, Economic Research Service, United States Department of Agriculture, Agriculture Information Bulletin, no. 391 (March 1976), https://naldc.nal.usda.gov/download /CAT87210025/PDF.

9 Barker, "Portland's Works Progress Administration," 430–31.

10 Robbins, "Surviving the Great Depression," 312.

11 Sharon Ann Musher, "Art and the New Deal," in *The New Deal and the Great Depression*, ed. Aaron D. Purcell (Kent, OH: Kent State University Press, 2014), 111, 124n1.

12 Harry Hopkins, "Address on Federal Relief Delivered at a WPA Luncheon," September 19, 1936, Harry L. Hopkins Papers, Federal Relief Agency Papers, box 9, Franklin D. Roosevelt Library (FDRL), Hyde Park, New York.

13 Sharon Ann Musher, *Democratic Art: The New Deal's Influence on American Culture* (Chicago: University of Chicago Press, 2015), 1.

14 George Biddle to Franklin D. Roosevelt, New York, May 9, 1933, Selected Documents from the Papers of President Franklin D. Roosevelt concerning the Federal Arts Program, microfilmed at FDRL, June 1965, NDA/HP1, Archives of American Art, Smithsonian Institution.

15 Musher, *Democratic Art*, 18–24, 86–94.

16 Musher, "Art and the New Deal," 92.

17 "Speaking of Pictures . . . This Is Mural America for Rural Americans," *Life*, December 4, 1939, 12–13.

18 Richard D. McKinzie, *The New Deal for Artists* (Princeton, NJ: Princeton University Press, 1973), 71.

19 Dorothea Lange, *Sand Point, Bonner County, Idaho. Abandoned Storage Shed of the Humbird Lumber Company*, October 1939, Farm Security Administration, Library of Congress Prints and Photographs Division, Washington, DC, http://www.loc.gov/pictures/collection/fsa /item/2017774088/.

20 Karal Ann Marling, *Wall-to-Wall America: A Cultural History of Post Office Murals in the Great Depression* (Minneapolis: University of Minnesota Press, 1982), 20.

21 "Indians at the Post Office: Native Themes in New Deal–Era Murals," Smithsonian National Postal Museum, https://postalmuseum.si.edu /indiansatthepostoffice/index.html. The mural of General Alfred Sully illustrates when, in August 1864, Sully and more than 5,000 mostly infantry and cavalrymen completed a 120-mile "Indian Expedition" from northwestern Iowa and Minnesota to the Yellowstone River in Montana in over 100-degree weather. The mural does not visually reference the roughly 450 Native Americans they killed on the way, or the 600 to 700 they wounded. Sully lost 23 men on the journey. Historical Society of Montana, "Battle with the Combined Tribes of Sioux Indians among the Bad Lands of the Little Missouri," in *Contributions to the Historical Society of Montana*, vol. 2 (State Publishing Co., 1896), http://genealogytrails.com/ndak/dunn/military/military _1864expedition.html.

22 Christine Bold, *The WPA Guides: Mapping America* (Jackson: University Press of Mississippi, 1999), 37–63.

23 Barker, "Portland's Works Progress Administration," 422.

24 Sara Guthu, "Special Section: Theatre Arts in the Great Depression," The Great Depression in Washington State Project, University of Washington, 2009, http://depts.washington.edu/depress/theater _arts_index.shtml.

25 Charlotte H. Upton, "A W.P.A. Art Project Brings Water to the Desert," no date, ser. 3.7, reel 1107, frame 169, Holger Cahill papers, 1910–1993, bulk 1910–1960, Archives of American Art, Smithsonian Institution; quoted in Musher, *Democratic Art*, 164–65.

26 Barker, "Portland's Works Progress Administration," 434.

27 Musher, *Democratic Art*, 200.

28 Oral history interview with Opal Fleckenstein, November 19–20, 1965, Archives of American Art, Smithsonian Institution.

29 Musher, *Democratic Art*, 143–44.

30 See Linda Gordon and Gary Y. Okihiro, eds., *Impounded: Dorothea Lange and the Censored Images of Japanese American Internment* (New York: W. W. Norton, 2006).

31 Alex Lash, "For SF Muralist Dewey Crumpler, the Controversial Past Is Present," The Frisc, April 19, 2019, https://thefrisc.com/for-muralist -dewey-crumpler-the-controversial-past-is-present-375ccbdafd9e.

32 Robert W. Cherny, *Victor Arnautoff and the Politics of Art* (Urbana: University of Illinois Press, 2017), 108–9.

33 David K. Li, "San Francisco Will Cover, Not Destroy, Controversial George Washington Mural," NBC News, updated August 14, 2019, https://www.nbcnews.com/news/us-news/san-francisco-school-will -cover-not-destroy-controversial-george-washington-n1042111.

34 Musher, "Art and the New Deal," 114, 123.

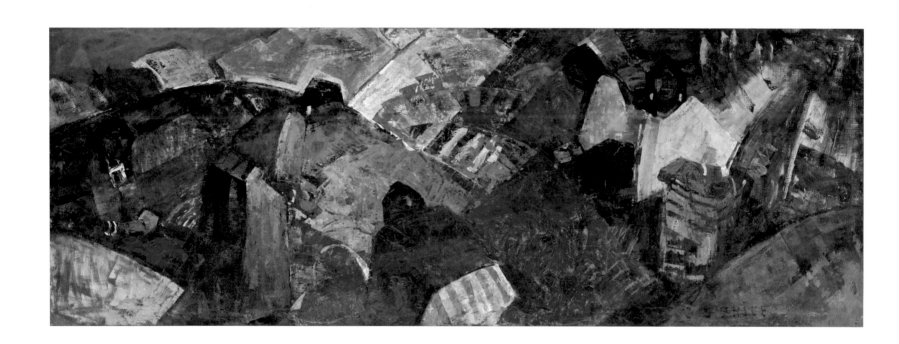

AESTHETIC DIVERSITY AND THE ART OF HARD TIMES

ROGER HULL

New Deal art in the Pacific Northwest paralleled other government-sponsored art across the country in the 1930s and early 1940s in its range of media, style, quality, and intended audiences. Created under the very particular, defining circumstances of national emergency, New Deal art initiatives were designed to meet several goals: provide work for artists; offer aesthetic solace for Americans demoralized by economic disaster; and set forth a vision of American life, present and past, that emphasized the nation's strengths, only temporarily disabled. These goals provided a template for art making within a narrow range that encouraged what we think of as variants of regionalism—salt-of-the-earth subjects such as farm and family, hearth and home, civic pride, and regional history. New Deal art patronage leaned toward the conservative, and this was true in the Federal Art Project's Region 16—comprising Washington, Oregon, Idaho, and Montana—as it was elsewhere in the nation.

Nonetheless, the aesthetic approach varied widely, even as artists were working with a limited range of subject matter in styles appealing to a mass public audience. While many New Deal artists worked in traditional, even academic terms, others depicted regional subjects in styles that reflected European and American modernist movements. In Washington and Oregon, New Deal support allowed for some artists to experiment stylistically in ways that incubated a Northwest avant-garde that remains in play in the 21st century. Treasury Department funding for murals in post offices and other public buildings yielded more conservative results throughout Region 16, but one can find in some of these highly public paintings the geometric clarity and formal rigor associated with modern abstraction.

To explore this matter—the interplay of traditional sensibility and modernist invention in Depression-era art—this essay focuses primarily on paintings in several key sites of New Deal activity in the Pacific Northwest: Timberline Lodge on Mount Hood in Oregon; the federal art centers in Salem, Oregon, and Spokane, Washington; and the lobbies of United States post offices throughout Region 16.

From these hot spots (some hotter than others because they were sites of multiple projects), artists could move on to other opportunities, as when the Oregon artist Louis Bunce involved himself in no fewer than four different Northwest art projects. Such flexibility between and among the federally funded art initiatives provided artists in the Northwest and elsewhere with opportunities that ranged from public murals to portable paintings created

Figure 1
C. S. Price (1874–1950)
Huckleberry Pickers (one from a two-panel mural), 1936–37
Oil on canvas
4 feet 8 inches × 14 feet 8 inches
USDA Mount Hood National Forest, Timberline Lodge

in the solitude of their studios. A given artist's production could vary greatly depending on context, and the aesthetic range of New Deal art must be understood as a phenomenon based on particular circumstances in particular places.

New Deal art patronage, of course, owed its existence to the Great Depression and its cataclysmic birthing event of October 29, 1929—the devastating crash of the stock market. Some 10 months earlier, the painter C. S. Price moved from Monterey, California, to Portland, Oregon, such that his arrival in the Northwest and the advent of the Great Depression closely coincided. His art, variously inspired by Albert Pinkham Ryder, Paul Cézanne, and European expressionism, recalibrated the local art scene, and the impact of his work strengthened the modernist strain of New Deal art produced in Oregon.

For the Federal Art Project, a program of the Works Progress Administration (WPA) established in August 1935, Price created one of the greatest government-sponsored paintings in the Northwest. This is *Huckleberry Pickers* (1936–37; fig. 1), from a pair of large oils by Price, each more than 14 feet wide, intended to flank a major doorway at Timberline Lodge, the ski hotel on Mount Hood that arguably is the gem of New Deal projects in the Pacific Northwest. *Huckleberry Pickers* and its mate, *Pack Train*, are now accepted as examples of New Deal painting at its best, but their reception was fraught and their history marred by their rejection by the chief forester of the US Forest Service, which officially owns the lodge. He considered them too modern for contemporary taste and claimed erroneously that they were inches too wide for their intended locations.[1]

Here was a case, one of a number in Region 16 and nationwide, of New Deal art being refused and even destroyed for various reasons—political, aesthetic, or other. In the case of *Huckleberry Pickers* and *Pack Train*, the reason was one individual's aesthetic taste. The chief forester did not like them and refused to install them. They resided at the Portland Art Museum for years before being moved only in 1975 to Timberline, where they can be viewed today.

Despite its initial rejection, *Huckleberry Pickers* is a majestic painting that marries the Pacific Northwest—its topography, flora, and Indigenous peoples—with the art of Giotto, Paul Gauguin, Cézanne, *Blaue Reiter* German expressionism, and the tradition of field workers and gleaners as a subject for painting. In a frieze-like composition, Price renders five figures seen variously in profile, front-facing, or from the back. Their simplified shapes interplay with rounded and angular landforms, and their striped garments and patterned baskets set up a rhythm of color accents against the green, gray, and brown of the landscape. In its segmented composition, the painting suggests a quilt pieced from a variety of fabrics, and to this extent it echoes the WPA craft projects that included weaving Timberline's upholstery, curtains, and bedspreads.

Among the numerous other artists and craftspeople doing work at or for Timberline Lodge was Charles Heaney, for whom Price was mentor and friend. Heaney's major WPA painting for Timberline is *The Mountain* (fig. 2), "finished about September 1937" and "hung at Timberline Lodge with my temporary white frame," according to Heaney's notes.[2] This is a boulder of a painting, the mountain so big that its peak is cut off by the top of the canvas. Our viewpoint is elevated so that we look through space at the upper flanks of the mountain and beyond it to the rolling, semiarid landscape of central Oregon. In contrast to *Huckleberry Pickers*, there are no figures; a white house with a red roof is the only sign of lonely habitation.

In referencing the mountain paintings by Cézanne, the American modernist Marsden Hartley, and the American 19th-century painters Frederic Church and Albert Bierstadt, not to mention the art of such Northwest folk painters as Eliza Barchus, Heaney created works that, like Price's, anchored WPA-funded production to European and American art traditions while honoring regional natural grandeur. At the same time, with its reassuring weight and heft, the mountain could serve as a symbol of endurance in a time of upheaval.

Price's *Huckleberry Pickers*, during its years of exile from Timberline, hung in the library of the Portland Art Museum, where the painter Lucinda Parker, a student at the Museum Art School in the early 1960s, took inspiration from it and to this day counts it as a vital influence that sustains her. Throughout her long career as a modernist painter, she has also admired Heaney's *The Mountain*, always on view at Timberline. Pinned to her studio wall in

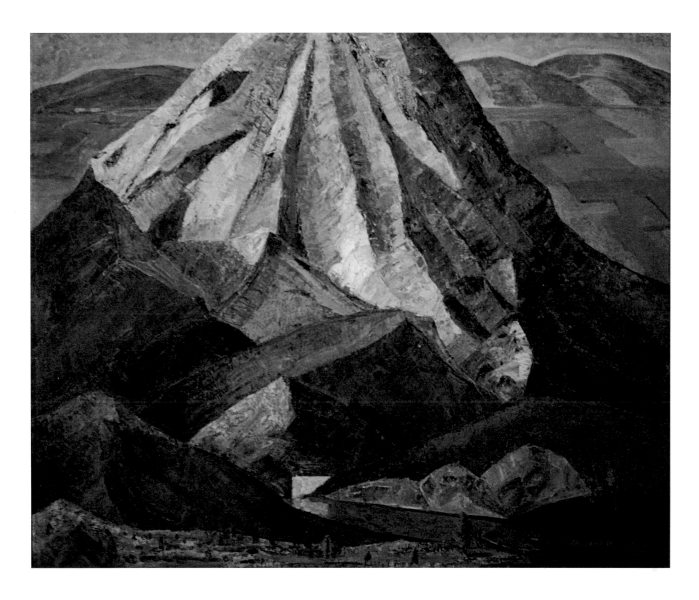

Figure 2
Charles Heaney (1897–1981)
The Mountain, 1937
Oil on canvas
34¼ × 42½ inches
USDA Mount Hood National Forest, Timberline Lodge

Portland is a postcard illustration of *The Mountain*, inspiration for Parker's own late-career mountain paintings and a work, she claims, that she would like to directly replicate. "I'm channeling the WPA," she acknowledges. "In a way."[3] She has helped assure that *Huckleberry Pickers* and *The Mountain*, born of the WPA, are landmark paintings in the evolution of modern art in the Pacific Northwest.

Off the mountain and down in the Willamette Valley, the federal art center in the capital city of Salem was another Oregon WPA hub. It opened during the first week of June 1938 (eight months after Franklin D. Roosevelt

dedicated Timberline Lodge on September 28, 1937) in the recently vacated Salem High School.[4] One of the instructors was Bunce, a veteran of New Deal art projects: in 1936 he had assisted John Ballator in painting the mural for the post office in the Saint Johns neighborhood of Portland and in 1937 received his own commission for a mural at the Grants Pass Post Office, both of these being Treasury Department projects.

Bunce arrived in Salem in 1938. With his advanced painting students, and in conversation with local school children, he coordinated the creation of two murals—*Alice in Wonderland* and *Arabian Nights* (1938; see page 206, fig. 3)—for the library of Bush Elementary School, a Salem Art Center outpost. The designs were by one of the student artists, Clifford Gleason (later a significant modern painter on the Salem-Portland scene); the murals were executed by Bunce, assisted by Gleason and other students,

in Bunce's studio at the art center, from where they were transferred to the school.

The Bush School paintings have been described as "the most modernist Depression-era murals in Oregon,"[5] and they do set forth imagery quite different from the more officially sanctioned murals for post offices and other public buildings. In *Alice in Wonderland*, radical differences in scale among the figures and the disjunctive composition create a sense of magic, mystery, and perhaps even menace. When Bush School was demolished in 2005, school administrators considered the scenes too scary for modern-day elementary students, and they were installed at North Salem High School (itself a WPA project) instead of the new Bush School.

Created as a class project free from juries and review boards, these murals sidestepped any official standards that might have been in play. Compared with Bunce's own mural, *Rogue River Valley* (discussed below), painted in conservative obedience to Treasury Department standards for the Grants Pass Post Office, *Alice in Wonderland* and *Arabian Nights* are adventurously surreal and experimental, in the spirit of Bunce's later art making. Here is an example of the flexibility provided by particular circumstances that allowed for experimentation and innovation, even if unsanctioned, in New Deal art. For Gleason, working with Bunce on the Bush School murals set the stage for his life of painting with avant-garde freedom, and it is likely that participation in this collaborative, unorthodox project liberated Bunce stylistically as well.

Another instance of local circumstance allowing for unintended opportunities occurred at the Spokane Art Center, which opened its doors in a renovated downtown space in September 1938. An instructor there was the Seattle artist Z. Vanessa Helder, a skilled watercolorist who taught that medium at the art center and also launched a lithography course—atypical of federal art centers because of the cost of presses and limestone blocks. In Spokane, Helder and Robert O. Engard, another instructor, persuaded a print shop to donate a press and stones.[6] Some of the more distinctive works produced at the Spokane Art Center are Helder's and Engard's lithographs—created, like the Bush School murals in Salem, under the auspices of but outside the standard programming of the art center.

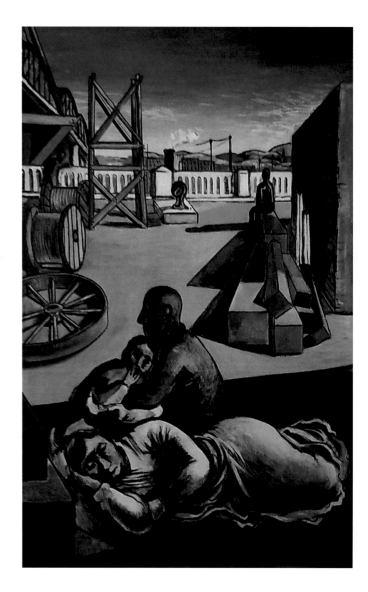

Figure 3
Louis Bunce (1907–1983)
Seawall, 1939–40
Oil on canvas
41½ × 25½ inches
Private collection

Federal art centers generated other unintended but fruitful long-term enhancements to the aesthetics of their regions. In conjunction with his work at the Salem Art Center, for instance, Bunce taught an art appreciation course at the Oregon State Tuberculosis Hospital in Salem. One of the patients was Lillie Lauha, who recalled that Bunce's class was the bright spot of her convalescence.[7] She was able to visit some of the exhibitions at the art center, and this introduction set the stage for her lifetime of collecting Oregon modern art that has since been dispersed to museums in the region. It's an accurate claim that long after their physical existence, the art centers cast light on regional aesthetics.

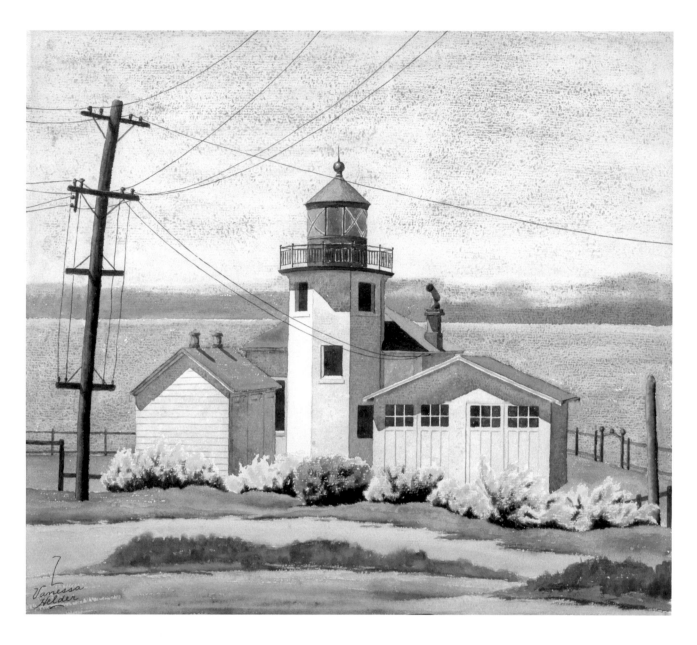

Figure 4
Z. Vanessa Helder (1904–1968)
Alki Point Lighthouse, circa 1935–38
Watercolor and pencil on paper
19½ × 22½ inches (sheet)
Smithsonian American Art Museum, Transfer from the General Services
Administration, 1974.28.154

Bunce left Salem in 1939 and, back in his hometown of Portland, spent several prolific months painting for Oregon's WPA easel project.[8] His paintings of the industrialized banks of the Willamette River demonstrate an expressive freedom and modernist sensibility absent in his Grants Pass mural, an example of how context and locale determined the type of art and the aesthetic norms that could be tolerated within the New Deal. Bunce's canvases of the Portland embankment respond to recognizable

urban locales along the river, rendered in a variant of Giorgio de Chirico's *Pittura Metafisica*. An example is *Seawall* (1939–40; fig. 3), an invented scene on a small plaza that still exists at the foot of the Hawthorne Bridge. Bunce's use of de Chirico's strongly cast shadows, stage-like setting, and industrial buildings and smokestacks on the horizon speaks of the international coinage of *Pittura Metafisica*, while the bridge and structures are recognizable Portland landmarks. International art and local infrastructure are joined, and in a rare instance in New Deal art, poverty is also acknowledged in the form of the homeless family huddled in the foreground.

Meanwhile, in Seattle, Helder rendered that city's streets and buildings in WPA-sponsored watercolors and lithographs that paralleled Bunce's Portland scenes but in

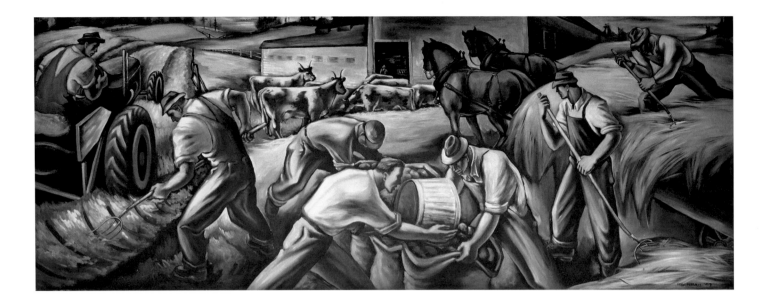

Figure 5
Carl Morris (1911–1993)
Agriculture (one from a two-panel mural), 1941–43
Tempera on canvas
6 feet × 15 feet 7 inches
Eugene, Oregon, Post Office
Courtesy of United States Postal Service. © 2019 USPS

a quite different aesthetic. Her watercolor of the Alki Point Lighthouse at the southern entrance to Seattle's Elliott Bay (circa 1935–38; fig. 4), for instance, renders the structure in terms of geometry, clarity of planes, and crystalline light. The work is in the spirit of Charles Sheeler's classical precisionism rather than de Chirico's protosurrealism that inspired Bunce. Helder's crisply rendered lithographs of telephone poles lining Beacon Avenue and a house at the top of stairs on Yesler Way (both circa 1935; Newark Museum of Art) are other beautiful examples of her work reflecting the New Deal's mission to support art that acknowledges the local.

Helder's appointment in 1939 as an instructor at the Spokane Art Center immersed her in a type of landscape entirely different from the western side of Washington. She found that the austere terrain of eastern Washington aligned with her aesthetic of strong forms sharply delineated in clear light. She was particularly attracted to the Grand Coulee Dam construction project on the Columbia River northwest of Spokane, and independent of the WPA she painted a series of watercolors of the dam's structures, mechanical equipment, and terrain that comprise, in her own estimation, her most significant body of work (see page 137, fig. 35).[9] Here was a case of a New Deal initiative

creating opportunity outside government patronage: it was Helder's residency at the Spokane Art Center that afforded her proximity to a subject that inspired her greatest work.

Helder and Bunce were close contemporaries, born in 1904 and 1907, respectively, but for Helder the Grand Coulee paintings were to be the pinnacle works of her career while Bunce's embankment scenes were steppingstones to his full-blown modernism in the 1950s, '60s, and '70s. Creative accomplishment made possible by the New Deal represented different degrees of significance in the careers of individual artists.

Carl Morris, the first director of the Spokane Art Center, paralleled Bunce's experience by moving on from art center work to other New Deal art opportunities. Morris painted his two murals for the Eugene, Oregon, Post Office as vivid and muscular versions of what the historian Sharon Ann Musher refers to as "art as enrichment." Advocates and practitioners of the enrichment approach encouraged realistic painting that "celebrated the American scene," conveying messages "about the nation's strength [to] remind Americans of their own resilience and help them cope with daily life during the Depression."[10]

Morris's Eugene murals *Lumber* and *Agriculture* (1941–43; fig. 5) depict healthy, robust men leaning into their work in rhythmic union with their machines, tools, horses, and resources (timber, wheat). These men are engaged in processes they know well, whether in fertile fields or a humming sawmill. The message that Americans know how to work hard and by implication are capable of

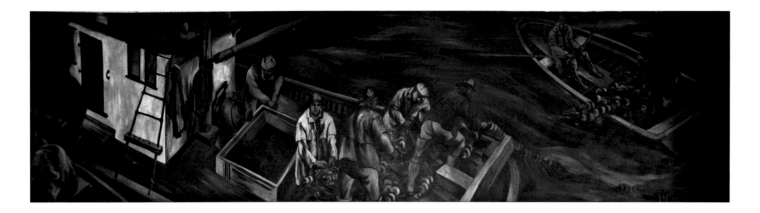

Figure 6
Kenneth Callahan (1905–1986)
Fishing, 1939–40
Oil on canvas
4 feet 6 inches × 16 feet
Anacortes, Washington, Post Office
Courtesy of United States Postal Service. © 2019 USPS

lifting themselves and the country out of economic crisis is clearly conveyed in these murals that are beautifully if traditionally painted, the realism underpinned by the abstract rhythms of circles, curves, and diagonals, and the interplay of light and shadow.

Variations of these subjects occur in other post office murals such as, in Washington, Kenneth Callahan's *Industries of Lewis County* in Centralia and *Fishing* in Anacortes. Like Bunce and Morris, Callahan would emerge as one of the Northwest's leading modern painters, and he brought a degree of original invention to his murals. *Industries of Lewis County* (1937–38; see page 84, fig. 22) climbs its way around a door in the middle of the wall, using a stacked compositional approach that can be traced back to pre-Renaissance Italian frescoes. Avoiding the unified perspective that Morris employed in Eugene, Callahan presents separate vignettes of a dairy operation, poultry farming, lumbering, field planting, and carpentry. Quite in contrast compositionally is his *Fishing* (1939–40; fig. 6), in which the point of view is steeply from above, looking down on fishermen in their boats—cropped, diagonal forms that differ from the more typical front-on compositions of New Deal post office art.

In Ambrose Patterson's mural *Local Pursuits* (1936–38; fig. 7), originally for the Mount Vernon, Washington, Post Office, agriculture and food processing are set side by side as linked enterprises. A farmer tills his field with a

horse-drawn plow while cows graze in the middle ground, and a red-roofed barn and red silo draw our eye out across the Skagit Valley. Another farmer delivers produce to the processing plant, which occupies the left two-thirds of the composition. The plant is partly open-air, with a furnace-like cooker being tended by two men and a woman. All five figures, like those in Morris's Eugene murals, lean into their work in accordance with public art in support of economic recovery.

Aesthetically, Patterson's mural evokes children's book illustrations of the era with its clear, simplified renderings of closely observed details and forms (the giant cooker is a wonder) and the earnest innocence of the workers as they go about their duties. At the same time, Patterson's geometric shapes, smooth surfaces, and detailed description of the mechanics of the processing machine align with the work of such 1920s European moderns as the French purists Fernand Léger and Le Corbusier. Patterson, who had studied art in Australia and Paris and established the School of Painting and Design at the University of Washington in 1919, brought to New Deal art a modernist sensibility that in a work such as *Local Pursuits* he combines with anecdotal description. The result is an aesthetic of direct appeal that merges storybook charm and international modernism.

A variation of this fusion of naivete and sophistication occurs in the work of Albert C. Runquist, as in *Loggers and Millworkers* (1939–41; see page 89, fig. 30), his mural for the Sedro-Woolley, Washington, Post Office, in which workers tug, saw, and chop logs in the foreground and stack lumber in the middle ground, while in the distance a mill operates at full tilt, smoke belching from its tall stack. With its specifically rendered details of architecture, piled lumber,

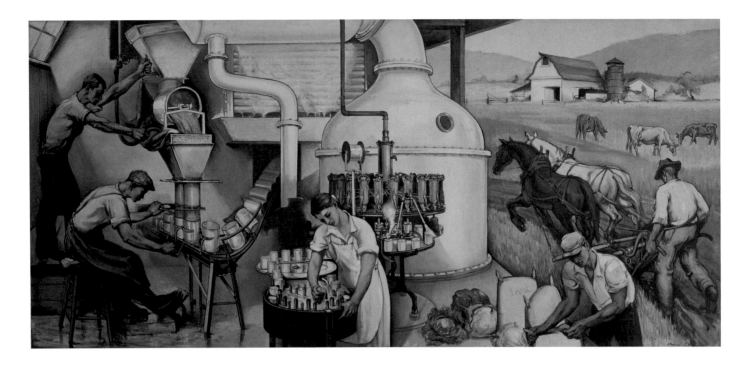

Figure 7
Ambrose Patterson (1877–1966)
Local Pursuits, 1936–38
Oil on canvas
5 feet 3 inches × 11 feet
Mount Vernon, Washington, Post Office
Courtesy of United States Postal Service. © 2019 USPS

This mural is now at Skagit Valley College, Mount Vernon.

and outsize ferns and leaves, one can think of parallels to the work of artists as diverse as Grandma Moses and the French painter Henri Rousseau.

The worker's world of mining is the subject in some post office murals. For Kellogg, Idaho, home of the Bunker Hill mining and smelting operation, Fletcher Martin proposed a mural entitled *Mine Rescue*, for which the study (1939; see page 21, fig. 2) survives. In a heavily timbered tunnel, two men carry an injured third, who lies prone on a stretcher, one arm dangling over the side. The ordered structure of posts and beams, the prismatic rock faces, the ore cars on the tracks that curve to form the front edge of the composition—all provide a closely focused setting for a dramatic moment quite common to the deep-mine operations of the Idaho panhandle: the region's history is rife with injuries and deaths underground.

Mine Rescue, favored by the miners' union, was rejected by Bunker Hill officials as being too realistic a depiction of the dangers of underground mining.[11] In its stead, Martin hastily painted *Discovery* (1940–41; see page 21, fig. 3), a

goofily theatrical mural of two prospectors and their jackass (Kellogg fondly describes itself as having been founded by Noah Kellogg and his jackass) coming upon pay dirt. In a landscape of branches and snags, two prospectors adopt exaggerated poses of surprise and delight. The ass, standing on top of the postmaster's door, seems to doze. Kellogg lost out on receiving a powerful, locally relevant painting when *Mine Rescue* was replaced by the mediocre *Discovery*, a situation that makes clear that politics and power could thwart good art within the New Deal.

Unlike Bunce, Morris, Callahan, and Patterson, who all became iconic figures in the modern art of the Pacific Northwest, Martin was from California and remained in the Northwest only briefly. As with other New Deal artists who were brought to regions underserved by artists, his case illustrates the hazards of identifying regional aesthetics since he had no lasting ties to the region.[12] Still, in losing *Mine Rescue*, Kellogg was deprived of a work that could have stimulated grassroots artistic development in northern Idaho.

It needs to be said, at the same time, that transplanting artists to outlying regions could have lasting benefits. Morris, a California artist who had studied at the Art Institute of Chicago and in Europe, was recruited for the art center in Spokane. There he met the New York artist Hilda Deutsch; they married, and as Carl Morris, painter, and Hilda Morris, sculptor, established themselves in Portland as major modernists permanently wedded to the

region. The New Yorker Helen Blumenstiel arrived as an instructor at the Salem Art Center and spent the rest of her life in Oregon, teaching at Linfield College and, at her death, leaving a bequest in support of the Portland Center for the Visual Arts.[13] Although Martin moved on to Iowa, the Morrises, Blumenstiel, and others remained in the Northwest as pillars of regional modernism—embodying another example of the influence of New Deal art programs long after their demise.

The subject matter of New Deal art ranges from scenes of modern life to historical vignette to western romance. Most post office murals in Region 16 represent one of these categories, with historical vignette and western romance often combined in single works, especially in the inland, rural areas. Basic subjects there are settlers traveling west in wagon trains (Elizabeth Davey Lochrie's mural of pioneers on the Oregon Trail in Burley, Idaho, or Edmond Fitzgerald's *The Trail to Oregon*, in Ontario, Oregon, both 1937–38; see pages 70, 78, figs. 5, 14); 19th-century mail delivery (Ernest Norling's 1937 *Mail Train in the 80's* in Prosser, Washington);[14] and building infrastructure in the early settled West (Lance Hart's 1939–40 *The Construction of a Skid Road in the 80's* in Snohomish, Washington; see page 87, fig. 27).

Yet another historical subject is the American Indian, whether as warrior or peaceful dweller on the land. Bunce's *Rogue River Valley* (1937–38; see page 77, fig. 13) in the post office at Grants Pass, Oregon, is an example of the latter: Bunce composes the figures in groups of three or four standing and sitting figures in the foreground of an idyllic landscape. These people are at peace, at ease with one another and their natural surroundings, in an imagined presettlement paradise (Erich Lamade's contemporaneous mural *Early and Contemporary Industries* on the facing wall depicts postsettlement developments; see page 77, fig. 12).[15]

In contrast, Fitzgerald's *The Battle of Bear River* (1941; see page 24, fig. 7) in the Preston, Idaho, Post Office, depicts Native warriors and white soldiers in pitched battle. The scene is a gloss on what is also known as the Bear River Massacre of 1863 in which the US Army attacked a Shoshone encampment near modern-day Preston, killing hundreds of men, women, and children. How this scene of soldiers astride rearing steeds dominating Indians

struggling in the water, a tipi ablaze on the shore, was received in 1941 is unknown, and how it should be interpreted eight decades later is problematic.[16] *The Battle of Bear River* combines history painting with the hyped drama of cavalry-and-Indian movies (the colors are evocative of the Technicolor films new in the early 1940s) so that historical fact is subsumed in dramatic effect, permitting a long-ago atrocity to be experienced as entertainment.

Compared to Fitzgerald's mural, Lochrie's *The Fur Traders* (1938–39; see page 165, fig. 4), painted for the Saint Anthony Post Office in Idaho, presents a nonviolent but nonetheless discomfiting scene of interactions between Indians and white people. Stacked in separate piles are the furs from the Indians and, at center, the fabrics, utensils, and trinkets from the traders. The two groups face each other as their bargaining winds down. The white men are visitors (the Native village is seen in the background) who have arrived with guns at the ready. One group clearly has the upper hand in this transaction.

Native American history paintings created under New Deal auspices are nearly all the work of non-Native artists, but an exception was Andrew Standing Soldier of the Oglala Lakota nation, who painted three murals—*The Arrival*, *Celebration*, and *The Round-Up* (1938–39; see pages 162, 167, figs. 1, 6)—for the Blackfoot, Idaho, Post Office. The scenes relate to Bunce's mural in the Grants Pass Post Office in their depiction solely of Indian tribal members; white people are not present at this gathering to celebrate the seasonal round-up and branding of cattle. But buckboards and cowboy-style dress tell us of the influence of white settlement on Indigenous peoples, in contrast to Bunce's vision of a presettlement arcadia. Standing Soldier's mural can be understood as an acknowledgment of a tribe's assimilation of elements of white culture into its own traditions of seasonal gathering and celebrating. Tipis and buckboards are spread through the composition, at home with each other and with the sagebrush and rocks set against a unifying backdrop of distant mountains.

Native American culture withstands, more or less, 20th-century industrial reality in Forrest Hill's *Montana's Progress* (1941–42; fig. 8) in the post office in Glasgow, Montana. Here, figures of pioneers and Native Americans, all rendered in subdued colors suggesting dimming

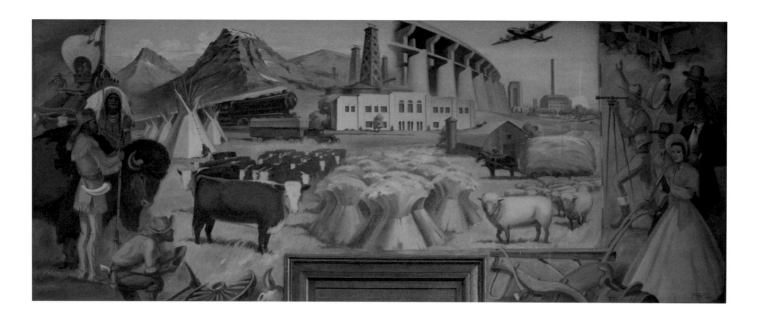

Figure 8
Forrest Hill (1909–death date unknown)
Montana's Progress, 1941–42
Oil on canvas
6 feet 6 inches × 15 feet 10 inches
Glasgow, Montana, Post Office
Courtesy of United States Postal Service. © 2019 USPS

memories from long ago, provide the frame for the brightly colored and illuminated center scene (in the shape of the map of Montana) of the state in modern times. A somewhat overwhelmed but still rugged landscape is the setting for a speeding train, a cargo truck, and the Fort Peck Dam and electric power plant, which rival in mass and scale the towering mountains beyond. An airplane soars overhead. Agriculture flourishes in the form of a barn and silo, herds of cattle and sheep (on different sides of the composition, to be sure), and countless sheaves of wheat at center that evoke fertile fields and bountiful crops. Also in this new Montana, albeit a distant detail, is a cluster of tipis, a nod to the survival of Indian culture despite everything else.

Although New Deal art programs offered opportunities for women, several Native American artists in addition to Standing Soldier, and a handful of Asian American artists, aesthetic diversity found in New Deal art is generally not the result of cultural differences but of variety based on region and locale. This variety is explained in part by the fact that the Pacific Northwest, though perceived as a single entity when identified as Region 16 for New Deal purposes, is at least two quite separate regions: the West (Idaho and Montana) and the Pacific states (Washington and Oregon, especially their westside urban zones).

To the east, in rural areas of the West, the storied and romanticized past of settling the land and unsettling Indigenous populations captured the imagination of local communities who saw such epochal subjects as appropriate for public art in their hometowns. Artists both from outside the region and from within it painted in support of the pioneer myth of how the West was won. For these subjects depicting an idealized past, they painted in an accomplished, traditional style that relates their work to American history painting, the models for which were provided as early as the 18th century by Benjamin West (*Penn's Treaty with the Indians*, 1771–72; Pennsylvania Academy of the Fine Arts) and John Trumbull (*The Death of General Warren at the Battle of Bunker's Hill*, after 1815–before 1831; Museum of Fine Arts, Boston).

It's clear that the aesthetics of New Deal painting in the Pacific Northwest encompass styles that extend 18th- and 19th-century narrative realism as well as those that adapt or allude to modern art in this country and abroad—whether Italian *Pittura Metafisica*, French purism, American precisionism, or in some cases surrealism. By and large, New Deal artists who ventured toward the avant-garde chose styles that involved clear, simplified forms that could yield easily recognizable figures, structures, landscape features, and supporting details—a wonderful leaf pattern, tractor wheels and horses' rumps, the beautiful cylindrical tube of a racing locomotive.

But innovation and variety occurred within the circumscribed goal of New Deal patronage—to create for the people an art that exists within centrist aesthetic territory. The combination of freedom and constraint that New Deal art embodied resulted in a mass of artworks that established American art as necessarily middle-American, lively and varied (and to modern-day eyes fascinating) but conservative. This made the full outbreak of modernism during World War II, in the aftermath of the New Deal, all the more startling as European artists immigrated to New York and seeded an avant-garde that almost immediately overshadowed and even eclipsed the government-sponsored art that had held sway only months before. And yet, exploring Region 16 just as an example, we can find intimations of modernism in New Deal art even though the intimations are embedded in variations of realistic scene painting. Protomodernism tempered by a populist aesthetic coincided with traditionalism extending into the distant past, and therein lies the richness of New Deal art in Region 16 and beyond.

Whatever the aesthetics may have been for individual New Deal artists in the Pacific Northwest and throughout the nation, the shared imperative was to create art in a time of crisis that would appeal to, comfort, and even charm a general audience enduring hard times. Breaking new ground aesthetically was beside the point. The goal was to communicate with the populace, the makeup of which could vary enormously from town to town, from one locale to another, and from state to state—especially in the New Deal's vast Region 16, made up of numerous areas as diverse as the art created in them and for them.

NOTES

1 Roger Saydack, *Price: A Portrait* (Salem, OR: Hallie Ford Museum of Art, forthcoming).

2 Charles Heaney, in Roger Hull, *Charles E. Heaney: Memory, Imagination, and Place* (Salem, OR: Hallie Ford Museum of Art, 2005), 38.

3 Lucinda Parker, artist's talk, University of Oregon, October 25, 2016, quoted in Roger Hull, *Lucinda Parker: Force Fields* (Salem, OR: Hallie Ford Museum of Art, 2019), 118.

4 Victoria Grieve, *The Federal Art Project and the Creation of Middlebrow Culture* (Urbana: University of Illinois Press, 2009), 151.

5 Mark Humpal, *Ray Stanford Strong: West Coast Landscape Artist* (Norman: University of Oklahoma Press, 2017), 94.

6 David F. Martin, "Lucid Dreams: Z. Vanessa Helder and the Rendering of Reality," in Margaret E. Bullock and David F. Martin, *Austere Beauty: The Art of Z. Vanessa Helder* (Tacoma: Tacoma Art Museum, 2013), 28.

7 Barbara J. McLarty, ed., *Lillie Helvi Lauha: An Oregon Collector* (Portland, OR: McLarty's Choice, 2001), 7.

8 In early 1940 Bunce and his wife moved to New York, where he managed to affiliate with the WPA program there—Bunce surely being one of the most mobile of artists within the New Deal art initiatives.

9 Bullock and Martin, *Austere Beauty*, 49. Helder's Coulee Dam watercolors are in the collection of the Northwest Museum of Arts and Culture/Eastern Washington State Historical Society, Spokane.

10 Sharon Ann Musher, *Democratic Art: The New Deal's Influence on American Culture* (Chicago: University of Chicago Press, 2015), 65.

11 Stanley A. Easton, President, Bunker Hill and Sullivan Mining and Concentrating Company, to Federal Works Agency, November 9, 1939, and Kellogg Chamber of Commerce to Federal Works Agency, November 6, 1939, Kellogg—P.O. (ID); Entry 133, Textual Records of the Section of Fine Arts, Public Buildings Administration, and Its Predecessors, Case Files Concerning Embellishments of Federal Buildings, 1934–43 ID–IL, Box 19; Records Concerning Federal Art Activities; Records of the Public Buildings Service, Record Group 121; National Archives at College Park, College Park, MD.

12 See Margaret Bullock's discussion in the present volume, page 103.

13 The Portland Center for the Visual Arts, founded by Portland artists to present the work of major artists from beyond the Northwest, was a key presence in the city's art scene from its founding in 1971 to its closing in 1987.

14 The title is given as *Mail Train—1885* on the data sheet from the artist on file at the National Archives. Section of Fine Arts contract with Ernest Norling for the Prosser, Washington, Post Office, April 11, 1937; Prosser—P.O. (WA); Entry 133, Textual Records of the Section of Fine Arts, Public Buildings Administration, and Its Predecessors, Case Files Concerning Embellishments of Federal Buildings 1934–43 WA Lynden–Wenatchee, Box 112; Records Concerning Federal Art Activities; Records of the Public Buildings Service, Record Group 121, National Archives at College Park, College Park, MD.

15 Bunce originally proposed a violent battle scene from the Rogue River War of 1850, which was rejected. See Margaret Bullock's discussion in the present volume, page 76.

16 See Philip Stevens's essay in the present volume, page 164.

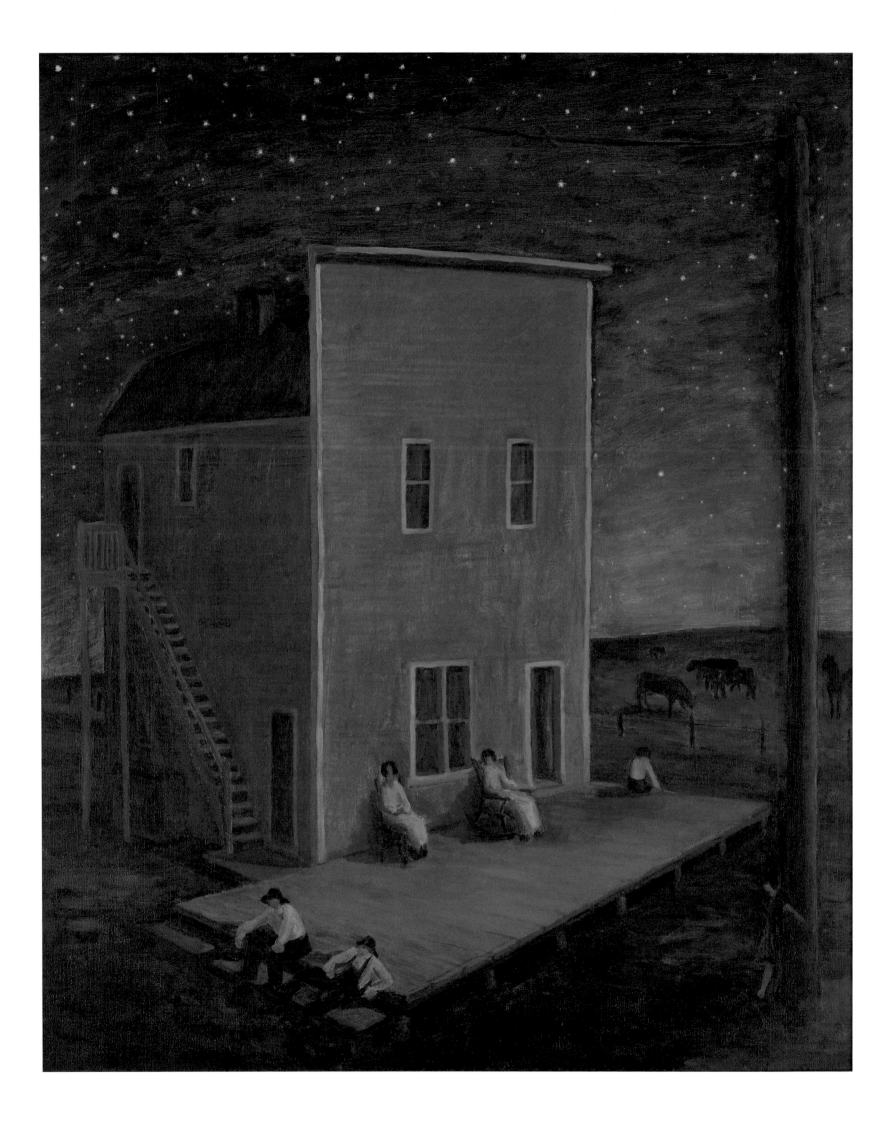

THE PUBLIC WORKS OF ART PROJECT

MARGARET E. BULLOCK

The first of the New Deal art projects began tentatively. Under the Federal Emergency Relief Act of 1933, the Civil Works Administration (CWA) was created to provide jobs to a broad swath of Americans, many through public works projects such as the construction of highways, dams, schools, and government buildings. Art-related jobs were not part of the original plans. Ideas for their inclusion began to percolate, however, through the advocacy of artist groups as well as sympathetic government administrators and influential friends of President Franklin Delano Roosevelt and Eleanor Roosevelt. Notably, George Biddle, an artist and lawyer who was an admirer of the public murals he had seen in Mexico, approached President Roosevelt suggesting a program to add similar works to US government buildings. Biddle was encouraged to speak to administrators in the Treasury Department, where he captured the interest of Lawrence Robert and Edward Bruce. Together they created a plan to employ artists to provide artworks for public buildings and government offices. The Public Works of Art Project (PWAP) was launched with an initial budget of $1 million in early December 1933, under the direction of Edward Bruce and Forbes Watson, an art

Dora Erikson (1905–death date unknown)
Dakota Hotel, 1933–34
Oil on canvas
35⅞ × 29½ inches
Portland Art Museum, Portland, Oregon, Courtesy of the Fine Arts Collection, US General Services Administration, New Deal Art Project, L34.2

critic. It was a quiet revolution in government attitudes. Art making not only was treated as a legitimate profession rather than a luxury for private patrons but also was embraced as an important component of national culture and a key resource for boosting public morale.[1]

The administrative structure of the PWAP became the model for the other art projects that followed. The country was divided into 16 regions, some encompassing a single state, others clusters of states. The Northwest, designated as Region 16, included Idaho, Montana, Oregon, and Washington. Each region had a director and an advisory board composed of respected figures in the arts who helped select the tasks to be undertaken and the artists to be employed. Names were acquired by recommendation, through artist applications, and from the lists of those who had officially applied for government relief. Every state also had an advisory committee that worked at the community level, adding to lists of eligible artists and identifying tax-supported organizations that might be interested in receiving PWAP artworks. Artists were paid a weekly wage ranging from $26.50 to $42.50, depending on their expertise and the scope of the job for which they were hired, and received an additional sum of up to 10 percent of their wages for buying materials. Organizations requesting work also were asked to help with the costs of supplies if possible.

The PWAP was launched almost overnight. On December 10, 1933, the same day it was authorized by

Congress, Bruce and Watson began sending telegrams to the regional offices of the Federal Emergency Relief Administration (FERA), asking for the names of artists on the relief rolls. They also reached out to a variety of governmental and nongovernmental contacts for suggestions of arts figures in their area who might head the regional and state PWAP committees. Almost as soon as candidates for regional directors were suggested, a telegram was on the way inviting their participation and encouraging them to form their committees immediately.

Since the PWAP was envisioned as a short-term economic stimulus, a number of approaches were used to get money into the hands of artists as quickly as possible. In a telegram sent to all regional directors they were given broad latitude:

> Work may include embellishment of Federal and other publicly owned buildings throughout the country such as buildings supported wholly or in part by tax funds and also public hospitals land grant colleges custom houses court houses Federal and State buildings on Indian reservations public schools municipal museums and zoos municipal libraries, etc.[2]

Artworks for these buildings were a mix of purchases, new commissions, and artist donations. Some artists also were assigned to the Civilian Conservation Corps (CCC) camps to document activities. There were certain standards and restrictions to be met. Directors were advised to instruct artists to focus on "the American scene," that is, images from the history and everyday life of each region, though they were given some leeway for special projects.[3] Artists were to be clearly informed that they were government workers and the art created was government property.

Structural and philosophical issues within the PWAP foreshadowed debates that would complicate the other New Deal art projects. The largest was whether the PWAP was meant primarily to employ artists registered on the federal relief rolls or, more broadly, to find work for any artists in need. Harry Hopkins, the administrator of FERA, believed that anyone registered for government assistance who identified as an artist should be employed,

regardless of skill. Bruce, on the other hand, wanted to hire only artists of real ability and preferably with some experience, and was quite adamant with regional directors to avoid calling the PWAP relief work.[4] His primary aim was to ensure that all art created was of good quality, not only because he believed it was important that everyone experience art in their everyday lives but also because he hoped that if the PWAP was successful, it would encourage the Roosevelt administration to consider a larger and longer-term federal art project.[5] His concerns reflected a real challenge in having to choose artists from the relief rolls, where anyone from a professional to a hobbyist could be identified as a qualified artist; it was often a problem to find enough artists with sufficient expertise to fulfill project needs who were also registered for government relief.

The other difficulty that beset all the New Deal art projects was the entwining of personal politics with the committee structure. Professional jealousies, aesthetic preferences, political leanings, organizational affiliations, and personal conflicts all played a part in the formation and function of the various advisory committees as well as some of the public responses to the art created. The mix of longtime government employees, short-term hires, and volunteer participants involved in the PWAP added further to the challenges of efficiently and effectively running the program. Disputes recorded in the archives and the press range from the writing of poison-pen letters about successful rivals to community protests that led to the reworking or removal of artworks. Despite these hurdles, the PWAP proved resilient and had a substantial impact on locales across the country.

The PWAP in the Northwest

The director chosen for Region 16 was Burt Brown Barker, vice president of the University of Oregon in Eugene and a noted historian and philanthropist (fig. 1). He was a Harvard-trained lawyer who had practiced in Chicago and New York and then returned to his native Northwest in 1928, settling in Portland and devoting his life to public service. He accepted the position on the PWAP for the symbolic salary of one dollar per year, the same as his salary at the University of Oregon.

Figure 1
Photographer unknown
Burt Brown Barker, Historian and Vice-President of the University of Oregon,
January 21, 1936
Gelatin silver print
5 × 4 inches
Oregon Historical Society Research Library, #00446

For his state committees Barker culled from an array of sources: colleges, museums, and architectural firms but also the worlds of law, business, and art. These committees were meant as booster and advocacy groups, so a broad range of participants was preferable. Outside of reporting their names to Bruce, Barker rarely mentions them again in his correspondence with the DC office, indicating they were not actively involved in his administrative decisions. However, the variety and reach of the PWAP projects, particularly in Oregon and Washington, prove they were quite active locally.

Region 16 was allocated $32,500 and given a maximum quota of 50 senior or professional artists (Class A) and 25 assistants and trainees (Class B).[6] In a letter to Bruce, Barker described how the regional advisory committee functioned and their intense commitment:

> This committee meets every day except Sunday. . . . Every artist appears in person. He submits a sample of his work. He is questioned as to his need and experience. After the artist is chosen, he must bring his work to the committee for inspection. First, we ask him to bring in his sketches and then the work as it progresses. In this way, we know exactly what each artist is doing. In addition to this, the members of our committee visit the various artists in their studios. . . . Working thus with the artists, as we do, personally, seeing them in their homes and studios, we come to have a pretty fair conception of the need, and now that the work is reaching its culmination, we likewise are getting a pretty clear conception of the capabilities of the artists.[7]

He continued on in his eight-page letter to describe all the individual tasks of the committee, their travels to meet artists throughout the region, and a number of works in progress. The level of enthusiasm and dedication is astonishing considering that all the committee members also had demanding professional jobs.

Despite Barker's attempts to avoid complaints and intergroup battles, they were inevitable. In Washington State, for example, the artist, art critic, and Seattle Art Museum curator Kenneth Callahan wrote a letter to

Barker moved swiftly to form his regional advisory committee. He deliberately selected people with ties to the Northwest art scene but who were not actively involved with particular groups in order to forestall conflicts and accusations of favoritism. He chose Ellis Lawrence, the dean of the School of Fine Arts of the University of Oregon; Robert Dieck, an engineer and former chairman of the Portland Art Commission; and H. M. Tomlinson, a prominent judge and former head of the Society of Oregon Artists. Later, after prompting from Bruce, Barker added Harry Wentz, an artist and longtime instructor at the Portland Art Museum's school.

Watson expressing his displeasure that the regional headquarters were in Portland rather than Seattle, dismissing Barker's chosen state committee members for Washington as unqualified, and suggesting his own candidates.[8] Unbeknownst to him, Barker had already been in touch with the men Callahan suggested, and they had helped him choose the state representatives for Washington.

Furthermore, there were critics of the quality of the artwork created on the PWAP who felt the scramble to get as much done as possible in the five short months it existed was energy that could have been spent elsewhere. After viewing an exhibition of PWAP artwork, the curator of the Portland Art Museum, Anna B. Crocker, opined:

> It seems to me there have been the faults natural under the circumstances—the main troubles being too little sensible and helpful evaluation, a good deal of misunderstanding and a considerable amount of uneasy criticism—both just and unjust. . . . There was plenty of good technique and accomplishment of that order, but the paintings seemed so lacking in spontaneous expression of artistic feeling (again to be expected under the circumstances but none the less unacceptable) that I found myself shunning the gallery where these paintings hung.[9]

For the most part, however, the PWAP was enthusiastically embraced by the region's artists, even those who received only a few days' work. Major institutions lined up for commissions, and the public schools in particular benefited from a bounty of artwork and arts-related projects (see Appendix 2, page 221).

Idaho

The PWAP in Idaho was fairly small, employing 21 artists in all. The chairman of the state committee was T. J. Prichard, head of the Department of Art and Architecture at the University of Idaho, Moscow. The remaining members came from across the state, including Mrs. Willard W. Burns, president of the Boise Art Institute; Catherine Crossman, head of the Art Department at Boise Junior College; Dale Goss from Kellogg High School; Mrs. J. A. Howser, president of the Art and Travel Club of Pocatello; and community members Lewis Ensign of Boise and Raymond Wilder of Kellogg.[10]

To date, only very limited information has been found on the artworks created for the Idaho PWAP. Olaf Moller, who had trained at the Pennsylvania Academy of the Fine Arts with N. C. Wyeth, painted three fanciful and rather daring scenes illustrating the fairy tale *The Little Mermaid* for the children's room of the Boise Public Library (now privately owned) (1934; fig. 2). One painting by the western artist Cecil Smith was allocated to the governor's office (see page 210). Records also show that Donald Joice, a University of Idaho graduate, taught art classes in the Potlatch area. Herbert Steiniger, another university alumnus, is known to have created sculptures and paintings, though how many and where they went are not known. When the PWAP ended, sets of prints were donated to the University of Idaho and the State Normal School (now Lewis-Clark State College) in Lewiston. They have not been located, so it is unknown if they were works by Idaho artists or those from other states.

The University of Idaho played the leading role in the Idaho PWAP, as it was the primary art-focused institution in the state. Half of the artists working in Idaho were based out of Moscow and had some tie to the university's art department as faculty, alumni, or students. The university continued its prominent role in the later Federal Art Project. There was no major museum in Idaho to call upon until the founding of the Boise Art Museum in 1937.

Although the Idaho PWAP was not extensive, its impact on the lives of artists was meaningful. As committee member Ensign noted, "The Art Project in this territory, has been very valuable in that it has helped a few artists of ability at a time when they were greatly discouraged. It is fortunate . . . the government has opened the way in this art project to help a few men of ability carry on in these difficult times."[11]

Montana

The Montana PWAP was the smallest in Region 16, employing only seven artists. The committee consisted of Fred F. Willson, an architect from Bozeman; Frederich

Figure 2
Olaf Moller (1901–1985)
The Little Mermaid (one from a three-panel mural), 1934
Oil on canvas
5 feet 5 inches × 9 feet
Boise Public Library (now privately owned)

Scheuch, an architect and a professor at the State University of Montana (now University of Montana), Missoula; and W. P. Pleu, a professor of agriculture at the Montana State Agricultural College (now Montana State University), Bozeman.[12]

One of the first projects proposed was a memorial for the much-loved western artist Charles M. Russell, who had died in 1926. Although it was backed by the Montana branch of the American Artists Professional League and a resolution from the Montana State Legislature, Bruce's response was unequivocal: "We can not [sic], within the scope of our Public Works of Art Project, use any of our funds for a building or memorial as our expenditures are limited to the employment of artists and supplying the materials necessary for the production of their art."[13]

The one large project that was commissioned, in 1934, was a six-panel mural tracing the history of the lumbering industry in Montana for the School of Forestry building (now the Gifford Pinchot Hall of Forestry) at the University of Montana in Missoula (fig. 3).[14] Irvin Shope, a painter of western subjects and cartoonist, was selected. He had an eclectic background, including a stint as both a forestry and a fine arts student at the university. Shope completed three panels under the PWAP but was unable to finish the others in the few months allotted. In 1935 he was given a commission under the Federal Art Project to continue his work but took a job elsewhere. The remaining three panels were not completed and installed until the 1950s. The murals are still in place today in the main stairwell of the building.[15]

Figure 3
Irvin Shope (1900–1977)
Granville Stuart Coming up the Bitterroot (details), 1934
Oil on canvas
79 × 66 inches, each panel
Gifford Pinchot Hall of Forestry, University of Montana, Missoula

Figure 4
Stanley Martineau (1915–1977) with his plaque for the University of Montana library, from *Great Falls Tribune*, May 21, 1934, page 5

Two other artworks were commissioned for the university's library in 1934. The 19-year-old sculptor selected, Stanley Martineau, already had a reputation as a skilled portraitist as well as having a rather colorful second life as a prizefighter in the Missoula area. For the library he was hired to create a ceramic relief plaque depicting a story from the lives of Granville and James Stuart, early Montana gold miners and explorers. Rather than a traditional pioneer motif of struggle or triumphant arrival, the subject was geared to its library setting: the brothers, culturally starved from a long winter in the wilderness, are shown arranging to purchase books from a Hudson's Bay Company trader (fig. 4).[16]

Martineau then sculpted a grouping of Meriwether Lewis and William Clark, with Lewis gazing contemplatively into the distance and Clark seated, holding a map. The local newspaper noted that the buckskin garments worn by the figures were modeled on ones owned by the well-known western painter and Missoula resident Edgar S. Paxson.[17] Both this sculpture and the plaque of the Stuarts are currently unlocated. After leaving Montana, Martineau continued to attract attention. He was selected to create a bust of President Roosevelt in 1938, then appeared in the papers a few years later after eloping with a recently divorced millionairess. He later served a key role during World War II in the top secret Ghost Army, officially known as the 603rd Engineer Camouflage Battalion, alongside the designer Bill Blass and the artist Ellsworth Kelly, among other well-known figures.

The records say little else about artworks created for the Montana PWAP or those who made them. It is worth noting, however, that the small group of artists employed on the Montana PWAP was a diverse mix. There were two women, including Dorothea Donovan, who, departing from favored

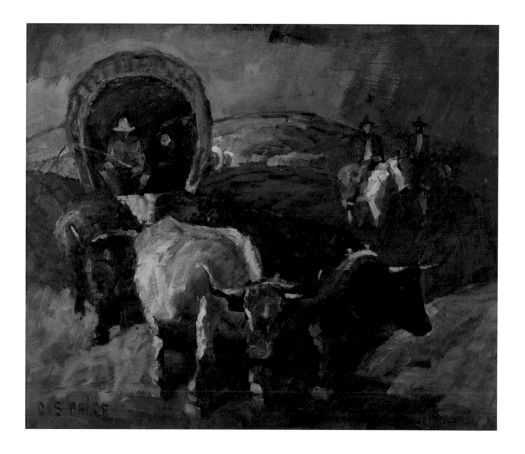

Figure 5
C. S. Price (1874–1950)
The Covered Wagon, circa 1934
Oil on canvas
30¼ × 36 inches
Portland Art Museum, Portland, Oregon, Courtesy of the Fine Arts Collection,
US General Services Administration, New Deal Art Project, L55.27

images of landscapes and western subjects, painted scenes of Montana industries.[18] The list also included Cutapuis, known on the project as John Louis Clarke, an artist from the Blackfeet Tribe. Mostly self-taught, Clarke worked in a variety of media but was best known for his wildlife carvings. A few details about some of his sculptural commissions for later New Deal projects under the Indian Arts and Crafts Board and Indian Health Service are known (see page 111), but there is currently no information on his PWAP works.[19]

Oregon

As the headquarters for Region 16, Oregon was a highly active area, particularly Portland. Artists were at work in the state by December 18, less than a week after Barker accepted the directorship. The regional committee also served as the Oregon state committee, which simplified and sped up preparations since the members were already familiar with many of the artists and their work.

The Oregon PWAP employed 128 artists, about 40 percent of whom were women, a notable percentage as nationwide only about 16 percent of the artists on the PWAP were female.[20] Most of the artists lived in Portland or its immediate surroundings, with the remainder concentrated in Salem, Corvallis, and Eugene, where there were art departments in local universities. The list is a snapshot of the Oregon art community and illustrates the PWAP committee's commitment to benefiting as many artists as possible. The names include a variety of established and respected painters such as the landscapist Eliza Barchus, the portraitist Sidney Bell, and the impressionist C. C. McKim, as well as the modernists C. S. Price and Edward Sewall (figs. 5, 6). Those just beginning their careers but destined to become key figures in the Oregon art world were Louis Bunce, William Givler, Aimee Gorham, Charles Heaney, and Erich Lamade (fig. 7), to name a few.

There are no accurate counts of work produced in Oregon, but an exhibition at the Portland Art Museum held in May of 1934 after the PWAP had ended included 108 oil paintings, 72 watercolors, 59 sculptures and

Figure 6
Edward Sewall (1905–2000)
Farm Scene, 1934
Oil on canvas
25¾ × 31¾ inches
Horner Collection, Benton County Historical Society, Courtesy of the Fine Arts
Collection, US General Services Administration

Figure 7
Erich Lamade (1894–1969)
Paper Mills, Willamette River, Oregon City, Oregon, 1934
Oil on canvas
29½ × 35½ inches
Horner Collection, Benton County Historical Society, Courtesy of the Fine Arts
Collection, US General Services Administration

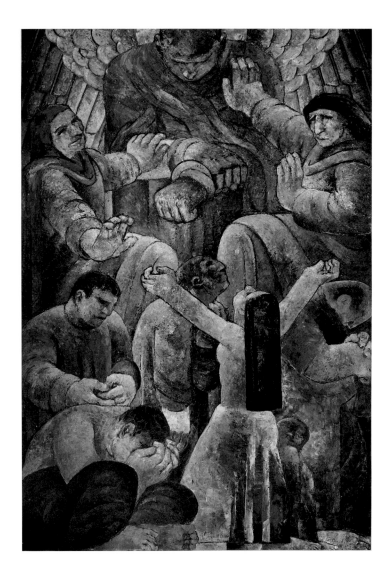

Figure 8
Darrel Austin (1907–1994)
Ignorance (one from a four-panel mural), 1934
Oil on canvas
96 × 72 inches
University of Oregon Medical School, Portland (now lost)
Courtesy of Oregon Federal Art Project 1935–1943, John Wilson Special
Collections, Multnomah County Library, Portland, Oregon

woodcarvings, and 39 works in other media.[21] Beyond the works in the exhibition there were a number already allocated to various institutions both in Oregon and in other states, and a variety of site-specific commissions. Taken together, a conservative estimate of the total number of artworks created by Oregon PWAP artists is around 350 to 400 during the five months of the program.

Part of the Oregon PWAP's success sprang from partnerships with a variety of institutions. One of the notable projects was a large four-panel mural (each 8 feet high by 6 feet wide) titled *The Evolution of Medical Education*

by Darrel Austin, painted in 1934 for the University of Oregon Medical School (now the Oregon Health and Science University) in Portland (fig. 8).[22] Austin was a commercial artist and painter who had trained with the muralist Emil Jacques in Portland and later at the University of Notre Dame in Indiana. Through Jacques, he came to know the Oregon modernists Heaney and Price, who were important stylistic influences. Though the Medical School murals are now lost and known only from black-and-white photographs, Austin also did a series of thematic paintings the same year (*Science and Chemistry*, *Architectural Drawing*, *Social Science*, and *Machine*) for Oregon State College (now Oregon State University) in Corvallis, which are today in the collection of the Benton County Historical Society. These works display the simplified blocky style and earth-toned palette typical of Austin in this period, offering a glimpse into how the missing murals might have looked (fig. 9).

Figure 9
Darrel Austin
Machine, 1934
Oil on canvas
35½ × 35½ inches
Horner Collection, Benton County Historical Society, Courtesy of the Fine Arts Collection, US General Services Administration

The public schools also benefited from allocations of prints, easel paintings, and sculptures as well as a handful of mural commissions. One striking work was a large mural in the auditorium of Hood River Middle School by the landscapist Percy Manser. Titled *How Manifold Are Thy Works, The Earth Is Full of Thy Riches* (1934; fig. 10), the painting spans the proscenium arch over the stage with brightly colored images of Native peoples and the arrival of covered wagons on the left and farmers at work on the right.

Another commission that year, now known only from photographs, was a series of watercolors of scenes from fairy tales created for Doernbecher Memorial Hospital for Children (now Doernbecher Children's Hospital) in Portland by the children's book illustrator Margot Helser. These illustrated a variety of classic tales, notably those by Hans Christian Andersen (see fig. 11 for a related work).

One of the most spectacular works created on the Oregon PWAP was *Oregon Vistas* (1934; figs. 12, 13), a pair of wood triptychs, each measuring 9 feet high by 9 feet wide,

for the newly constructed library at the University of Oregon depicting activities of the CCC. These highly detailed relief sculptures were carved in cedar wood by Arthur Clough, assisted by Jim de Broekert and Ross McClure, who called themselves the Grey Gypsy Craftsmen. Existing accounts are somewhat confused as to the sequence of completion, but original documents confirm the triptychs were finished under the PWAP; the 12-inch-high frieze, titled *The Release of Youth from Depression Conditions*, that runs underneath both triptychs was executed under the Federal Art Project.[23] Each triptych panel features a different Cascade mountain as the backdrop to scenes taking place at the foot of the mountain.[24] CCC activities were a common subject for the

New Deal art projects. Oregon artists W. H. Gilmore, Aimee Gorham, and Harlow Hudson were all assigned to CCC camps to document daily life there.

There were plans for another monumental sculptural work, this one for the Federal Building in Portland, though it was only partially completed and is now lost. The sculptor Gabriel Lavare was commissioned to create a memorial for Oregonians who died in World War I. The white marble monument was to be carved on each side with symbolic imagery in bas-relief. Lavare completed one of the panels, which was exhibited at the Portland Art Museum in May 1934, but Barker was not able to get the Public Buildings Service to allocate funds to complete the work.[25]

A rather unusual commission was a wrought-iron door grille for an unidentified site created by the blacksmith O. B. Dawson. Dawson had worked shoeing horses during World War I and then in shipyards and machine shops before being introduced to ornamental ironwork at a shop in Los Angeles. In Portland he began executing

Figure 10
Percy Manser (1886–1973)
How Manifold Are Thy Works, The Earth Is Full of Thy Riches (detail), 1934
Tempera on canvas mural
10 × 70 feet approx.
Hood River Middle School, Hood River, Oregon
Courtesy of Hood River County School District

Figure 11
Margot Helser (1909–1990)
Rapunzel, 1936
Watercolor on paper
Dimensions unknown
Doernbecher Memorial Hospital for Children, Portland, Oregon (now lost)
Courtesy of Oregon Federal Art Project 1935–1943, John Wilson Special Collections, Multnomah County Library, Portland, Oregon

architectural commissions for ironwork (see page 116; fig. 11). It is most likely through his connections to the architects on the PWAP committee that he was hired, but the skill and talent in wrought iron he exhibited secured him a key role in the outfitting of the spectacular Timberline Lodge under the later Oregon Federal Art Project.

A large number of the works from the Oregon PWAP were individual canvases that were allocated to government

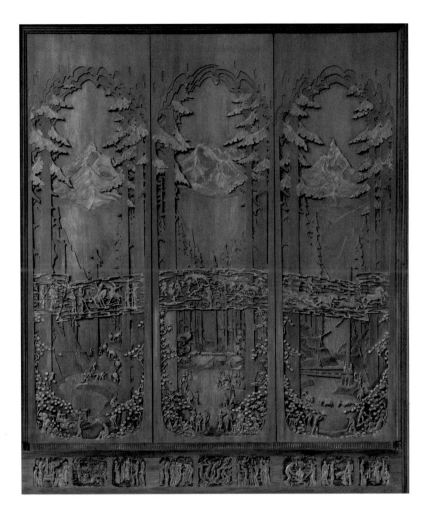

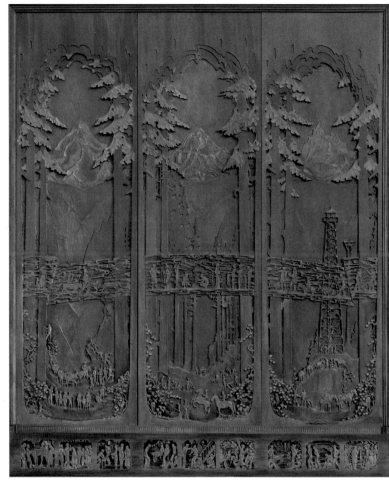

Figure 12
Arthur Clough (1891–1977) assisted by Jim de Broekert (dates unknown) and Ross McClure (dates unknown)
Oregon Vistas #1, 1934
Cedar
10 × 9 feet
Paulson Reading Room, Knight Library, University of Oregon, Eugene

Figure 13
Arthur Clough assisted by Jim de Broekert and Ross McClure
Oregon Vistas #2, 1934
Cedar
10 × 9 feet
Paulson Reading Room, Knight Library, University of Oregon, Eugene

offices all over the state or sent to Washington, DC, for exhibition.[26] Despite the volume produced, Barker had no problem finding eager recipients. He noted in a letter to Bruce, "We had a dream of being able to furnish each high school in the state with some work of art, but the demands from county, state, and federal officials have been so great that we will not be able to realize this dream."[27] He went on to describe how the PWAP had inspired several of its partner institutions to expand their community work, allowing the project's influence to live on.

Perhaps the best measure of the scope and variety of the Oregon PWAP is the enthusiastic listing provided by Ellis Lawrence, the chairman of the regional and Oregon state committee, to Lawrence Robert, one of the founders of the PWAP:

> What are they doing? Well, here are a few of the projects. From the painters are coming scenes of natural beauty, flowers, the moods of the Columbia Gorge—and Oregon mountains and sea, the color of the Public Market . . . murals of the trades, for Benson High School, fairy tales from Grimm, Oscar Wilde, Marco Polo, Indian folk lore, historical scenes and architecture, industries, shipping, farming, the life of the cowboy, the pioneer, the prospector, the Horse Show, the workers. . . . From the sculptors are panels in stone and Tennessee marble for the zoo . . . in Brownsville stone, panels of Indian legends for Crater Lake . . . a bird bath for a Eugene Park, and mighty Paul Bunyan and his Great Ox, which the sculptor sees in colossal scale at Bonneville Dam. . . . Weavers and art metal workers add their contributions. Modelers, too, with panels in plaster of Alice in Wonderland, and others . . . clocks and signboards. . . . Many decorative panels in color have been produced—of childrens' [sic] games— fairy tales—scientific microscopic fungi forms . . . abstract Indian legends; birds and flowers . . . and field sketches in pencil and water color of those C.C.C. camps and their life.[28]

Washington

Seattle's active art scene contributed to substantial employment numbers in Washington. Of the 108 artists employed, all but about 20 lived in or near the city.[29] Tacoma and Spokane were the other two small clusters in the state. The committee was headed by the architect Charles H. Alden and included fellow architects Henry Bertelsen, George Gove, and Andrew Willatsen; Dr. Richard Fuller, the president and director of the Seattle Art Museum and the museum educator Mrs. A. M. Young; Clara P. Reynolds, the art director for Seattle Public Schools; Lea Puymbroeck from the University of Washington Art Department; and Mary von Phul, the manager of Northwest Art Galleries in Seattle.

As in Oregon, a wide variety of activities were supported by PWAP funding as long as they benefited public institutions. Numerous paintings and prints were allocated to the offices of government officials. Artists included modernists such as Margaret and Peter Camfferman, Kenjiro Nomura, and Kamekichi Tokita, among others (figs. 14, 15, 16). Two of the artists later to be labeled as the Northwest Mystics, Guy Anderson and Morris Graves, also were employed by the Washington PWAP to create easel paintings. The impressionist Myra Albert Wiggins, the printmaker Elizabeth Colborne (fig. 17), and a painter celebrated for Alaska scenes, Eustace Ziegler, all supplied works. Ernest Norling, known for his regionalist depictions of the Northwest lumber industry, also was hired to capture a number of images of life in CCC camps on Orcas Island and at Lake Cushman in the northwestern part of the state (figs. 18, 19). Though around 40 percent of the artists employed were women, only four non-Caucasian artists have been identified to date; they are Salvador Gonzalez, Nomura, Tokita, and Elwood Winslow.

Individual oil paintings and prints were distributed to public schools as well, including Auburn, Blaine, Chehalis, Hoquiam, Pullman, Spokane, and many others. Other artists painted series for the schools, including the Canadian Estelle Claussen, who executed watercolors of scenes around Seattle, and Irene Cope, who created a number of illustrations of 19th-century children's games (fig. 20). More unusual objects included wooden animals by Ivan Marion Kelez, a chest and a cabinet carved in gumwood by Frank de Mole, and woven textiles by Theodore Abrams, all for Seattle Public Schools (fig. 21).

Figure 14
Margaret Camfferman (1881–1964)
Landscape, circa 1933
Oil on board
25 × 29⅜ inches
Seattle Art Museum, Public Works of Art Project, Washington State, 33.213

Figure 15
Kenjiro Nomura (1896–1956)
Farm Buildings, 1934
Oil on canvas
27⅚₆ × 35½ inches
Seattle Art Museum, Public Works of Art Project, Washington State, 33.223

Figure 16
Kamekichi Tokita (1897–1948)
Backyard, 1934
Oil on canvas
26¹¹⁄₁₆ × 21⁹⁄₁₆ inches
Seattle Art Museum, Public Works of Art Project, Washington State, 33.231

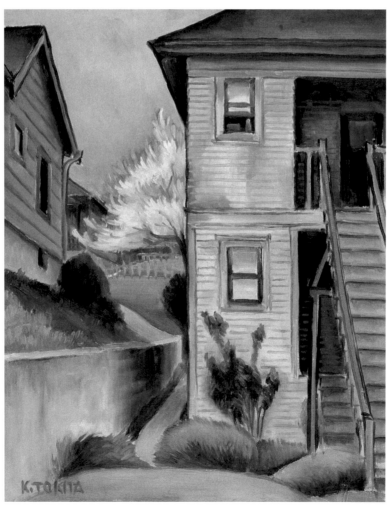

Figure 18
Ernest Norling (1892–1974)
Barber Shop—Recreation Hall, 1934
Pencil on paper
10 × 13½ inches (sheet)
Northwest Room/Special Collections, Tacoma Public Library, Washington

Figure 17
Elizabeth Colborne (1885–1948)
Mossy Wood, Washington, 1934
Color lithograph
13½ × 9 inches
Courtesy of Seattle Public Library Special Collections

Figure 19
Ernest Norling
Road Construction, 1934
Pencil on paper
10 × 13½ inches (sheet)
Northwest Room/Special Collections, Tacoma Public Library, Washington

Figure 20
Irene Cope (dates unknown)
Skipping Rope—1855, 1934
Watercolor on paper
22 × 30 inches (sheet)
Seattle Public Schools (now lost)
Courtesy of University of Washington Libraries, Special Collections,
UW40054

Figure 21
Theodore Abrams (dates unknown)
Example of hand weaving, 1934
Woven textile
Dimensions unknown
Seattle Public Schools (now lost)
Courtesy of University of Washington Libraries, Special Collections,
UW40053

The University of Washington also received some substantial contributions of work. Elizabeth L. Curtis, a graduate of the university's art department, painted two large murals for campus buildings in 1934. Her *Women in Sports* for the Women's Gymnasium (now Hutchinson Hall) is 4 feet high by 9 feet wide. *Oceanography* is even larger—the 9-by-7-foot image of sailors and ocean scientists framed by laboratory implements and marine life for the Oceanography Building was later relocated to the Ocean Sciences Building (fig. 22). Artists also provided study materials for university students. For example, Weyand Schlosser did a series of geological drawings, and other artists made hand-colored lantern slides to be used in lectures.

Julius Ullman's watercolors for the Seattle Marine Hospital (now the Pacific Tower) were part of a nationwide effort to provide artworks to the government's Marine Hospital Service, which served veterans, merchant seamen, the US Coast Guard, and the US Lighthouse Service. His images of the Seattle waterfront painted for the PWAP were later supplemented with a mural cycle by Kenneth Callahan commissioned under the Treasury Relief Art Project (see page 69, figs. 3, 4).

One of the more spectacular surviving works from the Washington PWAP is a large decorative map for Fort Nisqually titled *Settlements, Forts, Ships, Indian Tribes, and Events of the Territory now Comprising the State of Washington to 1855* made in 1934 by Ralph Bishop, an architect and painter from Tacoma. In the body of the map, Bishop meticulously illustrated in ink and watercolor early pioneer settlements, territories of Indigenous peoples,

geographical features, and other details. Around the borders he drew and described major state landmarks (figs. 23, 24). He created similar maps for Fort Nisqually in Tacoma and the state capitol in Olympia.

One unusual commission was undertaken in 1934 by Theodora Harrison, a professional illuminator from Ireland who had done heraldry work for the British royal family. In Seattle she served as president of the Women Painters of Washington, among other roles. For the Seattle Art Museum she re-created pages and motifs from medieval illuminated manuscripts. It is unclear if these were meant as educational tools or reproductions for exhibition, but they are beautifully executed (fig. 25). Only a handful of sculptural commissions have been identified to date, including an allegorical head by Walter Varney (fig. 26). In addition, two ironworkers, Adam Gruble and Mike Uttendorfer, were employed by the Washington PWAP to create a pair of large wrought-iron entrance gates for South Park in Seattle.

To date, a list of 550 Washington PWAP artworks and commissions from 94 organizations has been compiled, but there are likely more still to be recovered.

———

By late April 1934 the PWAP began to shut down nationwide. Artists who were still completing works were transferred to their state's Federal Emergency Relief Administration.[30] During its short five-month run, the PWAP employed more than 3,700 artists nationwide and sponsored the creation of more than 15,000 artworks. In Region 16, 264 artists were put to work for a total cost of $26,164.[31] The final report of the PWAP listed 1,014 works

Figure 22
Elizabeth L. Curtis (1892–1971)
Oceanography, 1934
Oil on canvas
9 × 7 feet
Oceanography Building, University of Washington

from Idaho, Montana, Oregon, and Washington, including 19 murals, 308 oil paintings, 95 watercolors, 186 sketches, 72 sculptures, 73 wood carvings, 188 prints, and 73 miscellaneous objects.[32] Though only about 130 of them are accounted for, these works reveal the breadth of talents and variety of interests embraced by Barker and his committees. He spoke proudly of their guiding philosophy:

I wish to say in conclusion that we have not ourselves, as a committee, conceived of a single assignment in our entire list. In every instance, without exception, we have ask [*sic*] the artist what he would rather do than anything else, what he has dreamed of wanting to do, what is his life's ambition. . . . And when we have found the artist's desires, we have given him a commission with God speed. . . . We have given them absolute freedom of artistic taste and we have explained to them that we want them to make their contributions to American Art.[33]

Figure 23
Ralph Bishop (dates unknown)
Settlements, Forts, Ships, Indian Tribes, and Events of the Territory now Comprising the State of Washington to 1855, 1934
Ink and watercolor on paper
42 × 70 inches (sheet)
Washington State Historical Society, 1934.96.1

Figure 24
Ralph Bishop
Detail of *Settlements, Forts, Ships, Indian Tribes, and Events of the Territory now Comprising the State of Washington to 1855*, 1934

The success and scope of the PWAP in the Northwest startled its supporters and skeptics alike. By the end of the project, local journalists who had shown little interest at its launch were enthusiastic advocates. Requests for

Figure 25
Theodora Harrison (1890–1969)
Armorial Achievement: "Degenerante Genus Opprobrium," from the series
Examples of Illumination and Heraldry, 1934
Ink and watercolor on paper
15 × 19¹⁵⁄₁₆ inches (sheet)
Seattle Art Museum, Federal Public Works of Art Project, Region #16,
Washington State, 2013.6.1

speakers and exhibitions were constant, and organizations were knocking on the door asking for artwork. In a letter to Bruce in June 1934, Barker enthused: "We are meeting with wonderful success in the distribution of our works. You will not be bothered with much coming from this district. . . . In Oregon we have had such a demand that I really believe we could have disposed of as many more things if we had them."[34]

Works from the Northwest also received some national attention. For its spring 1934 *National Exhibition of Art by the Public Works of Art Project*, the Corcoran Gallery of Art in Washington, DC, selected 14 works by Northwest artists, including Jacob Elshin, Aimee Gorham, Morris Graves, Kenjiro Nomura, C. S. Price, Olivia Shepard, and Eustace Ziegler. They joined hundreds of others from across the country.[35] Further, one of Price's paintings was featured in the Sunday *New York Times* in May 1934.[36]

Critical to the success of the PWAP in the Northwest was the scope of the work Barker and his advisers supported. Though their primary focus was to hire artists to create artworks, they also funded a number of arts-related projects that offered other benefits. In addition,

they allowed for media beyond painting, sculpture, and printmaking, such as wrought iron and textiles. Although dictates from the national office called for an emphasis on American Scene painting, in reality artists in the Northwest were given more latitude, and though there is a strong regionalist thread, abstraction, expressionism, and other interests also were expressed.

Bruce had a letter sent to every artist employed on the PWAP, thanking them for their contributions. The files at the National Archives are bursting with letters he received in return from artists describing the importance of the projects to them personally, to their region, and to the country. From Bellingham, Washington, the printmaker Elizabeth Colborne wrote, "I appreciate very much the help given at this time by the P.W.A. It makes one feel certainly that Uncle

Figure 26
Walter Varney (1908–death date unknown)
Four Sources of Happiness, 1934
Yew wood
10⅝ × 9½ inches diameter
Seattle Art Museum, Public Works of Art Project, Washington State, 34.155

has given an impetus to public consumption of art and public interest in art which will be felt for a long time and may even be the beginning of an American renaissance in the arts. . . . I feel, however, that the greatest value of the Public Works of Art Project lies in the fact that each painter may feel that his work has a use, a meaning which relates to the life of the community in which he lives, that his painting has a real place, serves a real purpose as in the past great periods of art. The interest displayed in the Project leads one to hope that with the good start your work has contributed this movement may gain enough of strength, so that the artist and craftsman may again take his place as a worker whose products are considered as necessary as those of the architect and engineer with whom he works.[39]

The outpouring of appreciation and enthusiasm received by Bruce, the national and regional administrators of the PWAP, and President Roosevelt—not to mention the bounty of artwork created in such a short time—became the impetus that helped launch the larger projects that followed.

Sam is taking care of all his people that he can reach out to such a far corner of his country as this and find his artists."[37] The painter Elizabeth L. Curtis of Seattle echoed that sense of wonder: "Never since the time perhaps of Benvenuto Cellini has such a situation existed, and an artist been given a wall, freedom to work in his own way, and a regular salary adequate to permit of the purchase of the materials he likes to work with. . . . Again and again I wonder if this thing can really be true and myself a part of it."[38] In her letter, Rachael Griffin of Portland sounded a theme repeated by artists across the country—the gratitude for seeing their work valued and their hope that the PWAP was simply the beginning of government support of the arts:

> Besides the personal material gain for which each artist has been grateful in these "bad times" all of us recognize that the Public Works of Art Project

NOTES

1 There have been few studies focused on the short-lived PWAP. The head of the Public Works Administration, Harold L. Ickes, discussed it in his history *Back to Work: The Story of PWA* (New York: Macmillan, 1935). The most recent consideration is Ann Prentice Wagner, *1934: A New Deal for Artists* (Washington, DC: Smithsonian American Art Museum; London: in association with D. Giles Ltd., 2009).

2 Forbes Watson, Technical Director, Public Works of Art Project, and Edward Bruce, Secretary, Advisory Committee to Treasury on Fine Arts, to Regional Directors, telegram, December 10, 1933; Blanket Communications #2; Entry 106, Textual Records of the Public Works of Art Project Central Office Correspondence and Related Records, 1933–34 (Correspondence with Artists), Box 1; Records Concerning Federal Art Activities; Records of the Public Buildings Service, Record Group 121; National Archives at College Park, College Park, MD (hereafter NACP).

3 Despite these instructions, the artworks themselves as well as numerous letters from artists in the National Archives saying how much they appreciated the freedom to express themselves and pursue their interests demonstrate that this dictate was not rigidly followed.

4 "The Public Works of Art Project was authorized by the Civil Works Administration. It is not relief work and the word relief should be eliminated by you in all reference to the project and in any discussions with

artists employed. . . . We want to put competent artists to work who are out of work You must use your discretion in not expending money on people of affluence." Edward Bruce, Secretary, Advisory Committee to Treasury on Fine Arts, to Regional Chairmen, telegram, December 18, 1933; Blanket Communications #2; Entry 106, Textual Records of the Public Works of Art Project Central Office Correspondence and Related Records, 1933–34 (Correspondence with Artists), Box 1; Records Concerning Federal Art Activities; Records of the Public Buildings Service, Record Group 121; NACP.

5 "[W]e are naturally going to have a lot of scoffers at the Public Works of Art Project who do not realize its true significance and the possibilities of its effect on the well-being and culture of the lives of our people. . . . Aside from the immediate objective of the project in putting artists to work the movement, I think, has a larger significance and purpose and that is to develop in this country a realization of what art may mean to the lives of the people and a consciousness that it contributes to the national well-being through the sense of contentment that beauty brings to the lives of people." Edward Bruce, Secretary, Advisory Committee to Treasury on Fine Arts, to Burt Brown Barker, January 9, 1934; XVI—Bruce, Edward #2; Entry 116, Textual Records of the Public Works of Art Project Selected Records of the Regional Office 1933–34, Box 6; Records Concerning Federal Art Activities; Records of the Public Buildings Service, Record Group 121; NACP.

6 Edward Bruce, Secretary, Advisory Committee to Treasury on Fine Arts, to Julius F. Stone, Federal Civil Works Administration, February 15, 1934; Art Appropriations; Entry 106, Textual Records of the Public Works of Art Project Central Office Correspondence and Related Records, 1933–34 (Correspondence with Artists), Box 1; Records Concerning Federal Art Activities; Records of the Public Buildings Service, Record Group 121; NACP.

7 Burt Brown Barker, Regional Director, Public Works of Art Project, to Edward Bruce, Secretary, Advisory Committee to Treasury on Fine Arts, January 16, 1934; XVI—Bruce, Edward #1; Entry 116, Textual Records of the Public Works of Art Project Selected Records of the Regional Office 1933–34, Box 6; Records Concerning Federal Art Activities; Records of the Public Buildings Service, Record Group 121; NACP.

8 "For some reason, the committee for the four states of this region . . . consists of four Oregon men, none of whom hold positions of artistic import. This, regardless of the fact that Seattle is regarded nationally as the center of art activities in the Pacific Northwest. . . . The outstanding art authorities of Washington are Dr. Richard E. Fuller of the Seattle Art Museum . . . and Walter F. Isaacs, head of the University of Washington Art Department and Director of the Henry Gallery of Art, Seattle." Kenneth Callahan, Art Critic, The Town Crier, to Forbes Watson, Technical Director, Federal Art Works Board, December 28, 1933; Region No. 16—Portland—Dec. 1933–Feb. 1934; Entry 2, Textual Records of the Public Works of Art Project Central Office Correspondence with Regions, 1933–34 Regions 14–17, Box No. 6; Records Concerning Federal Art Activities; Records of the Public Buildings Service, Record Group 121; NACP.

9 Anna B. Crocker, Portland Art Association, to Holger Cahill, Director, Federal Art Project, February 26, 1936; Oregon; Entry 1023, Textual Records of the Federal Art Project Office of the National Director, Correspondence with State and Regional Offices, 1935–1940, 1935–1936 Oregon to Tennessee, Box 27; Correspondence Files, 1935–1939; Records of the Work Projects Administration, 1922–1944, Record Group 69; NACP.

10 Burt Brown Barker, Regional Director, Public Works of Art Project, to Edward B. Rowan, Assistant Technical Director, Treasury Department Art Project, January 29, 1934; Region No. 16—Portland—Dec. 1933–Feb. 1934; Entry 2, Textual Records of the Public Works of Art Project

Central Office Correspondence with Regions, 1933–34 Regions 14–17, Box No. 6; Records Concerning Federal Art Activities; Records of the Public Buildings Service, Record Group 121; NACP.

11 Lewis Ensign, Public Works of Art Project, Idaho, to Forbes Watson, Technical Director, Public Works of Art Project, April 10, 1934; Region No. 16—Portland—Feb.–Oct. 1934 #1; Entry 2, Textual Records of the Public Works of Art Project Central Office Correspondence with Regions, 1933–34 Regions 14–17, Box No. 6; Records Concerning Federal Art Activities; Records of the Public Buildings Service, Record Group 121; NACP.

12 Burt Brown Barker to Edward B. Rowan, Assistant Technical Director, Treasury Department Art Project, January 29, 1934; Region No. 16—Portland—Dec. 1933–Feb. 1934; Entry 2, Textual Records of the Public Works of Art Project Central Office Correspondence with Regions, 1933–34 Regions 14–17, Box No. 6; Records Concerning Federal Art Activities; Records of the Public Buildings Service, Record Group 121; NACP.

13 Edward Bruce, Secretary, Advisory Committee to Treasury on Fine Arts, to Joseph P. Monaghan, House of Representatives, February 13, 1934; Region No. 16—Portland—Dec. 1933–Feb. 1934; Entry 2, Textual Records of the Public Works of Art Project Central Office Correspondence with Regions, 1933–34 Regions 14–17, Box No. 6; Records Concerning Federal Art Activities; Records of the Public Buildings Service, Record Group 121; NACP.

14 "Western Artist Painting Murals," Montana Standard, March 11, 1934, 16.

15 Carlie Magill, "100 Years of Forestry at The University of Montana–Missoula, 1913–2013," Archives & Special Collections, University of Montana, 2013, accessed January 15, 2019, http://www.cfc.umt.edu/Files/100YearsofForestryatTheUniversityofMontana.pdf; Montana State Historic Preservation Office, National Register of Historic Places registration form for the University of Montana Historic District, accessed January 15, 2019, ftp://ftp.ci.missoula.mt.us/DEV%20ftp%20files/HistoricPreservation/NRApps/UniversityHD.pdf.

16 "Stanley Martineau to Make Plaque for Library at U.," Billings Gazette, March 26, 1934, 8; "Two Young Artists Depict Montana History in Work Being Done at the State University," Missoulian, May 6, 1934, 11.

17 "Sculptor's Work Is Nearly Done," Missoulian, September 2, 1934, 8.

18 In 2001 a group of works by Dorothea Donovan were donated to the Yellowstone Art Museum by the Western Sugar Company, where they were found in a closet. The images of men at work in the factory have been dated to the 1930s or 1940s and illustrate the kind of images she most likely created for the PWAP. See Jim Gransbery, "Pastels in the Closet," Billings Gazette, September 16, 2001, 45; and Jim Gransbery, "YAM Accepts Recluse's Industrial Art," Billings Gazette, December 7, 2001, 7.

19 Larry Len Peterson, Blackfeet John L. "Cutapuis" Clarke and the Silent Call of Glacier National Park: America's Wood Sculptor (Helena: Larry Len Peterson, in cooperation with Montana Historical Society; Great Falls, MT: C. M. Russell Museum, 2019), 216–18, 221.

20 The final report on the PWAP lists 115 artists employed in Oregon. However, it is noted that no list was forwarded to the national office from Region 16, so it was assembled from other sources. Archival research to date has added an additional 13 names. See Public Works of Art Project, Report of the Assistant Secretary of the Treasury to Federal Emergency Relief Administrator, December 8, 1933–June 30, 1934 (Washington, DC: US Government Printing Office, 1934).

21 *Exhibition of Work Done in Oregon under the Public Works of Art Project*, Portland Art Association, May 13–June 3, 1934, on file, Portland Art Museum Crumpacker Family Library, Bound Catalogues, Vol. 1930–1939, File 1.

22 These murals were removed during remodeling in the 1950s and disappeared at that time. The subjects were listed as ignorance, doubt, revolt, and triumph. "Mystery of Missing Paintings Remains Unsolved," *University of Oregon Health Sciences Center News*, July 1976, 5.

23 Three of the panels—"Trails in the Shadow of Hood," "Halcyon Days at the Foot of Jefferson," and "Below the Spires of Three-Fingered Jack"— were on view in *Exhibition of Work Done in Oregon under the Public Works of Art Project*, Portland Art Association, May 13–June 3, 1934 (cat. no. 179). The catalogue notes they were from a set of six. The date "1934" is also carved in the other triptych set.

24 "Paulson Reading Room," *Guide to the Art and Architecture of the 1937 Historic Knight Library*, *University of Oregon, Eugene*, last updated May 10, 2019, http://researchguides.uoregon.edu/historic-knight/paulson. See also Kenneth O'Connell, "Stories Carved in Cedar," *Oregon Quarterly*, Summer 2013, accessed January 6, 2019, https://around.uoregon.edu/oq/stories-carved-in-cedar. The sequence and dates for the creation of these panels are confused in these accounts, notably the timing and the project that funded the addition of the frieze at the bottom.

25 Gabriel Lavare to Burt Brown Barker, not dated; Region No. 16— Portland—Feb.–Oct. 1934 #3; Entry 2, Textual Records of the Public Works of Art Project Central Office Correspondence with Regions, 1933–34 Regions 14–17, Box No. 6; Records Concerning Federal Art Activities; Records of the Public Buildings Service, Record Group 121; NACP.

26 "County Officials Receive Pictures," *Oregonian*, June 7, 1934, 11.

27 Burt Brown Barker, Regional Director, Public Works of Art Project, to Edward Bruce, Secretary, Advisory Committee to Treasury on Fine Arts, June 14, 1934; XVI—Bruce, Edward #2; Entry 116, Textual Records of the Public Works of Art Project Selected Records of the Regional Office 1933–34, Box 6; Records Concerning Federal Art Activities; Records of the Public Buildings Service, Record Group 121; NACP.

28 Ellis Lawrence, Public Works of Art Project, Oregon, to L. W. Robert, Jr., Assistant Secretary of Treasury Department, February 9, 1934; Region No. 16—Portland—Dec. 1933–Feb. 1934; Entry 2, Textual Records of the Public Works of Art Project Central Office Correspondence with Regions, 1933–34 Regions 14–17, Box No. 6; Records Concerning Federal Art Activities; Records of the Public Buildings Service, Record Group 121; NACP.

29 The final report on the PWAP lists 76 artists employed in Washington. Archival research to date has added an additional 32 names. See *Public Works of Art Project*.

30 Edward Bruce, Secretary, Advisory Committee to Treasury on Fine Arts, to Burt Brown Barker, Regional Director, Public Works of Art Project, telegram, April 26, 1934; Blanket Communications #1; Entry 106, Textual Records of the Public Works of Art Project Central Office Correspondence and Related Records, 1933–34 (Correspondence with Artists), Box 1; Records Concerning Federal Art Activities; Records of the Public Buildings Service, Record Group 121; NACP.

31 *Public Works of Art Project*, n.p.

32 List of Works Completed under the Public Works of Art Projects, April 1, 1934; Lists of Works Done under PWAP; Entry 106, Textual Records of the Public Works of Art Project, Central Office Correspondence and Related Records, 1933–34, Box 3; Records Concerning Federal Art Activities; Records of the Public Buildings Service, Record Group 121; NACP.

33 Burt Brown Barker, Regional Director, Public Works of Art Project, to Edward Bruce, Secretary, Advisory Committee to Treasury on Fine Arts, January 3, 1934; XVI—Bruce, Edward #1; Entry 116, Textual Records of the Public Works of Art Project Selected Records of the Regional Office 1933–34, Box 6; Records Concerning Federal Art Activities; Records of the Public Buildings Service, Record Group 121; NACP.

34 Burt Brown Barker, Regional Director, Public Works of Art Project, to Edward Bruce, Secretary, Advisory Committee to Treasury on Fine Arts, June 3, 1934; Region No. 16—Portland—Feb.–Oct. 1934 #2; Entry 2, Textual Records of the Public Works of Art Project Central Office Correspondence with Regions, 1933–34 Regions 14–17, Box 6; Records Concerning Federal Art Activities; Records of the Public Buildings Service, Record Group 121; NACP.

35 The exhibition was on view April 24–May 20, 1934. Entry 112, Textual Records of the Public Works of Art Project Card Lists of Allocated Paintings and Other Works of Art, 1934/Region 12—Corcoran Gallery Exhibition, Box 4; Records Concerning Federal Art Activities; Records of the Public Buildings Service, Record Group 121; NACP.

36 Elizabeth Luther Cary, "Experiencing Art: The Vital Need of Enjoyment," *New York Times*, May 27, 1934, X7.

37 Elizabeth Colborne to Edward Bruce, Secretary, Advisory Committee to Treasury on Fine Arts, April 1, 1934; Co–Cz; Entry 108, Textual Records of the Public Works of Art Project Central Office Correspondence with Artists, 1933–34, Box 1; Records Concerning Federal Art Activities; Records of the Public Buildings Service, Record Group 121; NACP.

38 Elizabeth L. Curtis to Edward Bruce, Secretary, Advisory Committee to Treasury on Fine Arts, March 30, 1934; Co–Cz; Entry 108, Textual Records of the Public Works of Art Project Central Office Correspondence with Artists, 1933–34, Box 1; Records Concerning Federal Art Activities; Records of the Public Buildings Service, Record Group 121; NACP.

39 Rachael Griffin to Edward Bruce, Secretary, Advisory Committee to Treasury on Fine Arts, April 3, 1934; Go–Gz; Entry 108, Textual Records of the Public Works of Art Project Central Office Correspondence with Artists, 1933–34, Box 1; Records Concerning Federal Art Activities; Records of the Public Buildings Service, Record Group 121; NACP.

THE SECTION OF FINE ARTS AND THE TREASURY RELIEF ART PROJECT

MARGARET E. BULLOCK

The most widely known works created on the New Deal art projects are the murals, sculptures, and other artworks that adorn post offices and federal buildings. These were commissioned primarily under two projects that followed closely on the Public Works of Art Project (PWAP): the Section of Fine Arts (Section) and the Treasury Relief Art Project (TRAP). They ran separately at first but eventually were merged into a single program.[1]

In October 1934, a few months after the PWAP ended, one of its former directors, Edward Bruce, established a program within the Treasury Department that drew funds for artwork from a 1 percent allotment for artistic decoration of new government buildings. As the program grew, additional sources were added. Called originally the Section of Painting and Sculpture, it was renamed the Section of Fine Arts in 1938, at a time when hopes were high that it might lead to the creation of a permanent government department for the arts.[2] Because it was funded directly through the Treasury and not as part of any of the job creation or other New Deal stimulus programs, the Section did not have to wrestle with the relief requirements and other strictures that were a constant challenge for the

other art projects. Bruce was able to put the focus on quality rather than on work relief, a goal he had passionately advocated for but only partially achieved for the PWAP.

At first artists were chosen by an advisory committee, but that process was eventually replaced by anonymous, open competitions. Though originally held for each building, for efficiency's sake these shifted to state and national calls. The national competitions were supervised by the Section office in Washington, DC, and used an advisory jury of artists to help select winning designs. At the regional level, a well-known figure in the arts would be asked to chair and choose a local committee.[3] The statewide and nationwide contests generated a pool of artists and designs from which commissions for specific buildings were awarded. Artists could be assigned anywhere in the country if the building's architect and the Section administrators agreed. The largest of these contests was the 1939 Forty-Eight States Competition for which there were more than 3,000 entries. The winners were awarded commissions for post offices all over the country.

Similar large-scale competitions were conducted for the Interior Department, the War Department, and the US Government Building at the 1939 World's Fair in New York. In addition to the commissions for government buildings, the Section also occasionally assigned some artists to Civilian Conservation Corps (CCC) camps. They were expected to devote "forty hours a week to their art

Ernest Norling (1892–1974)
Northwest Logging (detail), 1937–38
Oil on canvas
6 feet 3 inches × 23 feet 3 inches
Bremerton, Washington, Post Office
Courtesy of United States Postal Service. ©2019 USPS

work, making a pictorial record of the life and achievements of the camps, painting murals in the recreation rooms, and wherever possible assisting the camp authorities in matters relating to art."[4]

Section administrators kept a careful eye on every aspect of these works in progress. They expressed a strong preference for American Scene painting, which included realist scenes of regional life, re-creations of regional historical events, and social realist subjects such as celebrations of economic or civic progress. As works progressed from sketch to finished mural, the administrators also made suggestions and corrections down to the level of the smallest details. Letters flew back and forth between artists and the DC office as plans were finalized. Postmasters, architects, members of the various advisory committees, and local citizens also could send criticisms to the national office of the Section where final decisions were made about necessary changes.[5] Once the work was completed, the artist was required to submit a biography, a detailed report on all aspects of the work (from materials used to final adhesives and other installation notes), and professional photography, generating a set of files that are a primary resource for conservators and other stewards of these works today. Payment was withheld until these final requirements were completed.

Though the system of anonymous competitions was meant to forestall accusations of favoritism, it created other controversies. Artists with no roots in or knowledge of local history or lifeways were assigned subjects and locations they knew nothing about. Communities were often passionately opinionated about the style and subject of the work being added to their post offices and courthouses and protested or outright rejected a number of artworks. Postmasters were not always well informed about plans for their buildings and were startled to find artists measuring and marking their walls. By the early 1940s, as the United States entered World War II, people also began to protest the use of government funds for anything they considered nonessential to the war effort. Despite these challenges, the Section was highly successful, producing 1,124 mural paintings and 289 sculptures and running until 1943, for a total cost of $2.4 million.[6]

A second program for the decoration of public buildings ran parallel to the Section for several years. In 1935,

encouraged by the success and popularity of the PWAP, the Roosevelt administration began to consider adding a second arts program to ongoing job and economic stimulus programs. The president asked Bruce and Harry Hopkins, the director of the Federal Emergency Relief Administration, to propose a second public works project for visual artists under the administration of the Treasury Department. Hopkins, driven by the philosophy that the skills of arts workers were as valuable as those of other workers, presented a sprawling program encompassing all creative disciplines.[7] Though the president did not immediately embrace this idea, Hopkins's ambitious vision eventually became Federal One under the Works Progress Administration (WPA). Bruce modeled his more modest idea on the PWAP, suggesting a limited relief-focused program. The Treasury Relief Art Project (TRAP) was authorized in July 1935 as part of the Emergency Relief Appropriation Act with an allotment of $530,784 and a hiring cap of 450 artists.[8]

The TRAP was headed by Olin Dows, a classically trained painter, with the businessman Cecil H. Jones as assistant chief. Bruce and Forbes Watson, who had administered the PWAP, served as advisers. In contrast to the PWAP, around 90 percent of the artists hired for the TRAP were registered on the government relief rolls. They were paid from $69 to $103 per month for 96 hours of work to create artworks for small post offices and existing federal buildings. These included not only murals and sculptures but also easel paintings, prints, and posters, which were allocated to federal organizations in the United States and abroad. Again, a strong preference for American Scene images was expressed to all artists. The TRAP used anonymous competitions along the same lines as those organized for the Section and in some instances chose artists from submissions to Section competitions.[9] Most commissions were headed by a master artist (usually not on relief), who then chose artists from the relief rolls as assistants. With this setup, TRAP administrators hoped to avoid the problem that had emerged under the PWAP of finding well-qualified artists on relief.[10]

The widespread reach of the Section and the rollout of the broad and ambitious Federal Art Project (FAP) under the WPA in August 1935 quickly made the TRAP

redundant. In 1936 projects began to be transferred to the Section for completion, and all remaining artists on the payroll were transferred to the FAP by July 1938. The TRAP officially closed down in June 1939.[11]

Because of this slow merger, in a number of instances half a commission was funded by the TRAP and the other half by the Section. As well, the TRAP and Section were jointly called the Treasury Department Art Projects, confusing contemporaries as well as scholars and caretakers today as to what artworks were created under which project. Though it may seem a trivial concern to distinguish between these projects with the same essential aims, the distinctions have proven important to resolving contemporary controversies around the ownership, restoration, and relocation of a number of artworks as federal buildings have been recommissioned or sold.

During the TRAP's existence, 89 murals and 43 sculptures were completed for federal buildings and housing projects. In addition, approximately 10,000 easel paintings were allocated to government institutions and embassies. In his official report on the TRAP, Dows proudly noted:

> The money spent on this project has produced a social wealth which is impossible to estimate in dollars. . . . This placing of fine murals, concerned with the locality and produced by citizens of the region, will result in greater breadth of vision on the part of children and citizens in general. Through these wall pictures, they will see the life around them with new eyes. Everyday scenes, familiar objects, industries, daily work, etc., will achieve a new dignity and importance. . . . The effect on the lives of all of us, of this record of our work seen through the eyes of individuals of talent, cannot be exaggerated.[12]

The Treasury Relief Art Project in Region 16

TRAP support was limited in the Northwest, resulting in just one panel of a post office mural in Oregon, a mural cycle in Washington, and some easel paintings and prints. It was not from lack of regional interest. Artists from Region 16 actively submitted work to the competitions or to the regional committees for consideration. That so few were hired by the TRAP may be due to the requirement that most had to be registered for government relief. It is a constant thread found throughout the administrative correspondence of all the New Deal art projects in Region 16 that artists in the Northwest were highly reluctant to sign up for government help.

In Oregon the largest TRAP commission was one panel of a two-panel mural for the post office in Saint Johns, a small town at the confluence of the Willamette and Columbia Rivers that was annexed to Portland in 1915.[13] The level of enthusiasm and desire for this kind of work in the region is illustrated in a letter from Ellis Lawrence, the head of the selection committee, who was stunned that 76 artists had submitted work for consideration for this small commission.[14] The two panels in egg tempera on canvas, *Local Industries and Characters* (1935–36) and *Development of St. John's* (1936), illustrate the history of the founding of the town (figs. 1, 2). The project was originally a Section commission to Oregon artist John Ballator for one mural, but Dows, on hearing of the project, approached him about creating another mural on the opposite wall to be funded by the TRAP. Ballator agreed to assist with the design and to oversee the work of two artists off the relief rolls: Erich Lamade, a commercial artist who had recently relocated to Oregon, and Louis Bunce, who had returned several years before after studying at the Art Students League in New York. All three artists jointly signed the work when it was completed, but correspondence indicates that Ballator painted most of the Section commission *Local Industries and Characters* and served as the volunteer supervisor for the other panel, which was executed by Bunce and Lamade.[15]

In Washington State the TRAP commissioned murals for the Marine Hospital (now the Pacific Tower) in Seattle. The Marine Hospital Service was dedicated to the care of ill and disabled seamen from the US Merchant Marine and Coast Guard, with hospitals located in port cities. They were supervised by the Treasury Department until 1939 and so their facilities were commonly chosen for TRAP and Section artworks.

Washington painter Kenneth Callahan was hired in September 1935 to create a series of mural panels for the main reception room of the Seattle Marine Hospital. He

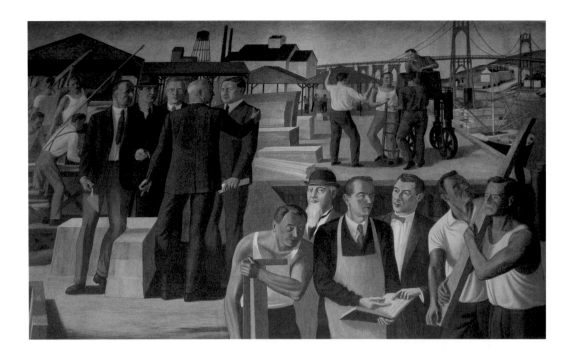

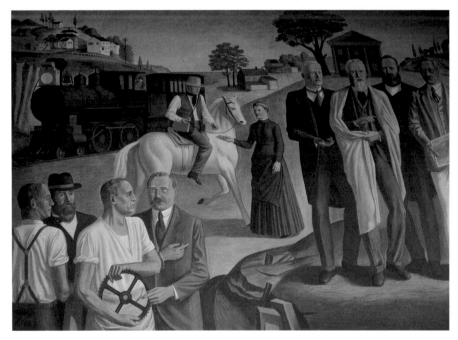

was selected based on the work samples he had submitted to the Saint Johns Post Office competition. He chose the theme *Men Who Work the Ships*, drawing upon his own experiences as a merchant marine (figs. 3, 4). He was assisted by two local artists hired from the government relief rolls, Hovey Rich and the Ute artist Julius Twohy (Two-vy-nah-up). Callahan created 10 panels, most documenting everyday tasks such as standing watch and loading cargo. Four of the images symbolize different locations that border the Pacific Ocean—Alaska, Australia, Asia, and South America—to which the sailors traveled.[16]

Figure 1
John Ballator (1909–1967) assisted by Louis Bunce (1907–1983) and Erich Lamade (1894–1969)
Local Industries and Characters (north wall, detail), 1935–36
Tempera on canvas
7 feet 10 inches × 16 feet
Saint Johns, Oregon, Post Office
Courtesy of United States Postal Service. © 2019 USPS

This post office building was decommissioned and sold. It is now the Baha'i Faith Center, Portland. The mural is still in place in the lobby.

Figure 2
Louis Bunce and Erich Lamade
Development of St. John's (south wall, detail), 1936
Tempera on canvas
7 feet 10 inches × 16 feet
Saint Johns, Oregon, Post Office
Courtesy of United States Postal Service. © 2019 USPS

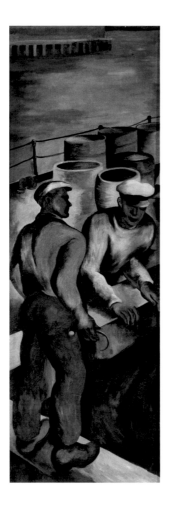
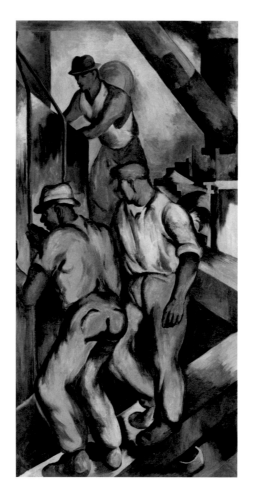

Figure 3
Kenneth Callahan (1905–1986) assisted by Hovey Rich (dates unknown) and Julius Twohy (Two-vy-nah-up) (1902–1986)
Unloading (one from a ten-panel mural), 1935–36
Oil and canvas on Masonite
96 × 37 inches (framed)
Museum of History & Industry, Seattle

Figure 4
Kenneth Callahan assisted by Hovey Rich and Julius Twohy
Dock Scene (one from a ten-panel mural), 1935–36
Oil and canvas on Masonite
95 × 52 inches (framed)
Museum of History & Industry, Seattle

As for many of the artists on the New Deal art projects, large-scale mural painting was a new experience for Callahan. The primary criticism of his first sketches was that the paintings would be too large and would overpower the room.[17] He was generally responsive to other suggestions and criticisms from Dows and the selection committee. This willingness is in marked contrast to later mural commissions where, with experience behind him, he was emboldened to reject or debate proposed changes.

Beyond these two TRAP commissions in Region 16, records indicate that a number of easel paintings were created or purchased for government buildings under the project. The few artists who have been identified to date include James FitzGerald in Washington, and Bunce and Lamade in Oregon.

The Section of Fine Arts in Region 16

The Section of Fine Arts provided a bonanza for Region 16, mostly in the form of post office murals. There are 39 spread across the four states in both large cities and small towns. Further, of the 32 artists employed, all but 9 were Northwest artists, so the murals offer a snapshot of the styles and interests of the region's artists in the 1930s and early 1940s. The Section commissions proved particularly important in Idaho and Montana, where the PWAP and FAP were more limited. What is notably striking about the post office murals in the Northwest is their eclectic mix of styles. Though a number of artists embraced the Section preference for American Scene imagery, many did not and met no resistance from administrators. It is an erroneous but firmly held belief that the Northwest in this period was

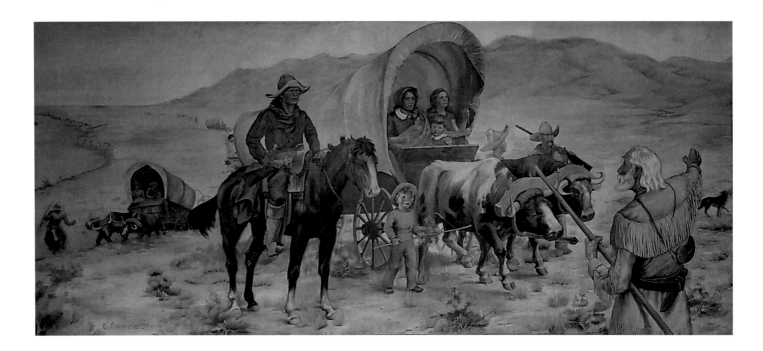

Figure 5
Elizabeth Davey Lochrie (1890–1981)
Pioneers on the Oregon Trail Along the Snake River, 1937–38
Oil on canvas
5 feet 6 inches × 12 feet
Burley, Idaho, Post Office
Courtesy of United States Postal Service. © 2019 USPS

lacking in cultural opportunities and highly conservative in taste. In reality, art schools, museums, and other cultural experiences from dance to theater were not only well established in the Northwest by the 1930s but also attracted and nourished a variety of artistic styles and expressions, including some of the most avant-garde. The size and location of a community were no predictor of people's interest in or familiarity with modernist styles, as the predominantly positive reception of the Section murals throughout the region attests.

Idaho

Murals were commissioned for six post offices in Idaho and offer a number of surprises. The first to be completed, *Pioneers on the Oregon Trail Along the Snake River* (1937–38; fig. 5), was painted by the Montana artist Elizabeth Davey Lochrie for the post office in Burley. Though she was well known, the selection of a woman artist for a prominent commission and a western subject stereotypically considered the domain of male artists was unusual for the period. Lochrie emphasized realistic detail and researched the town's history in order to add lots of local characters and color. She noted in a letter to Edward Rowan at the Section offices in DC that she had asked the postmaster to call a meeting of local citizens to discuss their hopes for the mural before she visited. She also hired a photographer

to take pictures of local scenery to serve as inspiration. She was presented with a very specific list from community members, which she mostly followed in her composition: "They are situated on the Oregon Trail and would like to have a scene having a covered wagon drawn by oxen, the Snake River in the background and their favorite mountain which overlooks the town, in the far distance."[18] The mural was installed in January 1938 and executed for a total cost of $670.

Late that year Lochrie was paid $750 to paint a mural for the post office in Saint Anthony, Idaho. Her oil-on-canvas mural titled *The Fur Traders* was installed in May 1939 and was well received by the community (see page 165, fig. 4). In a letter to the Treasury Department, the postmaster noted: "Mrs. Elizabeth Lochrie, the artist, did a beautiful piece of work and our townspeople as well as myself feel very proud to accept it and want to thank The Treasury Department for this beautiful painting. You may rest assured the Postal personnel will do all in our power to protect it along with our beautiful building."[19] In contrast to her Burley commission, the subject requested by the

community—a history of mail delivery—was rejected by the Section in favor of her fur-trading image. As with her other murals in Idaho and Montana (see below), Lochrie's imagined scene included a wealth of historical details as well as subtly enshrining negative stereotypes about Native Americans (see pages 37 and 164 for further discussion).

The artist hired to create a mural for the Blackfoot Post Office was Andrew Standing Soldier, a young Oglala Lakota painter from Pine Ridge, South Dakota, and one of a small handful of Native American artists on the New Deal art projects. He had been brought to the attention of Rowan by Redford Dibble, the managing editor of the *Rapid City Daily Journal* (South Dakota), who had seen his art in *Indians at Work*, the biweekly newsletter published by the Office of Indian Affairs. Blackfoot, Idaho, is situated on the north-central border of the Fort Hall Reservation, and the daily life of the Shoshone-Bannock tribes who lived there was chosen as the subject for the mural. Rowan was fairly ahead of his time in deliberately choosing a Native American artist for the project. However, he ascribed to a spurious pan-Indian view that espoused the belief that individuals from different tribal groups shared the same broad lifeways, attitudes, and aesthetics and therefore could represent each other.[20]

Standing Soldier's mural is unusual in a number of ways, including its scope. Most of the Section post office murals were limited to the wall above and surrounding the door to the postmaster's office. Occasionally there was a second image if the layout of the lobby and the amount of money available allowed for it. Standing Soldier's mural surrounds the postmaster's door, extends around the corner up over the counter, and continues down the lobby wall with scenes he titled *The Arrival* and *Celebration*. In the lockbox lobby are three additional scenes called *The Round-Up* (1938–39; see pages 162, 167, figs. 1, 6). His composition is also unusual, with figures widely spaced within small clusters of activity and stretches of stark landscape between. Standing Soldier painted directly on the plaster wall rather than on canvases that would then be attached to the wall, which was the more common method. He executed the entire scene in just one month, in August 1939. He was paid $2,000 for the whole cycle, the largest stipend paid in the Northwest.

Standing Soldier reported the community's response in a letter to Rowan: "The Indians, cowboys and all the others are satisfied with my work, except the one individual he told you about. . . . I know he is still telling the other people, what a poor artist I am. But I don't mind that at all."[21] The man Standing Soldier was referring to was a local historian who had originally advocated for a cowboy scene by Frederic Remington; he then began protesting Standing Soldier's selection, complaining about all the details that he considered inaccurate based on his knowledge of life on the reservation. In January 1941 a second letter of protest was sent to the Office of Indian Affairs by a group from the Blackfoot Rotary Club, the Fort Hall Indian Council, and the Blackfoot Chamber of Commerce asking that the mural be replaced because it did not accurately reflect the Shoshone-Bannock people and what was described as their transition to civilized life.[22] It is unclear if the signatories of the letter included any Shoshone-Bannock tribal members.

The most controversial mural for Idaho is also the most eccentric in look and tone. The California artist Fletcher Martin was awarded the mural for the Kellogg Post Office in November of 1939. However, his proposed image of a mine accident caused an uproar in the community, where the mines were the primary industry (see page 21, fig. 2). Martin was asked to redesign the mural and settled on an image of the town's namesake discovering a new lode (see page 21, fig. 3). It took him more than a year—from December 1939 to early summer of 1941—and much goading to complete the new painting.

The mural in Preston, Idaho, was one of the last to be commissioned in the state. The Washington artist Edmond Fitzgerald was selected based on his submission to the Forty-Eight States Competition and his earlier well-received works for the post offices in Ontario, Oregon, and Colville, Washington. His Preston mural, *The Battle of Bear River*, was completed and installed in 1941 (see page 165, fig. 3). It is one of the more startlingly violent scenes of the US Army attacking Indigenous peoples created for a US post office (see pages 24, 37, and 164 for further discussion).

The frieze-like arrangement of static figures in *Snake River Ferry* (1941; fig. 6), the post office mural for Buhl, is one of the more modern variations on the early settler theme. Richard Guy Walton visited the town while

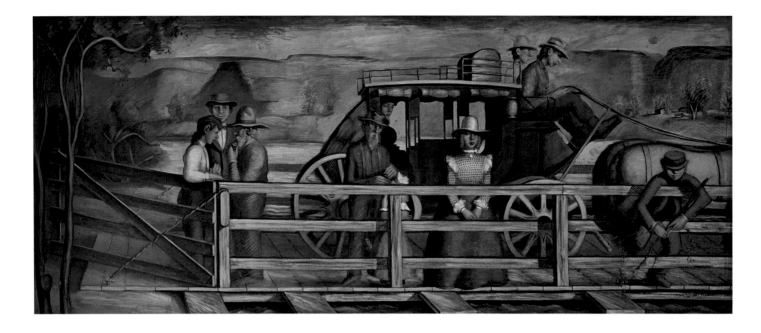

Figure 6
Richard Guy Walton (1914–2005)
Snake River Ferry, 1941
Tempera on canvas
5 feet × 11 feet 11 inches
Buhl, Idaho, Post Office
Courtesy of United States Postal Service. © 2019 USPS

planning his composition and settled on a scene of local interest. He was introduced to Molly Systers, whose father had run the first ferry across the Snake River, and based his design on details she recounted. He noted in a letter to Rowan, "Her dog bit me and her two parrots have seriously prejudiced me but when I wiped their odor out of my head I found out that she really had the information."[23] Walton married the descriptive details of his tempera painting with a flattened, hieratic presentation of the figures in a manner borrowed from tapestry designs. The contrast between the simplified background and the illusionistic painting of the foreground lends a slightly otherworldly tone to the work. Originally, the Oregon modernist painter C. S. Price had been approached with the commission, but he was unable to accept it and Walton was chosen from among the finalists in the Forty-Eight States Competition.

Two other murals were planned for post offices in Orofino and Payette, Idaho, but they were never completed. Money was put aside in 1938, but construction of the buildings was delayed for several years. By the time plans were revived, the national focus had begun to shift toward World War II. The Section received several protests from the community against what they saw as nonessential government spending during wartime and the artworks were never commissioned.

Montana

There were six Section commissions for post office murals in Montana, located primarily in small towns across the center and in the northeastern corner of the state. Most depict classically western subjects celebrating Anglo-American settlers and the region's ranching life or battles to seize land from Indigenous populations. Unusually, all but one were painted by artists from the state.

One of Montana's favorite artists, Elizabeth Davey Lochrie, was selected to paint the first of the post office murals in the state. The commission for the Dillon Post Office overlapped with her work for the Burley, Idaho, Post Office and is related in tone and subject. Her mural in Dillon is titled *News from "The States"* and illustrates a range of characters—cowboys, miners, trappers, and two Native American figures—listening while a man reads a newspaper aloud (fig. 7). The myriad details throughout the image incorporate numerous historical and local references, including a wanted poster for the notorious Montana bandit and local celebrity Henry Plummer. The mural was received with much local acclaim when installed in May 1938.

The next location selected was the post office in Deer Lodge. The competition in February 1939 attracted 27

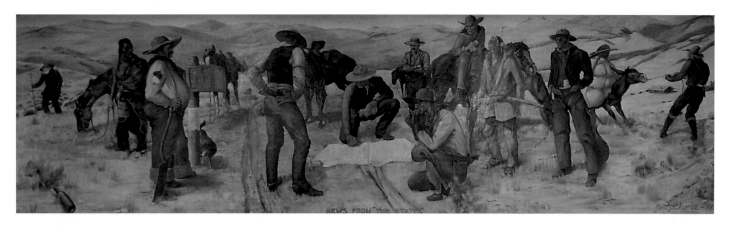

artists for the $630 commission. Verona Burkhard of New Jersey was chosen partly based on a mural she had just completed in Powell, Wyoming. She finished and installed her oil-on-canvas painting *James and Granville Stuart Prospecting in Deer Lodge Valley, 1858* in late August 1939 (fig. 8). It is more scenic landscape than historical scene, despite its title. Responding to local preferences conveyed by the postmaster, Burkhard ensured that Mount Powell, which dominates the center of the painting, was accurately depicted by requesting photographs of the landmark. Two years later an enthusiastic letter from postmaster Robert Midtlyng to the Public Buildings Administration extolled ongoing community interest in the work: "People from our adjoining sections come to Deer Lodge especially to view this painting and the many tourists that come this way during the summer season make special stops to see this mural."[24]

After a two-year hiatus in Section commissions for Montana, in June of 1941 a competition was held for two

new post offices in the northeastern corner of the state. Billings painter J. K. Ralston was selected for the commission in Sidney. In consultation with the postmaster, Ralston chose as his subject *Sully at the Yellowstone*, illustrating an event that took place 15 miles above Sidney on the Yellowstone River in 1864. General Sully had been sent on an expedition to establish a fort near this popular crossing to protect immigrant wagon trains. Ralston made several trips

Figure 9
J. K. Ralston (1896–1987)
Sully at the Yellowstone, 1941–42
Oil on canvas
5 × 12 feet
Sidney, Montana, Post Office
Courtesy of United States Postal Service. © 2019 USPS

This post office is now the Disaster and Emergency Services Building. The mural is still in place, though access is limited.

to visit and sketch the crossing and also did research and talked to elderly residents. He chose to focus on the chaotic scene at the crossing with men on horseback, multiple wagons, and even a steamer worked into his dynamic composition (fig. 9). The mural was installed in August 1942.

Another Montana painter, Forrest Hill, created the painting for the Glasgow Post Office. Titled *Montana's Progress* (1941–42; see page 38, fig. 8), it contains a surprising mix of pioneer imagery and industry. As described in the local newspaper, "The mural's two interwoven themes tell the story of early occupation and settlement and later and present day accomplishments of citizens."[25] Along the sides in muted tones washed with blue and sepia are figures from the early days of Anglo-American exploration and the builders of the town. Along the bottom are the symbolic tools of wagon wheel and plow. In full color at the center are the varied industries that have made the town prosperous, from agriculture to the new Fort Peck Dam power house and the local sugar beet factory. It is an epic celebration of American progress and hopeful boosterism commissioned and designed just two months before the attack on Pearl Harbor and the US entry into World War II. Installed in July 1942, it was meant to remind the community of the town's strengths and to reassure them of good things to come after the war was over.

The contract for the mural in the Billings Post Office was signed in November 1941. Leo Beaulaurier of Great Falls chose a cattle drive as his subject. His oil-on-canvas painting *Trailing Cattle* was completed and installed in a rush in April 1942. Beaulaurier had been called up by his local draft board in February but had received a brief deferment to complete his mural before heading overseas. Despite his haste, he created a dramatic and striking image with a cowboy and his horse silhouetted against the horizon on the right and the cattle herd passing on the left, all unified by a broad expanse of rugged landscape.[26]

The last commission in Montana was authorized as the Section's activities and budget were being curtailed. Henry Meloy was hired in April 1942 to create a mural for the Hamilton Post Office, and Rowan urged him to get the work done as soon as possible before the $800 stipend set aside for his commission was withdrawn. Meloy chose an imaginary subject he titled *Flat Head War*

Figure 10
Henry Meloy (1902–1951)
Flat Head War Party, 1942
Oil on canvas
6 feet 6 inches × 14 feet 5 inches
Hamilton, Montana, Post Office
Courtesy of United States Postal Service. © 2019 USPS

Party (fig. 10). He described the oil-on-canvas mural as "a group of Flathead Indians making up a war party to fight against an approaching band of their traditional enemies, the Blackfeet of Northern Montana. The incident, though not specific as to place or date, is one that happened many times in the Bighorn Mountains, as these two tribes were constantly at war."[27] Meloy's sketch of the scene had been chosen as the winner from a competition, but as it progressed Rowan became increasingly worried that the finished painting was not measuring up to the sketch. After seeing the full-size cartoon, he wrote to Meloy: "It is the feeling of the members of this office that the figures are not drawn with very much strength and that anything you can do to give them the vitality promised in the large color sketch which you submitted in competition will be to the good. Frankly, I was a little shocked at the weakness of the figures and want to urge you to continue strengthening them in the final painting."[28] The mural was completed the following month. There is no other correspondence in the Section files that record Rowan's thoughts on the final composition, though local press and residents were pleased.[29]

Several other Section commissions were originally planned for Montana though never completed. Post offices in Anaconda and Great Falls were both allocated funds but work was never begun. There is also great confusion in the files over a mural for the Butte Post Office. Hearing that the Treasury Department was considering a mural for the building and unaware of, or attempting to bypass, established procedures, Ray Enyart, the recreation supervisor for the Butte WPA, encouraged the local prospector-artist C. W. Scott to paint two scenes, one showing the first post office in Butte and the other the discovery of gold and silver lodes in the area.[30] He arranged for local sponsors to cover Scott's costs. Enyart then contacted the Section offices to receive authorization to have the murals accepted for the post office. Rowan and his administrators, worried about the quality of the work based on the sketches they saw, retained final approval but allowed the artist to proceed, believing erroneously that the work was being produced under FAP oversight. Scott completed at least one of the paintings, but installation in the post office was never approved by the Treasury Department. It is currently unknown what happened to the finished work.

Oregon

Nine post office murals were completed across Oregon. As previously discussed, the two-panel mural for the Saint Johns Post Office by Ballator, Bunce, and Lamade was financed partly by the TRAP and partly by the Section (see figs. 1, 2). It was the first commission completed in the state and was in place by June 1936.

A small flurry of Section commissions followed for the post offices in Newberg, Grants Pass, and Ontario. Rockwell Carey was selected to paint the mural for the Newberg Post Office based on a design he had submitted for the Saint Johns competition. His painting *Early Mail Carriers of the West* was completed and installed by November 1937 (fig. 11). Eager to provide a comprehensive survey of early mail delivery in his composition, he included not only a Pony Express rider and the railroad but also a stagecoach, a farm wagon, and a steamer on the river in the background.

On the strength of their painting for the Saint Johns Post Office, Bunce and Lamade were awarded a second

Figure 11
Rockwell Carey (1882–1954)
Early Mail Carriers of the West, 1937
Oil on canvas
4 × 6 feet
Newberg, Oregon, Post Office
Courtesy of United States Postal Service. © 2019 USPS

commission, this time in Grants Pass, in the south-central part of the state (1937–38; figs. 12, 13). They each created a painting for one wall of the lobby, making sure to harmonize their palettes. Lamade chose *Early and Contemporary Industries* as his subject, depicted as a frieze-like series of vignettes. Bunce originally proposed a battle scene from the Rogue River War in the 1850s between Indigenous tribes and the US Army, but was asked for a less violent subject. The composition of his mural *Rogue River Valley* echoes Lamade's, presenting his imagined scenes of daily life among the Indigenous people of the region. The paintings were exhibited in a show of New Deal art project work at the Portland Art Museum in April 1938, before being installed in Grants Pass.

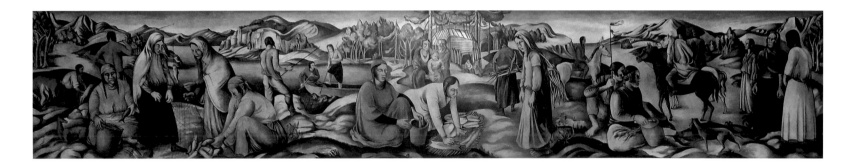

Figure 12
Erich Lamade
Early and Contemporary Industries (north wall), 1937–38
Tempera on canvas
2 feet 8 inches × 14 feet 7 inches
Grants Pass, Oregon, Post Office
Courtesy of United States Postal Service. © 2019 USPS

Figure 13
Louis Bunce
Rogue River Valley (south wall), 1937–38
Tempera on canvas
2 feet 8 inches × 14 feet 7 inches
Grants Pass, Oregon, Post Office
Courtesy of United States Postal Service. © 2019 USPS

Edmond Fitzgerald's *The Trail to Oregon* (1937–38; fig. 14) was the first of his three Section commissions. (The others were in Preston, Idaho, and Colville, Washington.) In Ontario, a town on the far eastern border located along the Oregon Trail, he painted a dramatic composition depicting the aftermath of an attack on a wagon train anchored by the heroic figure of the leader at center. Fitzgerald noted of the design: "The silhouette type of composition was suggested by the characteristics of the space for which it is planned. The light in the lobby of the Post Office is diffused and rather cool and there is a warm buff coloring on the wall. It is my opinion that the use of low key, rich colors in the foreground masses opposed to rather cool color in the background would harmonize well with these conditions."[31] The oil-on-canvas painting was in place by May 1938.

The system of nationwide competitions often resulted in convoluted pathways to assignments. The Portland artist Paul Grellert was hired for a commission in his hometown based on sketches he submitted to a competition for a post office in Dallas, Texas. His tempera-on-canvas painting *The Post Rider* (1938–39; fig. 15) was installed in the East Portland Station Post Office in March 1939 but had to be reinstalled in late August after his adhesive failed and the canvas began to peel off the wall. Overall, the Section committee was pleased with his design, though with their characteristic oversight of every detail they noted, "It is also our opinion that a child of this period would not be permitted to run at large without clothing,"[32] a criticism Grellert apparently took to heart as the child in the foreground in the finished painting is fully clothed.

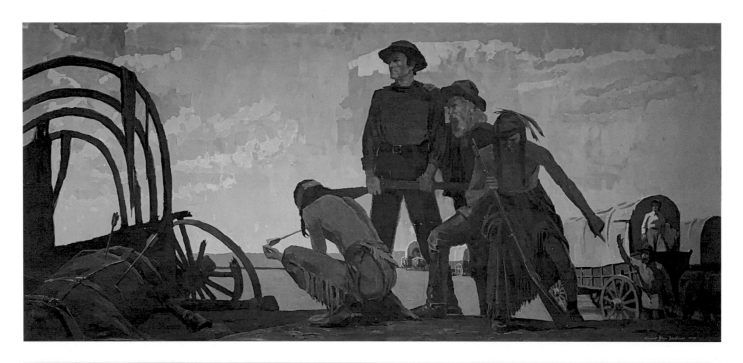

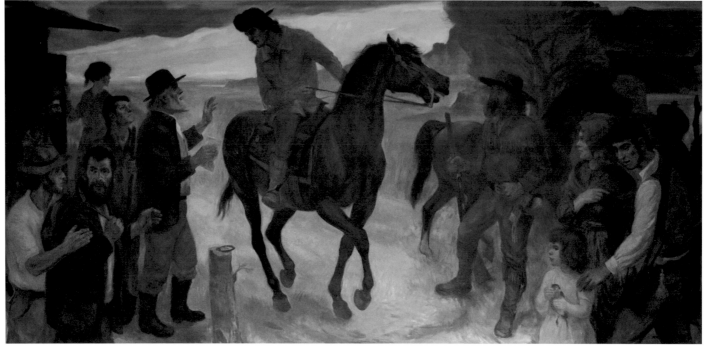

Figure 14
Edmond Fitzgerald (1912–1989)
The Trail to Oregon, 1937–38
Oil on canvas
5 feet 6 inches × 12 feet
Ontario, Oregon, Post Office
Courtesy of United States Postal Service. © 2019 USPS

Figure 15
Paul Grellert (1916–2005)
The Post Rider, 1938–39/1970
Tempera on canvas
7 feet × 14 feet 6 inches
East Portland Station Post Office, Portland, Oregon
Courtesy of United States Postal Service. © 2019 USPS

The artist repainted this mural in 1970 and gave it a new date at that time.

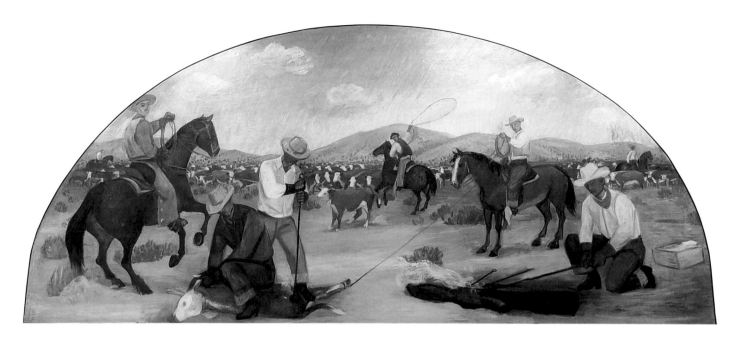

Figure 16
Jack Wilkinson (1913–1974)
Cattle Round-Up, 1940–41
Oil on canvas
5 feet 6 inches × 12 feet 2 inches
Burns, Oregon, Post Office
Courtesy of United States Postal Service. © 2019 USPS

This mural was transferred to the Harney County Courthouse in Burns when the post office was remodeled. It hangs in the courtroom.

It was local residents rather than the Section office in DC that proved to be the nemesis for Jack Wilkinson, a San Francisco artist selected in July 1940 to paint the post office mural in Burns, a ranching town in eastern Oregon. From the beginning, the selection of an artist who had never left the big city for a mural in a small, rural town proved problematic. Wilkinson was given the contract in Burns based on the sketches he had submitted to the Forty-Eight States Competition, for which he was a finalist. The subject of those images is not recorded, but apparently carried away by his setting in the frontier West, Wilkinson first proposed cattle thieves and then a violent battle between Native Americans and the US Army as his themes for Burns. After both were rejected, he traveled to the town, where he was taken to watch the roundup and branding of new calves and other cattle ranching activities. These became the subject of his painting (fig. 16).

His travails, however, did not end there. Choosing to paint the mural on-site, he found himself subject to constant scrutiny and criticism of every detail. Responding to comments from local cattlemen, he shortened branding irons, repainted horses, redrew ropes, and repositioned hands in attempts to make his scene as realistic as possible.[33] Others proposed he visit the zoo so he would know how to draw antelope and other wildlife, to read Zane Grey novels for inspiration, and to study the scenes of eastern Oregon captured by the American impressionist painter Childe Hassam in the early 1900s.[34] Reporting on the experience to Rowan in June 1941 after completing the painting, Wilkinson noted wryly, "From my experience— and my position on the scaffold in the lobby—I was soon convinced that collectively there are more ways of branding a calf than most individual cattlemen will admit."[35] Bruised but unbowed by his experiences in the state, he gamely joined the faculty of the University of Oregon that fall.

Andrew Vincent likewise encountered opposition to his mural for the Salem Post Office, but his came from the postmaster and poor timing. The competition for the Salem mural was held in February 1939. Vincent was chosen at that time, but the work did not get underway until August 1940 and was not completed until January 1942.[36] Vincent, like a number of other artists, encountered local resistance to the idea of spending government money on anything other than the war effort. As well, the Salem postmaster from the start was displeased with the idea of a mural and proved uncooperative. Vincent's design, *Builders of Salem*, occupied

Figure 17
Andrew Vincent (1898–1993)
Builders of Salem, 1940–42
Oil on canvas
10 feet 8 inches × 17 feet 11 inches
Salem, Oregon, Post Office
Courtesy of United States Postal Service. © 2019 USPS

The lobby of the former post office is now a conference room in the Oregon State Executive Office Building. The mural is still in place.

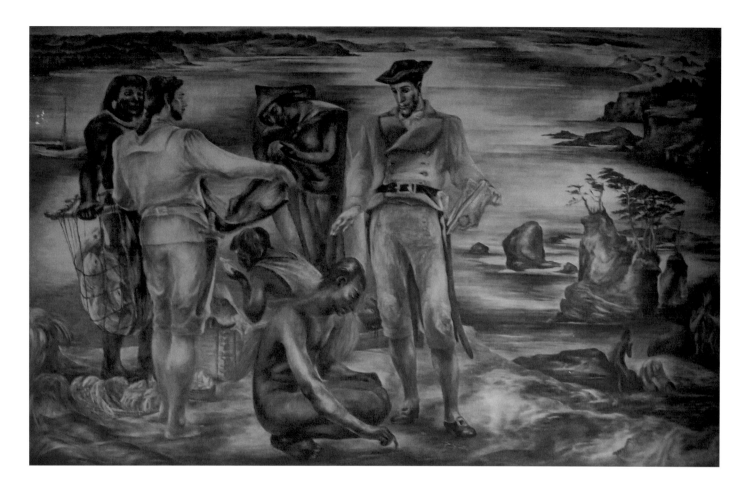

most of an entire wall (fig. 17). After the mural was installed, he found there was a vendor in the lobby whose stand was located directly in front of the painting. The vendor was willing to relocate, but the postmaster refused to permit the move as a protest against the mural.[37] The Section committee, however, loved the painting and its lively composition arching over and down alongside the doors.

In contrast, the mural created by Lucia Wiley for the Tillamook Post Office, though painted after the country's entry into World War II and in a town with a naval air base, was warmly embraced by the community. This is most likely because Wiley was a local artist and the commission was assigned to her at the request of the Tillamook community. Wiley's design took more than a year to complete, from her contract in November 1941 to installation in April 1943. *The Tillamook Indians Show Captain Gray the Location of the Great Northwest Passage, 1788* was painted in egg tempera and oil directly on the wall (fig. 18). Wiley noted delightedly, "I know that the public is pleased with it; during the entire painting time I heard no criticism regarding either the painting or the fact that it was being done. . . . Tillamook was booming, a Naval Air Base being built

Figure 18
Lucia Wiley (1906–1998)
The Tillamook Indians Show Captain Gray the Location of the Great Northwest Passage, 1788, 1941–43
Tempera and oil on plaster
7 × 12 feet
Tillamook, Oregon, Post Office
Courtesy of United States Postal Service. © 2019 USPS

This post office is now Tillamook City Hall. The mural is still in place in the lobby.

there . . . evidence of the war was on every side. . . . And yet I heard no suggestion that I should be in a critical industry, nor any criticism of the administration for going ahead with the painting. The public's reaction seemed rather to be one of a great hunger and need for just this sort of thing."[38] In fact, public reception was so positive that she was asked to do murals for the local courthouse as well, and photographs of the post office mural were forwarded to Eleanor Roosevelt as an example of the importance of culture during wartime.[39]

The final mural completed in Oregon was finished just before the Section was closed down. The competition for the Eugene Post Office was held in July 1941, with 31 artists submitting sketches. The list was narrowed to two:

Figure 19
David McCosh (1903–1981)
Incidents in the Lives of Lewis and Clark, 1936–38
Oil on canvas
6 feet × 15 feet 6 inches
Kelso, Washington, Post Office
Courtesy of United States Postal Service. © 2019 USPS

Jacob Elshin, a Seattle-based painter who had already done murals for the Section and the FAP, and Carl Morris, who had run the Spokane Art Center for the Washington FAP and then relocated to Oregon, where he was working in the shipyards by day and painting at night. Both artists were asked to submit a second set of sketches, and the commission was awarded to Morris. Elshin was furious and wrote a long, aggrieved letter to Rowan protesting the decision and accusing Morris of manipulating the committee. This was his standard response throughout the projects when decisions went against him, even though he received a steady stream of other commissions.[40] Morris created two tempera-on-canvas paintings, *Lumber* and *Agriculture*, one for each side of the lobby, installing them in mid-June 1943 as the Section's offices were closing (see page 34, fig. 5). In a letter to Rowan he noted that local residents were pleased to see public artworks painted by an Oregon artist, reporting their comments that "they had seen such things in the East and elsewhere, and, it was about time they had such things in the West as well."[41]

Four other commissions were planned for Oregon but not completed. Funds were approved though later withdrawn for works in the Hood River and Lakeview Post Offices. A competition was organized for the Medford Post Office in February 1942, then postponed indefinitely. The custodian of the Roseburg Post Office reached out to the Section after being contacted by a local artist interested in painting a mural, but there was no further action taken by the DC office.

The other disappointment for the Oregon artist community was the hiring of two New York artists to decorate the new state capitol in Salem. The original building had burned down in 1935, and a new capitol was constructed by the Public Works Administration. Although the building was a public works project, the architects selected the artists themselves rather than consulting the Section or the Oregon FAP about available local talent.[42]

Washington

The Section approved commissions for an astounding 18 federal buildings in the state of Washington. It is not clear why the state was targeted for so many—the presence of the Roosevelts' daughter in Seattle might have been one motive—but artists were happy to oblige. Two of the first contracts were awarded in 1936 to University of Washington professor Ambrose Patterson for the Mount Vernon Post Office and David McCosh at the University of Oregon for the Kelso Post Office. Patterson was a highly reputable artist in a prominent academic position, so it must have been somewhat of a shock to receive a letter from Rowan telling him the committee was disappointed

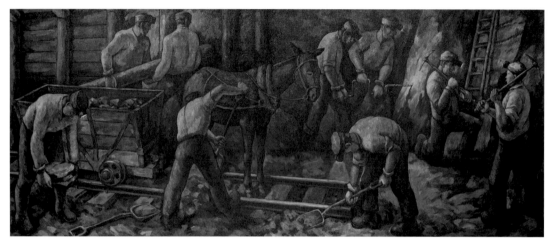

in his preliminary designs. His response is not in the files, but he did make many of the organizational changes the committee suggested. The finished mural, *Local Pursuits* (1936–38; see page 36, fig. 7), pays homage to the importance of agriculture in the Skagit Valley. McCosh's *Incidents in the Lives of Lewis and Clark* (1936–38; fig. 19) was imagined based on his interview with one of the original settlers of Kelso. McCosh described his composition as a loose triptych, but it teems with overlapping figures and events. Clearly bursting with ideas, McCosh needed three pages to describe to Rowan all the elements and symbols in his image.[43]

Another cluster of contracts was awarded in the summer and fall of 1937. Ernest Norling's *Mail Train in the 80's* was installed in the Prosser Post Office by September.[44] The image of a group of townspeople at the train station was a departure for Norling, who specialized in pictures of the Northwest lumber industry. His Prosser commission was followed almost immediately by a contract for a mural in the Bremerton Post Office for which he reverted to his favorite subject. His idyllic painting *Northwest Logging* was

Figure 20
Ernest Norling (1892–1974)
Northwest Logging, 1937–38
Oil on canvas
6 feet 3 inches × 23 feet 3 inches
Bremerton, Washington, Post Office
Courtesy of United States Postal Service. © 2019 USPS

Figure 21
Jacob Elshin (1892–1976)
Miners at Work, 1937–38
Oil on canvas
5 × 12 feet
Renton, Washington, Post Office
Courtesy of United States Postal Service. © 2019 USPS

When the post office was decommissioned and sold, this mural was moved to the Renton Public Library. The building is now the Sunset Multi-Service Center.

installed in May 1938 and harmonizes unexpectedly but gracefully with the unusual marble paneling of the wall below (fig. 20). Norling also later painted a smaller tempera titled *Pastoral Scene* for the same post office.

Two additional Section contracts were awarded in October 1937. Jacob Elshin was commissioned to create a mural for the Renton Post Office (fig. 21). He chose a scene titled *Miners at Work*, referencing the coal mining

Figure 22
Kenneth Callahan (1905–1986)
Industries of Lewis County (detail), 1937–38
Tempera on canvas
10 × 14 feet
Centralia, Washington, Post Office
Courtesy of United States Postal Service. © 2019 USPS

This mural has been covered with Plexiglas, making photography difficult.

that had led to the founding of the town. In his original sketches Elshin optimistically proposed to cover all the lobby walls with murals, but money was available for only the one panel. The second contract was for the Centralia Post Office. Having a larger budget of $870 to work with, Kenneth Callahan created a large tempera-on-canvas painting *Industries of Lewis County* (1937–38; fig. 22), though in his correspondence with Rowan he showed little enthusiasm for the community's history:

> Centralia is situated in a more or less flat area, the principal products being four; dairying, lumber production, chickens and strawberries. Its history is unremarkable—the usual pony express, block houses, decisive Indian wars, trappers and settlers, a story that is repeated throughout the west. The one outstanding thing in its history is the now famous "Centralia Massacre" of recent date, a matter, . . . if dealt with justly, would probably result in my having the same fate as the unfortunate victims, should the painting ever reach the walls of the Postoffice [*sic*]. Consequently my sketches are concerned with the industries.[45]

Callahan's attitude did not improve over the course of the commission. Rowan complained several times about the artist's lack of response to criticisms. The cloud continued over the completed work, which was received with resistance from the postmaster and confusion from local press. Callahan may, however, have learned a lesson in the politics of public art from this commission. A year later he was hired to create an oil painting for the lobby of the Anacortes Post Office (see page 35, fig. 6). Having worked as a merchant marine, he felt secure in his knowledge of the ships, rigging, and other nautical elements in his painting *Fishing*, but remained open to comments from local fishermen and made several changes based on their feedback. He also noted in a letter to Rowan that he had held his tongue when confronted with conflicting public opinions and a cranky postmaster.

Fitzgerald, who had just completed his mural for the Ontario, Oregon, Post Office, was awarded the commission for Colville, Washington, in July 1938. Rowan was delighted with Fitzgerald's sketches and invited him to submit designs for a number of other locations while completing his work for Colville. *The Pathfinders* is a simple but striking composition (fig. 23). The detailed fort in the background was modeled on the replica of the early Hudson's Bay Company settlement of Fort Nisqually in Point Defiance Park, Tacoma.

In Seattle Elshin painted a two-panel mural, *Historical Review of Education* and *Present Day Education*, for the University Station Post Office, completed in April 1939 (fig. 24). This time his budget of $1,600 was sufficient for him to paint the entire scheme he envisioned, and he packed his images with important cultural figures and

Figure 23
Edmond Fitzgerald
The Pathfinders, 1938–39
Oil on canvas
4 × 12 feet
Colville, Washington, Post Office
Courtesy of United States Postal Service. © 2019 USPS

Figure 24
Jacob Elshin
Historical Review of Education (details), 1938–39
Oil on canvas
4 feet × 13 feet 6 inches
University Station Post Office, Seattle, Washington
Courtesy of United States Postal Service. © 2019 USPS

The post office has been remodeled, and the former lobby is now a storage room. The mural is still in place, though access is restricted.

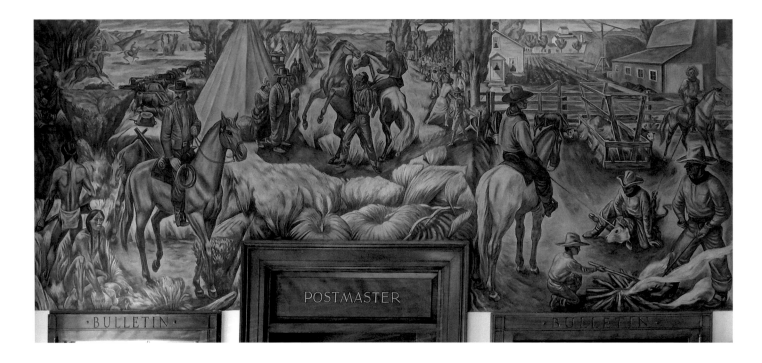

Figure 25
Andrew Vincent
Local Theme, 1939–40
Oil on canvas
4 feet 9 inches × 12 feet
Toppenish, Washington, Post Office
Courtesy of United States Postal Service. © 2019 USPS

aspiring scientists. In an interview in the *Seattle Daily Times*, Elshin outlined a dizzying list: "the first person on the left is Newton. . . . And the next figure—ah, yes—that's Dostoevski. . . . The next three figures represent Pasteur, Homer, and Cezanne. . . . The others . . . represent Beethoven, Dante, Shakespeare, Socrates, and Gutenberg. In the mural of students . . . the figures represent bacteriologists, engineers, three chemistry students and forestry students."[46]

Three works completed in the latter half of 1940 responded to the particular setting and history of each town. For his *Local Theme* in the Toppenish Post Office, Andrew Vincent from the University of Oregon strove to reflect the community, notably the robust Native American population (fig. 25). He noted: "Toppenish is a very small town in a district larg[e]ly composed of indian reservations and ranches. It is my intention to develop a mural design interesting to the local indians and other citizens thru use of subject matter and details familiar to them, presented with reasonable dramatization by design."[47] Richard Haines, a Minneapolis artist selected from his Forty-Eight States Competition submission, reflected the history of Shelton, Washington, as a timber company town in his tempera painting *The Skid Road* (fig. 26). Despite the appeal to local interests, the mural was not without controversy. Resident artist Waldo S. Chase wrote a scathing seven-page letter berating the Section for choosing someone from

outside the community with no regional knowledge.[48] Haines took it in stride, bravely choosing to paint directly on the wall and to talk with residents as they came through the post office. He made numerous alterations based on their feedback, ultimately creating a mural that pleased his audience: "In this lumber town where huge log trains roll down the main street to the mills, almost to a man the people agreed that the finished mural was exactly [*sic*] the kind of a painting they wanted in their Post Office—Wherever possible I feel the painting of these murals on the spot should be encouraged. It is an enlightening experience both for the artist and community."[49] Northwest artist Lance Hart's logging image *The Construction of a Skid Road in the 80's* (1939–40; fig. 27) for the Snohomish Post Office was accepted without comment or controversy.

The most lively and extensive mural for Washington was painted by Peggy Strong for the Wenatchee Post Office. A Tacoma native, Strong was a young modernist artist who was steadily building a regional and national reputation. Six years before receiving the commission, Strong had been partially paralyzed in an automobile accident but had

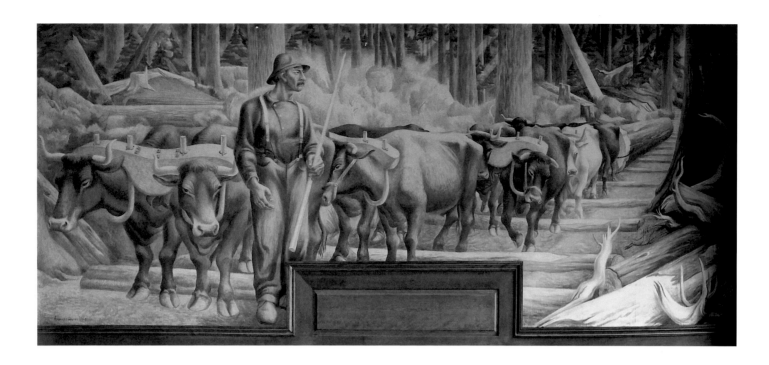

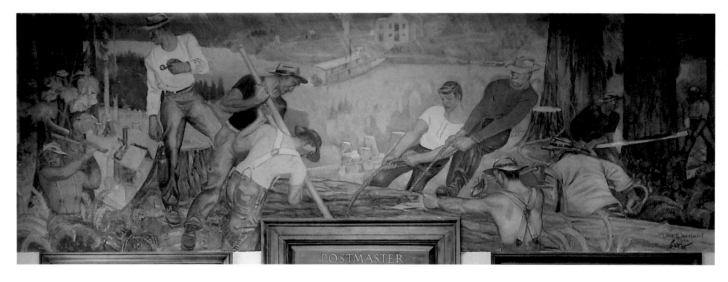

Figure 26
Richard Haines (1906–1984)
The Skid Road, 1940
Tempera on plaster
4 feet 10 inches × 12 feet
Shelton, Washington, Post Office
Courtesy of United States Postal Service. © 2019 USPS

Figure 27
Lance Hart (1891–1941)
The Construction of a Skid Road in the 80's, 1939–40
Oil on canvas
4 feet 8 inches × 14 feet
Snohomish, Washington, Post Office
Courtesy of United States Postal Service. © 2019 USPS

This post office is now Snohomish City Hall. The mural is still in place in
the lobby.

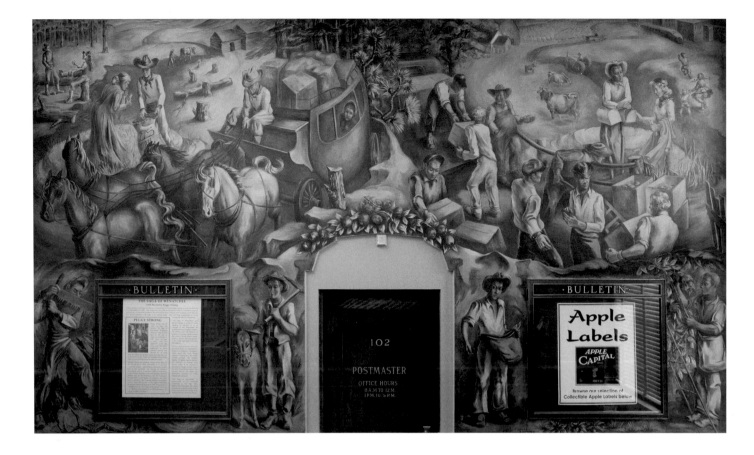

Figure 28
Peggy Strong (1912–1956)
The Saga of Wenatchee, 1939–40
Oil on canvas
6 feet 6 inches × 18 feet
Wenatchee, Washington, Post Office
Courtesy of United States Postal Service. © 2019 USPS

The post office was decommissioned and is now the Wenatchee Valley
Museum and Cultural Center. The mural is still in place.

created a system of rigging and platforms in her studio so
that she could continue working. Her completed mural, *The
Saga of Wenatchee*, installed in October of 1940, measured 117
square feet and featured an unusual decorative cutout arch
above the postmaster's door crowned by an apple bough
(fig. 28). People, animals, and activities pack every square
inch, folded into historical and contemporary vignettes and
surrounded by references to the apple orchards for which
Wenatchee is famous. The town's residents were wildly
enthusiastic. On October 12, 1940, the *Wenatchee Daily
World* ran the banner headline "BIG Painting and Little
Artist" above a large image of the artist and her mural.
Strong delightedly wrote to Rowan: "The Postmaster had
an unveiling, at which the Mayor spoke, and the crowd in
attendance was very enthusiastic and greatly pleased . . . in
fact so astonished and delighted apparantly [*sic*] that many
of them wept copiously when it was unveiled! (imagine my
amazement) . . . even the mayor was so enthused that he
made a second speach [*sic*] of appreciation."[50]

Another distinctive mural departs from the scenes of
local history and industry common in the post office paint-
ings, offering instead an allegorical fantasy. The California
artist Douglas Nicholson was assigned the contract for the

Camas, Washington, Post Office in April 1940. He chose
as his theme "the land and resources as the settler began to
develop them. Lumber, dairy, fruit and grain, and fish are
the industries which were to be developed in the region."[51]
The resulting image, titled *Beginning of a New World*
(1940–41; fig. 29), weaves symbolic figures within the
spreading branches of a stylized tree set in a simplified
landscape. The whole is painted in a muted palette of
greens and red-browns. Harmonizing the distinctive
palette with the building was a concern for Nicholson and
Rowan. Rather than following Rowan's suggestion to
extend the painting down the sides of the door arch to the
top of the bulletin boards, Nicholson instead chose to tone
his palette to more closely match the building.[52]

The steady flurry of contracts from the Section began
to slow in late 1940. Albert C. Runquist's mural *Loggers*

Figure 29
Douglas Nicholson (1907–1975)
Beginning of a New World, 1940–41
Tempera on canvas
4 feet 8 inches × 13 feet 11 inches
Camas, Washington, Post Office
Courtesy of United States Postal Service. © 2019 USPS

Figure 30
Albert C. Runquist (1894–1971)
Loggers and Millworkers, 1939–41
Tempera on canvas
6 feet 10 inches × 11 feet 11 inches
Sedro-Woolley, Washington, Post Office
Courtesy of United States Postal Service. © 2019 USPS

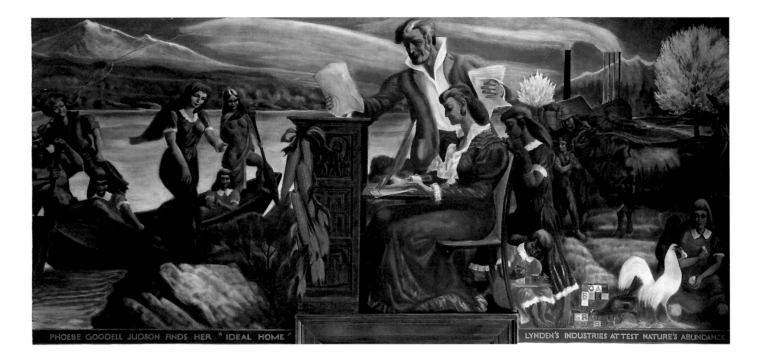

PHOEBE GOODELL JUDSON FINDS HER "IDEAL HOME" LYNDEN'S INDUSTRIES ATTEST NATURE'S ABUNDANCE

Figure 31
Mordi Gassner (1899–1995)
Three Ages of Phoebe Goodell Judson, 1941–42
Tempera on canvas
5 feet 3 inches × 12 feet 4 inches
Lynden, Washington, Post Office
Courtesy of United States Postal Service. © 2019 USPS

and Millworkers for the Sedro-Woolley Post Office, though officially recorded in May 1940, had actually been under design since the fall of 1939. Among the standard comments from Rowan on the color and composition of the completed work in April 1941 was the telling note that the expressions of the workmen were overly serious (fig. 30).[53] As the US war effort gained momentum and funding was gradually withdrawn, Section administrators carefully scrutinized details to avoid controversies and bolster their arguments to Congress that the arts were key morale boosters during wartime. Runquist and his brother Arthur, a fellow artist, were working in the shipyards. Both were known labor activists who were also on a police list of suspected communist sympathizers in Portland. Avoiding any suggestion of worker dissatisfaction would have been high on Rowan's list of community triggers to avoid.

One of the last Section contracts in Washington State was awarded to the New York artist Mordi Gassner, who was hired to paint a mural for the Lynden Post Office. He chose the town's founder as his subject. His tempera-on-canvas painting *Three Ages of Phoebe Goodell Judson* (1941–42; fig. 31) enthrones her at a massive desk in the center, surrounded by vignettes of her arrival and the farming and industrial activities attracted to the area by the town. Gassner highlighted Judson's love of learning and her founding of the Northwest Normal School, one of the first teacher training colleges in Washington State.

The Section awarded just two sculpture commissions for Washington post offices. The first went to Zygmund Sazevich in February 1941. The California sculptor proposed a three-panel work in mahogany wood over and around the postmaster's door in Kent. The center panel of his sculpture *From Far Away* depicts a logger at work, while the side panels illustrate the carrying of the mail to distant locations. The post office where this work was originally located has been sold and the sculpture moved to another post office in Kent.

The other sculpture, and the final Section commission in Washington, proved problematic from design to completion. Donlon P. McGovern of Los Angeles was selected in early 1941 for the Clarkston Post Office. He submitted his idea for a mahogany wood plaque, suggesting two possible subjects: Paul Bunyan or the explorers Meriwether Lewis and William Clark. The Section administrators chose Bunyan, but when McGovern shared his preparatory sketches with the postmaster and local residents, the subject was firmly rejected in favor of Lewis and the town's namesake, Clark. McGovern began again, trying to

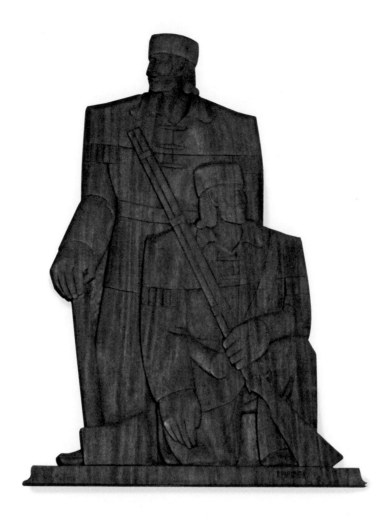

Figure 32
Donlon P. McGovern (1906–1990)
Lewis and Clark, 1941–42
Tabasco mahogany
54 × 40 inches
Clarkston, Washington, Post Office
Courtesy of United States Postal Service. © 2019 USPS

incorporate the community request for a landscape with figures but ultimately settling on a simplified design of just the two men (fig. 32). Despite the artist's accommodating attitude, the postmaster wrote to the Section early in 1942 to report growing community agitation over the use of government funds for art. A frustrating sequence of orders from the Section followed, alternately encouraging McGovern to keep working and ordering him to stop.[54] In December 1942 he completed the sculpture and shipped it to the Clarkston postmaster, who quietly put it into storage. It was finally installed in the lobby after the war ended.

Money was set aside in 1940 and 1941 for three other post office artworks for the towns of Auburn, Okanogan, and Yakima, none of which was ever completed. A competition was held for the Yakima commission, but once again public protests about wartime priorities ended the project.[55] In a letter from November 1940, Rowan notes

in passing plans for a mural for the Federal Building in Tacoma, but it too never developed.[56]

There was one more Section project in Washington. Fitzgerald was assigned to the CCC camp in Point Defiance Park, Tacoma, in March 1935. He was originally to be stationed there for six months but stayed only two, leaving for a job elsewhere. During his two months at the camp, he created a series of 30 or more images in oil, watercolor, and pen and ink of the activities of the CCC and daily life in the camp.[57] They were sent to the Section offices in DC for exhibition and are currently unlocated.

NOTES

1 Several of the classic texts examining the Section and TRAP projects include Olin Dows, "The New Deal's Treasury Art Program," *Arts in Society* 2 (Spring–Summer 1963): 51–88; Virginia M. Mecklenburg, *The Public as Patron: A History of the Treasury Department Mural Program* (College Park: University of Maryland, Department of Art, 1979); Karal Ann Marling, *Wall-to-Wall America: A Cultural History of Post-Office Murals in the Great Depression* (Minneapolis: University of Minnesota Press, 1982); and Marlene Park and Gerald E. Markowitz, *Democratic Vistas: Post Offices and Public Art in the New Deal* (Philadelphia: Temple University Press, 1984).

2 "On October 15, 1938, by order of the Director of Procurement, approved by the Secretary of the Treasury, the Section of Painting and Sculpture was changed to the Section of Fine Arts in recognition that in the past four years the methods employed by the Section have made so substantial a contribution to the development of native art that they constitute a sound basis for permanent governmental activity in this field." Report of the Section of Fine Arts 1938–1939; Section of Fine Arts—Fiscal Year 1938–39; Entry 128, Textual Records of the Section of Fine Arts, Public Buildings Administration, and Its Predecessors, Annual Reports, 1935–42, Box 1; Records Concerning Federal Art Activities; Records of the Public Buildings Service, Record Group 121; National Archives at College Park, College Park, MD (hereafter NACP).

3 Untitled, undated narrative about the organization of the Section of Fine Arts; Financial Report—August 1937; Entry 128, Textual Records of the Section of Fine Arts, Public Buildings Administration, and Its Predecessors, Annual Reports, 1935–42, Box 1; Records Concerning Federal Art Activities; Records of the Public Buildings Service, Record Group 121; NACP.

4 Edward Rowan, Assistant Technical Director, Treasury Department Art Project, Memo regarding artists in Civilian Conservation Corps Camps, not dated; Reports, Cont'd; Entry 118, Textual Records of the Treasury Relief Art Project, General Administrative and Reference File of the Chief, 1935–37, Box No. 2; Records Concerning Federal Art Activities; Records of the Public Buildings Service, Record Group 121; NACP.

5 The TRAP and Section commissions are fairly well documented. Contracts and a variety of related correspondence can be found in the textual records of both projects at the National Archives at College Park and are full of interesting details and exchanges.

6 Olin Dows, "The New Deal's Treasury Art Program: A Memoir," in *The New Deal Art Projects: An Anthology of Memoirs*, ed. Francis V. O'Connor (Washington, DC: Smithsonian Institution Press, 1972), 12.

7 Harry Hopkins, "Address on Federal Relief Delivered at a WPA Luncheon," September 19, 1936, Harry L. Hopkins Papers, Federal Relief Agency Papers, Box 9, Franklin D. Roosevelt Library, Hyde Park, New York.

8 Francis V. O'Connor, *Federal Support for the Visual Arts: The New Deal and Now* (Greenwich, CT: New York Graphic Society, 1969), 22.

9 Interim report, Treasury Relief Art Project, May 1, 1936, p. 2; Memo to Director/Peoples; Entry 118, Textual Records of the Treasury Relief Art Project, General Administrative and Reference File of the Chief, 1935–37, Box 1; Records Concerning Federal Art Activities; Records of the Public Buildings Service, Record Group 121; NACP.

10 O'Connor, *Federal Support for the Visual Arts*, 25–26.

11 "The sixteen employees on the payroll as of July 1, 1938 were transferred to the Works Progress Administration as their respective projects were completed. . . . The photographic and technical materials used by this Project were taken over by the Section of Fine Arts. . . . Of the 10,217 easel paintings completed under this Project, all except approximately three hundred were allocated to various Government activities. These remaining ones were allocated to the Section of Fine Arts as of June 30, 1939." Cecil H. Jones, Chief, Treasury Relief Art Project, to Mr. Schaefer, not dated; Reports; Entry 118, Textual Records of the Treasury Relief Art Project, General Administrative and Reference File of the Chief, 1935–37, Box 2; Records Concerning Federal Art Activities; Records of the Public Buildings Service, Record Group 121; NACP.

12 Interim report, Treasury Relief Art Project, May 1, 1936, p. 38; Memo to Director/Peoples; Entry 118, Textual Records of the Treasury Relief Art Project, General Administrative and Reference File of the Chief, 1935–37, Box 1; Records Concerning Federal Art Activities; Records of the Public Buildings Service, Record Group 121; NACP.

13 "John Ballator, assisted by Louis Bunce and Eric [*sic*] Lamade, is doing a panel 16' by 8' at each end of the public lobby. Mr. Ballator is doing one panel under the Section of Painting and Sculpture. The other one he has designed and supervised for six months." Interim report, Treasury Relief Art Project, May 1, 1936, p. 28; Memo to Director/Peoples; Entry 118, Textual Records of the Treasury Relief Art Project, General Administrative and Reference File of the Chief, 1935 37, Box 1; Records Concerning Federal Art Activities; Records of the Public Buildings Service, Record Group 121; NACP.

14 Ellis Lawrence, Chairman, Competition Committee, to Edward Rowan, Superintendent, Section of Painting and Sculpture, June 25 1935; St. Johns—P.O.—Jan.–July 1935 (OR); Entry 133, Textual Records of the Section of Fine Arts, Public Buildings Administration, and Its Predecessors, Case Files Concerning Embellishments of Federal Buildings, 1934–43 OR, Box 89; Records Concerning Federal Art Activities; Records of the Public Buildings Service, Record Group 121; NACP.

15 Olin Dows, Chief, Treasury Relief Art Project, to Robert Bruce Inverarity, May 25, 1936; Washington State; Entry 119, Textual Records of the Treasury Relief Art Project, Central Office Correspondence with Field Offices, State Supervisors, and Others, 1935–39 WA–VI, Box 27; Records Concerning Federal Art Activities; Records of the Public Buildings Service, Record Group 121; NACP.

16 Kenneth Callahan to Cecil R. Jones, Assistant Chief, Treasury Relief Art Project, November 4, 1935; Seattle Mar. Hos.; Entry 119, Textual Records of the Treasury Relief Art Project, Central Office Correspondence with Field Offices, State Supervisors, and Others, 1935–39 WA–VI, Box 27; Records Concerning Federal Art Activities; Records of the Public Buildings Service, Record Group 121; NACP. At one point these murals were taken down and stored, then transferred to the custody of the Museum of History & Industry in Seattle and restored. Some of the panels are on view in the original location (now Pacific Tower) and others at the museum.

17 Kenneth Callahan to Olin Dows, Chief, Treasury Relief Art Project, November 20, 1935; Seattle Mar. Hos.; Entry 119, Textual Records of the Treasury Relief Art Project, Central Office Correspondence with Field Offices, State Supervisors, and Others, 1935–39 WA–VI, Box 27; Records Concerning Federal Art Activities; Records of the Public Buildings Service, Record Group 121; NACP.

18 Elizabeth Lochrie to Edward Rowan, Superintendent, Section of Painting and Sculpture, February 16, 1937; Burley—P.O. (ID); Entry 133, Textual Records of the Section of Fine Arts, Public Buildings Administration, and Its Predecessors, Case Files Concerning

Embellishments of Federal Buildings, 1934–43 ID–IL, Box 19; Records Concerning Federal Art Activities; Records of the Public Buildings Service, Record Group 121; NACP.

19 Postmaster, St. Anthony, Idaho, to Treasury Department, May 18, 1939; St. Anthony—P.O. (ID); Entry 133, Textual Records of the Section of Fine Arts, Public Buildings Administration, and Its Predecessors, Case Files Concerning Embellishments of Federal Buildings, 1934–43 ID–IL, Box 19; Records Concerning Federal Art Activities; Records of the Public Buildings Service, Record Group 121; NACP.

20 "It was the feeling of this office that an American Indian could reflect Indian life and thought in a mural better than a white artist could or than a self-appointed critic could tell him how to do it. This office is particularly anxious not to influence the attitude of Indian artists in relation to their work and it was our further understanding that Mr. Standing Soldier reflected in his work Indians as he knew them." Edward Rowan, Assistant Chief, Section of Fine Arts, to Willard W. Beatty, Director of Education, Bureau of Indian Affairs, December 11, 1939; Blackfoot—P.O. (ID); Entry 133, Textual Records of the Section of Fine Arts, Public Buildings Administration, and Its Predecessors, Case Files Concerning Embellishments of Federal Buildings, 1934–43 ID–IL, Box 19; Records Concerning Federal Art Activities; Records of the Public Buildings Service, Record Group 121; NACP.

21 Andrew Standing Soldier to Edward Rowan, Assistant Chief, Section of Fine Arts, August 19, 1939; Blackfoot—P.O. (ID); Entry 133, Textual Records of the Section of Fine Arts, Public Buildings Administration, and Its Predecessors, Case Files Concerning Embellishments of Federal Buildings, 1934–43 ID–IL, Box 19; Records Concerning Federal Art Activities; Records of the Public Buildings Service, Record Group 121; NACP.

22 Multiple signatories to Office of Indian Affairs, Washington, DC, January 14, 1941; Blackfoot—P.O. (ID); Entry 133, Textual Records of the Section of Fine Arts, Public Buildings Administration, and Its Predecessors, Case Files Concerning Embellishments of Federal Buildings, 1934–43 ID–IL, Box 19; Records Concerning Federal Art Activities; Records of the Public Buildings Service, Record Group 121; NACP.

23 Richard Guy Walton to Edward Rowan, Assistant Chief, Section of Fine Arts, January 1941; Buhl—P.O. (ID); Entry 133, Textual Records of the Section of Fine Arts, Public Buildings Administration, and Its Predecessors, Case Files Concerning Embellishments of Federal Buildings, 1934–43 ID–IL, Box 19; Records Concerning Federal Art Activities; Records of the Public Buildings Service, Record Group 121; NACP.

24 Robert Midtlyng, Postmaster, to Public Buildings Administration, October 30, 1941; Deer Lodge—P.O. (MT); Entry 133, Textual Records of the Section of Fine Arts, Public Buildings Administration, and Its Predecessors, Case Files Concerning Embellishments of Federal Buildings, 1934–43 MT, Box 60; Records Concerning Federal Art Activities; Records of the Public Buildings Service, Record Group 121, NACP.

25 "This Mural Will Go on Glasgow Postoffice [sic] Wall," *Glasgow Courier*, October 2, 1941.

26 Changes in use of the building required enhanced security, and a new lobby wall was built just a few feet out from the wall on which the mural is installed, greatly restricting access and photography.

27 Henry Meloy, Columbia University, to Edward Rowan, Section of Fine Arts, May 23, 1942; Hamilton—P.O. (MT); Entry 133, Textual Records of the Section of Fine Arts, Public Buildings Administration, and

Its Predecessors, Case Files Concerning Embellishments of Federal Buildings, 1934–43, MT, Box 60; Records Concerning Federal Art Activities; Records of the Public Buildings Service, Record Group 121, NACP.

28 Edward Rowan, Assistant Chief, Section of Fine Arts, to Henry Meloy, August 11, 1942; Hamilton—P.O. (MT); Entry 133, Textual Records of the Section of Fine Arts, Public Buildings Administration, and Its Predecessors, Case Files Concerning Embellishments of Federal Buildings, 1934–43 MT, Box 60; Records Concerning Federal Art Activities; Records of the Public Buildings Service, Record Group 121, NACP.

29 E. G. Butterfield, Manager, Mountain States Telephone and Telegraph Company, to C. A. Smithey, Postmaster, September 30, 1942; Hamilton—P.O. (MT); Entry 133, Textual Records of the Section of Fine Arts, Public Buildings Administration, and Its Predecessors, Case Files Concerning Embellishments of Federal Buildings, 1934–43 MT, Box 60; Records Concerning Federal Art Activities; Records of the Public Buildings Service, Record Group 121, NACP.

30 Ray Enyart, Recreation Supervisor, Works Progress Administration Montana, to Frank Monaghan, Postmaster, December 30, 1937; Butte—P.O. (MT); Entry 133, Textual Records of the Section of Fine Arts, Public Buildings Administration, and Its Predecessors, Case Files Concerning Embellishments of Federal Buildings, 1934–43 MT, Box 60; Records Concerning Federal Art Activities; Records of the Public Buildings Service, Record Group 121, NACP.

31 Edmond Fitzgerald to Inslee Hopper, Section of Painting and Sculpture, November 16, 1937; Ontario—P.O. (OR); Entry 133, Textual Records of the Section of Fine Arts, Public Buildings Administration, and Its Predecessors, Case Files Concerning Embellishments of Federal Buildings, 1934–43 OR, Box 89; Records Concerning Federal Art Activities; Records of the Public Buildings Service, Record Group 121, NACP.

32 Edward Rowan, Superintendent, Section of Painting and Sculpture, to Paul Grellert, August 19, 1938; Portland—P.O. (OR); Entry 133, Textual Records of the Section of Fine Arts, Public Buildings Administration, and Its Predecessors, Case Files Concerning Embellishments of Federal Buildings, 1934–43 OR, Box 89; Records Concerning Federal Art Activities; Records of the Public Buildings Service, Record Group 121, NACP.

33 Jack Wilkinson to Edward Rowan, Section of Fine Arts, June 22, 1941; Burns—P.O. (OR); Entry 133, Textual Records of the Section of Fine Arts, Public Buildings Administration, and Its Predecessors, Case Files Concerning Embellishments of Federal Buildings, 1934–43 OR, Box 89; Records Concerning Federal Art Activities; Records of the Public Buildings Service, Record Group 121, NACP.

34 "The people of Burns would be very happy to know that the final design would be more suitable and more accurate in historical detail. Certainly it should be authentic and correct. The ludicrous features of the first design do not blind us to the artistic merit . . . but would, of course, have to be overcome, as it would be shocking to all observers to have such a conception perpetuated on the walls of a government building." Senator Walter M. Pierce to Treasury Department, not dated; Burns—P.O. (OR); Entry 133, Textual Records of the Section of Fine Arts, Public Buildings Administration, and Its Predecessors, Case Files Concerning Embellishments of Federal Buildings, 1934–43 OR, Box 89; Records Concerning Federal Art Activities; Records of the Public Buildings Service, Record Group 121, NACP.

35 Jack Wilkinson to Edward Rowan, Section of Fine Arts, June 22, 1941; Burns—P.O. (OR); Entry 133, Textual Records of the Section of Fine

Arts, Public Buildings Administration, and Its Predecessors, Case Files Concerning Embellishments of Federal Buildings, 1934–43 OR, Box 89; Records Concerning Federal Art Activities; Records of the Public Buildings Service, Record Group 121, NACP.

36 The delays were caused by a change of artist. The committee consisting of Frederick A. Sweet, Sally Hart, and Walter E. Church had selected Emma Davis for the commission, but administrators in the DC office vetoed the selection and assigned it to Andrew Vincent. Notes on Salem mural competition, not dated; Salem—P.O. (OR); Entry 133, Textual Records of the Section of Fine Arts, Public Buildings Administration, and Its Predecessors, Case Files Concerning Embellishments of Federal Buildings, 1934–43 OR, Box 89; Records Concerning Federal Art Activities; Records of the Public Buildings Service, Record Group 121, NACP.

37 Andrew Vincent to Edward Rowan, Assistant Chief, Section of Fine Arts, February 7, 1942; Salem—P.O. (OR); Entry 133, Textual Records of the Section of Fine Arts, Public Buildings Administration, and Its Predecessors, Case Files Concerning Embellishments of Federal Buildings, 1934–43 OR, Box 89; Records Concerning Federal Art Activities; Records of the Public Buildings Service, Record Group 121, NACP.

38 Lucia Wiley to Edward Rowan, Assistant Chief, Section of Fine Arts, April 30, 1943; Tillamook—P.O. (OR); Entry 133, Textual Records of the Section of Fine Arts, Public Buildings Administration, and Its Predecessors, Case Files Concerning Embellishments of Federal Buildings, 1934–43 OR, Box 89; Records Concerning Federal Art Activities; Records of the Public Buildings Service, Record Group 121, NACP.

39 Henry Anderson, Postmaster, to Edward Rowan, Section of Fine Arts, April 27, 1943; Tillamook—P.O. (OR); Entry 133, Textual Records of the Section of Fine Arts, Public Buildings Administration, and Its Predecessors, Case Files Concerning Embellishments of Federal Buildings, 1934–43 OR, Box 89; Records Concerning Federal Art Activities; Records of the Public Buildings Service, Record Group 121, NACP.

40 Jacob Elshin to Edward Rowan, Assistant Chief, Section of Fine Arts, January 7, 1942; Entry 133, Textual Records of the Section of Fine Arts, Public Buildings Administration, and Its Predecessors, Case Files Concerning Embellishments of Federal Buildings, 1934–43 OR, Box 89; Records Concerning Federal Art Activities; Records of the Public Buildings Service, Record Group 121, NACP.

41 Carl Morris to Edward Rowan, Assistant Chief, Section of Fine Arts, June 29, 1943; Eugene—P.O. (OR); Entry 133, Textual Records of the Section of Fine Arts, Public Buildings Administration, and Its Predecessors, Case Files Concerning Embellishments of Federal Buildings, 1934–43 OR, Box 89; Records Concerning Federal Art Activities; Records of the Public Buildings Service, Record Group 121, NACP.

42 Olin Dows, Chief, Treasury Relief Art Project, to Alton John Bassett, Secretary, State Capitol Reconstruction Commission, May 13, 1936; Oregon; Entry 119, Treasury Relief Art Project Central Office Correspondence with Field Offices, State Superintendents & Others, 1935–39, Box 25; Records Concerning Federal Art Activities; Records of the Public Buildings Service, Record Group 121, NACP.

43 David McCosh to Edward Rowan, Superintendent, Section of Fine Arts, May 13, 1936; Kelso—P.O. (WA); Entry 133, Textual Records of the Section of Fine Arts, Public Buildings Administration, and Its Predecessors, Case Files Concerning Embellishments of Federal Buildings 1934–43 VA–WA, Box 111; Records Concerning Federal Art Activities; Records of the Public Buildings Service, Record Group 121, NACP.

44 The title is given as *Mail Train—1885* on the data sheet from the artist on file at the National Archives. Section of Fine Arts contract with Ernest Norling for the Prosser, Washington, Post Office, April 11, 1937; Prosser—P.O. (WA); Entry 133, Textual Records of the Section of Fine Arts, Public Buildings Administration, and Its Predecessors, Case Files Concerning Embellishments of Federal Buildings 1934–43 WA Lynden–Wenatchee, Box 112; Records Concerning Federal Art Activities; Records of the Public Buildings Service, Record Group 121, NACP.

45 Kenneth Callahan to Edward Rowan, Superintendent, Section of Painting and Sculpture, September 1, 1937; Centralia—P.O. (WA); Entry 119, Textual Records of the Treasury Relief Art Project Central Office Correspondence with Field Offices, State Supervisors, and Others, 1935–39 WA–VI, Box 27; Records Concerning Federal Art Activities; Records of the Public Buildings Service, Record Group 121, NACP.

46 "P.O. Patrons See Premiere of Seattle Artist's Murals," *Seattle Daily Times*, April 5, 1939, 10.

47 Andrew Vincent to Edward Rowan, Assistant Chief, Section of Fine Arts, June 1, 1940; Toppenish—P.O. (WA); Entry 133, Textual Records of the Section of Fine Arts, Public Buildings Administration, and Its Predecessors, Case Files Concerning Embellishments of Federal Buildings 1934–43 WA Lynden–Wenatchee, Box 112; Records Concerning Federal Art Activities; Records of the Public Buildings Service, Record Group 121, NACP.

48 Waldo S. Chase to Miss Knight, Postmistress, Shelton Post Office, November 24, 1939; Shelton—P.O. (WA); Entry 133, Textual Records of the Section of Fine Arts, Public Buildings Administration, and Its Predecessors, Case Files Concerning Embellishments of Federal Buildings 1934–43 WA Lynden–Wenatchee, Box 112; Records Concerning Federal Art Activities; Records of the Public Buildings Service, Record Group 121, NACP.

49 Richard Haines to Edward Rowan, Section of Fine Arts, October 4, 1940; Shelton—P.O. (WA); Entry 133, Textual Records of the Section of Fine Arts, Public Buildings Administration, and Its Predecessors, Case Files Concerning Embellishments of Federal Buildings 1934–43 WA Lynden–Wenatchee, Box 112; Records Concerning Federal Art Activities; Records of the Public Buildings Service, Record Group 121, NACP.

50 Peggy Strong to Edward Rowan, Section of Fine Arts, October 12, 1940; Wenatchee—P.O. (WA); Entry 133, Textual Records of the Section of Fine Arts, Public Buildings Administration, and Its Predecessors, Case Files Concerning Embellishments of Federal Buildings 1934–43 WA Lynden–Wenatchee, Box 112; Records Concerning Federal Art Activities; Records of the Public Buildings Service, Record Group 121, NACP.

51 Douglas Nicholson to Edward Rowan, Section of Fine Arts, April 23, 1940; Camas—P.O. (WA); Entry 133, Textual Records of the Section of Fine Arts, Public Buildings Administration, and Its Predecessors, Case Files Concerning Embellishments of Federal Buildings 1934–43 VA–WA, Box 111; Records Concerning Federal Art Activities; Records of the Public Buildings Service, Record Group 121, NACP.

52 The surrounding walls today are an unusual warm pink tone that sets off the work and suggests the original lobby color is still maintained. The art historian Sharon Long Baerny also has noted that the colors in the mottled marble of the lobby are echoed in the painting. Baerny, "Public Art, Public History," *Artifact* (July/August 1995): 9–14.

53 Edward Rowan, Assistant Chief, Section of Fine Arts, to A. C. Runquist, Portland, June 20, 1940; Sedro Woolley—P.O. (WA); Entry 133, Textual Records of the Section of Fine Arts, Public Buildings Administration, and Its Predecessors, Case Files Concerning Embellishments of

Federal Buildings 1934–43 WA Lynden–Wenatchee, Box 112; Records Concerning Federal Art Activities; Records of the Public Buildings Service, Record Group 121, NACP.

54 See various letters in Clarkston—P.O. (WA); Entry 119, Textual Records of the Treasury Relief Art Project Central Office Correspondence with Field Offices, State Supervisors, and Others, 1935–39 WA–VI, Box 27; Records Concerning Federal Art Activities; Records of the Public Buildings Service, Record Group 121, NACP.

55 The archives include letters of protest from the Yakima Lions Club, Yakima Chamber of Commerce, *Yakima Daily Republic*, the state senator for the district, and several individuals. Yakima, Washington P.O. & C.H.; Entry 1, Textual Records of the Section of Fine Arts, Public Buildings Administration, and Its Predecessors, Records Relating to Murals, 1936–40, Box 6; Records Concerning Federal Art Activities; Records of the Public Buildings Service, Record Group 121, NACP.

56 Edward Rowan, Section of Fine Arts, to Virginia Darcé, November 2, 1940; Da–Dd; Entry 126, Textual Records of the Section of Fine Arts, Public Buildings Administration, and Its Predecessors, Correspondence with Artists ("Artists' Letters"), 1939–42 A–G, Box 1; Records Concerning Federal Art Activities; Records of the Public Buildings Service, Record Group 121, NACP.

57 Letters list a total of 27 different images. See Edmond Fitzgerald to Edward Rowan, Section of Fine Arts, April 16, 1935, and May 22, 1935; Fitzgerald, Edmond J.; Entry 142, Textual Records of the Section of Fine Arts, Public Buildings Administration, and Its Predecessors, Correspondence with and about Artists in the Civilian Conservation Corps Camps, 1934–37, Box 2; Records Concerning Federal Art Activities; Records of the Public Buildings Service, Record Group 121, NACP.

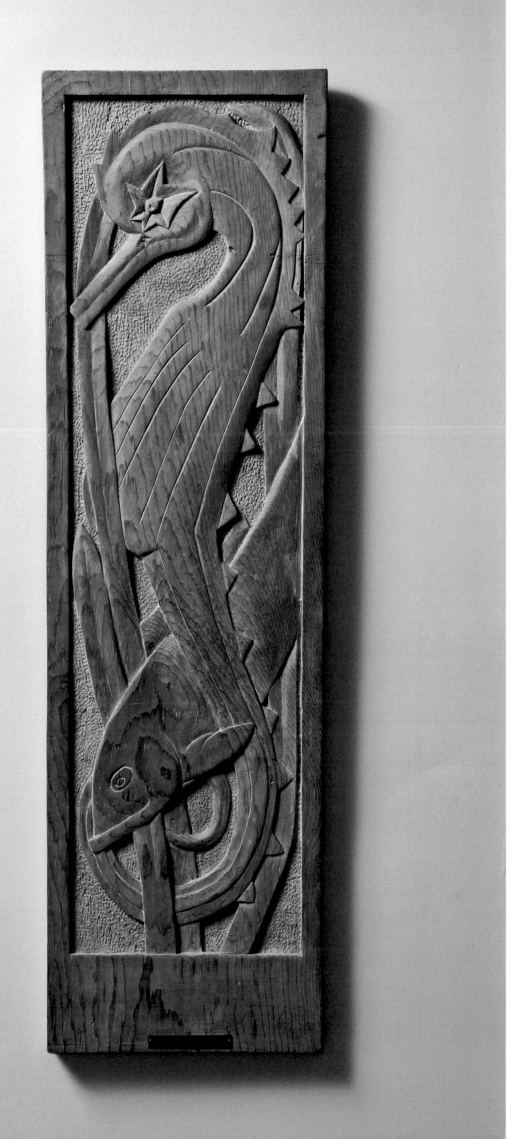

THE FEDERAL ART PROJECT

MARGARET E. BULLOCK

The largest and best known of the New Deal government art projects was the far-reaching program known as Federal One under the purview of the Works Progress Administration (WPA). Federal One was authorized in late August 1935. It had been proposed by Harry Hopkins, then the head of the Federal Emergency Relief Administration, as the follow-up project to the Public Works of Art Project (PWAP), but the Treasury Department had instead adopted Edward Bruce's more focused proposal, which became the Section of Fine Arts. After Hopkins was put in charge of the WPA, he resurrected his plan for employing people across the arts. Under the Federal One umbrella he set up the Federal Art, Music, Theatre, and Writers' Projects as well as the Historical Records Survey, which had the twofold mission of cataloguing America's important historical documents and employing office workers.

Holger Cahill, the director of exhibitions for the Museum of Modern Art, New York, as well as a noted writer and folklorist, was hired to run the Federal Art Project (FAP). The bureaucratic structure of the FAP echoed the earlier PWAP. There was a network of field advisers who reported directly to Cahill and oversaw the directors for each region. The regional directors then appointed state directors who could further add local supervisors and committees as desired.[1] These FAP administrators were expected to work collegially with their counterparts in the WPA to ensure that funding transfers and other details ran smoothly. Although the WPA was established by a liberal administration broadly supportive of the arts, the government employees who ran it had a spectrum of personal tastes and political opinions. WPA staff could effectively block the establishment of an art project in their state by simply refusing to authorize the release of funds or arbitrarily reducing or reassigning them. State WPA administrators were senatorial appointees, adding a further layer of complication. Because the politics were tangled, Hopkins sometimes had to resort to careful diplomacy rather than asserting his authority to keep the entire FAP moving forward.

Philosophically, the FAP was a mix of practical work relief and higher aspirations, just as the previous art projects had been. President Roosevelt and Hopkins saw Federal One as primarily an economic relief program for arts workers. Cahill and his network of administrators at the FAP wanted to foster artistic quality, increase art appreciation among the American public, and establish a network of community supporters who would sustain artists after government programs ended. A report on the

Paul L. Cunningham (1906–1968)
Untitled (plaque with seahorse and fish), 1938
Carved wood
11¹³⁄₁₆ × 4⅜ × 1 inches
Western Gallery, Western Washington University, WWU 2004.024.001.0

FAP written in February 1936, a few months after it was established, summarized these aspirational goals:

> The Federal Art Project of the Works Progress Administration is in the nature of a conservation movement of nationwide proportions. Our primary objective in the arts program, as in the fields of writing, theatre and music, is to conserve the talents and the skills of thousands of artists who, given the opportunity, are capable of making contributions of the utmost value to the enrichment of American life. . . . The national and state directors of the Federal Art Project believe that public demand—expressed in terms of economic support—is a necessary element in the development of American art. They believe that the artist must have a public if he is to function freely and fully, and make the contribution he is capable of making to contemporary American civilization. . . . Artists, like all other professional and skilled workers, want a job to do. And if the result of their activity is a better America, a more complete and well-rounded life for the community, they as well as the Federal Government have the satisfaction of supporting . . . an enterprise worthy of the best the creative workers of America can give.[2]

Bound up in this idealistic statement was the somewhat radical idea for the times that art making was a profession like any other and that artists should be able to make a living from their work rather than be forced to rely on the changeable support of wealthy patrons. Further, it asserted that the arts were an important component of the national cultural fabric and essential in maintaining the morale of the American public.[3] These claims became pivotal in arguments for continuing Federal One and the Section of Fine Arts in later years as the nation shifted toward war and most government resources were redirected to that effort.

The FAP set out to track and measure the amount of work being done. Artists were supposed to put in 96 hours per month, though they could determine their own schedules and use their individual studios. As might be expected, this honor system became increasingly unreliable as the number of artists on the FAP swelled. The administrators tried various procedures, such as sending monitors to randomly check on artists at their studios, creating central workplaces, and other variations, but none proved effective. Ultimately, it was the output in artwork that became the best measure of the FAP's productivity.

Another complexity was the requirement that the numbers of artists hired from the relief rolls be balanced against those not receiving government assistance. These quotas were a constant bugbear, as they had been for the PWAP (see page 42). At the outset of the FAP, 90 percent of the artists hired were required to be receiving government assistance, but state art project administrators immediately faced the challenge of finding enough well-qualified artists on the relief rolls to properly execute the commissions they were lining up. Within a few months, and after many protest letters from the states, the relief hire quota was reduced to 75 percent; it continued to shift constantly, and often drastically and with little warning, throughout the life of the FAP.[4]

Artists were classified into one of four categories. Professional and Technical workers were experienced artists capable of producing work of high standard and often used as supervisors on projects. The category included not only painters, sculptors, graphic artists, and photographers but also art teachers and researchers. Those in the Skilled category were loosely defined as artists capable of producing good work but not of the same quality as those in the highest category. In the Intermediate classification were less skilled and less experienced artists, craftspeople, and apprentices. Workers in the Unskilled category filled maintenance positions as well as serving as messengers, gallery attendants, and office staff.[5] Wages for each of these categories were fairly standardized nationwide, though there were some allowances made for more expensive cities or discrete commissions.

FAP administrators were given wide latitude in the choice of potential projects. In his foreword to the catalogue of an exhibition of FAP work at the Museum of Modern Art, Cahill described the underlying philosophy:

> The plan of the Federal Art Project provides for the employment of artists in varied enterprises. Through employment of creative artists it is

hoped to secure for the public outstanding examples of contemporary American art; through art teaching and recreational art activities to create a broader national art consciousness and work out constructive ways of using leisure time; through services in applied art to aid various campaigns of social value; and through research projects to clarify the native background in the arts. The aim of the project will be to work toward an integration of the arts with the daily life of the community, and an integration of the fine arts and the practical arts.[6]

To further habituate other government agencies, public institutions, and civic organizations to the process of commissioning work from artists, the FAP set up a system of cosponsorship. FAP work was restricted to tasks not normally performed by the sponsor's staff so that government work relief dollars were not paying for standard business expenses. An elaborate system of cosponsor contributions was put in place and covered everything from small watercolors to multipanel murals and monumental sculptures.[7] For specific commissions, sponsors generally paid for equipment, materials, and installation, with the FAP providing for the artist's labor. It varied from state to state how much of a role the sponsors had in choosing the artist, style, or subject of their selected work. Another avenue for spreading artwork across communities was the loan of works, which also often required a sponsorship fee. The FAP could loan for short-term or extended periods to "public agencies or institutions, supported in whole or in part by tax funds, the function of which does not include the purchase of works of art."[8] These loans were described as permanent, extending for a period of 99 years. The fee, the extremely long loan period, and the eventual ending of the FAP led many to feel that the work now belonged to them. However, the US government retained ownership rights in the artworks and continues to do so, a source of confusion and complication in the transfer of, restoration of, and other situations with these works today.[9]

Two other central strategies encouraged the general public's appreciation and support of fine art. The first was a program that circulated exhibitions of FAP work

across the country. An Exhibition Section was established in Washington, DC, under the direction of Mildred Holzhauer. She, her assistant, and a small staff of framers, carpenters, and clerks organized exhibitions of FAP artwork from all over the country, but they also borrowed from museum and private collections, historical societies, schools, and other sources. Exhibitions of Old Master works, Japanese woodblock prints, and paintings by Pablo Picasso were joined by those of children's art and quilts and shows about artistic process. They were shipped by rail to FAP galleries around the country and came complete with explanatory texts.

The FAP's second and more extensive form of public outreach and involvement was the establishment of community art centers.[10] Originally these were targeted to rural areas and small towns, though over time several were established in large cities. The art centers were the engine for Cahill's ambitious plan to make art a fundamental part of every American community by giving everyone the opportunity to experience it in some way. The prospectus on art centers sent by Cahill to all regional directors described this inclusive mandate:

> In general the program shall be designed to provide a center for community art activity; to develop a permanent educational program in the arts; to aid public school and recreational art service; to provide guidance for persons interested in art as a vocation; to inaugurate an avocational program for the community as a whole; and through these activities to develop interest and sponsorship for a permanent institution of this nature. . . . The program shall consist of four major divisions: (1) continuously changing exhibitions of fine and related arts; (2) a free art school; (3) extension department; (4) library and research department.[11]

Communities were required to fundraise for and otherwise support their art center; the hope was that their involvement might ensure continued operation after government funding ended. Each location arranged quarters and provided for utilities and upkeep, while the

FAP paid for teachers and other staff. The costs of equipment and art materials were paid by a mix of sponsor and FAP money. The centers were wildly popular, uniformly reporting enthusiastic community involvement, waiting lists for classes, and strong attendance for exhibitions. By December 1937 there were 50 community art centers in operation across the country and by the end of the FAP more than 100 were in operation.[12] In 1938 the FAP started temporarily transferring artists from major cities to work as teaching artists at the centers to further expose smaller communities to a variety of artistic ideas and styles. This strategy had mixed results; sometimes the culture shock experienced by both the visiting artist and the community proved too extreme to be successful.[13]

The community art centers embodied Cahill's desire to make art accessible to everyone by embracing a definition that encompassed craft as well as fine art traditions. Aligned with this effort was another nationwide project meant to preserve American heritage and celebrate American folk and decorative arts. The Index of American Design was launched in 1935 and ran until 1942. Artists were hired to create highly detailed watercolors of objects from the colonial period through 1900. Thirty-four states participated, generating some 18,000 images, which are now housed in the National Gallery of Art. These pictures of textiles, weather vanes, and a host of other objects were assembled into volumes by region and exhibited at the art centers to illustrate Americans' shared heritage.

Hopkins's all-encompassing vision for the FAP included artists of myriad styles and philosophies. He insisted that their politics and personal lives were not relevant to employment. He also did not express a preference for the realism and regional focus of American Scene painting as seen in the other art projects. Together, the wide variety of arts workers employed and Hopkins's embrace of creative freedom are what fostered the FAP's success, but it also exposed the program to a variety of controversies. Political concerns proved the most damaging. The arts were viewed as hotbeds of radical thought, loose morals, and other suspect habits. As well, a number of creative figures were involved with various leftist political movements and many were vocal advocates through their work or public forums. As early as 1938 employees

of the Theatre and Writers' Projects were called before the House Un-American Activities Committee investigating suspected communists and sympathizers. Ultimately, as war-related hysteria grew, political pressure forced the end of the Federal Theatre Project and reorganization of the remaining projects under Federal One. Stylistic differences were also a sticking point at times. Artists who were working with abstraction, social realism, expressionism, or other modern artistic styles sometimes experienced local resistance, harsh criticism, or outright rejection of their work. Overall, however, the work created by FAP artists is a rich conglomerate of voices and styles.

Over the life of the art projects, the political climate in Washington became increasingly conservative and opposed to the continuation of all the WPA programs. Controversies surrounding the FAP were seized upon as evidence of corruption, misuse of federal funds, and antigovernment activities and used to bolster the arguments for their cancellation. Oversight and funding of Federal One shifted constantly and a steady stream of new regulations attempted to limit and control its activities. The WPA state administrators were given increasing control over their state art projects and in 1937 were given the authority to unilaterally close them down if desired. In July 1939 the Works Progress Administration was given the more neutral title of the Work Projects Administration and put under the supervision of the new Federal Works Agency. This was followed by a congressional vote in September that ended Federal One and transferred the Federal Art, Music, and Writers' Projects to state control in collaboration with the central offices in Washington, DC. Congress also enacted new rules that required sponsors for all art project activities and added a restriction whereby artists could only work for 18 consecutive months before having to find other employment. This regulation was retroactive and forced the sudden layoff of a large number of FAP artists nationwide, causing chaos for many state art projects. In March 1942 the FAP became the Graphic Section of the War Services Program and most activity shifted to national defense work. All statewide art projects were closed by early February 1943. For Cahill and his administrators, the constantly shifting ground was a source of never-ending frustration and contradictory dictates. The most successful art project directors were those

Minor White (1908–1976)
Arthur Runquist and Martina Gangle working on their mural for Pendleton
High School at the Oregon Art Project studio in Portland, circa 1940
Nitrate negative
4 × 5 inches
Oregon WPA and SFA Negatives Collection, Anne and James F. Crumpacker
Family Library, Portland Art Museum, WPA 4960

whose personalities combined dedication with flexibility and diplomatic skills. Fortunately for the Northwest, the key personnel met that description.

The Federal Art Project in the Northwest

On October 15, 1935, Burt Brown Barker, formerly the director of the PWAP in the Northwest, was once again approached and asked to be the regional director for Idaho, Montana, Oregon, and Washington as well as the state director for Oregon.[14] As he had with the PWAP, he took on the task as a volunteer. Barker was technically under the supervision of the field representative for his territory, Robert H. Hinckley, but he was also considered a part of Cahill's staff and, in fact, much of the early correspondence is directly between Barker and Cahill.[15] Hinckley was replaced by Joseph Danysh in the fall of 1936; Barker was then directed to work through Danysh because Cahill's workload had become too great to personally supervise all the different regions.

Barker was authorized to proceed with projects by October 24. His instructions were to "approve or disapprove, on the basis of their artistic integrity and social desirability, projects calling for the employment of artists, craftsmen etc."[16] Barker relied on his network of committee members and advisers as well as lists of artists from the PWAP to jump-start the FAP in all four states. There also was a National Advisory Committee with members from

all over the country who could be consulted, including two Northwest representatives, Anna B. Crocker, the curator of the Portland Art Museum, and Richard E. Fuller, the director of the Seattle Art Museum.

Projects began almost immediately in Oregon. Barker then moved to launch projects for Idaho, Montana, and Washington, getting Montana underway by February 1936. Confusion over funding in Idaho and problems with the state administrator in Washington, however, delayed the start of those projects for some time. Furthermore, the projects in Idaho and Montana were fairly small, so Barker decided not to appoint state art project administrators; instead, oversight came from the Oregon office.

Barker immediately began fighting against the requirement to hire 90 percent of the artists from the relief rolls, complaining to Cahill that the qualified artists were not registered and this greatly hampered giving his sponsors artwork of which they could be proud. Though generally an even-tempered man in his correspondence, Barker was frustrated with the quota restrictions and he regularly railed against them with disgust throughout his tenure.

Barker's role in the region kept shifting. Just a few months after the FAP hired him as the regional director, they changed his title and he became the regional adviser for Idaho, Montana, and Washington, and the state director for Oregon. Early in 1937, as Danysh's role and title shifted to regional director, Barker's regional adviser status gradually ceased to have meaning and he became solely the director of the state art project for Oregon. Different administrators assumed oversight of the other three Northwest states.

In planning for the art projects in the Northwest states, Barker fully embraced Cahill's wide-ranging mandate. He reached out to a variety of public institutions, encouraging them to act as cosponsors for large-scale works and to request long-term loans of smaller-scale works for offices and meeting rooms. Barker also made the progressive decision to support a plan to provide artwork for a new ski lodge to be constructed on Mount Hood in Oregon, and as the plans expanded he maintained the art project's involvement in every aspect of what came to be one of the proudest achievements of the FAP. The highly varied list of commissions completed under the FAP in the Northwest (see

Appendix 2, page 221) is a testament to Barker's desire to benefit both artists in need and the region as a whole to the extent of his ability.

Idaho

The FAP in Idaho started fairly quickly but struggled to maintain momentum, sputtering to a halt for several years, then stopping altogether in 1940. As with the Idaho PWAP, information about only a handful of artists or projects has been recovered to date, so future discoveries will add more to the story.

It began with some bureaucratic confusion. While Barker was focused on launching the Oregon project, Frank Baird, the director of the WPA Professional and Service Projects division in Idaho, took it upon himself to organize the FAP for his state. In January 1936 he lined up six sponsored projects, got the funding approved by the state's WPA administrator, and sent the information on to Cahill's office, where they were promptly rejected. He was instructed about proper procedures and directed to Barker, who happily resubmitted them on his behalf; the projects were approved soon thereafter. They included murals for the Mackay Library, easel paintings for public schools in Saint Anthony, murals for Park and Lowell Schools in Boise, an educational display for the State Department of Education, posters for the Spaulding Centennial Celebration in Lewiston, and art classes in Latah County.[17] All the artworks are currently unlocated.

Baird continued to push for more, employing several artists through his adult education program as a stopgap, but by fall of 1936 the FAP work in Idaho had ended. The government archives record no activity in 1937. In spring 1938 J. M. Whiting, the superintendent of schools in Heyburn, attempted to get senatorial backing for his proposed project. The town had been sponsoring an annual art exhibition and related programs for several years and had begun to build an art collection. Whiting hoped the FAP might sponsor their efforts or establish a community art center in Heyburn.[18] Though Whiting noted that local interest and support were high and a building available, the idea was rejected on two counts. FAP funds were to be used for the employment of artists, not to support programs at

other public agencies, and it was purported that no one on the relief rolls in Idaho had the right qualifications for art center staff.

Other inquiries about an FAP project in Idaho followed from the president of the Idaho Art Association in the fall of 1938 and again from Baird in February 1939, but they received the same response. One bizarre attempt to get FAP funding was a letter-writing campaign designed to tug at the heartstrings initiated by a child in Coeur d'Alene saying he had lost his art teacher when WPA funding was withdrawn and pleading for it to be restored. The DC office was bombarded with letters forwarded from senators and administrators of government agencies who deplored the situation and demanded a response, but upon investigation it was found that the letters were faked, written by the teacher in question, who had been fired from the State Education project and who was trying to create other employment opportunities.[19]

It is worth noting that in the fall of 1936, when the Idaho project faltered after its promising start, Barker had been in Europe for several months; in 1937, shortly after his return, his role as regional adviser was ended. Barker's forceful advocacy, ability to find ways around the restrictions of the federal bureaucracy, and strong network among those in the arts in the Northwest were key to the success of the PWAP throughout the region and the extensive and diverse FAP in Oregon. The lack of his involvement in Idaho was likely a primary factor contributing to the limited and sporadic FAP efforts in the state.

The second small cluster of activity in Idaho began in 1939. The California artist Fletcher Martin was commissioned to create mosaic murals for the new Ada County Courthouse in Boise. The plans were quite extensive, covering multiple walls in the stairwells and outside the courtrooms on the top floor. Initial excitement turned to frustration as Martin made little progress. After 15 months and many angry letters from administrators, he finally turned in five sketches and two cartoons, and soon thereafter, his resignation. Ivan Bartlett, another California painter and printmaker, took over what had become an 18-panel oil-on-canvas pageant of scenes from Idaho history (see page 237). He and a team of four others finally completed and installed the work in the summer

of 1940. Martin, who had originally supported Bartlett as his replacement, then proceeded to give an interview to the *Idaho Daily Statesman* with the headline "Idaho Artist Believes Apathy Toward New Murals Justified," in which he described the murals as "nothing to write home about" and "disappointing."[20] He also asserted that the project had suffered from being rushed as well as worked on by more than 25 different artists, and claimed that panels had been installed in the wrong locations. The controversy rose all the way to Colonel F. C. Harrington, the commissioner of the WPA in DC. In answer to his letter expressing concern, FAP administrators responded with a two-page letter refuting Martin's claims. They noted that not only were the works to Martin's original design and layout but the rushed schedule was due purely to the delays Martin himself had caused.[21] In recent times, these murals have once again become the center of public controversy, this time for the subject of two panels that illustrate the seizure and lynching of a Native American man (see page 166, fig. 5).[22]

Simultaneous to this project, Martin was creating a set of three low-relief carved limestone friezes for the Boundary County Courthouse in Bonners Ferry and, for the Section of Fine Arts, designing a post office mural for Kellogg. These likewise took much prodding to get Martin to complete. The Bonners Ferry sculptures were delivered and installed in March 1940 to public acclaim. Each scene represents one of the three major industries of the area: logging, farming, and mining (see page 22, fig. 4). The Kellogg Post Office commission took almost two years to complete and was embroiled throughout in controversies about its subject and style (see page 21, fig. 3).

The situation with Martin illustrates how, despite the best intentions of the FAP to avoid such complications, personal politics and favoritism did come into play in some instances. Martin was a favorite of Danysh, who also ran the FAP in California, where Martin was based. Since there was no active program in place and no real advocate for Idaho, Danysh used the state's art project to employ artists from California. It is unfortunate that Martin's monopoly on assignments and his behavior mired down the Idaho art project when there were other qualified artists in the state and region who desperately needed work and would have been enthusiastic participants. If there had not been

so many delays and problems with Martin's three commissions and an out-of-state administrator, there might have been a more robust FAP in Idaho.

The archives record only two other FAP-related actions in the state. In May 1939 Robert Bruce Inverarity, who was the head of the Washington State FAP, spearheaded an effort to establish a community art center in Boise, but it quickly ran up against local resistance and the idea was abandoned. Members of the Boise Art Association opposed the center, arguing that it would be bad for local artists and art teachers if the FAP were to offer free art activities. The Association also was running a small exhibition gallery at the time and may have been worried about competition with their efforts. As well, a local attorney who was strongly opposed to New Deal programs managed to sabotage a public meeting presenting the idea.[23] Finally, in 1940 the FAP was contacted about helping with the repair of a painting in the Idaho Falls Public Library, but no further activity is recorded.

Montana

The FAP in Montana was slow to begin and took several years to gain momentum. When the DC office first contacted the state's WPA administrator in September 1935 about starting an art project, he replied that there was no need because only a few artists were on the relief rolls in Montana and no commissions had been identified.[24] Cahill had received an inquiry from the president of the Montana School of Mines (now Montana Tech) asking about murals for campus, but this was dropped based on the state WPA administrator's report. Shortly thereafter the FAP funds authorized for Montana were withdrawn. Cahill revisited the question of a Montana project with Barker in January 1936, but still no plans were developed.

It was Agnes Pauline, the director of the Montana WPA's Division of Women's and Professional Projects, who finally got an art project started in February 1936, hiring an artist to hand color lantern slides for the Northern District of the US Forest Service. By April she had lined up additional sponsors and had artists making illustrations for the Montana State Planning Board in Helena and others drawing images from the early history of the state to be used in

classes at the University of Montana.[25] Thomas Parker, the assistant director of the FAP in DC, also had started discussions with Daniel Defenbacher, the head of the community art center program, about the possibility of establishing a center in Montana. Defenbacher, though willing, was stymied by the lack of qualified personnel on the state's relief rolls with sufficient experience to run an art center.

As in most states, the Montana FAP stalled temporarily in the summer of 1936 as Congress squabbled over funding for Federal One. Several artists were transferred over to the WPA Recreation Project in the state and the others lost their jobs. In September, with the enthusiastic support of Joseph Parker, the new WPA administrator for Montana, and encouraged by Danysh, who had visited over the summer, Pauline launched a new project to employ up to eight artists. This small spurt also proved temporary, as congressional funding fluctuated once again, ending the Montana art project in early December.

Montana WPA administrators persisted. Rose Bresnahan, Pauline's replacement at the Division of Women's and Professional Projects, was equally eager to see an active art project in the state. She went straight to the top, visiting Cahill in Washington, DC. They agreed that a community art center would be the best option. It would allow them to bring in instructors from other locations and offer classes to local artists rather than be restricted to finding jobs for the small handful of inexperienced artists on the relief rolls. Money for a revived Montana art project was authorized in April 1937 but withdrawn once again in June, when the FAP was forced to reduce employment numbers nationwide. Because the Montana art project was small and had barely begun, it was readily sacrificed by FAP administrators in order to lessen the impact of the cuts on larger, more active state projects.

Bresnahan did not give up. She corresponded regularly with Cahill and convinced him to visit Montana when he toured the West that fall. She also persuaded her regional director to reach out to Cahill with suggestions and ideas for FAP involvement in Montana. Her efforts were finally rewarded in November 1937, when Defenbacher began work to establish a community art center in Butte.

Defenbacher moved quickly, connecting with city officials to find a suitable space. He was offered the second

floor of their administration building rent free with the costs of heat and light included. He also began a campaign to obtain $1,500 for renovations and operating funds for the center's first year, enlisting the Junior League and the Rotary Club to help with fundraising and organizing an advisory board to assist with outreach.[26] The community response was so enthusiastic that they quickly exceeded the goal and raised $1,750. The FAP authorized a quota of 10 employees, including a state director for the Montana FAP and, for the art center, a director, teachers, gallery attendants, maintenance staff, and office staff. Both the state director and the art center director positions were exempted from relief requirements, allowing Defenbacher more latitude in hiring.

To head the art center Joseph Parker and Bresnahan suggested a local woman with a degree in art and good local connections, but Defenbacher refused on several counts:

> You will recall our discussion of the importance of a man as Director—preferably one from out of the state who would have no local prejudices and affiliations. I have looked into Miss Keenans' record. I doubt that Dominican College prepares its students for Art Center work, and, of course, I doubt seriously that a woman could have the combination of administrative and artistic ability required for the job.[27]

His preferred candidate was Frank Stevens, who was working for the California FAP out of Los Angeles. Stevens arrived in Butte on January 4, 1938, to oversee renovations of the space and other organizational details. James Redmond, a protégé of the modernist artist Stanton MacDonald Wright and a specialist in mural painting, was also transferred from the California FAP to be the art center's first teacher.[28] Both were originally meant to be three-month temporary appointees, but almost immediately Defenbacher moved to keep them in Montana. Stevens was promoted to state director of the Montana FAP, and Redmond became the director of the Butte Art Center.

By the time Stevens arrived in Butte, the art center plan had already expanded. Defenbacher had found such strong community interest that he decided to push

Figure 1
Butte Art Center, circa 1938–43
Gelatin silver print
2¾ × 4¼ inches
Jim and Helen Edwards Collection, Butte Silver-Bow Public Archives

immediately for a more permanent location. The local committee quickly raised another $1,000 and secured a recently vacated school building at 111 North Montana Street (fig. 1).[29] A flurry of letters from Defenbacher to Stevens followed, with Defenbacher directing every detail of the remodeling of the gallery space and setup of the art center, down to the color of shelves and dimensions of the curtains.[30]

For the opening, Stevens requested from the FAP traveling exhibition department one that was "reasonably classical and containing plenty of 'sweetness and light,'" noting:

> Butte is a peculiar combination of sophistication and insularity rarely to be found in these United States. . . . It seems highly possible that some time must elapse before the general run of the people here will approach pictorial art from a purely intellectual standpoint. In fact . . . we shall probably have to exercise considerable tact and judgment in displaying the nudes which we hope you will send along with the other representative subjects.[31]

They settled on two separate exhibitions. One gallery held an exhibition of FAP work from around the country and the other showed the work of local and regional artists. The Butte Art Center officially opened on April 7, 1938, with several hundred people attending from all over the

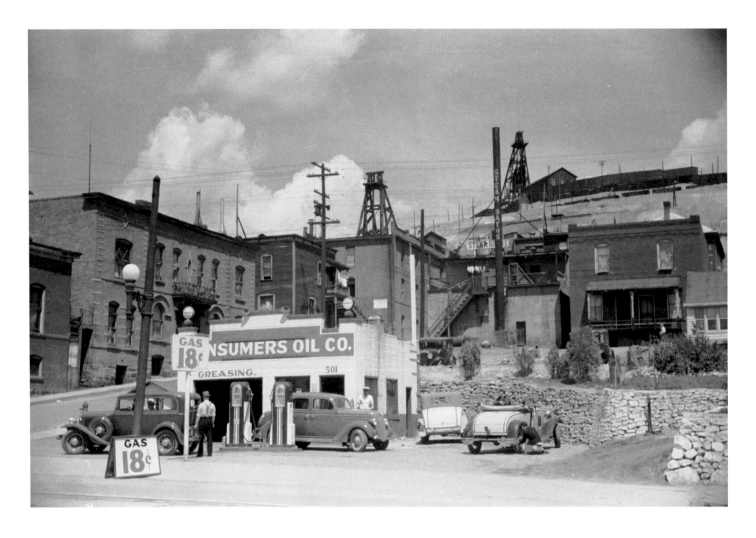

region as well as from Los Angeles, New York, Seattle, San Francisco, Minneapolis, and Salt Lake City.[32] Free art classes began a month later with an initial enrollment of 67 people. They included adult classes in watercolor and life drawing in addition to "black and white" (i.e., pen and ink, pencil, and charcoal drawing) classes for children and adults. Offerings were later added in oil painting, clay modeling and wood carving, etching, and commercial art. In addition to Redmond, instructors included Robert Hall, Anton Jovick, and Betty Keenan. Several months later Stevens wrote to Cahill, begging for additional help as his small staff of six teachers and gallery attendants was overwhelmed by their duties: "The galleries are open both afternoons and evenings including Sundays.... The enrollment will possibly exceed 250 as we are getting more registrations every day."[33] By December more than 1,000 school children had taken classes at the center.

The roaring success of the Butte Art Center was a surprise to all involved.[34] In 1938 Butte and its surroundings had a population of around 37,000, primarily involved

Figure 2
Arthur Rothstein (1915–1985)
Gas station, Butte, Montana, 1939
Nitrate negative
1 × 1½ inches
Library of Congress, Prints and Photographs Division, Farm Security Administration/Office of War Information Collection, Washington, DC, LC-USF33-003097-M5

with the copper-mining industry (fig. 2). The newspapers of the period detail a constant round of temporary layoffs, labor unrest, and other issues at the mines. The city boasted a thriving red-light district, turned a blind eye to prostitution, and hosted a communist newspaper. There also was strong anti-WPA sentiment in the area, particularly for white-collar job relief and other government aid programs that were seen as frivolous.

The community art center, however, tapped into a deep desire to make Butte a well-rounded city and to improve morale during difficult economic times. Community booster groups such as the Rotary and the Junior League were interested in any efforts that made the town more attractive to new businesses and that improved quality of

life for its residents. The art center's mix of exhibitions, classes, meeting spaces, and other community resources proved a perfect focal point for their efforts. It employed local people, encouraged resident artists, and brought visitors from around the region and beyond. As well, those working with the mines were a mix of people from all over the world; many were well traveled and so were attracted by the variety of artwork and art opportunities the art center offered. Preliminary enthusiasm did not wane, and during the years the Butte Art Center was in operation, attendance numbers remained high and the local papers were full of positive reports on its activities.

Encouraged by the strong start, Stevens began planning almost immediately for extension galleries so that art center exhibitions could reach other Montana communities. In May 1938 he sent in a proposal to open an extension in Anaconda, another mining town 35 miles northwest of Butte. FAP administrators in the national office, however, thought he was moving too quickly and counseled him to postpone the idea until the Butte Art Center was more established. As a compromise, Stevens arranged for Redmond to travel to Anaconda and help organize art classes.

There were also growing pains to contend with. Stevens and Redmond had no practical experience with the installation and display of exhibitions. Art center administrators were expected to regularly send photographs of their activities to the DC office, and every time Stevens sent in exhibition photos he received letters full of criticism and advice from Defenbacher. A year later, frustrated by the never-ending critiques, Stevens finally snapped back at Defenbacher, who responded, nothing daunted, "I am afraid you have a tendency to misconstrue our criticism as being destructive rather than constructive. . . . I can only add that suggestions and criticisms will continue to be forthcoming, if we feel that we can be helpful."[35]

Another sticking point was the relationship between Defenbacher and Bresnahan. They appear to have been two of a kind, with Bresnahan sending Defenbacher detailed letters full of suggestions and criticisms about the art center and Defenbacher responding diplomatically but ignoring all her feedback and questions. Surviving correspondence captures only a fragment of this tangled relationship, and it is unclear how Stevens was involved or how it affected him, but happily the personal clashes did not detract from the art center's success.

In the fall of 1938, Stevens took advantage of Defenbacher's new program to lend artists from large metropolitan areas to understaffed art centers. Their salaries and travel costs were paid by their state of origin, thus helping the smaller states with additional employees but not subtracting from their employment quotas and funds. Stevens requested teachers who could help with mural painting and sculpture classes or teach wood carving and photography. Three artists from the New York FAP were sent out in October, including Beatrice Mandelman, whose duties included designing exhibitions as well as teaching.[36] In addition to these extra staff, the Butte Junior League provided valuable volunteer help, organizing an art library and a file of art reproductions, which eventually grew to more than 60,000 images. They also formed a camera club with the support of art center instructors.

The Butte Art Center's two exhibition galleries rotated approximately once a month. Keeping to the initial plan, one was reserved for group or solo exhibitions of the work of Montana artists and the other hosted a round of monthly exhibitions from the FAP's traveling exhibition section. The FAP shows were widely varied, and in the course of a year the Butte community enjoyed such topics as Berenice Abbott's photographs, sculpture from the California FAP, paintings by Mexican children, Käthe Kollwitz prints, a history of food, Spanish Colonial art, the works of Honoré Daumier, and the making of tapestries, among many others.

A year into the Butte Art Center's operation, Curtis Wilson, chairman of the sponsoring committee, wrote to the FAP's national office:

> Perhaps the most important point in connection with considering the usefulness of the Art Center is the fact that there have been more exhibitions presented to the general Butte public in the past fiscal year than have been available in the previous 75 years. . . . The galleries have been faithfully attended by all classes of the people from all sections of the city. Miners have come in direct

from work and have mingled with executives of the large copper company here on a common and uncontroversial ground. The wide use of the public art classes both by adults and children has proved that a definite thirst for art experience has always existed in Butte, but the facilities have never before been available. . . . Not the least of the benefits derived from the Center has been the useful employment of talented persons whom industry at this time could not absorb and whose restlessness might be contagious. Instead, they have radiated a spirit of optimism that has had an ever-widening influence. . . . Communities outside of Butte are taking advantage of the rural exhibition program in increasing numbers. Among the Montana communities served so far are Anaconda, Billings, Helena, Kalispell, Glendive, Lewistown, Deer Lodge, Dillon, Red Lodge, and Fort Peck Indian Reservation, and there is every indication that this is but a beginning.[37]

In spring of 1939 Stevens finally received approval to launch his plan for extension galleries. In addition, the art center began lending some original works as well as exhibitions of art reproductions from their library to public schools and other civic organizations. They also started providing classes to other organizations in the surrounding community. They worked extensively with the Office of Indian Affairs on the reservations, offering a creative outlet as well as job training in illustration and other commercial art opportunities. The art center ethos also embraced art therapy. Centers were encouraged to offer art classes to institutions in their state that served the physically and mentally impaired. The Butte Art Center sent teachers to the Montana State Hospital for the Insane (later the Warm Springs State Hospital) and gave gallery talks to local nurses so they could also use art in their daily practice.[38]

In August 1939 Stevens and Joseph Parker began advocating for a second art center in Montana, suggesting both Great Falls and Billings as prime locations. It was not until the following year that discussions began in earnest. They settled on Great Falls, where a new Civic Center was being built and where the local people were so eager to have an art center that they were willing to displace the local National Guard unit's pistol range in the basement to provide more space.[39] The Great Falls Art Center was officially still in the planning stages when the Civic Center had its opening in April 1940; as Stevens described in his monthly progress report, "This is scheduled to take place about April 19, is to last one week and is expected to make as much noise in Northern Montana as Lewis & Clark sighting the Great Falls or water rushing over the Fort Peck Dam. The San Carlo Opera Co. will be brought in for a week's engagement by this town of some 30,000 and international Hockey matches will be held."[40] He felt it was imperative that the FAP participate in some way to help promote the art center, so Stevens arranged for an exhibition for the Civic Center's opening-week celebrations. It proved so popular that they continued to hold exhibitions under the auspices of the Great Falls Art Association while fundraising was completed and the rest of the center spaces were readied.[41] John McHatton was hired as the supervisor and the art center was fully operational by late December 1940. Its activity schedule was modeled on that of the Butte Art Center. There were two galleries—one for Montana artists and one for FAP exhibitions—art classes, and an art library, plus additional extension galleries in surrounding smaller towns. It was in operation until June 1942.[42]

Redmond left the Butte Art Center late in 1939 and was replaced by Elroy Houle, who had studied at the Art Institute of Chicago and was teaching art in the Helena public schools. With the support of Stevens, he continued the art center's active schedule of exhibitions and classes. A review in January 1940 of the past year's activities reported more than 17,000 visitors to the art center in Butte and more than 65,000 at the extension galleries as well as 2,255 adults and 9,271 children enrolled in art classes. The art center's logbook recorded visitors from not only western states but also Canada, Europe, China, and India.[43]

Simultaneously, the small art center staff of eight was completing a number of public services for other regional organizations. In states with larger FAP quotas, these kinds of tasks were generally set up as separate assignments and conducted by other artists, but for Montana's small project, the teaching artists did double duty. One sideline at Butte was the making of signs for the Adult Education

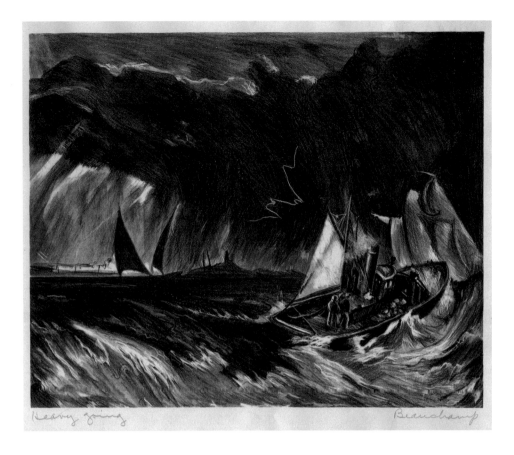

Figure 3
John Beauchamp (1906–1957)
Heavy Going, 1937
Lithograph on paper
8¾ × 11 inches
Montana Museum of Art and Culture, Missoula, Courtesy of the Fine Arts
Program, US General Services Administration, 36-003

and Recreation divisions of the Montana WPA as well as for Butte High School and the Wildflower Preservation Society. Artist and teacher Irene Caldwell silkscreened book covers for the Historical Records Survey and the Camp Fire Girls, and theater backdrops were painted for the Montana School of Mines and the Girls Central High School in Butte. Other agencies that benefited included the Rocky Boy's Indian Agency, the Montana State Hospital, and the Junior League.[44]

In January 1942 Stevens began work on a third art center, this one a cooperative venture with Carroll College in Helena. It opened on April 12 to a crowd of 800 visitors. When the first children's art class was offered several months later, it was overrun by excited participants and had to be moved to the college's gymnasium. The director of the Helena Art Center was John (Jack) Beauchamp, a member of the college staff. The art center board included the businessman and philanthropist Archie Bray, who in the 1950s went on to found the influential Archie Bray Foundation for the Ceramic Arts in Helena.[45] Unfortunately, the opening coincided with the last days of the FAP as it was converted to the Graphic Section of the War Services Program in March 1942 and then shuttered

completely in February of the following year. Although it was in operation for only about 10 months, the Helena Art Center held an active schedule of exhibitions, offered drawing and painting classes, hosted lectures, and provided a circulating library of art books. In November 1942 it extended services to the Fort William Henry Harrison service club. The Helena Art Center was closed during World War II, but it was reopened under the auspices of the Montana Institute of the Arts in November 1948 and remained active until 1962.

From the opening of the Butte Art Center in April 1938 to the end of the Montana FAP early in 1943, the state's artist quota hovered steadily around 21, with the majority employed at the art centers. There were, however, a handful of other FAP commissions in the state. Beauchamp created a number of prints in addition to his duties running the Helena Art Center (fig. 3). In July 1938 Robert Hall

Figure 4
Endpapers of *Land of Nakoda: The Story of the Assiniboine Indians* (Helena, MT: State Publishing Company, 1942), with illustration of *Map of Assiniboine Country* by William Standing (1904–1951)

created several images of saddles and a teapot for the Index of American Design. He also received a commission the next year to make a number of pen-and-ink sketches for the Montana Federal Writers' Project (FWP), which was gathering illustrations for possible use in the State Guide, State Almanac, or booklets on Montana subjects.[46] In addition, there was discussion in the fall of 1939 about the creation of a mural for the new library building under construction at the Montana School of Mines, with Hall and Earl Tyler as the project artists. It is currently unclear if this work was completed, and the school has no record of its existence.

One of the most distinctive commissions created in Montana was a joint project of the FAP and the FWP and was notable for employing both a writer and an artist who were Native American. The publication *Land of Nakoda: The Story of the Assiniboine Indians* was written by James Larpenteur Long (First Boy) and illustrated by William Standing (Fire Bear). It was intended to be one of a series recording the history and legends of all the tribes on Montana reservations.[47] Both Long and

Standing had grown up on the Fort Peck Reservation in northeast Montana. Standing's work was well known to Stevens. Trained at the University of Oklahoma, Standing was a painter and illustrator who had achieved national and international attention as part of the group of artists known as the Kiowa Five. He had been employed on one of the early Montana FAP illustration projects in 1936, and the Butte Art Center held an exhibition of his illustration work in August 1938, when he was selected for the *Land of Nakoda* commission. He created more than 100 drawings in pen and ink and wash, illustrating Assiniboine objects and scenes from daily life (fig. 4; see also pages 168, 172, figs. 1, 2). The book was published in 1942 and was the only one in the series to be completed. Though there is some anecdotal information that a third Indigenous artist, John

Louis Clarke, worked for the FAP, it appears there may be some confusion with his work for the earlier PWAP and other WPA projects besides Federal One.[48]

The last recorded commission in Montana was a mural for the community hall at the Great Falls Housing Authority, completed in August 1942. Very few details have survived and the mural is unlocated. McHatton was in charge of the project, but it is unclear if he was the artist and the subject is unrecorded. According to the archives, in February 1943, as the FAP drew to a close nationwide, there was an allocation of artworks to the Montana State Department of Public Instruction, but there is no detailed listing. Whether the artworks were by out-of-state or Montana artists is unknown, as is their current fate.[49]

Even though the Montana FAP did not employ large numbers of artists or create a large body of artworks, it embodied some of the highest hopes of Holger Cahill and other supporters of the New Deal art projects. Through the community centers, art became a part of everyday life for tens of thousands of Montanans in localities of all sizes. People could not only create their own art but also see that of others and witness its value to their community. Montana artists were given opportunities to show their work and receive critical recognition and support. Local art associations and interest groups were empowered to broaden their scope and continue their work both during and after the end of the FAP. Further detailed study of the Montana art centers and their impact would offer an excellent case study of the more intangible benefits of the FAP.

Oregon

The Federal Art Project in Oregon was the most active and extensive in the Northwest. Since the state was Barker's home base, the former headquarters of the Northwest's PWAP, and the initial headquarters of the region's FAP, it is not surprising that a broad slate of programs was enacted there. On October 16, 1935, Barker accepted the job as the regional head of the FAP and immediately reactivated his network of advisers and supporters to help identify sponsors and line up commissions.[50] He also revived some plans proposed to the PWAP that had not been realized before the short-lived project ended.

Barker asked for an exemption from the requirement to hire 90 percent of the artists from the relief rolls, arguing for a reduction to 50 percent. As with the PWAP, Barker and his committee were struggling to hire the artists they desired because a number of them refused to sign up for government assistance despite being in need. In a telegram to Cahill, Barker pleaded:

> After examining relief rolls find competent artists not registered / Consultations with artists reveals [*sic*] they are incensed at demand they go on relief rolls preferring to starve as they are doing / Could you possibly get ruling allowing us to certify artists eligible for relief up to fifty per cent of the projects / Have ample projects and many unemployed artists in dire distress but too proud to ask relief.[51]

He was granted a reduction in the relief hire requirement to 75 percent in early November. Barker was not alone in his request, and the 75/25 rule became nationwide policy later that month.

The office of the Oregon FAP was quickly established at 15 SW First Avenue in Portland. One of the earliest programs launched offered art classes to smaller communities. Cherie Dupee was among the first artists hired in early November 1935 to teach classes in Corvallis, Albany, and Eugene. Others followed and a progress report from June 1936 lists more than 450 people enrolled in FAP-sponsored classes statewide.[52]

Other projects began immediately to provide artworks for area schools. Several Portland public schools had received artworks from the Oregon PWAP, and they likewise became regular sponsors and recipients throughout the run of the Oregon FAP.[53] The first two murals completed were executed for schools in towns adjacent to Portland. Howard Sewall, a primarily self-taught painter and commercial artist, painted a six-panel mural for Oregon City High School in 1936 (fig. 5). A second mural, for the Milwaukie Union High School foyer, titled *Foreign Influence on Civilization*, was painted by Virginia Darcé in 1937. She was a Portland native with a specialty in mural painting and design who had studied art at the University of Oregon.

Figure 5
Howard Sewall (1899–1975)
Study for the mural panel *Immigration* (one from a six-panel mural), Oregon
City High School, 1936
Oil on canvas
12 × 24 inches
Oregon Historical Society Museum, 99-48.1.1

Unfortunately, her work was destroyed in a later remodel of the school and no photographs or detailed descriptions of the mural have yet been found. The works by Sewall and Darcé were much admired, and both artists would ultimately create a variety of artwork for the Oregon FAP.

A March 1936 progress report notes additional school murals underway: one for the auditorium of West Linn High School, painted by George Bendixon; a second set of five panels titled *The Theatre* being painted by Sewall for Oregon City High School; and a four-panel work titled *Pioneers* in production for the auditorium in Beach School in north Portland. The artist of this mural, measuring 7 feet by 32 feet, was one of Portland's most storied artists, C. S. Price. He had begun his art career as an illustrator of western scenes but had become interested in modernism after visiting the 1915 Panama–Pacific International Exposition in San Francisco, subsequently evolving a unique style that combined cubist elements with expressionist use of paint and color (fig. 6). His work for the PWAP had been greatly admired and much of it was claimed by the national office for exhibitions and allocation to senatorial offices.

Irvington School (now Irvington Elementary School) in northeast Portland was a particular focus for FAP commissions. The new building, opened in 1932, had been constructed by the Public Works Administration and was considered a model school. The largest artwork created for it was a five-panel mural for the lobby painted by the western artist Edward Quigley. Titled *Pioneers* (1936; fig. 7), the mural, covering nearly 40 feet of the lobby wall, draws upon traditional visual tropes of the Euro-American migration into the West with images of prairie schooners, Native American villages, and homesteading farmers.

A prominent characteristic of the Oregon FAP was an interest in artworks that drew upon craft traditions. One of the early commissions was for Irvington School. Aimee Gorham was a teacher, mural artist, and sculptor who had been trained in marquetry, a type of inlay using small pieces of different colored wood to create designs, usually on furniture. In 1936 she executed two marquetry scenes for the school: *Swans* for the Nature Study Room and *Persian Fairy Tale* for the library (fig. 8). She was assisted by a team of cabinetmakers who had been hired from the relief rolls.[54] This melding of fine art and craft became a useful strategy for the Oregon FAP. It enabled administrators to achieve a number of desired projects while meeting government

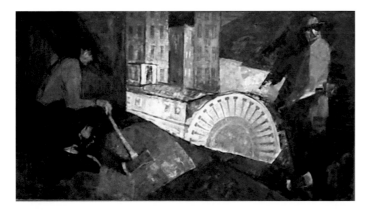
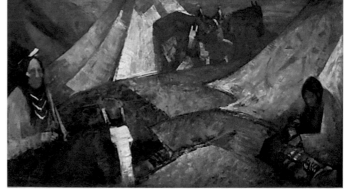
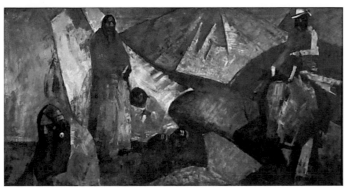
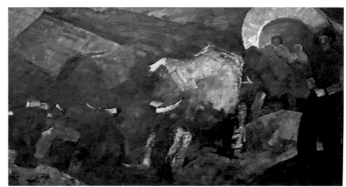

Figure 6
C. S. Price (1874–1950)
Pioneers, 1936
Oil on canvas
7 × 32 feet (overall)
Beach School, Portland
Courtesy of Portland Public Schools

hiring requirements by employing skilled technicians who were on government relief. The wood-carver Valentine Weise created a sculptural plaque for Irvington School, and other craftspeople were employed to build stage sets and wooden screens for use in the Portland schools. A textile by the multifaceted artist and designer Thelma Johnson Streat was later allocated to the Portland Art Museum along with other project works, but it is unclear if she was employed by the Oregon FAP or if it was done as part of her work for the California FAP and then later transferred to her home state (see page 220).[55] This FAP work is the sole item by an African American artist identified to date in Region 16.

Two other key partners who had supported the Oregon PWAP—the University of Oregon (UO) and Oregon State College (OSC, now Oregon State University)—became major sponsors for the Oregon FAP. They immediately began commissioning numerous works for their campuses. The first for UO was the completion of the elaborate carved

cedar panels in the new library building depicting activities in the Civilian Conservation Corps camps. In 1934 Arthur Clough, assisted by Jim de Broekert and Ross McClure, had created two large triptychs in cedar under the PWAP (see page 52, figs. 12, 13). For the FAP they now added the remaining element of the original design, a 12-inch frieze running beneath them, titled *The Release of Youth from Depression Conditions*.

A second major project for the UO library was the production of murals for the two main stairwells in 1936. These were the work of Arthur Runquist, a Washington native who had studied at UO before attending the Art Students League in New York. His two large-scale tempera-on-canvas murals were titled *Tree of Knowledge* and *Sciences* and were allegories of the growth of human knowledge (fig. 9). Arthur, and his younger brother and fellow artist Albert C. Runquist, worked closely together, often collaborating on the same canvases and signing each other's names. Both are reputed to have created the UO murals, along with the painter Martina Gangle, who was a close friend and also employed by the FAP; official project records, however, do not list them as contributing artists.[56] Two other library projects were a series of prints by Gordon Gilkey documenting construction of the building (fig. 10) and

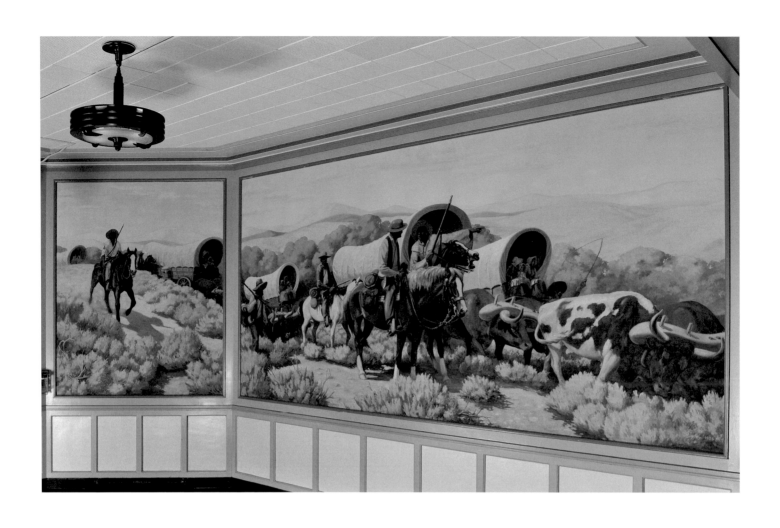

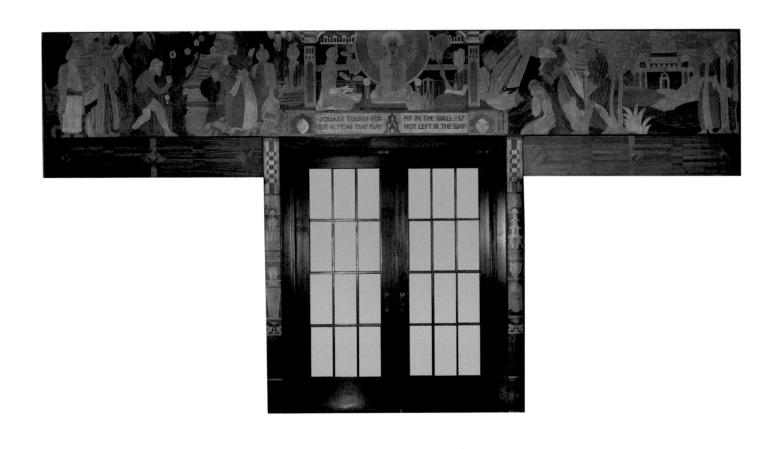

SQUARE THYSELF FOR FIT IN THE WALL · IT
USE · A STONE THAT MAY NOT LEFT IN THE WAY

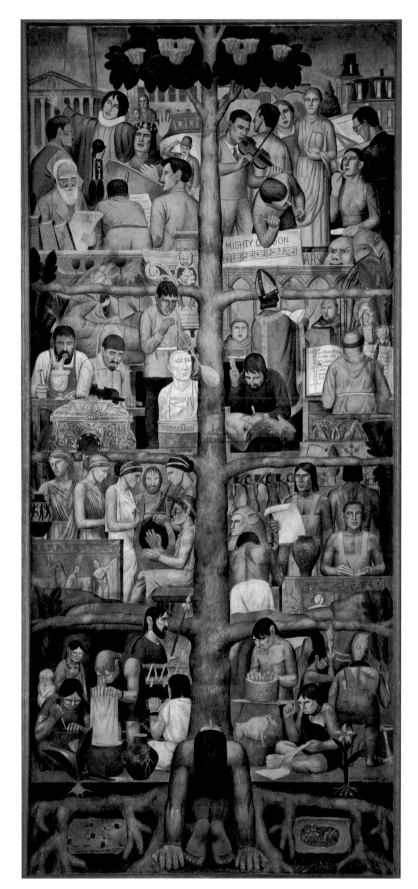

Figure 7
Edward Quigley (1895–1984)
Pioneers (two from a five-panel mural), 1936
Oil on canvas
84 inches high
Irvington School, Portland
Courtesy of Portland Public Schools

Figure 8
Aimee Gorham (1883–1974)
Persian Fairy Tale, 1936
Wood marquetry
12 × 28 feet approx.
Irvington School, Portland
Courtesy of Portland Public Schools

Figure 9
Arthur Runquist (1891–1971) with Albert C. Runquist (1894–1971) and
Martina Gangle (1906–1994)
Tree of Knowledge, 1936
Tempera on canvas
14 × 6 feet
University of Oregon Knight Library, Eugene

Figure 10
Gordon Gilkey (1912–2000)
University of Oregon Library Construction—Cresting, 1936
Etching on paper
8¾ × 5⅞ inches (plate)
Jordan Schnitzer Museum of Art, Eugene, Transfer from University of Oregon
School of Architecture and Allied Arts, 1976:8.282

Figure 11 and detail
O. B. Dawson (1917–2009)
Arnold Bennett Hall Memorial Gates, 1936
Wrought iron
Three pairs, each 84 × 84 inches
University of Oregon Knight Library, Eugene

decorations for the facade that included stone heads of famous cultural figures by Edna Dunberg.

A set of unusual commissions under the Oregon FAP was the creation of wrought-iron architectural features for the UO and OSC campuses. O. B. Dawson was a native of Portland who had learned blacksmithing in high school. He became interested in ornamental ironwork while stationed in Europe during World War I and upon his return studied metalworking in Los Angeles and at UO, becoming a master in the use of wrought iron. Once again, the Oregon FAP was able to employ skilled technicians from the relief rolls. Dawson oversaw a small

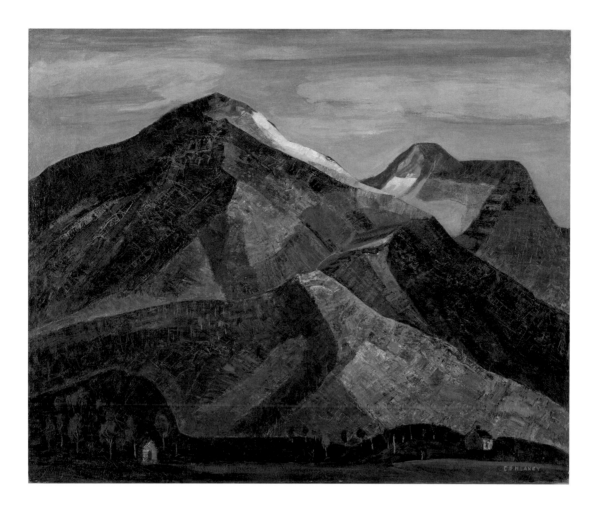

Figure 12
Charles Heaney (1897–1981)
Mountains, 1938
Oil on canvas
33⅜ × 38 inches
Portland Art Museum, Portland, Oregon, Courtesy of the Fine Arts Collection,
US General Services Administration, New Deal Art Project, L45.3.4

workshop that created ornamental gates for the entrances of both campuses, the Arnold Bennett Hall Memorial Gates inside the entrance of the new UO library (fig. 11), and window grilles, railings, and other architectural elements for various campus buildings. The workshop later constructed the entrance gates, ticket windows, and fence of the UO's Howe Field.

In addition to these varied commissions, in the first five months of the Oregon FAP a group of between 40 to 60 artists and artisans created work for Doernbecher Memorial Hospital for Children (now Doernbecher Children's Hospital) in Portland, hand-colored lantern slides for the US Forest Service, and completed works for the Port of Portland and the Corvallis Public Library, among others. Though these projects occupied most of their time, painters,

printmakers, and sculptors also were making artworks to be distributed to various civic institutions. Price and Arthur Runquist were working on easel paintings in addition to their other commissions. Two other artists who became prominent figures in Oregon art history were kept afloat by and honed their skills on the Oregon FAP. Charles Heaney had originally trained as a jeweler but became interested in printmaking while studying at the Museum Art School in Portland. He was first employed by the FAP to make maps, charts, and publicity posters. Over the course of the FAP he produced a number of prints and paintings, primarily of rural Oregon (fig. 12). A promising young artist named Louis Bunce also was an active figure. In the first half of 1936 Bunce was working on a mural for the Saint Johns Post Office under one of the Treasury Department art programs (see page 68, figs. 1, 2) while also generating easel paintings for the Portland office. He painted one other post office mural in Grants Pass completed in 1938 but, like Heaney, worked primarily as an easel painter.[57]

The scope and speed of what was accomplished in the Oregon FAP's early days are astonishing, particularly as

it took place under the constant threat of the cancellation of Federal One. In late January 1936, five months after the start of the FAP, all state projects were notified that funding was due to run out on May 15 and all work would be terminated. Cahill was able to find funds to guarantee the continuation of some work into June, but it was not until just before the deadline that congressional allocations were put in place for continuing Federal One.

The signature achievement of the Oregon FAP was the artistic program for Timberline Lodge, the ski resort on Mount Hood, and it too was begun early on.[58] Funds for construction of the lodge were approved in September 1935, and talks began in December to involve the art project in some way. The following month some limited work began, but with all the uncertainties around project funding in the first half of 1936, it was not until the reauthorization of Federal One in May that efforts began in earnest.

Margery Hoffman Smith was hired to oversee all facets of the design program for Timberline Lodge. Smith was an interior designer and painter who had trained at the Parsons School of Design and the Art Students League. She was the daughter of Julia Hoffman, founder of the Portland Arts and Crafts Society, from whom she had absorbed a deep and abiding love for handicraft. Smith envisioned the project for Timberline Lodge as a comprehensive design rather than simply an opportunity to include a few artworks. She provided a unifying decorative scheme for the team of architects and designers and is rightly credited with the harmonious and striking environment of the lodge's interior (fig. 13).

Smith's strong working relationship with Emerson J. (E. J.) Griffith, the WPA state administrator for Oregon, also was an essential element of her success. Griffith was a liberal Democrat who wholeheartedly embraced the tenets of the New Deal and was happy to support ambitious programs. Further, he was a passionate advocate for the construction of the lodge and he made sure Smith had the funds she needed, protected her from critics, and regularly advocated with the DC offices for additional money and employees. Another influential supporter was Gladys Everett, director of the Division of Women's and Professional Projects for the Oregon WPA. A lawyer, political activist, and art lover, she was a powerful and well-respected figure who recognized the cultural and economic benefits of the New Deal art projects.

The work on Timberline Lodge temporarily shifted the Oregon FAP strongly toward a craft and design focus. Another factor was the absence of Barker, who was in Europe from April to October 1936. Robert Dieck, the civil engineer appointed as his temporary replacement, served mainly as a conduit for requests and ideas to Danysh and Cahill. Dieck resigned in August and Smith was named acting state director, giving her further latitude in directing FAP activities. When Barker returned in late October, he found a very different project from the one he had left, with the majority of funds and employees directed toward work on the lodge. Though he fully supported the FAP's involvement at Timberline, he was concerned that it was absorbing all the art project's resources to the detriment of artists and relationships with other sponsor organizations. He wrote to Danysh in December 1936 expressing worries about "the shadow of Timberline" and describing conflicts with Griffith over the direction and purpose of the Oregon FAP.[59]

Griffith had attempted to appoint Smith as the state director of the FAP for Oregon in Barker's absence, though it is unclear if it was through ignorance of Barker's position or a deliberate ploy to push him out. When Barker returned to reassume his position, Smith had to be reassigned and was made assistant state director of the Oregon FAP under Barker.[60] It was an uneasy relationship marked by squabbles between them over office space, lines of authority, and allocations of funds. Though on the surface it seems simply to have been office politics, the conflict actually reflected the battle over the purpose of the Oregon FAP and Smith's desire to shift the mission from a broad-based focus on the arts to primarily craft and design. Barker's goal to return primary focus to fine art was further hampered by the reinstatement in late 1936 of the 90 percent relief employment requirement. Additional restrictions and a large cut in the state employment quota coincided in the first half of 1937. Smith was employing a number of craftspeople and technicians from the relief rolls for the work at Timberline so progress there was not as heavily affected, but it left little room to add artists to work on other tasks. Cahill and Danysh eventually intervened. Danysh, reporting on his visit in late June to Portland to meet with Griffith, noted:

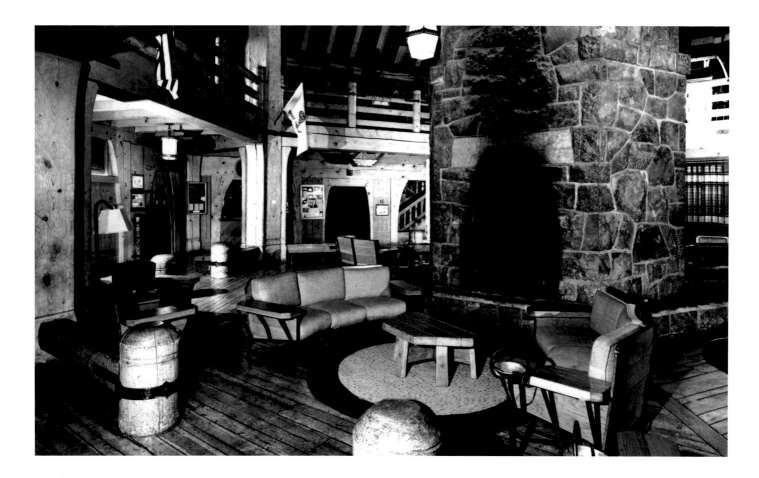

Figure 13
Interior view of Timberline Lodge, circa 1938
Courtesy of Friends of Timberline Archive

I made the point very strongly that the Oregon project had not been represented in any of the national aspects of this program, pointing out that this was an injustice to the artists as well as to his own state set-up and that I felt . . . that there was time enough to accomplish all work which he needed for Timberline Lodge and that we should begin immediately developing works to incorporate into the national program. Mr. Griffith is now in thorough accord with this need and I think such will be the policy of our Oregon program. All assignments to the Timberline Lodge will now be alternated with assignments for easel works, etc.[61]

There were other complications with the hiring of Smith that dogged the Oregon art project throughout her tenure. Smith came from a well-to-do family, her husband was a wealthy businessman, and they were both prominent Republicans. A number of protest letters were sent to the Oregon and DC FAP offices protesting the employment of someone who did not need the money on what was primarily a relief program. Further, her salary was higher than most others in her position nationally. Thomas Parker, assistant director of the FAP, tried several times to have it reduced, but Griffith held firm and it was eventually approved. There was no one on the government relief rolls who could have accomplished what Smith did at Timberline Lodge, but the appearance of favoritism and cronyism was hard to dismiss; the fact that Barker donated all his time as a volunteer only accentuated the problem.[62] It became such a distraction that Cahill made a visit to Portland in the summer of 1937 partly to investigate and resolve the situation.

Smith's vision for the decorative program of Timberline Lodge was breathtakingly ambitious, stretching from the fundamental structures of the building to the furnishings of every room and the artwork on the walls (see page 193, figs. 3, 4, 5).[63] The architect was Gilbert Stanley Underwood, known particularly for his lodges in national parks, including Bryce Canyon, Zion, and Yosemite. He wanted a rustic,

rugged structure hand built of stone and wood. This preference had the added advantage of employing a large number of skilled builders who were desperate for jobs. Smith readily embraced this aesthetic and advocated for handmade textiles, furniture, fixtures, and architectural accents throughout. Timberline Lodge came to personify one of the guiding propositions of the FAP—namely, to integrate art into daily life for all Americans by bringing beauty to everyday objects. Smith was right at home in this Arts and Crafts–inflected environment and through her oversight ensured that care and attention were paid to every detail. Underwood's architectural design had been inspired by pioneer stories and Native American imagery, and they, along with the regional wildlife, served as sources for decorative motifs throughout. The wrought-iron workshop was overseen by Dawson. His team forged gates, handles, door knockers, and other iron accents. The woodworking shop was under the administration of the cabinetmaker Ray Neufer. The woodworkers had been building a variety of objects and some furniture for the public schools, but happily embraced this new and more challenging opportunity. Smith ran the textile workshop with teams of women hand hooking rugs, weaving upholstery, and embroidering draperies.

The first artworks for Timberline Lodge were commissioned early in 1936 while architectural plans were still being drawn. Darrel Austin created a suite of five oil paintings of mountain activities to be hung throughout the lodge (fig. 14). Price was assigned two panels to flank the doorway of the lodge's dining room (see page 28, fig. 1). His rough-edged, blocky paint application and preference for western scenes made him the perfect candidate for a lodge commission. His *Huckleberry Pickers* and *Pack Train*, however, were rejected by the regional head of the US Forest Service, overseers of Timberline Lodge, and returned to Portland. They were finally installed when an addition was built in 1975. Other painters with work at the lodge included Heaney, who created the signature work *The Mountain* (1937; see page 31, fig. 2), and Sewall (fig. 15), who had recently completed his murals for Oregon City High School. An unusual set of paintings was created by the illustrator Douglas Lynch for the Ski Grille room. He carved and painted linoleum to create his *Calendar of Winter Sports*. More than 150 botanical watercolors and lithographs were

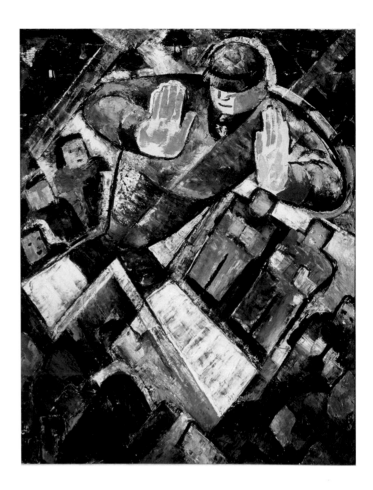

Figure 14
Darrel Austin (1907–1994)
Skiers, 1936
Oil on canvas
45 × 37 inches
USDA, Mount Hood National Forest, Timberline Lodge

produced by Edward Benedict, Dora Erikson, Karl Feurer, Martina Gangle, George Jeffery, and Elizabeth Hoffman Wood and were hung in the guest rooms.

A number of artworks that wedded art and craft traditions were featured. Gorham, known for her marquetry, created two images of wildlife for the central lobby, and Darcé created a series of stained-glass mosaics of the folk character Paul Bunyan and his companion Babe the Blue Ox in a technique called opus sectile for the bar (fig. 16). Darcé had been working as a painter for the Oregon FAP but she also had experience working for a glass company making stained-glass windows. The sculptor Thomas Laman used glass mosaic to create a woodland scene behind a fountain at Timberline Lodge, and Melvin Keegan carved a relief scene in wood titled *Pioneers* for the stairwell. On September 28, 1937, President and Mrs. Roosevelt

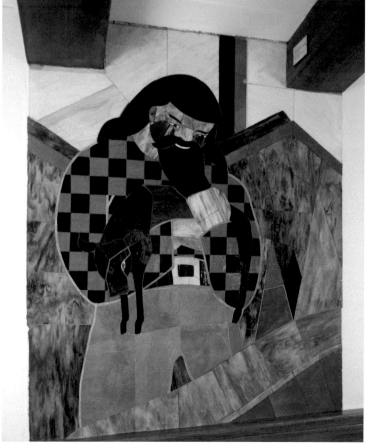

Figure 15
Howard Sewall
Symbolizing Lodge Builders: Wood Workers, 1937
Oil on canvas
4 feet × 9 feet 9 inches
USDA, Mount Hood National Forest, Timberline Lodge

Figure 16
Virginia Darcé (1910–1985)
Paul Bunyan Carrying Babe the Blue Ox, 1938
Opus sectile
65¾ × 56¾ inches
USDA, Mount Hood National Forest, Timberline Lodge

visited and dedicated the lodge, recognizing it as one of the great achievements of the FAP and WPA not only in Oregon but nationally as well. The lodge officially opened for visitors on February 4, 1938.

Although the work on Timberline Lodge occupied much of the Oregon art project's time in 1937, there were other activities taking place. Two artists were assigned to the Index of American Design in April. They submitted 26 images of historical objects with pioneer histories from the collection of the Oregon Historical Society, such as farm implements, quilts, and other domestic objects. This small cluster of Index works represented most of the Index submissions from Oregon. A few other images were produced, but by December 1938 Oregon had dropped out of the project, citing a lack of artists to assign to the work due to a combination of other large projects and reduced employment numbers.

In addition to their work for Timberline Lodge, Gorham and her crew created a two-panel marquetry mural titled *Indian Ceremonial Dances* for Alameda School (now Alameda Elementary School) in Portland in 1937. Two oil paintings of children and 16 watercolors on the theme of fairy tales were created for Doernbecher Memorial Hospital for Children by Margot Helser (fig. 17), most of which are now lost, along with her PWAP works for Doernbecher. Phillip Halley Johnson painted a mural in the arcaded entrance of Lawrence Hall on the University of Oregon campus; the mural was destroyed in a later remodeling project and exists now only in photographs (fig. 18).

Planning began late in 1937 for another major project in Oregon, the opening of a community art center.[64] Defenbacher, the head of the art center program, visited the Northwest region in late November and early December. He oversaw the launching of the Butte Art Center in Montana and checked in on evolving plans for an art center in Spokane, Washington, before traveling to Oregon. Barker had identified Salem, where he had grown up, as the site for the new center. He argued that the capitol city should be a cultural center and lamented in speeches to the community the lack of art opportunities: "I grew up here, and until I left Oregon and went to Chicago I had never seen a picture or a piece of sculpture, or anything artistic that would be called first class art. It was just not here."[65]

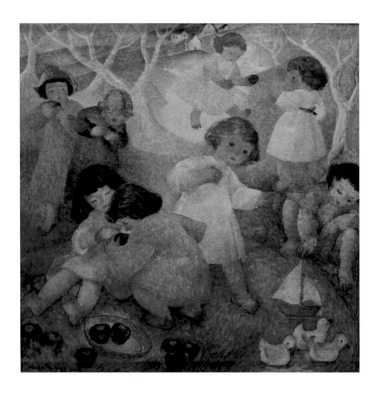

Figure 17
Margot Helser (1907–1990)
Children Playing, 1936
Oil on canvas
Dimensions unknown
Doernbecher Memorial Hospital for Children, Portland

He and Danysh visited Salem in November to talk with civic leaders and assess the level of interest in establishing a center there. Once Defenbacher approved their plans, they began to organize and fundraise. The community responded enthusiastically, holding a Beaux Arts–themed ball in February and working with multiple organizations and area schools to hold bake sales and penny drives to raise the needed sponsorship funds.[66] Every school in Salem put on a benefit, all the Salem banks made contributions, and individuals from the governor to the state librarian made donations. The various fundraisers netted almost $200 over the $2,000 goal. Members of the advisory committee also leveraged their school board connections to secure use of an old high school rent-free, and in March renovations began to turn school rooms into gallery space and workshops. Barker and Smith then began to choose staff for the center. They offered the two teaching positions to Heaney and to Erich Lamade, a painter and sculptor who had been working on murals for the Section of Fine Arts. Heaney declined, and Bunce was hired in

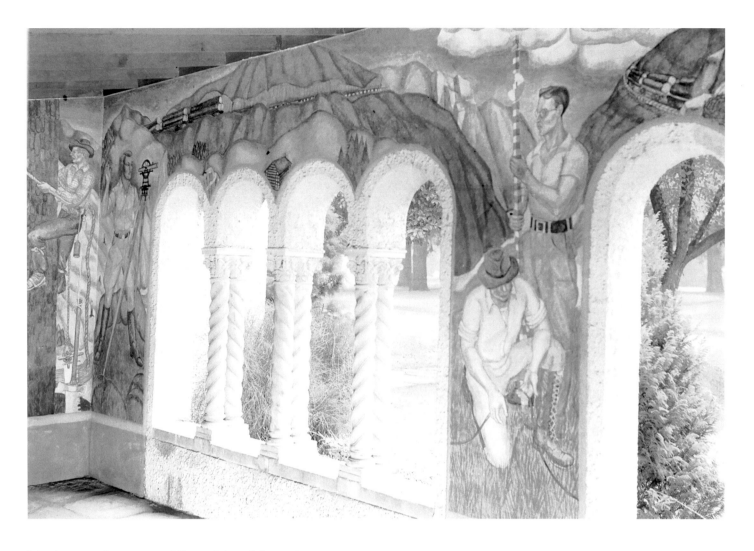

Figure 18
Phillip Halley Johnson (1910–1970)
Forestry from *Pioneer Element in History of Oregon*, 1937
Oil or tempera on plaster
Dimensions unknown
Lawrence Hall, University of Oregon Department of Art
Courtesy of Oregon WPA and SFA Negatives Collection, Anne and
James F. Crumpacker Family Library, Portland Art Museum, WPA 368c

This fresco was destroyed during a later remodel of Lawrence Hall.

his place. Barker successfully petitioned for an increase in the Oregon employment quota to hire center staff and lined up a third teacher for the opening named Charles Lemery. Charles Val Clear was hired as the director of the Salem Art Center in early April 1938. Val Clear was an artist and art educator who had worked at the Museum of the John Herron Art Institute in Indianapolis and at the Phillips Memorial Gallery (now Phillips Collection) in Washington, DC. He was serving as the director of the Art League of Washington (DC) when he was recruited.

The Salem Art Center (SAC) opened on June 5, 1938, at 460 North High Street to a crowd of some 1,000 people and a declaration from the mayor proclaiming an Art Week in celebration. Few knew that 24 hours before all the furniture and equipment that had been stored off-site until opening day had been destroyed in a fire. The staff had spent the day scrambling to borrow furniture from local stores and art-making supplies and equipment from the Museum Art School in Portland. Registration for classes

had to be closed on the first day because more than 300 people signed up and only two teachers had started work (fig. 19). Lamade began teaching classes in modeling, carving, and woodworking on July 1, but the overwhelming demand continued and Barker requested additional staff. It was not until October, however, that more teachers arrived to help. Three were sent on temporary transfer from the New York FAP to assist with painting, printmaking, and craft classes, with a fourth joining them several weeks later.[67] Classes were offered on two tracks: the Guild School, with intensive courses for full-time students, and the Open School, with short, informal sessions.

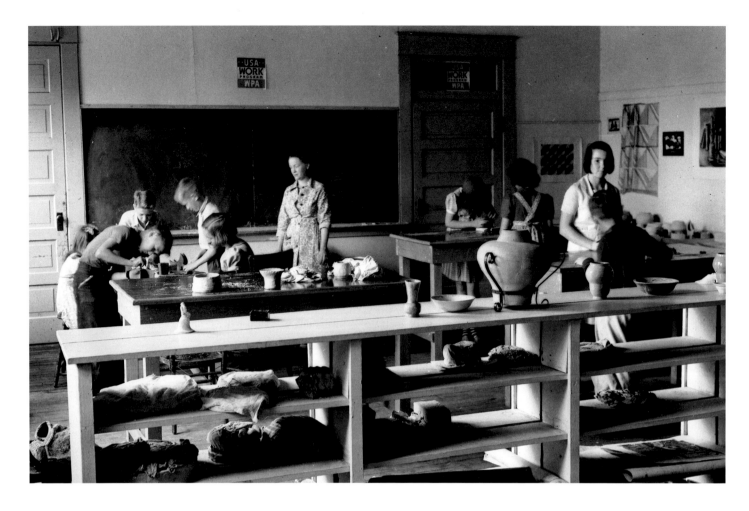

Figure 19
Children's pottery class, Salem Art Center (detail), circa 1938–41
Courtesy of Oregon WPA and SFA Negatives Collection, Anne and James F.
Crumpacker Family Library, Portland Art Museum, LS93

In addition to the highly successful art classes offered, the Salem Art Center participated in the traveling exhibition circuit of the FAP and also organized exhibitions of work from the Oregon art project and by local artists. Staff offered tours and lectures, and the building was used as a community meeting space.[68] In August, Val Clear began drawing up proposals for extension galleries in smaller or more remote communities. The Oregon FAP had been jointly running an exhibition gallery in Corvallis with the Corvallis Women's Club, but because of its proximity it was closed when the SAC opened. Val Clear was not able to get approval for other community galleries, but by the beginning of 1939 he had managed to open small galleries in eight public schools around Salem.[69]

Work continued in 1938 on projects for Oregon public schools and OSC. Martina Gangle created a pair of murals for Rose City Park School (now Rose City Park Elementary School) in north Portland. A Washington native, Gangle was a recent graduate of the Portland Museum Art School. She had begun working as a young child to help her mother support their family, and that history engendered in her a passionate concern for and interest in working people. Her two tempera murals titled *Pioneers Sailing by Raft down the Columbia River* and *Columbia River Settlement* documented the hardships faced by early Euro-American arrivals in the West (fig. 20; see also page 205, fig. 2).[70]

Gorham's work for Timberline Lodge and for Irvington School sparked a host of other commissions for both small- and large-scale marquetry scenes. In 1938 she created three major artworks: a three-panel mural for Chapman School in Portland titled *Send Us Forth to Be Builders of a Better World* (see page 202, fig. 1); a three-panel mural for the lobby of Bexell Hall at OSC titled *Wisdom*; and a massive work composed of two panels each measuring 11 feet by 15 feet for the lobby of Moreland Hall, home of the forestry department (fig. 21). The latter project, titled *The Forests*, was designed to showcase the many commercial woods of Oregon and is a mosaic of a variety of different

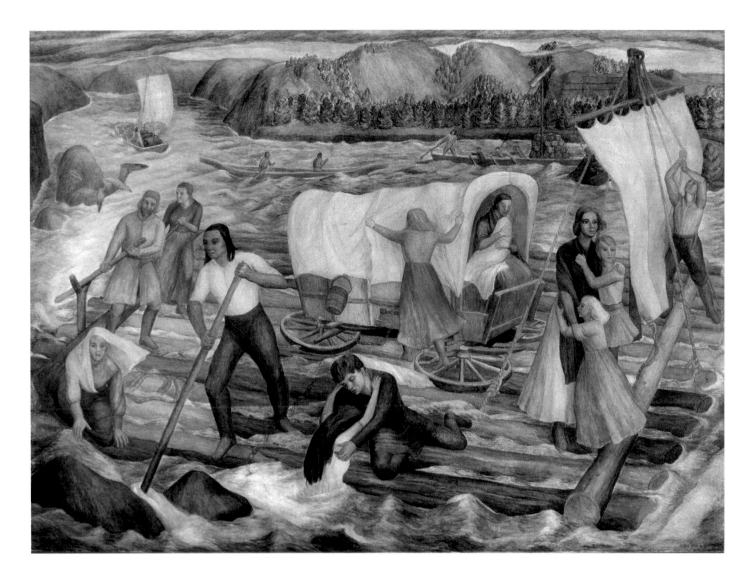

Figure 20
Martina Gangle
Pioneers Sailing by Raft down the Columbia River (one from a two-panel mural), 1938
Tempera on canvas
9 × 12 feet
Rose City Park School, Portland
Courtesy of Portland Public Schools

colors and grains that Gorham used to great effect in her symbolic designs (fig. 22).[71] The abiding interest in marquetry on the Oregon FAP seems to have had several sources. One was the previously mentioned interest in handicrafts of all kinds and particularly artists who were blending craft techniques with fine art. As well, the Northwest economy was built upon the timber industry, and works that showed off the abundance, variety, and versatility of wood as a building and craft medium were popular. Furthermore, the men who assisted Gorham with many of her marquetry projects were furniture makers and cabinetmakers. In employing them, the WPA forwarded a central tenet of helping to revive and sustain such industries during the economic depression. The interest in marquetry also speaks to the loose definition of "art-related activities" undertaken by the FAP fostered by both Barker and Smith (though with different emphases) and supported by Griffith in Oregon and by Cahill in DC.

Another highly unusual body of work created for the Oregon FAP was a series of fine art photographs of Portland and landscapes in northeastern Oregon by the modernist photographer Minor White. After having started a photography program at the Portland YMCA, White was hired in 1938 to help in the Oregon WPA's documentary unit. WPA photographers were assigned to take images of every aspect of WPA projects for publicity purposes as well as a historical record. White took a large number of straight documentary images for the Oregon WPA, but also created a series of meditative images of Portland's old iron-front buildings and studies of Portland's working

Figure 21
Aimee Gorham
The Forests, 1938
Wood marquetry
11 × 15 feet
Moreland Hall, Oregon State College

This panel and its companion, *Only God Can Make a Tree*, were relocated to the entrance of Richardson Hall on the Oregon State University campus in 1999.

Figure 22
Aimee Gorham
Solomon, 1937
Wood marquetry
61⅜ × 37¼ inches
Portland Art Museum, Portland, Oregon, Loan from the Fine Arts Program, US General Services Administration, WPA, Federal Art Project, 1935–1943, with Gratitude to Edsel Colvin, Mark Humpal, and Bill Rhoades, L2013.14.1

Figure 23
Minor White (1908–1976)
Untitled (Broadway Bridge), circa 1939
Gelatin silver print
10 × 13⅜₆ inches
Portland Art Museum, Portland, Oregon, Courtesy of the Fine Arts Collection,
US General Services Administration, New Deal Art Project, L42.3.13

waterfront. The photographs were his early forays into art photography and explorations of industrial-inflected aesthetics (fig. 23). It was while working in the Oregon FAP that this world-renowned photographer began to shape his art and photography career.[72]

Work continued apace with more traditional media as well. Numerous artists were making easel paintings, but Bunce, Heaney, Price, Arthur Runquist, and Sewall created particularly large bodies of work. These were distributed to schools and civic organizations around the state or sent to the central office in DC for distribution (fig. 24). Heaney, Price, and Runquist worked within a group of preferred motifs, but Bunce and Sewall ranged across styles and subjects (fig. 25). Printmakers and sculptors on the Oregon FAP were mostly assigned to specific commissions.

From 1936 to 1938 work was underway to replace the Oregon State Capitol, which had burned down in 1935. The reconstruction work was funded primarily by the Public Works Administration, and expectations were high that the Oregon FAP would be involved in the decorative program. The New York architectural firm, however, chose their own artists rather than working with one of the government art programs.[73] In 1939, for the Oregon State Library, they did hire a regional sculptor, Gabriel Lavare, who had done work for the PWAP and Oregon FAP. Some FAP work also was later allocated to the new State Library, including a set of floral watercolors from Timberline Lodge and a spectacular mural painting of the native flora of the state by Charlotte Mish, another Art Students League graduate who maintained a national career as an artist and a poet from her home base in Portland (fig. 26).

Two initiatives occupied much of the Oregon FAP administrators' time in 1939. In January, Smith was asked to assemble an exhibition celebrating the work done at Timberline Lodge for the New York World's Fair that year. The exhibit included a scale model, full-scale replicas of guest rooms displaying the furniture and textiles made for the lodge, artworks, and other objects. The Timberline Lodge project was trumpeted in this prominent forum as a signature achievement of the WPA and FAP, and a model for the integration of art and craft.

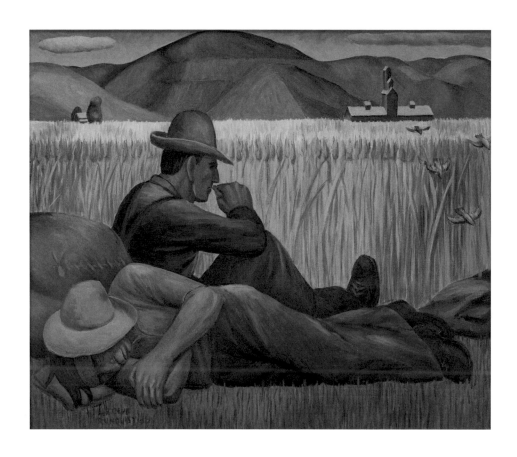

Figure 24
Arthur Runquist
Lunch, 1939
Oil on canvas
30 × 35 inches
Portland Art Museum, Portland, Oregon, Courtesy of the Fine Arts Collection,
US General Services Administration, New Deal Art Project, L45.3.7

Figure 25
Louis Bunce (1907–1983)
Lumber Yard, 1939
Oil on canvas
36 × 24 inches
Portland Art Museum, Portland, Oregon, Courtesy of the Fine Arts Collection,
US General Services Administration, New Deal Art Project, L42.13

Figure 26
Charlotte Mish (1896–1974)
Map of Oregon Flora, 1939
Tempera on canvas
54 × 72 inches
State Library of Oregon, Salem

Art center activities were also a primary focus of the Oregon FAP in 1939. The SAC published a pamphlet, "What the Art Center Means to Salem," that was used to launch a campaign for new memberships. Classes expanded to include weaving and theatrical arts in addition to painting, sculpture, and printmaking, and four new artists were temporarily assigned from Saint Louis and Chicago. Plans were briefly underway in June 1939 to add a second art center or extension galleries in Silverton and Klamath Falls but shifted by July to a second full-fledged art center in Gold Beach. This town of 400 on the southern Oregon coast was the smallest community nationwide considered for an art center. After visiting Gold Beach, Val Clear reported that there was "nothing in the nature of cultural activities in the community, or art, music or dramatics in the schools" and described the area as "probably the most isolated and primitive section of the state."[74]

Despite the small population in Gold Beach, the local response was generous and enthusiastic. The former high school building was offered as headquarters, and town residents donated labor and raised $1,500 to renovate the building and support art center operations. The Gold Beach Art Center opened in September 1939 with a staff of six headed by Arthur Wasser, a professional puppeteer and mask maker. Within a month after opening, it was serving not only area residents but also a steady stream of tourists traveling the Coast Highway. It offered art classes as well as a space for drama and music lessons and performances by local groups.

Figure 27
Louise Utter (1912–1965)
Deer and Fawn, 1939
Coated plaster
30 × 25 × 9¼ inches
University of Oregon Knight Library, Eugene

Figure 28
Valentine Weise (1895–1966)
Pegasus, 1936
White oak
36 inches diameter
Kidder Hall, Oregon State College

This work and its companion, *Mounted Amazon*, have been relocated to the Richardson Building on the Oregon State University campus.

Briefly in February 1939 there were plans in place for an art center in Portland, consisting of two buildings across from Holladay Park in east Portland. It was designed by Ralph B. Lloyd to cover a city block and serve as a cultural center that would house not only the art center but other arts organizations as well. WPA funds were allocated toward its construction but plans stalled; after the war it eventually became the site of the Lloyd Center Mall.[75]

Also in 1939 the furniture, wrought iron, and textile workshops organized for Timberline Lodge were once again called upon, this time to create works for several high-profile settings. Harry Hopkins, the head of the WPA and one of President Roosevelt's closest advisers, requested couches, tables, draperies, and a fire screen for his DC

office, as did the Secretary of Commerce. Also requested, though not completed until the following year, were furnishings for the Alaska Governor's Mansion. It is likely that several of these commissions were the result of the exhibition of Timberline objects at the New York World's Fair. Robert Bruce Inverarity, the head of the Washington FAP, was likewise inspired by Timberline Lodge to propose similar projects for ski lodges on Mount Rainier and Mount Spokane, as discussed below.

Dawson and his crew were continuing to make wrought-iron architectural elements for the UO and OSC campuses. One of the few sculptors employed on the Oregon FAP, Louise Utter, a recent graduate of the UO's art department, was making work for the university as well. Utter had assisted Edna Dunberg with the sculptural heads for the library's facade and completed them after Dunberg passed away in 1936. Utter was commissioned to create two sculptures of wildlife, *Cougar and Cub* and *Deer and Fawn* (1939; fig. 27), for rooftop patios at the library, and a relief

plaque titled *Freedom of the Press* (also known as *Influence of the Press*) for the Journalism Building (now Allen Hall). Wood relief plaques previously carved by Valentine Weise were allocated to offices at OSC (1936; fig. 28).

Commissions from the public schools included carvings and easel paintings as well as a monumental mural titled *Pageant of Oregon History* painted in 1939–40 by Erich Lamade (see page 207, fig. 4). Around the walls of the former library of Abernethy School in south Portland he painted a stylized frieze of images that traced the state's history from its Indigenous first inhabitants through the arrival of Euro-American settlers and the development of the state's towns and cities.[76]

The upheavals and reorganization at the national level of the FAP in the summer and fall of 1939 led to administrative, financial, and personnel changes in Oregon. The new rule that artists could only be employed for 18 consecutive months forced the resignations of several key favorites. New sponsorship requirements slowed and delayed some work. The end of Federal One and the transition from a unified federal art project to individual state ones finally forced the end of Barker's involvement as well. He had been transitioned to an advisory role several months before, but in November 1939 he was officially terminated from the Oregon FAP and Smith became the sole director. The art project consolidated its office space, closing the allocation gallery at 111 NW 11th Street and moving all activities back to 15 SW First Avenue.

Despite these hurdles, the Oregon FAP continued plans to greatly expand the network of art centers. They were strongly supported and encouraged by Cahill, Defenbacher, and the assistant WPA commissioner in DC, Florence Kerr. Val Clear was promoted to state director of the Oregon art centers so that he could focus on developing new ones in addition to the two in Salem and Gold Beach. Bunce took over briefly as the manager of the Salem Art Center, followed by Marian Field. Enthusiasm for the SAC continued unabated. A membership drive in February 1940 netted 400 new supporters. The SAC also served as a training ground for other art center directors, and there were plans for shaping it into a national training center.

In March 1940 the Oregon FAP submitted a proposal to open a third community art center, this one in La Grande,

Figure 29
Minor White
Tree Root, circa 1939
Gelatin silver print
13½ × 10⅝ inches
Portland Art Museum, Portland, Oregon, Courtesy of the Fine Arts Collection, US General Services Administration, New Deal Art Project, L42.3.20

a town in the northeast corner of the state with a population of just under 8,000. Val Clear temporarily relocated to the area and plans evolved rapidly. The Grande Ronde Valley Art Center opened on Depot Street on May 12, with Jane Robinson as manager. Robinson served only a few months before resigning due to ill health. She was replaced by Minor White, who was there teaching photography classes. The new position proved pivotal for White. The spectacular natural setting inspired him to create a new body of lyrical landscape photography (fig. 29), moving away from the urban and industrial scenes that had characterized his work in Portland (see pages 174, 176–78, figs. 1–4). He ran the art center until October 1941, when he was replaced by Marjorie Ebert.

The burst of momentum was short-lived, however. As elsewhere, the many funding and employment quota cuts

Figure 30
Arthur Runquist, Martina Gangle, and Albert C. Runquist
Early Oregon History (detail), 1940
Tempera on canvas
62 × 36 inches (framed)
Pendleton Senior High School

Originally commissioned as 5 panels, the mural now consists of 14 canvases, which have been transferred to the Heritage Station Museum, Umatilla County Historical Society, Pendleton.

Figure 31
Chair and draperies designed by Margery Hoffman Smith (1888–1981) for the Bachelor Officers Quarters, Tongue Point Naval Air Station, Astoria, circa 1942
Courtesy of Oregon Federal Art Project 1935–1943, John Wilson Special Collections, Multnomah County Library, Portland, Oregon

as well as the growing demands of World War II on the US economy and population were beginning to manifest as limitations on many aspects of the Oregon FAP. Plans to open a fourth art center, in Klamath Falls, near the south-central border of the state, were stymied in the fall by lack of personnel. Wasser resigned as the head of the Gold Beach Art Center, and there was a delay in finding a replacement, until the sculptor Walter Pritchard eventually stepped in. Cahill visited Portland and other parts of the Northwest in November 1940 to help art project administrators regroup and give them new heart. The art centers were particularly well placed to assist the war effort in their communities in a number of ways, a role they embraced. They arranged for exhibitions relating to war and national defense, offered space for war drives, and helped a number of organizations in producing needed handouts, pamphlets, and posters.

Work also slowed elsewhere on the art project as sponsorship money began to disappear or be redirected. The primary commissions in 1940 were for Oregon schools. The largest was a mural titled *Early Oregon History* for Pendleton Senior High School (fig. 30). Arthur Runquist and Gangle shared the work, assisted by Albert C. Runquist and others. The tempera-on-canvas mural depicts a number of scenes of life in the West, with images of pioneers, Native Americans, the Pendleton rodeo, and other settings. It was the second school mural for the town. Price had completed a two-panel mural for the Pendleton Junior High School several years before.[77] Elsewhere, Gorham's marquetry works continued to be in demand and she was commissioned to create several more for schools in Portland.

Art project work turned increasingly toward the war effort. In June 1941 the Oregon FAP was hired to draw up an interior design program for Tongue Point Naval Air Station in Astoria, on the northern Oregon coast. Plans were made for furnishings as well as murals, easel paintings, and decorative art objects. Designers included Val Clear, Smith, her assistant Thomas Laman, and two others, Howard Gibbs and Jack Price, about whom little is currently known.[78] In contrast to Timberline Lodge's rustic aesthetic, these designs drew upon contemporary modernist vocabularies, using sleek lines, painted woods, and textured patterned fabrics (fig. 31). A large number of easel paintings were transferred over from the Portland office, including

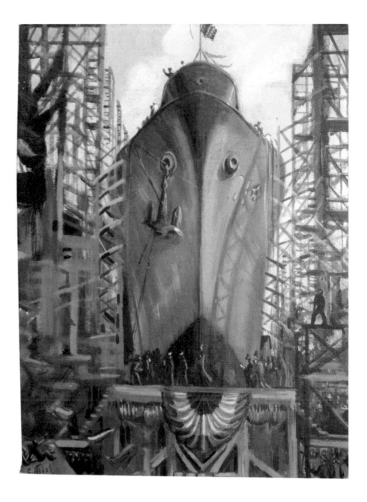

Figure 32
Charlotte Mish
Ship Launching, circa 1941
Oil on canvas
36 × 24 inches approx.
Courtesy of Astoria School District

a variety of regional scenes by art project stalwarts such as Austin, Darcé, Heaney, and Lamade, among others. Mish, who was known for her maritime scenes, created images specifically for the Naval Air Station of freighters and aircraft carriers, ship launchings, and cargo loading (fig. 32). Orie Graves painted compositions featuring sailors at leisure. Darcé contributed a whimsical stained-glass opus sectile scene titled *Marine Fantasy*, featuring sailors, officers, and a mermaid (fig. 33). Bue Kee modeled a number of ceramic fruit centerpieces that were allocated to Tongue Point. His work for the Oregon FAP is little documented. Kee was born in Portland to parents of Chinese descent and studied at the Museum Art School. He specialized in ceramic sculpture and after the war became an important figure at the Oregon Ceramic Studio (later the Museum of Contemporary Craft) in Portland. In addition to his work for Tongue Point, he

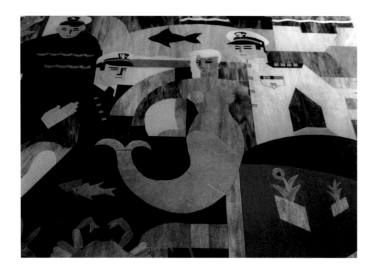

Figure 33
Virginia Darcé
Marine Fantasy, 1941
Opus sectile
Dimensions unknown (now lost)
Courtesy of Oregon Federal Art Project 1935–1943, John Wilson Special
Collections, Multnomah County Library, Portland, Oregon

made several whimsical ceramic sculptures of birds (see page 12). The body of work created for Tongue Point is one of the great losses of the Oregon FAP. When the base was decommissioned, artworks and unwanted furnishings were thrown away. A few works were saved by locals and are now in private or museum collections, but the majority of the artworks listed in the archives as being sent to Tongue Point are missing and presumed destroyed.

Cahill made another trip through the Northwest in September 1941, again to raise morale and to reconnect with art project administrators. He visited Medford, where yet another art center was being proposed, and once again visited the Salem Art Center. In his report on the trip, he revisited the idea of using the SAC as a hub for national community art center activities, recommending that the Oregon FAP

> consider the possibility of setting up a training center for art center directors and personnel, either in Portland or at the Salem Art Center. Possibly the Portland Art Museum and the University of Oregon might be willing to cooperate in such a program. At the present time there is no educational institution in this country which gives the type of training necessary for

community art center personnel. It is felt that in view of the rapid extension of the community art center movement and the demands for art participation activity in national defense recreation and morale programs, it is becoming highly important to provide this type of training.[79]

Yet another art center was proposed for Oak Grove, south of Portland, but neither it nor the Medford art center was ever authorized.

The Oregon FAP began fragmenting and dwindling in the first half of 1942, as the national offices began to shut down. Griffith, the Oregon art project's primary advocate, resigned his job as the head of the Oregon WPA to run for Congress in February. Many artists began working in the shipyards near Portland or in the camouflage and graphic services divisions of the War Services Program.[80] The art centers in La Grande and Gold Beach closed in May. The Salem Art Center relocated to new quarters and managed to keep operating with private financial support for a short period before closing. In her final report on the Oregon FAP, Smith said of the art center: "They inculcated the program into the life of the community and at this date, January, 1943, six months after the withdrawal of WPA, are still maintaining their entity . . . and are planning to carry on art center work."[81] After the war, the Salem Art Association, the primary local supporters of the SAC, revived it and it is still in operation today as the Bush Barn Art Center. Nationwide, all state art projects were officially closed in February 1943, but there is little sign of activity in Oregon after June 1942.

Ideally, all project records were to be forwarded to the DC offices for archiving and artworks sent to the Illinois Art Project for distribution. It appears that the Oregon records were never sent on, and it is unknown if any artworks were sent to the Illinois clearinghouse. Fortuitously for Oregon, Robert Tyler Davis, the director of the Portland Art Museum, recognized the value of what was being lost and requested a large allocation of works to the museum. Davis had arrived at the museum in 1939 and was a staunch supporter of the art projects during his tenure. Smith was a museum trustee, forging a further connection. A group of more than 400 FAP artworks from Oregon and

other states was put on permanent loan to the museum and is one of a handful of caches of Northwest New Deal art project work remaining in the region.

By the end, the Oregon FAP had completed commissions for 39 public schools, more than 40 public agencies and civic organizations, 13 libraries, 1 national and 2 state parks, 2 colleges, and 1 university, plus created one of the signature projects of the FAP in Timberline Lodge. In addition, it had supported three community art centers and hired artists to create numerous easel paintings, prints, and sculptures. To date the list compiled from archival records of artists employed by the Oregon FAP numbers 158 names (see Appendix 1, page 215).

A primary thread running through the Oregon FAP was the embrace of handicraft as both an art form and a worthwhile form of work. The revival and support of traditional techniques were seen as a way of training workers in skills that could translate to private industry. This focus was driven by Smith's own preferences and her dismissive attitude toward many of Oregon's artists. In her final report she unapologetically stated: "Based on the conviction that a good craftsman is better than a mediocre artist and the talent level of the Oregon artists assigned to the project was mediocre on the whole, the Oregon Art project was transformed as rapidly as possible and for the greater part to a craft project."[82] Despite Smith's strong biases, Barker and other administrators as well as the rush of eager sponsors and active art centers ensured that the Oregon FAP employed a variety of artists and left a diverse legacy.

Washington

The early days of the Washington FAP were a case study in the personal and political complexities that blocked the implementation of a number of WPA programs. As soon as he was authorized to act in mid-October 1935, Burt Brown Barker proposed an FAP project for Washington State. Approval arrived on October 24, and Barker called upon committee members from the earlier Washington PWAP to help him find artists and line up projects. He appointed Fred Wiggins, a local businessman and husband of the photographer Myra Wiggins, as state art director and put him in touch with George Gannon, the head of the WPA for Washington State, to receive funds and begin the work of organizing. There was no response from Gannon.

Barker then traveled to Seattle and attempted to visit Gannon at his office, only to be told he was out of town. He was directed to R. W. Lahr, the director of Professional and Service Projects for Washington. Lahr was a graduate of the Art Institute of Chicago and an art instructor with a decided antipathy toward avant-garde styles. He informed Barker "that he had no use for the modern school of art and that he would not stand for that sort of 'stuff'" in Washington and sent Barker away.[83] Shortly thereafter Barker received a letter from Gannon stating that no money had been allocated for an art project in Washington and rejecting Barker's candidate:

> I have personally checked the matter of the appointment of Mr. Fred A. Wiggins . . . as State Director of Art for this state, and regret that it is impossible for me to consent to this appointment. . . . I trust that as soon as you are able to secure additional funds that you will let us know how extensive a program you contemplate for this state, and I will be pleased to cooperate with you in wanting someone in charge who will be mutually satisfactory to both of us.[84]

Furious, Barker wrote to Cahill protesting the interference and asking for Cahill's intervention, but found that Gannon did have veto power over his appointment. After one last attempt, Barker withdrew from oversight of the Washington art project, feeling he could get nothing started as long as the state's WPA administrators were opposed to it.[85] Further attempts were made by the DC office, but they also were unable to make any progress. Gannon continued to insist there were no employable artists on the relief rolls and that, should they enroll in the future, Lahr could oversee any art commissions. In January 1936 Cahill withdrew the funds for the Washington FAP and redirected them to other states.

In May a hopeful change began. Gannon and Lahr were transferred to other positions and the new Washington State WPA administrators were much more welcoming to the art project. An employment quota of up to 15 artists

was authorized and work began to find a state director and launch a Washington FAP. Much of the work of revitalization appears to have been done directly by the DC office rather than through Barker. He continued to act as an occasional adviser but did not again take over supervision of Washington's art project. The FAP head office, encouraged by early progress, increased the employment quota to 25 people within the first few weeks, but there were still hiccups that delayed the start of activities in Washington State.

Gannon's replacement, Don Abel, was eager to begin but ignorant of procedure. He named a state art project director and organized a committee without consulting the FAP. His choices were Robert Bruce Inverarity as director and the Seattle sculptor Alonzo Lewis, the designer Ross Gill, and Nellie Cornish, the director of the Cornish School of Allied Arts (now Cornish College of the Arts), as his committee. Inverarity was a Seattle native with an eclectic background that included painting, printmaking, puppetry, and anthropology. Cahill asked Joseph Danysh, the regional representative and head of the California FAP, to travel to Seattle and interview Inverarity to make sure he was a good choice for the position. Danysh recommended that Inverarity's appointment be approved, and the Washington FAP was launched in early July. Upon receiving the telegram offering him the position, Inverarity responded to Cahill:

> I am extremely pleased that I may help in a small way the development of what I believe, is the finest program for artists which has ever been in existence. I know of nothing in the past in any country, which is comparable to this nation-wide program which is pouring blood into the veins of the creative artists in the country. Most of the artists whom I have interviewed are of the same opinion, and many, who, on account of their non-relief status will not be able to be used on this program, still are enthusiastic and would like to help in any way that they may.[86]

Contrary to Gannon's assertions that there were no artists on government relief, Inverarity found 69 registered across the state and also was contacted by 99 others who were desperately in need of employment though not officially registered.[87] He desired to help as many as possible but was hampered at once by the requirement that 90 percent of those employed had to be from the relief rolls. He found, as others had previously, that many of those registered were amateur artists or only minimally trained and unsuited to the commissions he was lining up. He heard, however, that a number of states had requested and received an exemption reducing the relief requirement to 75 percent and he successfully argued for the same standard in Washington.

Inverarity leapt into action, visiting artist studios, talking to artist organizations, and meeting with a variety of public institutions to interest them in commissioning the FAP for a specific project or paying for the long-term loan of artworks. He made an attempt to keep the advisory committee active, but the members were too busy with their own projects and it was allowed to lapse. He frankly noted several years later that he felt the project had done better without the interference of committee members.[88]

Two of the first sponsors to sign on became long-term partners who supported a variety of work from simple tasks to large-scale productions. Seattle City Light Department requested two large commissions. One was a scale model of parts of the Skagit Power Development (now the Skagit River Hydroelectric Project) on the Skagit River in the North Cascade Mountains. The focus was Diablo Dam, which had just begun operating. The Diablo Dam model (1936; fig. 34) was 5½ feet wide and 8 feet long, weighed close to 1,500 pounds, and included a working river supplied by a hidden water tank underneath. This large-scale project required painters, sculptors, carpenters, and even engineers. Simultaneously, the artist Glenn Sheckels was hired to design a series of mural panels for the auditorium in the City Light building in downtown Seattle. Information about this commission is fragmentary and confused. An early document lists plans for eight panels, but a later one, providing measurements, describes only four. One source indicates the murals were mosaics, another that they were paintings. They were to be quite large, measuring between 7 feet and 13 feet high and between 8 feet and 15 feet wide. Other artists who may have been involved alongside Sheckels were identified by last

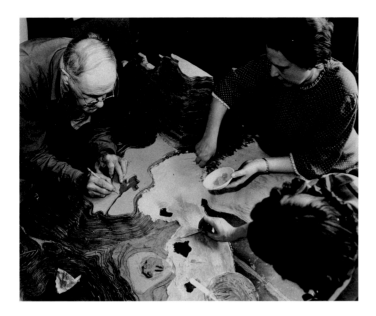

Figure 34
Artists working on a model of Diablo Dam, 1936
Robert Bruce Inverarity Papers, circa 1840s–1997, Archives of American Art, Smithsonian Institution

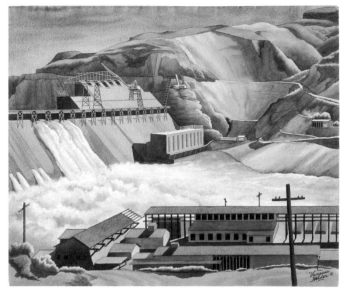

Figure 35
Z. Vanessa Helder (1904–1968)
Coulee Dam, Looking West, 1940
Watercolor on paper
18 × 21⅞ inches
Northwest Museum of Arts and Culture, Museum Purchase, 1954, 2585.3

name only (Spohn and Roberts). The murals are no longer extant and no photographs have yet been located, so these questions are currently unresolved.[89] Inverarity tried to leverage the work for Seattle City Light into a commission at the Grand Coulee Dam, then under construction by the US Bureau of Reclamation on the Columbia River in northeastern Washington. He was never able to line them up as sponsors for the FAP, but several artists did make images of work on the dam independently (fig. 35).

The second major sponsor was the University of Washington (UW) in Seattle. Inverarity had been working for the university's School of Drama when he was hired to run the Washington FAP, so it is not surprising that he had contacts that ensured UW's early involvement. However, several of the Art Department faculty, particularly Ambrose Patterson and Walter Isaacs, were not enthusiastic supporters, and throughout the run of the FAP there were a number of conflicts between them and Inverarity. Despite these challenges, UW remained a primary sponsor until the closing days of the Washington art project.

Among the first commissions for the university in 1937 was a three-panel mural for the Drama Library in Hutchinson Hall by Glenn Sheckels, assisted by other Seattle FAP artists. It depicts "three phases of the theatre" (fig. 36).

As described in one report, "The first panel represents the Theatre of the East, depicting the Japanese, Indian, Javanese and Chinese theatre. The second panel represents the Theatre of the West, depicting the Grecian and Roman theatre and the third panel, which is not designed as yet, will depict the Theatre of Shakespeare."[90] Irene McHugh, a painter and sculptor, was hired to create a set of bust portraits in stone of well-known authors such as Shakespeare and Chaucer for one of the libraries. The only one that has currently been located is a head of Shakespeare.[91]

The university's Department of Anthropology also became a regular sponsor. Their first request for the Washington State Museum (now the Burke Museum) was for dioramas of summer and winter village life among the Sanpoil people, one of the Salish tribes of north-central Washington (fig. 37). They also requested a model of a woman weaving a Chilkat-style blanket. Later, the Department of Anthropology and the museum sponsored the creation of copies of tools and other Native American objects in the collection for educational use.

Inverarity was approached in August by the head of the Cushman Indian Hospital in Tacoma regarding a mural for the dining room and two murals for the nurses' home. The hospital was under the administration of the US Indian

Figure 36
Glenn Sheckels (1885–1939) assisted by other FAP artists
Theatre of Shakespeare (detail), 1937
Oil on canvas
4 × 8 feet
Hutchinson Hall, University of Washington

All three panels of this mural are installed in the former Drama Library, now a classroom.

Service and was located on the Puyallup Reservation. The artist chosen for the commission was Two-vy-nah-up, known on the project as Julius Twohy, a primarily self-taught Ute painter and printmaker who had worked on the Washington PWAP. Inverarity deliberately chose a Native artist for the commission, but ascribing to the pan-Indian viewpoint common in the 1930s and particularly among Federal One administrators that all Indigenous groups shared the same traditions, he did not consider the cultural and aesthetic differences between Twohy's background and the mural's intended audience.

The dining-room mural consisted of a series of stylized scenes and symbols in black and white running for 72 feet and covering the entire wall from about 3 feet up to the ceiling (fig. 38). A narrow frieze of symbols ran around the top of the wall in the rest of the room. Twohy chose the mythological thunderbird as his primary motif, depicting four variations representing the Lake Region, the Plains,

the Rocky Mountains, and the Northwest. Under each thunderbird were generalized scenes from the life of the tribes that lived in each region.[92] The commission was originally envisioned as a full decorative scheme, including additional paintings as well as artist-designed tablecloths and other craft elements—a marriage of art and design, but the other components were put on hold as problems developed with the building. First, as Twohy prepared to begin painting, parts of the wall had to be replastered. About two years after the mural was complete, the building was found to have structural problems that were too expensive to resolve. It was eventually demolished, and Twohy's mural now exists only in photographs.[93]

Inverarity had a strong interest in folk art and craft traditions. From the start of the Washington FAP, he assigned artists to create illustrations for the Index of American Design. He began casting around for interesting objects in August 1936, but it was not until the following spring that images began to be produced. The first in Washington were created by Augustine Haugland, a painter and highly skilled illustrator based in Tacoma. He was later joined by Alf Bruseth, William Fletcher, and Clementine Fossek. Exhibitions of works created for the Index at the Rhodes Department Store in Tacoma and at the Henry Art Gallery in Seattle in the summer of 1937 included a number of their

Figure 37
E. M. Sando (dates unknown)
Diorama of a Sanpoil village in winter (detail), circa 1937
Mixed media
16 × 44 × 32 inches
Washington State Historical Society, 1989.100.2

This and several other dioramas were originally created for the Washington State Museum (now the Burke Museum) in Seattle.

Figure 38
Julius Twohy (Two-vy-nah-up) (1902–1986)
The Flight of the Thunderbird (detail), 1936–37
Oil on plaster
10 × 72 feet (main panel)
Cushman Indian Hospital, Puyallup Reservation, Tacoma (now destroyed)
Robert Bruce Inverarity Papers, circa 1840s–1997, Archives of American Art, Smithsonian Institution

Figure 39
Alf Bruseth (1900–death date unknown)
Toy Bank (detail), circa 1937
Watercolor, gouache, and pen and ink on paperboard
11⅝ × 9¹³⁄₁₆ inches
National Gallery of Art, Index of American Design, 1943.8.8469

drawings of the pioneer Ezra Meeker's covered wagon, the first printing press in Washington State, and cast-iron toy banks (fig. 39). Over the course of the Washington FAP, these four artists produced more than 100 plates for the Index, now in the collection of the National Gallery of Art.

One of the great strengths of the Washington FAP was the cohort of talented and innovative printmakers that it supported.[94] There had been a strong interest in prints among collectors and artists in Washington since the 1880s.[95] The encouraging atmosphere supported robust production and exchange as well as innovation. For the FAP, the great advantages of print workshops were the relatively inexpensive supplies and the multiple copies that resulted. A division known as the Graphic Arts Project was organized within the FAP specifically to support these workshops. In Washington, the clusters of printmakers at the Seattle headquarters and later at the Spokane Art Center working under the Graphic Arts Project created a variety of exciting images and pioneered new approaches to several techniques. Among them was Richard Correll, whose aesthetic drew upon his family roots in building and wood-carving, resulting in expressive rough-hewn woodcuts and linocuts. His most distinctive body of work for the FAP was a series on the folk hero and lumberjack Paul Bunyan, a favorite character in the timber-focused Northwest (fig. 40). Twohy

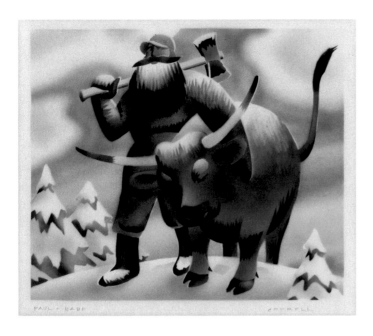

Figure 40
Richard Correll (1904–1990)
Paul and Babe, 1938
Lacquer airbrush stencil on paper
8½ × 11 inches (sheet)
Labor Archives of Washington, University of Washington Libraries, Special Collections, UW38035

Figure 41
Julius Twohy
Round Dance, circa 1938–39
Lithograph on paper
19 × 12⅞/₁₆ inches (sheet)
Henry Art Gallery, University of Washington

also produced a series of unique prints for the FAP, bringing his flattened, stylized image making to his depictions of Native American dances and other celebrations (fig. 41). Two others in this talented group were Z. Vanessa Helder and Malcolm Roberts. Helder was a Washington native who had studied at the Art Students League and was a prominent member of the American Watercolor Society renowned for her tightly controlled regional landscapes in that medium. She later taught at the FAP's Spokane Art Center, where she was instrumental in establishing a lithography studio (fig. 42). Roberts was a graduate of the Art Institute of Chicago and one of the few artists in the Northwest to actively pursue surrealism (fig. 43).

A change in WPA regulations in the fall of 1936 forced the layoff of all employees over the age of 65, which temporarily paused the Seattle City Light and University of Washington projects for several months. In November

1936 the Seattle School District signed a sponsorship agreement "for murals, sculpture, easel paintings, or anything else that we might have or could do for them."[96] This was the start of several years' worth of work for the Washington FAP.

One of the first commissions was a series of mural panels for the lobby at West Seattle High School. The painter selected was Jacob Elshin, an immigrant from Russia who had settled in Seattle in the 1920s. His subjects were varied but often had a regional slant. He had been employed on the Washington PWAP and executed several Section of Fine Arts commissions for post office murals in Renton and University Station when he was not working for the FAP (see pages 83, 85, figs. 21, 24). For the school, Elshin created three paintings depicting the arrival and activities of the first Euro-American settlers on the Alki peninsula on the west side of Seattle (fig. 44; see also pages 196, 201,

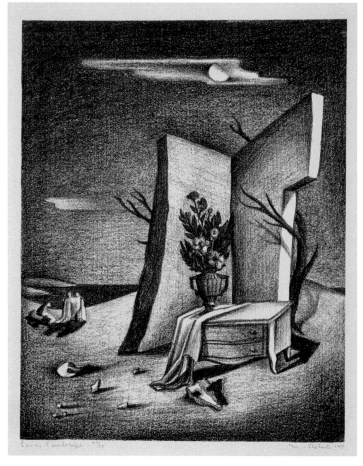

Figure 42
Z. Vanessa Helder
Rain Storm, 1938
Lithograph on paper
9⅞ × 14⅛ inches
Western Gallery, Western Washington University, 2004.006.043.0

Figure 43
Malcolm Roberts (1913–1990)
Lunar Landscape, 1937
Lithograph on paper
12⅜ × 9¹³⁄₁₆ inches (plate)
Jordan Schnitzer Museum of Art, Eugene, Allocated by the US Government
Commissioned through the New Deal art projects, WPA56:1.181

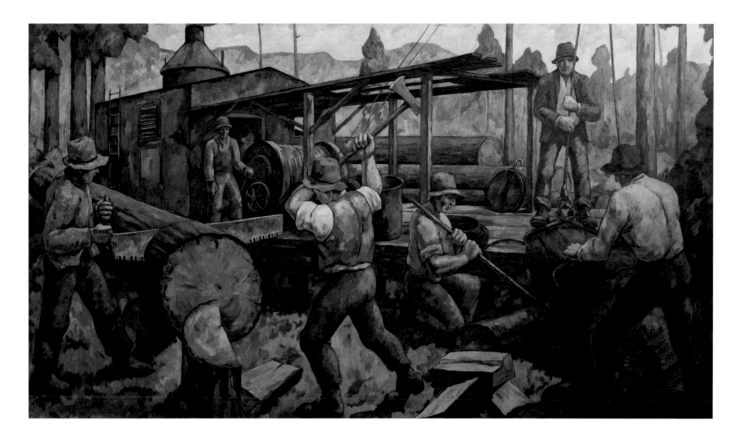

Figure 44
Jacob Elshin (1892–1976)
Logging (one from a three-panel mural), 1937–38
Oil on canvas
5 × 9 feet
West Seattle High School
Courtesy of Seattle School District

figs. 1, 5). The work was begun in March 1937 and the murals installed May 9, 1938. The paintings were later relocated multiple times and eventually put into storage; they were rediscovered and restored in 2002.[97]

Also in March of 1937 plans were launched for adding murals and decorative maps by FAP artists to the new state capitol building in Olympia.[98] The legislature approved an initial appropriation of $20,000 and planned to vote again for a similar sum at the next biennial session. Inverarity reported to Danysh several months later that the head of the state capitol committee was enthusiastic about the plans and sketches that he had seen, but the project began to stall in September. Inverarity and Abel visited Governor Clarence Martin to further the plans but instead found new hurdles. Martin insisted on a detailed work plan and budget as well as an oversight committee of nine to decide on the subjects of the murals and approve final designs. What at first had seemed like a major coup for Inverarity and the

Washington FAP instead became a lingering headache and eventually was abandoned.

Impressed by the scale of the Washington art project and Inverarity's unbounded enthusiasm, Cahill visited in early September 1937. Together the two traveled to eastern Washington to visit Spokane and see the Grand Coulee Dam. The trip was the start of an abiding friendship that weathered controversies, funding crises, and the myriad other ups and downs of the art project. Their subsequent letters carry inside jokes and personal notes alongside the business at hand, and the two men speak frankly with each other of their opinions and states of mind.

Part of the purpose of Cahill's trip to Spokane was to begin discussions about opening a community art center in northeastern Washington. Also, the FAP had learned that President and Mrs. Roosevelt would be visiting Seattle, the Olympic Peninsula, and Bonneville Dam, then traveling on to Oregon at the end of September, and Cahill wanted to make sure everyone on the Northwest art projects was prepared to show their best. Apparently, Mrs. Roosevelt was particularly impressed with what she saw in Seattle when they visited on September 29. When she returned to Seattle six months later, in March 1938, she again visited the art project headquarters.[99] Simultaneous with her visit,

the state's employment quota was increased by 10 artists, perhaps a gesture from the national office acknowledging the Washington FAP's successes or simply a politic move.

Throughout 1937 and into mid-1938, work was in progress on the murals for Seattle City Light and new projects for the University of Washington museum, the Public Lands and Social Security Building in Olympia, and Sand Point Naval Air Station. Designs were also completed for a fountain at Felts Field in Spokane and a mosaic mural for Point Defiance Zoo, though there is no record these designs were ever realized.

The Washington FAP was so busy that when they were asked to assist with preparations for the 1939 New York World's Fair, they had to decline. In addition to the projects for their various sponsors, plans were finally in progress for a community art center in Spokane. Discussions about establishing an art center in eastern Washington had begun almost as soon as the Washington art project was launched.[100] Inverarity traveled to Spokane in August 1936 to interview artists and meet with the Spokane Art Association. Because the Washington art project was newly launched after a rocky beginning, Defenbacher and other FAP administrators counseled delay. To lay the groundwork for future discussions, Inverarity sent a teacher to the Spokane Vocational School and helped the Spokane Art Association locate exhibitions.

During their visit to Spokane in September 1937, Cahill and Inverarity had begun selling the idea of a community art center to city leaders and civic groups. Several local people were inspired to begin a fundraising campaign, but Cahill encouraged Inverarity to "go to Spokane and stay there for a week or ten days—two weeks if necessary—and bring the whole thing to fruition before it has a chance to lose momentum. Remember that the ultimate success of the art center will depend in great measure upon how it is started."[101]

As in other communities, it was groups such as the American Legion, Rotary, Kiwanis, and Junior League that both contributed financially and enlisted their members to help with fundraising. The original target of $2,500 was reached in May 1938, but enthusiasm was so strong that the art center advisory committee continued the campaign. With money in hand, talk began about finding the right director. Inverarity was concerned about the conservative

bent of Spokane and advocated strongly for "a he-man with a bass voice, as there is still a bit of the pioneer liking of manliness in Spokane, and we need a two-fisted sort of a fellow to go in there if that Gallery is going to run and turn out to be successfully independent."[102] He also asked for a very traditional exhibition for the opening in order not to offend local sensibilities.

A building was obtained at 106 North Monroe Street in downtown Spokane, and carpenters set to work modifying the interior for classrooms and an exhibition gallery (fig. 45). Progress at first was swift, but delays with supplies and building permits throughout the summer postponed the opening until the end of September. Carl Morris, the newly appointed director of the art center, arrived in early July to oversee preparations. Morris was a California native who had studied at the Art Institute of Chicago and in Europe. He was teaching in Chicago but dreaming of a move west when Danysh recruited him.

Morris had big plans, feeling the art center could be a connector and catalyst for the arts throughout the northeastern part of the state. He asked for information on building his own kiln and making a potter's wheel out of a Singer sewing machine in the hopes of adding a ceramics studio. He had discussions with the Spokane Camera Club about providing them space in the art center building, and he began working on a cooperative agreement with the exhibition gallery at Washington State College in Pullman to take FAP exhibitions after they were shown in Spokane. He even floated a plan for a civic auditorium in association with the art center, dreaming big before the art center was fully realized.

The Spokane Art Center (SpAC) opened on September 29, 1938, with a staff consisting of Morris, two teachers (Helder and Guy Anderson), two gallery attendants, a carpenter, a janitor, and a secretary. The local papers had been following the progress of the center with great anticipation, and their constant coverage led to a booming opening day and strong community interest. The teachers were overwhelmed by the demand—both the numbers of students and the variety of classes requested. A newspaper article on the art center from March 1939 notes a schedule of 30 different one- to two-hour day and evening classes in drawing and painting, modeling, sculpture, children's

Figure 45
Spokane Art Center exhibition galleries (detail), circa 1938–40
Robert Bruce Inverarity Papers, circa 1840s–1997, Archives of American Art, Smithsonian Institution

drawing and painting, life drawing, graphic arts, watercolor painting, and creative color composition as well as lectures on art history and art appreciation. The same article reported more than 13,000 visitors in the first five months the center had been in operation.[103]

Morris begged for extra help. Defenbacher had just started the program that temporarily transferred artists from art projects in major metropolitan areas to regional art centers. He lined up four new teachers for Spokane: Hilda Deutsch, Kenneth Downer, Ruth Egri, and Joseph Solman. All were modernists of one form or another, which was an interesting gamble for purportedly conservative Spokane. They arrived in early October to help manage the growing flood of avid students, leading several to complain some weeks later that because of the teaching demands, they no longer had time for their own work. Despite the challenges, a few months later they all agreed to extend their assignments and stay for at least six months.

The SpAC pursued the same general round of activities as community art centers elsewhere, with art classes and exhibitions their primary offerings. The SpAC also served as a community meeting space, offered lectures on the arts, organized a lending library of FAP lithographs, and hosted a variety of other activities. In November the Washington State College gallery was adopted as an art center extension gallery, headed by professor Worth Griffin. Discussions also began about opening a second art center, in Tacoma.

The overwhelming success of the SpAC caught the attention of the national office. Thomas Parker, the assistant director of the FAP, advocated forcefully for additional staff and a higher employment quota, noting that "the limited staff of this Center cannot meet the public demands" and calling it "one of the most outstanding projects on the West Coast."[104] Downer was promoted to assistant director and given oversight of the art classes so that Morris could concentrate on other aspects of the center's growing activities.

The national reorganization of the FAP in the summer of 1939 threatened the art center's survival just as it was booming. A snapshot of programs from an art center report that summer lists classes in drawing, painting, sculpture, photography, mural painting, crafts and metalwork, life drawing, design, and cartooning, with a total enrollment of more than 1,000 students. It also lists off-site classes at the Washington Children's Home, Spokane Children's Home, Hutton School, and Kiwanis Home for Children.[105] The impact on the SpAC budget of the transfer from federal to state oversight and the changes in rules regarding sponsorship and employment numbers forced the layoffs of several staff and jeopardized all the center's activities. Remarkably, the staff chose to band together and share what money was available for salaries rather than lose anyone. Thankfully, by fall the SpAC was able to regroup and rehire those who had been essentially volunteering their time. Further evidence of the staff's dedication to the art center's work was the publication *Art Horizons*, which they launched in October 1939 and generated every three to four weeks until the end of 1941 to spread the word regionally about SpAC events and programs.

Although the uptick in the 1939 employment quota for Washington from 20 to around 40 people was primarily to provide staff for the Spokane Art Center, work elsewhere in

Father and Son.

The Esquimo has taken his child in his Kyak, to teach him how to fish I. McHugh

Figure 46
Irene McHugh (1891–1955)
Father and Son, 1939
Graphite on paper
5 × 5¾ inches
Courtesy of the Burke Museum of Natural History and Culture, L3560/2

the state continued unabated. The broader Washington art project also had to deal with the effects of national organizational shifts. Activities statewide shut down for several weeks, and the Seattle headquarters was relocated to the Bailey Gatzert School at 12th Avenue South and Weller Street, a less expensive location. Funding stabilized and the project roared back to life in September. There was a dizzying array of commissions for the University of Washington, ranging from sketches and clay models for a diorama of Copper Inuit life by Irene McHugh for the Burke Museum (fig. 46) to striking scientific drawings of marine life by the illustrator and portraitist Agatha B. Kirsch (fig. 47). In addition, a woodworking shop was organized to produce historical markers for the State Highway Department.

A conversation began in November 1939 that resulted in the one monumental work created by the Washington

FAP. The State Highway Department and Washington Toll Bridge Authority were building a new floating bridge over Lake Washington. They commissioned the FAP to create sculptural panels for the approach tunnel being bored under Seattle's Mount Baker neighborhood. James FitzGerald designed three decorative panels, each 26 feet high by 11 feet wide, for the east entrance (fig. 48). FitzGerald's designs were modeled first in clay, then cast in concrete by the sculptor James Wehn and mounted on the bridge.[106] Titled *Portal of the North Pacific*, the decorative program had a central "panel of lettering with a decorative whale design breaking up some of the space . . . [and] symbolic of the ocean separating this country from the Orient." This was flanked on the left by "a formalized dragon symbolic of the Orient" and on the right by "formalized Indian forms symbolizing the great Northwest and Alaska."[107] The panels were designed, created, and installed in a rush, going from idea to installation in the space of just a few months.

Simultaneously, the Seattle headquarters was abuzz with artists creating artworks for allocation to civic organizations. The work produced by the small group of about

Figure 47a–b
Agatha B. Kirsch (1879–1953)
Untitled (radiolarians), 1939
Graphite on paper
20 × 15 inches each (sheet)
Washington State Historical Society, 2000.51.1, 2000.51.4

20 artists is startling in its variety and volume. A summary completed between September 1939 and January 1940 is indicative of the output of the Washington FAP from 1937 to late 1940. The report lists 114 miniature figures for models, 10 tracings and wash drawings, 1,500 silkscreen brochures, 9 Index of American Design plates, 45 watercolors, 27 easel paintings, 500 greeting cards, a map of the state of Washington, preliminary sketches for murals at Arlington High School, and a host of other tasks. During this period a large number of allocations were made to schools and universities across the state, including in Aberdeen, Bellingham, Chehalis, Colville, Pullman, and Yakima, among many others.

The FAP headquarters in Seattle and the SpAC proved pivotal in shaping the future history of Northwest art. Both were important gathering places where young artists worked alongside veterans, commercial artists with fine artists, and students with professionals (fig. 49). Work was shared, discussed, and critiqued, and relationships formed that continued long beyond the end of the art projects. Several artists who are now nationally recognized were given their first opportunities through the FAP. The four painters commonly labeled the Northwest Mystics, who rose to prominence in the 1950s, were all connected through the Washington FAP. Mark Tobey returned from England to the Northwest because he was offered a job on the FAP.[108] Inverarity saw the great promise in a young unknown painter named Morris Graves and hired him.[109] Guy Anderson taught at the Spokane Art Center. And Kenneth Callahan, though adversarial to Inverarity and other FAP administrators, was connected as a teacher and mentor to young FAP artists such as Hans Bok[110] and William Cumming and knew many others.

Though geographically isolated, the SpAC was a particularly important catalyst. Many of the artists who temporarily transferred there from out of state chose to stay in the Northwest. Carl Morris and Hilda Deutsch

Figure 48
Lacey V. Murrow Bridge tunnel entrance, circa 1960, showing James
FitzGerald's and James Wehn's cast-concrete sculptures *Portal of the North
Pacific*, 1939–40 (each decorative panel 26 × 11 feet)
Courtesy of the Seattle Public Library, Spl_shp_20062

(later Hilda Morris) subsequently became leading artists
in Oregon. Clyfford Still, though not employed there, was
teaching nearby in Pullman and visited the SpAC almost
weekly in its early years; he had his first solo exhibition
there in 1939.[111] Others became university professors and
art instructors at public schools and trained several genera-
tions of Northwest artists.

A less tangible but equally important effect stemmed
from the variety of artists and artistic styles supported by
the Washington FAP. Modernism was a particularly strong
thread through much of the work produced and regional
subjects were common, but the lack of aesthetic strictures
resulted in a richly varied body of work. Furthermore, the
FAP gave opportunities to those who were struggling to
support themselves as artists. Approximately 33 percent of
those employed were women, many of whom were given
substantial commissions. There were, however, only two
non-Caucasian artists that have been identified to date
working for the Washington FAP. In addition to Twohy, the

Chinese American artist Fay Chong created a number of
paintings and prints (fig. 50).

In January 1940 Morris and Deutsch were transferred
from Spokane to Seattle, over the strong objections of
Cahill. Inverarity had been working on an ambitious plan
to create a series of galleries in public schools throughout
the state for art exhibitions organized by the Washington
FAP rather than borrowed from the national circuit.[112]
Morris had been thinking along the same lines and joined
Inverarity in Seattle to help him launch the program.
Downer was promoted to director of the SpAC on Morris's
departure. Though Cahill argued against the transfer, fear-
ing the loss of Morris would hurt the art center, there is no
sign of a downturn in the records. Monthly reports show
activities continuing at a frenzied pace and new teachers,
classes, and facilities being added regularly, including the
ceramics studio Morris had long desired, a metal-craft
shop, and proposals for several new extension galleries.

The effort to open satellite galleries waxed and waned
throughout 1940 and 1941. In April 1940 the Lewis
County Community Exhibition Gallery in downtown
Chehalis was opened under the codirectorship of Betsy
Sabin and Louise Corbin. They offered an interesting
slate of classes, including drawing and painting, interior

Figure 49
Hans Bok (1914–1964)
In the Project Studio, 1939
Pen and ink on paper
20 × 25½ inches (framed)
Museum of History & Industry, Seattle

Figure 50
Fay Chong (1912–1973)
Marine Hospital, 1938
Linoleum block print
6⁹⁄₁₆ × 7¹⁄₁₆ inches (plate)
Jordan Schnitzer Museum of Art, Eugene, Allocated by the US Government
Commissioned through the New Deal art projects, WPA56:1.22

decorating, art appreciation, handicrafts, photography, costume design, and pattern cutting. Instructors included Corbin, who was a trained interior decorator, and Sabin, who had studied art at the University of Chicago, as well as Betty Harper, an architect; Olga Prior, a dress designer; and Frank Evernden, a photographer.[113]

A second extension gallery, run by Ruth Nosker, was launched simultaneously in Bremerton. Both began hosting FAP traveling exhibitions. Plans were floated for extension galleries in Bellingham, Ellensburg, and West Seattle, though none was completed. Inverarity's program to set up galleries in public schools came to fruition the following spring. In February 1941 he reported that six Seattle schools and the school at Fort Lewis in Tacoma were all turning hallways into art galleries.[114] A few months later the Wenatchee Exhibition Gallery opened in the basement of the city museum, and the library at Fort Lewis also became an extension gallery.

In May 1940 work began in earnest on a project that had been in the planning stages since 1938.[115] The chemistry department at the University of Washington had requested murals for the entrance lobby of Bagley Hall. The commission had been bogged down in the approval process because all 20 faculty members needed to sign off on the design before it could move forward.[116] Inverarity, who was designing the work, had finally gotten the group to agree upon his latest round of sketches. The completed commission was a two-panel linoleum tile mosaic, *Ancient Chemistry* and *Modern Chemistry*, depicting the history of the development of chemistry as a science (fig. 51).[117] Late in the process Cahill's office suddenly protested the use of tile, but Inverarity's aggrieved response and the advanced state of the mural combined to see it completed as planned.[118]

Inspired by the Oregon FAP's successful marriage of art and craft that resulted in the stunning Timberline Lodge on Mount Hood, Inverarity turned his attention to a proposal for an arts and crafts project for Mount Rainier National Park. Several artworks by David Stapp had already been allocated there in 1939, but Inverarity proposed adding furnishings and other artworks to the ski lodge. He had managed to employ a few artists on the FAP to create textiles and metalwork but had long hoped to start a more ambitious and focused craft-based program. The commission for Mount

Rainier fell through, but the Washington FAP was hired to help with interior decoration of the new ski lodge being built on Mount Spokane. In addition to providing furniture, project artists turned from painting and printmaking to designing and producing textiles. Twohy put on a two-day public demonstration of rug weaving at the September 1940 Washington State Fair to help advertise the Washington FAP's new interest in craft commissions.[119]

The unsettling effects of World War II began to affect the Washington FAP in mid-1940. Cuts in funding caused another relocation of art project headquarters, this time to the Latona School on the corner of Fourth Avenue NE and East 42nd Street in Seattle's University District. By this time the art project's primary sponsor was the University of Washington, followed by the Seattle Public Schools and the State Department of Public Instruction. The Washington FAP also began creating a number of works for military facilities, including Fort Lewis, Sand Point Naval Air Station, and later the Annette Island Landing Field in Alaska, and for the US Engineers Office of the War Department. Commissions included distributions of artwork, decorations for service clubs and officers' quarters, and models and maps of airfields. There are, unfortunately, few records or photographs of these works, and most are now unlocated.

More cuts to personnel and budgets had to be weathered in late 1940, and as the art project slowed and changed focus to war work, artists began to protest the loss of jobs and creative freedom and other scrutiny of the FAP intensified. Inverarity became the target of a campaign in October to have him removed from his position. The instigators were all prominent in the regional art scene and included Charlotte Upton of the Spokane Art Center board; Richard E. Fuller, director, and Kenneth Callahan, curator, of the Seattle Art Museum; and professors Walter Isaacs and Ambrose Patterson at the University of Washington. Patterson, and particularly Callahan, had a history of previous grievances against Inverarity stretching back to the beginning of the art project.[120] The group accused Inverarity of not cooperating with the Seattle Art Museum, driving away qualified artists, and general incompetence.[121] Their letters resulted in a full investigation of Inverarity, but he was ultimately cleared and the controversy marked down to local politics.[122] Another letter-writing campaign led to the ouster of one of the SpAC

Figure 51
Robert Bruce Inverarity (1909–1999)
Modern Chemistry (one from a two-panel mural), 1940–41
Linoleum mosaic
8 feet 8 inches × 11 feet
Bagley Hall, University of Washington, Seattle
Courtesy of University of Washington Department of Chemistry

staff. A self-proclaimed communist, he had been leaving political literature around the art center and was accused of threatening others who did not agree with him. He was quietly transferred to another WPA project.[123]

The last documented commission for Washington public schools was completed early in 1941. Correll created a mural for Arlington High School in north central Washington. One panel shows a dairy farm and the other is an image of Paul Bunyan, in homage to the local farming and lumbering industries. By March 1941 the Washington FAP was working primarily on civil defense activities doing camouflage work for the US Navy and creating Air Raid Precaution armbands for the city of Seattle as well as a map to be used for planning blackouts. Work on the Index of American Design was suspended in July, and Inverarity's letters to the DC office noted a steady stream

of artists leaving to enlist or to take better-paying jobs in the defense industry. After the attack on Pearl Harbor in December 1941, the Washington FAP's work was exclusively for the military, creating propaganda posters and other graphic work.

The Spokane Art Center and extension galleries continued to operate on a limited basis for the first half of 1942. The SpAC was losing staff to the war, and community sponsorship was lagging as organizations turned their attention to supporting local war efforts. Downer left in the

summer of 1941 and was replaced by FitzGerald. He oversaw the closing of the SpAC in November 1942. As thousands of soldiers began to pour into Fort Lewis in 1942, FAP traveling exhibitions were shown at the base's Service Club as well as in the library gallery to provide recreational opportunities for as many soldiers as possible. Even after all FAP projects nationwide were converted to the Graphic Section of the War Services Program in March 1942, extension galleries like the one at Fort Lewis were able to continue for a brief period if they were benefiting a military or defense agency. The closing of the FAP traveling exhibition section eventually brought them to an end as well.

Despite its rocky beginning, the Washington FAP was highly successful. It employed 111 artists and produced more than 400 individual artworks in addition to the many and varied commissions for specific organizations. The SpAC's reach was particularly impressive, both through its own active program of classes and exhibitions and through the network of extension galleries it activated.

A primary reason for the Washington FAP's impact was Inverarity's indefatigable commitment and determination. As he wrote in a 1938 letter, "My attitude has always been that the only way to get things done in W.P.A. is to do them and fight out the reasons for it later. If we had not worked this way our Project, long ago, would have been stifled."[124] Another critical factor was his close relationship with Cahill, which gave him a direct line to the national administrative offices and insider information on the political ups and downs of the project. Ultimately, it was idealism that drove him on, as it did many of the others who kept the FAP going despite numerous obstacles. He fully embraced the FAP's vision of a project that would support the artistic community in all its aspects and offer art experiences to every citizen.

––––––––––

Despite the funding limitations, quota requirements, and constant battles with congressional opponents and FAP detractors, Hopkins's and Cahill's vision won through. At its peak, the FAP was employing around 5,000 artists, artisans, and arts workers nationwide. They created some 2,500 murals, more than 100,000 easel paintings, over 200,000 prints, and almost 18,000 sculptures along with 2 million silkscreen posters from 35,000 original designs and 22,000 plates for the Index of American Design. The FAP's community art centers had further offered personal encounters with art to millions of Americans through their classes, exhibitions, lectures, and other art-related activities. The FAP had proved that work relief and art could be a highly effective mix with far-reaching and sometimes unexpected benefits.

For the Northwest, the FAP was of varying import. In Idaho, activities were minimal. In Montana, most of the energy and funding went into the state's three art centers and numerous extension galleries; although the numbers of artworks created and artists employed were not high, the count of art center visitors and students ranged into the hundreds of thousands. Oregon's and Washington's statistics were impressive in all aspects, a smaller-scale reflection of the national tally in scope and reach. Particularly worth noting is the success of the community art centers and extension galleries across the region. Not only was the number of them established significant, even on a national scale, but the volume of people who participated in art center activities indicates the level of desire for cultural activities and the understanding of their value. This response is in marked contrast to narratives that depict the area in this period as isolated and culturally unaware.

There were other important developments across the region as well. Oregon's highly successful emphasis on handicraft and the marriage of art and craft not only resulted in unique commissions but also revived and supported an array of craft traditions that offered economic benefits and inspired artists during the war years and beyond. A less tangible but equally critical role the Washington FAP performed was to support and connect a varied network of artists, a number of whom went on to be key figures in the Northwest art world and nationally. Beyond the tallies and statistics, the FAP and the other New Deal art projects in the Northwest provided employment and appreciation for hundreds of regional artists, forestalling a mass exodus that would have irrevocably impoverished the art community for decades to come.

NOTES

1 The administrative structure of the FAP shifted a number of times throughout the run of the program as funding and congressional oversight changed. For the most detailed accounting, see William F. McDonald, *Federal Relief Administration and the Arts: The Origins and Administrative History of the Arts Projects of the Works Progress Administration* (Columbus: Ohio State University Press, 1969).

2 *Report on Art Projects: Federal Art Project . . . February 15, 1936* (Washington, DC: Works Progress Administration, 1936), 1.

3 For further discussion, see Sharon Ann Musher's essay in the present volume.

4 Holger Cahill, Director, Federal Art Project, to all regional administrators, January 14, 1936; Oregon; Entry 1023, Textual Records of the Federal Art Project, Office of the National Director, Correspondence with State and Regional Offices, 1934–40, 1935 to 1936 Oregon to Tennessee, Box 27; Correspondence Files, 1935–1939; Records of the Work Projects Administration, 1922–1944, Record Group 69; National Archives at College Park, College Park, MD (hereafter NACP).

5 Francis V. O'Connor, *Federal Support for the Visual Arts: The New Deal and Now* (Greenwich, CT: New York Graphic Society, 1969), 65; Joan A. Saab, *For the Millions: American Art and Culture between the Wars* (Philadelphia: University of Pennsylvania Press, 2004), 40.

6 Holger Cahill, *New Horizons in American Art* (New York: Museum of Modern Art, 1936), 19.

7 Schedule of Co-Sponsors' Contributions for the Loan of Works of Art, Folder 1-68, Timberline Lodge papers, on file at Friends of Timberline, Portland, OR (hereafter Friends of Timberline).

8 Memorandum from Holger Cahill, Director, Federal Art Project, to State Art Directors, August 28, 1936, Folder 1-111, Timberline Lodge papers, Friends of Timberline.

9 General Services Administration Fine Arts Program, Legal Fact Sheet, https://www.gsa.gov/real-estate/design-construction/art-in-architecture-fine-arts/fine-arts/legal-fact-sheet, last reviewed February 26, 2019.

10 For a collection of essays on aspects of the community art center program, see John Franklin White, ed., *Art in Action: American Art Centers and the New Deal* (Metuchen, NJ: Scarecrow Press, 1987).

11 Undated prospectus on Federal Art Centers, Folder 1-116, Barker—Federal Art Project—State of Oregon—1937 (Sept.–Dec.), Timberline Lodge papers, Friends of Timberline.

12 Jonathan Harris, *Federal Art and National Culture: The Politics of Identity in New Deal America* (Cambridge, UK: Cambridge University Press, 1995), 45.

13 White, *Art in Action*, 104.

14 Holger Cahill, Director, Federal Art Project, to Burt Brown Barker, Vice President, University of Oregon, telegram, October 15, 1935; Folder 1-116, Barker—Federal Art Project—State of Oregon—1935 (Oct.), Timberline Lodge papers, Friends of Timberline. For more on Barker and the PWAP, see Chapter 3 in the present volume.

15 For numerous examples of their early correspondence, see Entry 1023, Textual Records of the Federal Art Project, FAP Office of the National Director, Correspondence with State and Regional Offices, 1935–1940, 1935 to 1936 Oregon to Tennessee, Box 27; Correspondence Files, 1935–1939; Records of the Work Projects Administration, 1922–1944, Record Group 69; NACP.

16 Holger Cahill, Director, Federal Art Project, to Burt Brown Barker, Regional Director, Region 16, telegram, October 24, 1935; 651.315 Oregon 1935–1936; Entry PC-37 12-40, Textual Records of the Federal Art Project, Administrative and Operational Correspondence Relating to Oregon, 1935–1944, Box 2374; Administrative and Operational Correspondence Relating to Oregon; Records of the Work Projects Administration, 1922–1944, Record Group 69; NACP.

17 Jacob Baker, Assistant Administrator, WPA, DC, to Holger Cahill, Director, Federal Art Project, May 18, 1936; Idaho; Entry 1023, Textual Records of the Federal Art Project, FAP Office of the National Director, Correspondence with State and Regional Offices, 1935–1940, 1935 to 1936 Florida to Idaho, Box 18; Correspondence Files, 1935–1939; Records of the Work Projects Administration, 1922–1944, Record Group 69; NACP.

18 J. M. Whiting, Superintendent of Schools, Heyburn, Idaho, to Senator James Pope, March 10, 1938; 651.315/1938; Entry PC37 12-14, Textual Records of the Federal Art Project, Work Projects Administration Central Files: State/1935–1944 Idaho 651.3–651.3169, Box 1174; Administrative and Operational Correspondence Related to Idaho; Records of the Work Projects Administration, 1922–1944, Record Group 69; NACP.

19 Related letters can be found in Folder 651.315/1938; Entry PC37 12-14, Textual Records of the Federal Art Project, Work Projects Administration Central Files: State/1935–1944 Idaho 651.3–651.3169, Box 1174; Administrative and Operational Correspondence Related to Idaho; Records of the Work Projects Administration, 1922–1944, Record Group 69; NACP.

20 "Idaho Artist Believes Apathy Toward New Murals Justified," *Idaho Daily Statesman*, July 4, 1940.

21 Herbert C. Legg, WPA Administration, Southern California, to Colonel F. C. Harrington, Commissioner, Work Projects Administration, August 1, 1940; Idaho 651.315; Entry PC37 12-14, Textual Records of the Federal Art Project, Work Projects Administration Central Files: State/1935–1944 Idaho 651.3–651.3169, Box 1174; Administrative and Operational Correspondence Related to Idaho; Records of the Work Projects Administration, 1922–1944, Record Group 69; NACP.

22 For further discussion, see Philip Stevens's essay in the present volume.

23 Robert Bruce Inverarity, Director, Washington Federal Art Project, to Joseph Danysh, Regional Adviser, Federal Art Project, May 15, 1939; Correspondence Joseph Danysh; Entry 1023 Textual Records of the Federal Art Project, Office of the National Director, Correspondence with State and Regional Offices, 1935–1940, 1938 to 1940 Georgia to Illinois, Box 42; Correspondence Files, 1935–1939; Records of the Work Projects Administration, 1922–1944, Record Group 69; NACP.

24 Ray Hart, State Administrator, Montana, to Ann Craton, Assistant Director, Federal Art Project, September 13, 1935; Montana 1936; Entry 1023, Textual Records of the Federal Art Project, Office of the National Director, Correspondence with State and Regional Offices, 1935–1940, 1935 to 1936 Mississippi to New Mexico, Box 22; Correspondence Files, 1935–1939; Records of the Work Projects Administration, 1922–1944, Record Group 69; NACP.

25 Agnes Pauline, Director, Women's and Professional Projects, Montana, to Holger Cahill, Director, Federal Art Project, April 13, 1936; 615.315 Mont. 1935–1936; Entry PC 37 12-28, Textual Records of the Works Progress Administration, Central Files: State/1935–1944 Montana 651.314 to 651.315, Box 1807; Administrative and Operational Correspondence Relating to Montana, 1935–1944; Records of the Work Projects Administration, 1922–1944, Record Group 69; NACP.

26 The first committee included Dr. Wilson as chairman, Dr. J. X. Newman as secretary, J. R. Thomas as treasurer, W. C. Orton, Dr. Milo Roberts, Frank Ward, Mrs. Frank Ward, Mrs. G. Otis Baxter, Frank L. Leonard, and Robert Hall. D. S. Defenbacher, Regional Adviser, Federal Art Project, to Thomas Parker, Assistant Director, Federal Art Project, November 11, 1937; Montana 1937; Entry 1023, Textual Records of the Federal Art Project, Office of the National Director, Correspondence with State and Regional Offices, 1935–1940, 1937 Massachusetts to Montana, Box 33; Correspondence Files, 1935–1939; Records of the Work Projects Administration, 1922–1944, Record Group 69; NACP.

27 Daniel Defenbacher, Regional Adviser, to Curtis L. Wilson, Butte, December 3, 1937; Montana 1937; Entry 1023, Textual Records of the Federal Art Project, Office of the National Director, Correspondence with State and Regional Offices, 1935–1940, 1937 Massachusetts to Montana, Box 33; Correspondence Files, 1935–1939; Records of the Work Projects Administration, 1922–1944, Record Group 69; NACP.

28 He is variously misidentified in local newspapers as John Redmond, James Raymond, and James Redman.

29 D. S. Defenbacher, Regional Adviser, to Thomas Parker, Assistant Director, Federal Art Project, January 11, 1938; 651.315 Montana Jan. 1938 1 of 2; Entry PC 37 12-28, Textual Records of the Works Progress Administration, Central Files: State/1935–1944 Montana 651.314 to 651.315, Box 1807; Administrative and Operational Correspondence Relating to Montana, 1935–1944; Records of the Work Projects Administration, 1922–1944, Record Group 69; NACP.

30 An example of these detailed instructions stretching over four pages includes "Unbleached sheeting should be used for the curtains at the window. These curtains should extend from ceiling to floor and from the corner of the room to a point just beyond the casing of the window. The curtains should be extremely full, having a width 2½ times the width of the space to be covered by the curtain." Daniel Defenbacher, Regional Adviser, to Frank Stevens, State Director, Federal Art Project, Montana, January 15, 1938; 651.315 Montana Jan. 1938 1 of 2; Entry PC 37 12-28, Textual Records of the Works Progress Administration, Central Files: State/1935–1944 Montana 651.314 to 651.315, Box 1807; Administrative and Operational Correspondence Relating to Montana, 1935–1944; Records of the Work Projects Administration, 1922–1944, Record Group 69; NACP.

31 Frank Stevens, State Director, Federal Art Project, to Mildred Holzhauer, Exhibition Department, Federal Art Project, January 22, 1938; Montana Centers 1938 to 1940; Entry 1023, Textual Records of the Federal Art Project, Office of the National Director, Correspondence with State and Regional Offices, 1935–1940, 1938 to 1940 Minnesota to Montana, Box 47; Correspondence Files, 1935–1939; Records of the Work Projects Administration, 1922–1944, Record Group 69; NACP.

32 "Art Center Is a Tourist Lure," *Montana Standard*, April 13, 1938, 9.

33 Frank Stevens, State Director, Federal Art Project, to Holger Cahill, Director, Federal Art Project, May 17, 1938; Montana Centers 1938 to 1940; Entry 1023, Textual Records of the Federal Art Project, Office of the National Director, Correspondence with State and Regional Offices, 1935–1940, 1938 to 1940 Minnesota to Montana, Box 47; Correspondence Files, 1935–1939; Records of the Work Projects Administration, 1922–1944, Record Group 69; NACP.

34 "This project is a very important one to Butte. It has taken the fancy of a group of people in Butte who heretofore have been anti-W.P.A. in their attitude, and we are really anxious that it should be carried out in a way that will satisfy them." Joseph Parker, State Administrator, Montana WPA, to Ellen Woodward, Assistant Administrator, Works Progress Administration, December 14, 1937; Mont. 651.315 1937–Aug. 1939; Entry PC 37 12-28, Textual Records of the Works Progress Administration, Central Files: State/1935–1944 Montana 651.314 to

651.315, Box 1807; Administrative and Operational Correspondence Relating to Montana, 1935–1944; Records of the Work Projects Administration, 1922–1944, Record Group 69; NACP.

"Incidently [*sic*] some of the skeptics here can hardly believe that such splendid and whole hearted cooperation would be possible in such a short time in the city of Butte." Frank Stevens, State Director, Federal Art Project, Montana, to Joseph Danysh, Regional Adviser, January 22, 1938; Montana Centers 1938 to 1940; Entry 1023, Textual Records of the Federal Art Project, Office of the National Director, Correspondence with State and Regional Offices, 1935–1940, 1938 to 1940 Minnesota to Montana, Box 47; Correspondence Files, 1935–1939; Records of the Work Projects Administration, 1922–1944, Record Group 69; NACP.

35 D. S. Defenbacher, Regional Adviser, Federal Art Project, to Frank Stevens, State Director, Federal Art Project, Montana, February 4, 1939; Montana Centers 1938 to 1940; Entry 1023, Textual Records of the Federal Art Project, Office of the National Director, Correspondence with State and Regional Offices, 1935–1940, 1938 to 1940 Minnesota to Montana, Box 47; Correspondence Files, 1935–1939; Records of the Work Projects Administration, 1922–1944, Record Group 69; NACP.

36 The others were Armand Catenaro to teach painting and mural workshops and Antonio Giordano to teach sculpture. Holger Cahill, Director, Federal Art Project, to Frank Stevens, State Director, Federal Art Project, Montana, October 3, 1938; 651.315 Montana Jan. 1938 2 of 2; Entry PC 37 12 28, Textual Records of the Works Progress Administration, Central Files: State/1935–1944 Montana 651.314 to 651.315, Box 1807; Administrative and Operational Correspondence Relating to Montana, 1935–1944; Records of the Work Projects Administration, 1922–1944, Record Group 69; NACP.

37 Curtis Wilson, Chairman of Sponsoring Committee, to Thomas Parker, Assistant Director, Federal Art Project, April 27, 1939; Mont. 651.315 1937–Aug. 1939; Entry PC 37 12-28, Textual Records of the Works Progress Administration, Central Files: State/1935–1944 Montana 651.314 to 651.315, Box 1807; Administrative and Operational Correspondence Relating to Montana, 1935–1944; Records of the Work Projects Administration, 1922–1944, Record Group 69; NACP.

38 "The first concerns work executed by patients of the State Hospital, Art Therapy classes. This particular class, supervised by project personnel is not to be confused as an occupational or manual therapy group; rather, it was used as an aesthetic camouflage to achieve a psychological result. Most of the patients are of the schizophrenic or 'split personality' type, and very often resist the efforts of the institution's staff to elicit additional personal information which would aid in relieving their mental ailments." Frank Stevens, Director, State Art Project, Montana, to Walter Kiplinger, Director, Public Activities Programs, Federal Art Project, March 20, 1942; Final Inventory Mont. 651.3115/3118 Final Inventory of State HRS Feb. 15, 1942; PC 37 12-28, Textual Records of the Works Progress Administration, Central Files: State/1935–1944 Montana 651.2 to 651.313, Box 1806; Administrative and Operational Correspondence Relating to Montana, 1935–1944; Records of the Work Projects Administration, 1922–1944, Record Group 69; NACP.

39 "Civic Center Space Granted to Art Society," *Great Falls Tribune*, March 24, 1940, 7.

40 Frank Stevens, Director, State Art Project, Montana, Monthly Progress Report of Federal Sponsored Community Art Centers, Butte Art Center, March 1940, 6; Mont. 651.315 1937–Aug. 1939; Entry PC 37 12-28, Textual Records of the Works Progress Administration, Central Files: State/1935–1944 Montana 651.314 to 651.315, Box 1807; Administrative and Operational Correspondence Relating to Montana, 1935–1944; Records of the Work Projects Administration, 1922–1944, Record Group 69; NACP.

41 The board of the Great Falls Art Association included Branson Stevenson, president; James Logan, vice president; Charlotte Southmayd, secretary; and C. C. Wells, treasurer. "Stevenson Elected Temporary Chairman of Falls Art Group," *Great Falls Tribune*, March 7, 1940, 9.

42 "Art Center Closing to Aid War Effort," *Great Falls Tribune*, June 19, 1942, 2.

43 "Detailed Report of Butte Art Center Activities for Year Issued by Committee," *Montana Standard*, January 28, 1940, 12.

44 Frank Stevens, Director, State Art Project, Montana, Monthly Progress Report of Federal Sponsored Community Art Centers, Butte Art Center, March 1940, 3–5; Mont. 651.315 1937–Aug. 1939; Entry PC 37 12-28, Textual Records of the Works Progress Administration, Central Files: State/1935–1944 Montana 651.314 to 651.315, Box 1807; Administrative and Operational Correspondence Relating to Montana, 1935–1944; Records of the Work Projects Administration, 1922–1944, Record Group 69; NACP.

45 The art center board included Edmond G. Toomey, president; Archie Bray, vice president; Marie Buterbaugh, second vice president; Ellen Whitcomb, secretary; and (no first name given) Bateron, treasurer. "Formal Opening Held at Carroll for Art Center," *The Prospector* (Carroll College) 30, no. 8 (April 24, 1942): 1.

46 Frank Stevens, Director, State Art Project, Montana, to Thomas Parker, Assistant Director, Federal Art Project, February 6, 1939; Mont. 651.315 1937–Aug. 1939; Entry PC 37 12-28, Textual Records of the Works Progress Administration, Central Files: State/1935–1944 Montana 651.314 to 651.315, Box 1807; Administrative and Operational Correspondence Relating to Montana, 1935–1944; Records of the Work Projects Administration, 1922–1944, Record Group 69; NACP. See also oral history interview with R. H. (Bob) Hall, 1965 Nov. 28; Archives of American Art, Smithsonian Institution.

47 For detailed discussion of this project, see Mindy Morgan's essay in the present volume.

48 For information on Clarke's life and work, see the website assembled by his daughter, http://www.theclarkegallery.com/john-clarke, and Larry Len Peterson, *Blackfeet John L. "Cutapuis" Clarke and the Silent Call of Glacier National Park: America's Wood Sculptor* (Helena: Larry Len Peterson, in cooperation with Montana Historical Society; Great Falls, MT: C. M. Russell Museum, 2019). Clarke was working on a number of government commissions during this period. They included sculptural friezes for the Blackfeet Community Hospital in Browning, the Museum of the Plains Indian (constructed by the WPA), and the University of Montana. All appear to have been supported by agencies other than the FAP, notably the Indian Arts and Crafts Board and Indian Health Service. The archives do not record any FAP involvement, though this tie may have yet to be discovered.

49 Final Inventory Mont. 651.3115/3118, Final Inventory of State HRS (Historical Records Survey), Feb. 15, 1942; Entry PC 37 12-28, Textual Records of the Works Progress Administration, Central Files: State/1935–1944 Montana 651.2 to 651.313, Box 1806; Administrative and Operational Correspondence Relating to Montana, 1935–1944; Records of the Work Projects Administration, 1922–1944, Record Group 69; NACP.

50 The state committee for Oregon included Ellis Lawrence, dean of the University of Oregon Art Department; Henrietta Failing, assistant curator, Portland Art Association; Morris H. Whitehouse, architect; H. M. Tomlinson, former president, Oregon Society of Artists; H. P. Wentz, instructor in painting and decorative arts, Portland Art Association; H. M. Barr, principal, Irvington School, and research director of School District No. 1; and Esther Wuest, director of art, Portland Public Schools. Burt Brown Barker, Regional Director, Federal Art Project, to Holger Cahill, Director, Federal Art Project, December 19, 1935; Burt Brown Barker papers, 1935–1938; reel 2551, frames 65–66; Archives of American Art, Smithsonian Institution.

51 Burt Brown Barker, Regional Director, Federal Art Project, to Holger Cahill, Director, Federal Art Project, telegram, October 28, 1935; Burt Brown Barker papers, 1935–1938; reel 2551, frame 457; Archives of American Art, Smithsonian Institution. See also Burt Brown Barker, Regional Director, Federal Art Project, to T. J. Edmonds, Field Representative, Works Progress Administration, Portland, undated; Burt Brown Barker papers, 1935–1938; reel 2551, frames 375–376; Archives of American Art, Smithsonian Institution.

52 E. J. Griffith, Administrative Report, WPA, State of Oregon, December 16, 1935–June 30, 1936. Folder I-III, papers related to Timberline Lodge, Friends of Timberline. In the report Griffith lists enrollment numbers by class: art, 100; art appreciation, 8; arts and crafts, 310; art fundamentals, 7; freehand drawing, 7; mechanical drawing, 22; and photography, 16.

53 "It has been our particular effort to provide for decoration of Oregon educational institutions through projects calling for work in painting and in the plastic arts." R. G. Dieck, Project Director, WPA, Oregon, to Holger Cahill, Director, Federal Art Project, March 31, 1936; Oregon; Entry 1023, Textual Records of the Federal Art Project, FAP Office of the National Director, Correspondence with State and Regional Offices, 1935–1940, 1935 to 1936 Oregon to Tennessee, Box 27; Correspondence Files, 1935–1939; Records of the Work Projects Administration, 1922–1944, Record Group 69; NACP.

54 R. G. Dieck, Project Director, WPA, Oregon, to Holger Cahill, Director, Federal Art Project, March 31, 1936; Oregon; Entry 1023, Textual Records of the Federal Art Project, FAP Office of the National Director, Correspondence with State and Regional Offices, 1935–1940, 1935 to 1936 Oregon to Tennessee, Box 27; Correspondence Files, 1935–1939; Records of the Work Projects Administration, 1922–1944, Record Group 69; NACP.

55 Streat's employment by the California FAP after 1938 is well documented. She was living and actively exhibiting in Portland prior to that time, though her name has not appeared in any Oregon FAP resources consulted for this book. See for example https://streat.webs.com and https://oregonencyclopedia.org/articles/streat_thelma_johnson.

56 Ginny Allen and Jody Klevit, eds., *Oregon Painters: The First Hundred Years (1859–1959)* (Portland: Oregon Historical Society Press, 1999), 271.

57 For further information on both artists' time on the New Deal art projects and subsequent influential careers, see Roger Hull, *Charles E. Heaney: Memory, Imagination, and Place* (Salem, OR: Hallie Ford Museum of Art, 2005), and Roger Hull, *Louis Bunce: Dialogue with Modernism* (Salem, OR: Hallie Ford Museum of Art, 2017).

58 Timberline Lodge today is operated through a public/private partnership with the US Forest Service as a ski lodge and living museum. It is the one project of the Oregon FAP that has been extensively described and studied. See, for example, Oregon Works Progress Administration, *The Builders of Timberline Lodge* (Portland, OR: Hallwyler Printing Company, 1937); Rachael Griffin and Sarah Munro, eds., *Timberline Lodge* (Portland, OR: Friends of Timberline, 1978); Sarah Baker Munro, *Timberline Lodge: The History, Art, and Craft of an American Icon* (Portland, OR: Timber Press, 2009); and Sarah Baker Munro, *Timberline Lodge* (Charleston, SC: Arcadia Publishing, 2016). For discussion of the ongoing stewardship of the lodge, see Munro's essay in the present volume.

59 Burt Brown Barker, State Director, Federal Art Project, Oregon, to Joseph Danysh, Regional Director, Federal Art Project, December 4, 1936; Burt Brown Barker papers, 1935–1938; reel 2551, frames 109–110; Archives of American Art, Smithsonian Institution.

60 Thomas Parker, Assistant Director, Federal Art Project, to Lawrence Morris, December 10, 1936; Danysh (Con't) 1936–39; Entry 1023, Textual Records of the Federal Art Project, Office of the National Director, Correspondence with State and Regional Offices, 1935–1940, 1938 to 1940 Georgia to Illinois, Box 42; Correspondence Files, 1935–1939; Records of the Work Projects Administration, 1922–1944, Record Group 69; NACP.

61 Joseph Danysh, Regional Adviser, Federal Art Project, to Holger Cahill, Director, Federal Art Project, June 30, 1937; 211.5; Entry PC 37 11, Textual Records of the Works Progress Administration, Administrative and Operational Correspondence, 1935–1944, Box 440; "General Subject" Series; Records of the Work Projects Administration, 1922–1944, Record Group 69; NACP.

62 For a selection of correspondence regarding the controversy over Smith's salary, see Ellen Woodward, Assistant Administrator, Works Progress Administration, to C. E. Triggs, Assistant Regional Director, Women's Professional and Service Projects, February 3, 1937; Thomas Parker, Assistant Director, Federal Art Project, to Joseph Danysh, Regional Adviser, July 27, 1937; and E. J. Griffith, Director, Works Progress Administration, Oregon, to Holger Cahill, Director, Federal Art Project, July 31, 1937, all in 651.315 Oregon 1937–Jan. 38; Entry PC-37 12-40, Textual Records of the Federal Art Project, Administrative and Operational Correspondence Relating to Oregon, 1935–1944, Box 2374; Administrative and Operational Correspondence Relating to Oregon; Records of the Work Projects Administration, 1922–1944, Record Group 69; NACP.

A variety of other letters making accusations and protesting her position can be found in Oregon 651.3159; Entry PC-37 12-40, Textual Records of the Federal Art Project, Administrative and Operational Correspondence Relating to Oregon, 1935–1944, Box 2376; Administrative and Operational Correspondence Relating to Oregon; Records of the Work Projects Administration, 1922–1944, Record Group 69; NACP.

63 Munro, *Timberline Lodge: The History, Art, and Craft of an American Icon*, 71–115.

64 R. R. Boardman, "The Federal Art Center, Salem, Oregon: A History of Its Beginning, Organization and Campaign Plan for Raising Salem's Quota," undated manuscript; Burt Brown Barker papers, 1935–1938; reel 2551, frames 724–732; Archives of American Art, Smithsonian Institution.

65 Quoted in Boardman, "The Federal Art Center, Salem, Oregon" 1.

66 The initial sponsorship committee for Salem included Senator Douglas McKay, chairman, along with Charles Sprague, owner of the *Daily Statesman*, and Dr. B. G. Pound, a local businessman and civic advocate. As the fundraising drive gained momentum, others were added; later drives also organized committees. Boardman, "The Federal Art Center, Salem, Oregon," 2.

67 The artists were Harry Bowden, Helen Blumenstiel, T. Danaher, and Helen Nelson. Thomas Parker, Assistant Director, Federal Art Project, to Charles Val Clear, Director, Salem Art Center, October 17, 1938; 651.315 Oregon July 38–May 39; Entry PC-37 12-40, Textual Records of the Federal Art Project, Administrative and Operational Correspondence Relating to Oregon, 1935–1944, Box 2374; Administrative and Operational Correspondence Relating to Oregon; Records of the Work Projects Administration, 1922–1944, Record Group 69; NACP.

68 [Charles] Val Clear, "The Salem Art Center," *Oregon Magazine* (1938): 7–11.

69 The small school galleries were McKinley Branch Art Gallery, McKinley Public School; Washington Branch Art Gallery, Washington Public School; and Bush Branch Art Gallery, Bush Elementary School. E. J. Griffith, State Administrator, Works Progress Administration, Oregon, to Thomas Parker, Assistant Director, Federal Art Project, March 27, 1939; July 38–May 39; Entry PC-37 12-40, Textual Records of the Federal Art Project, Administrative and Operational Correspondence Relating to Oregon, 1935–1944, Box 2374; Administrative and Operational Correspondence Relating to Oregon; Records of the Work Projects Administration, 1922–1944, Record Group 69; NACP.

70 The diptych is also known by the alternate titles *The Columbia River Pioneer Migration: The Raft*; *Homesteaders*. See Allen and Klevit, *Oregon Painters: The First Hundred Years*, and David A. Horowitz, "Martina Gangle Curl (1906–1994): People's Art and the Mothering of Humanity," 2004, Oregon Cultural Heritage Commission, www.ochcom.org/gangle.

71 The two panels are individually titled *The Forests* and *Only God Can Make a Tree*. They were conserved and moved to Richardson Hall, the new Forestry Building at OSC, in 1999. For additional information on Gorham's marquetry technique, see Nina Olsson's essay in the present volume.

72 For detailed discussion of White's time in Oregon, see Tiffany Stith Cooper's essay in the present volume.

73 The artists chosen were the sculptors Ulric Ellerhusen and Leo Friedlander and the muralists Frank Schwarz and Barry Faulkner.

74 Charles Val Clear, Director, Salem Federal Art Center, to Gladys Everett, Director, Women's and Professional Division, Oregon, July 7, 1939; June–Nov. 1939; Entry PC-37 12-40, Textual Records of the Federal Art Project, Administrative and Operational Correspondence Relating to Oregon, 1935–1944, Box 2374; Administrative and Operational Correspondence Relating to Oregon; Records of the Work Projects Administration, 1922–1944, Record Group 69; NACP.

75 "A fund of $423,585 has been approved by President Roosevelt as a Works Progress allotment to construct a state art center in Portland. These federal funds will be available when deeds to the site, to be constructed by Ralph B. Lloyd and the City of Portland, have been obtained. The sponsor, the state board of control, is pledged to contribute $197,025 of the cost and a drive for funds by popular subscription has been under way for several months." Thomas Parker, Assistant Director, Federal Art Project, to Lawrence S. Morris, February 4, 1939; 211.5 AAAA/Jan. 1937–Jan. 1938; Entry PC 37 11, Textual Records of the Works Progress Administration, Administrative and Operational Correspondence, 1935–1944, Box 438; "General Subject" Series; Records of the Work Projects Administration, 1922–1944, Record Group 69; NACP.

76 For detailed discussion of the mural's rediscovery and conservation, see Nina Olsson's essay in the present volume.

77 The Pendleton High School murals are now in the care of the Umatilla County Historical Society's Heritage Station Museum. Price's mural for the Pendleton Junior High School has been relocated above the doors of the auditorium in Pendleton High School.

78 There was another Howard Gibbs (Howard Manning Gibbs) working on the Federal Art Project in Boston who is sometimes misidentified with the one in Oregon. There is an interview with him on file at the Archives of American Art.

79 Field Report by Holger Cahill, Director, WPA Art Program, November 14, 1941, 2–3; 211.5 Holger Cahill; Entry PC 37 11, Textual Records of the Works Progress Administration, Administrative and Operational Correspondence, 1935–1944, Box 457; "General Subject" Series; Records of the Work Projects Administration, 1922–1944, Record Group 69; NACP.

80 The Portland Art Museum organized an Arts Bureau late in 1941 with the hope that it would act as a clearinghouse for artists' services that could be used in the war effort. They desired to aid the art project and its artists in some way so that the end of the federal projects was not a hardship. Robert Tyler Davis, Director, Portland Art Museum, to Olin Dows, Office of Civilian Defense, January 16, 1942. On file, object history records, Portland Art Museum, Oregon.

81 Margery Hoffman Smith, "The Federal Art Project of the Work Projects Administration and Its Aims and National Program in the State of Oregon," January 1943, on file, Friends of Timberline, 3.

82 Smith, "The Federal Art Project," 5–6.

83 Burt Brown Barker, Regional Art Director, to Holger Cahill, Director, Federal Art Project, December 17, 1935; 651.315 Wash. 1935–Jan. 1937; PC 37 12-52, Textual Records of the Work Projects Administration, Central Files: State/1935–1944 Washington 651.3121–651.315 (1935–37), Box 2741; Administrative and Operational Correspondence Relating to Washington, 1935–1944; Records of the Work Projects Administration, 1922–1944, Record Group 69; NACP.

84 George Gannon, Works Progress Administrator, Washington, to Burt Brown Barker, Regional Art Director, December 14, 1935; 651.315 Wash. 1935–Jan. 1937; PC 37 12-52, Textual Records of the Work Projects Administration, Central Files: State/1935–1944 Washington 651.3121–651.315 (1935–37), Box 2741; Administrative and Operational Correspondence Relating to Washington, 1935–1944; Records of the Work Projects Administration, 1922–1944, Record Group 69; NACP.

85 "[I]n view of fact that Gannon has refused to approve appointment of Wiggins as State Director of Art without consulting me or giving me his reasons therefore I feel that his arbitrary actions have created a condition such that it will be impossible for me to work with him. . . . I am satisfied you will find that the administration is unfriendly to the art project and if I cannot appoint those who are friendly and have them approved I am sure I could not work successfully in that state." Burt Brown Barker, Regional Art Director, to Holger Cahill, Director, Federal Art Project, telegram, December 23, 1935; 651.315 Wash. 1935–Jan. 1937; PC 37 12-52, Textual Records of the Work Projects Administration, Central Files: State/1935–1944 Washington 651.3121–651.315 (1935–37), Box 2741; Administrative and Operational Correspondence Relating to Washington, 1935–1944; Records of the Work Projects Administration, 1922–1944, Record Group 69; NACP.

86 R. B. Inverarity, State Director, Washington, to Holger Cahill, Director, Federal Art Project, August 27, 1936; Washington State 1936; Entry 1023, Textual Records of the Federal Art Project, Office of the National Director, Correspondence with State and Regional Offices, 1935–1940, 1935 to 1936 Texas to Wyoming, Box 28; Correspondence Files, 1935–1939; Records of the Work Projects Administration, 1922–1944, Record Group 69; NACP.

87 R. B. Inverarity, State Director, Washington, to Joseph Danysh, Regional Adviser, Federal Art Project, July 13, 1936; Washington Regional 1936–1937; Entry 1024, Textual Records of the Federal Art Project, Office of the National Director, Copies of Correspondence of Regional and State Offices forwarded to the Federal Director's office, 1935–1937, Box 57; Correspondence Files, 1935–1939; Records of the Work Projects Administration, 1922–1944, Record Group 69; NACP.

88 R. B. Inverarity, State Director, Washington, to Thomas Parker, Assistant Director, Federal Art Project, June 12, 1939; 651.315 Wash. April–Dec. 1939; Entry PC 37 12-52, Textual Records of the Work Projects Administration, Central Files: State/1935–1944 Washington 651.315 (1935–42) to 651.3152 (1939), Box 2742; Administrative and Operational Correspondence Relating to Washington, 1935–1944; Records of the Work Projects Administration, 1922–1944, Record Group 69; NACP.

89 Judith G. Keyser, "The New Deal Murals in Washington State: Communication and Popular Democracy" (master's thesis, University of Washington, 1982), 87, 123n52.

90 Report on the Washington Federal Art Project, October 21, 1936; Employment Quotas State N–Z; Entry 1021, Textual Records of the Federal Art Project, Office of the National Director, General Records, 1935–1940, Congressional Correspondence to FERA Trend of Relief during 1936, Box 2; General Records, 1935–1939; Records of the Work Projects Administration, 1922–1944, Record Group 69; NACP.

91 For discussion of the discovery of the Shakespeare bust, see Roger van Oosten's essay in the present volume.

92 R. B. Inverarity, State Director, Washington, to Joseph Danysh, Regional Adviser, Federal Art Project, October 27, 1936; Washington Regional 1936–1937; Entry 1024, Textual Records of the Federal Art Project, Office of the National Director, Copies of Correspondence of Regional and State Offices forwarded to the Federal Director's office, 1935–1937, Box 57; Correspondence Files, 1935–1939; Records of the Work Projects Administration, 1922–1944, Record Group 69; NACP.

93 Robert Bruce Inverarity papers, circa 1840s–1997; reel 1130, frame 195; Archives of American Art, Smithsonian Institution.

94 For further discussion, see David F. Martin's essay in the present volume.

95 David F. Martin, Territorial Hues: The Color Print and Washington State, 1920–1960 (Edmonds, WA: Cascadia Art Museum, 2017).

96 R. B. Inverarity, State Director, Washington, to Joseph Danysh, Regional Adviser, Federal Art Project, November 15, 1936; Washington State 1936; Entry 1023, Textual Records of the Federal Art Project, Office of the National Director, Correspondence with State and Regional Offices, 1935–1940, 1935 to 1936 Texas to Wyoming, Box 28; Correspondence Files, 1935–1939; Records of the Work Projects Administration, 1922–1944, Record Group 69; NACP.

97 For discussion of the mural's rediscovery and restoration, see Roger van Oosten's essay in the present volume.

98 There are numerous letters on the capitol decoration project in the folder Washington Regional 1937; Entry 1024, Textual Records of the Federal Art Project, Office of the National Director, Copies of Correspondence of Regional and State Offices forwarded to the Federal Director's office, 1935–1937, Box 57; Correspondence Files, 1935–1939; Records of the Work Projects Administration, 1922–1944, Record Group 69; NACP.

99 "I feel I should write and tell you that we had a very pleasant visit from Mrs. Roosevelt, to our project today. We were very fortunate in having her visit us due to the fact that she visited very few projects here, and she spent more time at our project than at any other except one at which she had luncheon. . . . After leaving our project she gave a speech in which she mentioned the Art Project and the work it has been doing; so, all in all, I feel that we were particularly lucky in having her see what we are doing." R. B. Inverarity, State Director, Washington, to Holger Cahill, Director, Federal Art Project, March 25, 1938; 651.315 Wash. Jan. 1938; Entry PC

37 12-52, Textual Records of the Work Projects Administration, Central Files: State/1935–1944 Washington 651.315 (1935–42) to 651.3152 (1939), Box 2742; Administrative and Operational Correspondence Relating to Washington, 1935–1944; Records of the Work Projects Administration, 1922–1944, Record Group 69; NACP. See also "Mrs. Roosevelt at Art Project," *Seattle Daily Times*, March 22, 1938. Mrs. Roosevelt's daughter was married to the publisher of the *Seattle Post-Intelligencer*, so she was also visiting family in the area.

100 There are a number of sources on the history and activities of the Spokane Art Center, some of which provide conflicting information. See, for example, Oral history interview with Opal R. Fleckenstein, 1965 Nov. 19 and 20; Oral history interviews with Robert Bruce Inverarity, 1964 Oct. 29–Nov. 4; Oral history interview with Robert Oliver Engard, 1965 Nov. 26; Archives of American Art, Smithsonian Institution. See also Sue Ann Kendall, "The Spokane Art Center," in White, *Art in Action*, 98–113. The Spokane newspapers also covered the activities of the art center extensively.

101 Holger Cahill, Director, Federal Art Project, to R. B. Inverarity, State Director, Washington, December 29, 1937; 651.315 Wash. 1935–Jan. 1937; PC 37 12-52, Textual Records of the Work Projects Administration, Central Files: State/1935–1944 Washington 651.3121–651.315 (1935–37), Box 2741; Administrative and Operational Correspondence Relating to Washington, 1935–1944; Records of the Work Projects Administration, 1922–1944, Record Group 69; NACP.

102 R. B. Inverarity, State Director, Washington, to Holger Cahill, Director, Federal Art Project, May 16, 1938; 651.315 Wash. Jan. 1938; Entry PC 37 12-52, Textual Records of the Work Projects Administration, Central Files: State/1935–1944 Washington 651.315 (1935–42) to 651.3152 (1939), Box 2742; Administrative and Operational Correspondence Relating to Washington, 1935–1944; Records of the Work Projects Administration, 1922–1944, Record Group 69; NACP.

103 "Spokane Art Center Uncovers Hidden Talent," *Spokesman Review*, March 26, 1939, 2.

104 Thomas Parker, Assistant Director, Federal Art Project, to Lawrence Morris, Executive Assistant, March 31, 1939; 651.315 Wash. April–Dec. 1939; Entry PC 37 12-52, Textual Records of the Work Projects Administration, Central Files: State/1935–1944 Washington 651.315 (1935–42) to 651.3152 (1939), Box 2742; Administrative and Operational Correspondence Relating to Washington, 1935–1944; Records of the Work Projects Administration, 1922–1944, Record Group 69; NACP.

105 Monthly Progress Report, Washington Art Project, August 1939, 4. In folder "Monthly Project Reports," Federal Art Project, Washington, Records, Box 2; University of Washington Libraries, Special Collections.

106 There is some confusion over who employed James Wehn to assist with this project. Though it is generally cited that he was working for the Washington FAP, he was actually employed by the Toll Bridge Authority. R. B. Inverarity, Supervisor, Washington Art Project, to Carl Smith, State Administrator, Work Projects Administration, June 24, 1940. In folder "May–June 1940," Federal Art Project, Washington, Records, Box 2; University of Washington Libraries, Special Collections.

107 R. B. Inverarity, Supervisor, Washington Art Project, to Carl Smith, State Administrator, Work Projects Administration, June 24, 1940. In folder "May–June 1940," Federal Art Project, Washington, Records, Box 2; University of Washington Libraries, Special Collections.

108 Keyser, "New Deal Murals in Washington State," 91–92.

109 "This chap will also be heard from later. . . . I believe that he will be perhaps the outstanding landscape artist from our state in time to come." R. B. Inverarity, Supervisor, Washington Art Project, to Marion Cunningham, San Francisco, December 28, 1937; Robert Bruce Inverarity papers, circa 1840s–1997; reel NDA 16, frame 915; Archives of American Art, Smithsonian Institution.

110 Hans Bok was the professional name of Wayne Woodard.

111 Oral history interview with Carl Morris, 1983 Mar. 23; Archives of American Art, Smithsonian Institution.

112 R. B. Inverarity, State Director, Federal Art Project, to Thomas Parker, Assistant Director, Federal Art Project, June 21, 1939; 651.315 Wash. Apr.–Dec. 1939; Entry PC 37 12-52, Textual Records of the Work Projects Administration, Central Files: State/1935–1944 Washington 651.315 (1935–42) to 651.3152 (1939), Box 2742; Administrative and Operational Correspondence Relating to Washington, 1935–1944; Records of the Work Projects Administration, 1922–1944, Record Group 69; NACP.

113 "Art Center to Open in Chehalis," unlabeled, undated newspaper clipping. Robert Bruce Inverarity papers, circa 1840s–1997; reel NDA 16, frame 633; Archives of American Art, Smithsonian Institution.

114 R. B. Inverarity, State Supervisor, Washington Art Project, to Holger Cahill, Director, WPA Art Program, February 17, 1941; 651.315 Wash. Jan.–Apr. 1941; Entry PC 37 12-52, Textual Records of the Work Projects Administration, Central Files: State/1935–1944 Washington 651.315 (1935–42) to 651.3152 (1939), Box 2742; Administrative and Operational Correspondence Relating to Washington, 1935–1944; Records of the Work Projects Administration, 1922–1944, Record Group 69; NACP.

115 In a telephone interview in 1982, Inverarity stated that he originally had offered the commission to Mark Tobey in 1938, but because of the complications in getting the design approved, Tobey dropped the commission and left town. Keyser, "New Deal Murals in Washington State," 91.

116 Inverarity received numerous detailed suggestions about the themes and appearance of these murals from department faculty. See, for example, the letter from the University of Washington Department of Chemistry and Chemical Engineering [signature illegible] to R. B. Inverarity, State Director, Federal Art Project, September 30 (no year given), Robert Bruce Inverarity papers, circa 1840s–1997; reel NDA 16, frames 796–797; Archives of American Art, Smithsonian Institution.

117 No author or date given, Robert Bruce Inverarity papers, circa 1840s–1997; reel NDA 16, frames 370–371; Archives of American Art, Smithsonian Institution. Inverarity described the main themes of the panels as "Ancient chemistry is based on alchemy" and "the modern chemist at work."

118 "The second point in your letter regarding linoleum as a mosaic medium grieves us greatly. Why was this point not brought up in earlier correspondence and not after all the arrangements have been completed? The question of linoleum mosaic being a valid art form is difficult for us to understand, particularly in light of your suggestion to do this design in large areas of linoleum. Why linoleum in large areas is valid and not when cut into tesserae escapes us." R. B. Inverarity, Supervisor, Washington Art Project, to Holger Cahill, Director, Federal Art Project, June 28, 1940; 651.315 Wash. Jan. 1940; Entry PC 37 12-52, Textual Records of the Work Projects Administration, Central Files: State/1935–1944 Washington 651.315 (1935–42) to 651.3152 (1939), Box 2742; Administrative and Operational Correspondence Relating to Washington, 1935–1944; Records of the Work Projects Administration, 1922–1944, Record Group 69; NACP.

119 Press release, Work Projects Administration, Seattle, September 15, 1940, 2; 651.315 Wash. Jan. 1940; Entry PC 37 12-52, Textual Records of the Work Projects Administration, Central Files: State/1935–1944

Washington 651.315 (1935–42) to 651.3152 (1939), Box 2742; Administrative and Operational Correspondence Relating to Washington, 1935–1944; Records of the Work Projects Administration, 1922–1944, Record Group 69; NACP.

120 See, for example, R. B. Inverarity, State Director, Federal Art Project, to Ambrose Patterson, Professor of Art, University of Washington, March 14, 1938; Carl Morris, Director, Spokane Art Center, to Morris Graves, Washington Art Project, October 19, 1939; and Washington Artists Union to R. B. Inverarity, Supervisor, Washington Art Project, December 20, 1939; Robert Bruce Inverarity papers, circa 1840s–1997; reel NDA 16, frames 428–429, 445, 895; Archives of American Art, Smithsonian Institution.

121 Mary Isham, Chief Regional Supervisor, Professional and Service Projects, Region 8, to Florence Kerr, Assistant Commissioner, WPA DC, October 15, 1940; 651.3151 Wash.; Entry PC 37 12-52, Textual Records of the Work Projects Administration, Central Files: State/ 1935–1944 Washington 651.315 (1935–42) to 651.3152 (1939), Box 2742; Administrative and Operational Correspondence Relating to Washington, 1935–1944; Records of the Work Projects Administration, 1922–1944, Record Group 69; NACP.

122 The letters around this controversy contain much information on the feuds and jealousies of the Seattle art world of this period, particularly the uneasy relationship between major institutions and Inverarity, as evident in the following two excerpts:

"She [Helen Savery, director at the Henry Art Gallery] advises us that for the past several years she has had many dealings with Dr. Fuller and has found him at all times to be impossible to work with. . . . She informed us that Mr. Callahan has the reputation of operating behind persons' back and that he is very underhanded in his methods when dealing with people. She was somewhat concerned at Dr. Isaacs' expressions . . . however, [feels] that the situation surrounding the murals at the Chemistry Building at the University has quite a bit to do with his personal feelings toward Mr. Inverarity." Carl W. Smith, Work Projects Administrator, to R. L. Nicholson, Regional Director, Work Projects Administration, October 11, 1940.

"Washington has a good many art factions which, so far as I can determine, have always been at war with one another. Certainly that has been the case ever since we started to set up a program there. . . . Dr. Fuller, director (and one might say owner) of the Seattle Museum, has never cooperated with the project. . . . So far as I can judge, he has always followed a 'Caesar or nothing' policy in the Seattle art world and he would probably not show any interest in the project unless he could control it absolutely. Kenneth Callahan, curator of the Seattle Museum, is an artist who has been employed for many years by Dr. Fuller and he would support anything Dr. Fuller said or did. . . . I imagine that most of the attack on Bruce Inverarity is directed by Fuller and Callahan." Undated memorandum from Holger Cahill, Director, Federal Art Project, to C. E. Triggs, both in 651.3151 Wash.; Entry PC 37 12-52, Textual Records of the Work Projects Administration, Central Files: State/1935–1944 Washington 651.315 (1935–42) to 651.3152 (1939), Box 2742; Administrative and Operational Correspondence Relating to Washington, 1935–1944; Records of the Work Projects Administration, 1922–1944, Record Group 69; NACP.

123 R. B. Inverarity, Supervisor, Washington Art Project, to Carl W. Smith, Acting State Administrator, Work Projects Administration, April 9, 1940; in unlabeled folder of carbon copies of correspondence, Federal Art Project, Washington, Records, Box 2; University of Washington Libraries, Special Collections.

124 R. B. Inverarity, State Director, Washington Art Project, to Joseph Danysh, Regional Adviser, Federal Art Project, May 16, 1938; 651.315 Wash. Jan. 1938; Entry PC 37 12-52, Textual Records of the Work Projects Administration, Central Files: State/1935–1944 Washington 651.315 (1935–42) to 651.3152 (1939), Box 2742; Administrative and Operational Correspondence Relating to Washington, 1935–1944; Records of the Work Projects Administration, 1922–1944, Record Group 69; NACP.

"We hold these truths to be self-evident."

PHILIP STEVENS

> When Native art and culture is displayed and represented in public institutions, such as museums, it is often packaged, presented, and consumed through the lens of the dominant culture, creating an imagined past where Native peoples are static, immutable parts of colonial history and conquest. Museums that display Native art using anthropological, ethnographic, and Western art historical models as interpretative lenses work to sublimate Native peoples and cultures into an imagined or romanticized past, creating an absence of authentic Native representations in the present.
>
> —JOHN PAUL RANGEL[1]

am San Carlos Apache. I have two clans. If you were to translate my clan name into English, it would be "Dark Water people." My father's clan would be "Red Earth people." This is who I am. As such, my clans depict a particular place. My identity is situated within the land I come from. This connection to a particular place seems to be represented differently in Eurocentric people. It seems that they have a particular cultural perspective that allows them to view place as interchangeable. In essence, place is a mutable thing: lush green lawns in the desert, New York, New Hampshire. Of course, like the myriad of switches and dials on a sound-mixing table, people have their own level of each switch that cumulatively forms their overall identity, which can create blurred boundaries. The position that I am attempting to describe is that if your culture and identity are situated in a particular place for many generations, then your culture and identity will create a strong connection with that place. If your culture and identity are comparatively migratory, then your culture and identity

will place less of an emphasis on connection with a place. A more migrant culture would not necessarily forget where it came from, but it would supersede this desire for home with the skills needed to develop a new place into a new home. Chief among these skills would be a rationale for acquiring this new place. Enter the term "discovery"; you can't discover what is already known. A quick and dirty rationale is to use the same measure of a culture that you would apply to your own. If the pursuit of happiness for your culture includes the individualized accumulation of wealth and resources, bereft of need for royal title or pedigree, then those who do not attempt to harvest as you do are not human, or at least are less human. Perhaps a "savage" is a better term.

As we live in a society that draws its morals and beliefs from a migrant culture, these morals and beliefs become reaffirmed in this society. Everything—from schools, to laws, to economics, to art—acknowledges these morals and beliefs. Acknowledgment may be a reification, or even a rejection, of these morals and beliefs. However, what soon becomes normalized is the belief that these particular morals and beliefs are the only morals and beliefs. Everyone then becomes quickly assessed by a Eurocentric migrant standard and begins to fall into a hierarchy of identities.

Figure 1
Andrew Standing Soldier (1917–1967)
The Round-Up (detail), 1938–39
Oil on plaster
5 feet 9 inches × 41 feet 6 inches (overall)
Blackfoot, Idaho, Post Office
Courtesy of United States Postal Service. © 2019 USPS

If your identity is close enough to a Eurocentric migrant culture, you may be deemed a normal person just trying to make it. If your identity is further from this, you may fall into subhuman categories. But no worries, if your identity ceases to be a threat, you may apply for salvation, redeemable upon your death.

From the naming of "Indians" to the portrayal of Native people in films by Audrey Hepburn, Burt Lancaster, and Johnny Depp, Native identity has been one of mystery, romanticism, savagery, and ultimately misunderstanding by non-Indigenous people. As John Paul Rangel points out in the epigraph above, Native people are often presented as "static, immutable parts of colonial history and conquest." In essence, the representation of Native people in popular culture serves as a variant to the identity of colonial people. Natives are measured by a non-Native standard. This is the heart of "Kill the Indian and save the man," the famous saying of Captain Richard H. Pratt of Carlisle (Pennsylvania) Indian School infamy. Naturally, the definition of man is by Eurocentric standards. John Gast's 1872 painting *American Progress* (see fig. 2 for a variant) is an icon of killing the Indian and saving the man; the wresting of the potential bounties of this land could not be achieved without the morality of order over disorder, light over darkness, gentility over savagery. The painted identity of indigeneity becomes emblematic of the dreams and desires of the identity of Eurocentric America, not of the Indigenous people themselves.

The Massacre at Boa Ogoi of the Shoshone by the US Army is depicted in Edmond Fitzgerald's mural (1941; fig. 3). The death and destruction of Shoshone people cast against the backdrop of purple mountain majesties reaffirms the myth that the Indigenous inhabitants of the land are unfit for it if they do not adhere to Eurocentric standards. If not, well, you kill the Indian, no matter if man, woman, or child. As one Shoshone tribal member explained to me, this mural is representative of what has been done all over the West. The imagery of wresting the land from the clutches of the savages, those red devils, reaffirms the belief that the rightful owners of the land are those who will exploit it for commercial wealth . . . I mean, use it in the pursuit of happiness.

Elizabeth Davey Lochrie's *The Fur Traders* (1938–39; fig. 4) shows a slightly more nuanced view of indigeneity.

Figure 2
George A. Crofutt (1844–1922) after John Gast (1842–1896)
American Progress, circa 1873
Chromolithograph
14⅞ × 19¼ inches (sheet)
Library of Congress, Prints and Photographs Division, Washington, DC

The scene represents the initial commercial exchange between European Americans and the Shoshone at Fort Henry. Again, purple mountain majesties, here the Teewinot, frame the scene. Gun-toting traders are watching dancing Shoshone. The safety precaution of armed men evokes imagery of inner-city bodegas replete with bulletproof glass; common commerce with a tinge of distrust. While there could be more of a focus on the imagery of what may be a husband asking his wife which cooking pan she would like, it is hard to completely dismiss the act of buying a loved one a gift under the watch of a gun. However, this exchange is representative of what has become, unfortunately, a common event that continues to influence the lives of minoritized people—a constant reminder of differences and distrust. The distrust breeds indignity. The indignity reaffirms the disconnect between cultural beliefs and morals.

The mural of a lynching on the walls of the University of Idaho Law and Justice Learning Center in Boise (the old Ada County Courthouse) became a contentious issue regarding its continued existence when the university took over the building (fig. 5). The majority of news articles regarding the piece center on the binary of destroying/painting over the mural versus leaving it open for public view. A 2015 nonscientific poll in the *Idaho Statesman* found

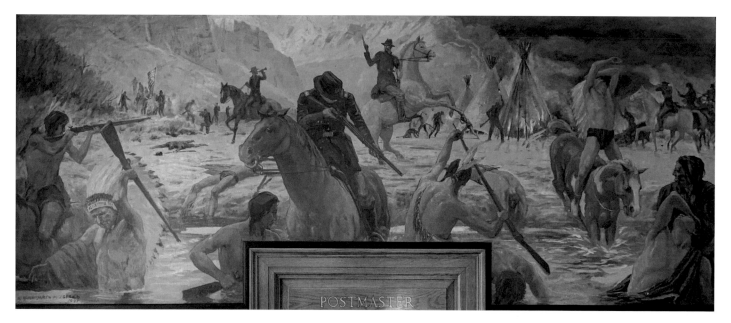

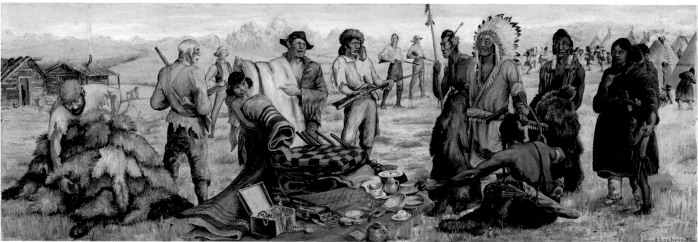

that 67 percent of the respondents wanted the mural to be displayed.[2] While it is my personal opinion that the mural should be displayed, I would like to situate this mural along with Fitzgerald's *The Battle of Bear River* and Lochrie's *The Fur Traders*.

Ivan Bartlett's depiction of a lynching as the form of mob justice is another example of Eurocentric America's standardized implementation of values and beliefs. While the image is presented as the lowest rung in the overall hierarchy of images conveying the advancement of justice, the effects are the same as President Lincoln's 1862 mass execution of 38 Dakotas at Mankato, Minnesota. The message is also the same: kill the Indian to save . . . well, maybe just kill. Considering that Bartlett's mural is situated within a former courthouse, it is hard to view this without a bit of cynicism. Cynics could equate this to preachers professing their sins in the light of their duplicity.

Figure 3
Edmond Fitzgerald (1912–1989)
The Battle of Bear River, 1941
Oil on canvas
5 × 12 feet
Preston, Idaho, Post Office
Courtesy of United States Postal Service. © 2019 USPS

Figure 4
Elizabeth Davey Lochrie (1890–1981)
The Fur Traders (study for Saint Anthony, Idaho, Post Office mural), 1938
Oil on paperboard
14⅛ × 28 inches
Smithsonian American Art Museum, Transfer from the General Services Administration

The completed 4-by-12-foot oil-on-canvas mural, which closely replicates this study, was installed in the post office lobby in 1939.

Figure 5
Ivan Bartlett (1908–1976) assisted by other FAP artists
Detail from an untitled 18-panel mural cycle to a design by Fletcher Martin
(1904–1979), 1939–40
Oil on canvas
4 × 3 feet
Ada County Courthouse, Boise

When the courthouse became the University of Idaho Law and Justice
Learning Center, this image was covered with a banner that can be only
partially moved for photography.

At times it is hard to see the hope and humanity that
many Indigenous people use to counteract these hege-
monic forces. Yet many of us continue to live our lives to
the fullest breadth of our happiness. This happiness is often
manifest in the daily events of a community that adheres to
a shared belief. Andrew Standing Soldier's 1938–39 murals

The Arrival, *Celebration*, and *The Round-Up* share some of
this humanity (figs. 1, 6). When compared to the murals of
Bartlett, Lochrie, and Fitzgerald, the Indigenous people
depicted by Standing Soldier are noticeably embedded
within the land as if to reaffirm the connectivity of place with
person. The land shares equally with people and animals in
the paintings. Standing Soldier renders the land as many
Indigenous people see it: as the foundation of our identity.

There are very few stories telling of the mundane.
Rather, stories tend to be about the extremes of our cul-
tural understanding. What is great and what is taboo to
our particular culture. Indigeneity, when viewed through
the lens of western expansion, is often represented as a
taboo or hindrance in the pursuit of happiness. When I see
these types of artwork, I am reminded that my identity is
a deeply personal affair. I am the grandson of Armstrong
and Andrea, Jess and Evelyn. I am the son of Homer and
Nalani. I am the brother to Sandra, Audrey, and Danielle.
I am husband to Vanessa and father to Carmen and Hazel.
I am also Tudiłhiłhi. That is where I come from. Stories
that I tell, and that many Indigenous people tell, are those
of resistance, continuance, and hope. These are the beliefs
that I hold as truth.

NOTES

1 John Paul Rangel, "Moving Beyond the Expected: Representation and
Presence in a Contemporary Native Arts Museum," *Wicazo Sa Review* 27,
no. 1 (2012): 31–32.

2 "What You Said: Old Ada Courthouse Lynching Murals," *Idaho
Statesman*, [November] 2015, https://www.idahostatesman.com
/opinion/article43421625.html.

Figure 6
Andrew Standing Soldier
The Round-Up (detail), 1938–39
Oil on plaster
5 feet 9 inches × 41 feet 6 inches (overall)
Blackfoot, Idaho, Post Office
Courtesy of United States Postal Service. © 2019 USPS

LAND of NAKODA

THE STORY OF THE ASSINIBOINE INDIANS

"Through Word and Picture": *Land of Nakoda* and the Montana Writers' Project

MINDY J. MORGAN

On February 4, 1942, Michael Kennedy, the state supervisor for the Montana Writers' Project, issued a publication report for the book *Land of Nakoda*, which "represents a departure from any technique previously known to have been used in a work of this kind. The Indian is allowed to tell, through word and picture, his own story of himself."[1] Kennedy had imagined the publication as the first in a series from the various Montana reservations that would employ tribal members as authors and artists to create books about Native communities as alternatives not only to the romanticized and stereotypical depictions of popular fiction but also to the dull treatments found in scholarly accounts of the tribes. The state office intended the books to be lively and engaging works accessible to a wide audience; but above all, they were to be "authentic" representations of Native life prior to European contact.[2] This preoccupation with authenticity was shared by the Office of Indian Affairs, which wanted to preserve Indigenous cultures even while pushing for significant reforms to tribal institutions. Though research and preliminary drafts were completed for at least five of the proposed books, *Land of Nakoda* was ultimately the only one published (fig. 1).

As a result of its unique status, *Land of Nakoda* provides an important window into the editorial and decision-making processes regarding the representation of American Indian communities in the New Deal era. The book was a collaboration between James Larpenteur Long (First Boy), the author, and William Standing (Fire Bear), the illustrator, both of whom were members of the Fort Peck Assiniboine community. Its creation, however, depended on the support and participation of tribal elders who supplied stories, advised on illustrations, and offered detailed explanations of cultural practices. Long and Standing wanted to use the book to represent this shared knowledge in ways the community would find acceptable; however, they were also beholden to the expectations of the state office, which had its own ideas about how Native life should be portrayed. The editorial back-and-forth illuminates these tensions and the ways in which Long and Standing negotiated the demands of both.

The project began with the idea of collecting the stories of tribal elders for use in a history of the Assiniboine community. During the summer of 1938, Byron Crane, then the director of the Montana office, corresponded with Henry Alsberg, the director of the Federal Writers' Project, about employing Long to conduct interviews among the oldest members of the tribe and to use this information to compile a more general history.[3] Long was uniquely positioned to do this work. He was of mixed English and

Assiniboine heritage; however, his father had died before Long was born and he was raised exclusively by his mother and grandmother among the Assiniboine community at Fort Peck.[4] When he was 10 years old, he was given his Nakoda name of First Boy. He attended the government boarding school in Poplar, Montana, obtaining the equivalent of an eighth-grade education. He then worked as a clerk, ran a small ranch, and eventually became a business owner. Prior to his work on the Writers' Project, Long had already authored a number of stories about the Assiniboine community for local papers and was a contributor to the periodical *Indians at Work*.[5] He owned and operated the Hi-Way Grocery in Oswego, Montana, which served as a frequent gathering place for tribal members to share and tell stories. Most important, he was fluent in Nakoda, which was essential for carrying out the work with elders for whom this was their only language.

After getting permission from the state and federal offices, Long set about interviewing 25 elders and drafting their stories through the fall and winter of 1938–39, sending his handwritten texts to the state office for editing and typing. The stories ranged in topic from descriptions of material culture and local practices to historical events to the establishment of the reservation. In June 1939, after Long spent 10 days in the state office working intensively on rewrites with the editors, Crane submitted a completed manuscript tentatively titled "The Assiniboine" to Alsberg. Accompanying the manuscript were seven pages of sketches done by Long and his daughter Maxine and a request that a "Federal Arts Project worker in the east reproduce these sketches for inclusion in the volume."[6]

After the initial submission, the federal office offered a number of editorial suggestions and changes. These reports were passed on to Long through editors at the state office who were continuing to develop the work. In a letter regarding editorial reviews, Long notes that he has provided further additions to the text as well as edits, warning, "Don't think that I am trying to prolong the work, it is just the fact that those subjects should be a part of the write up of the 'Assiniboine' if it is going to be interesting and not dry like the regular anthropological reports."[7] Long also responded to the reviews with detailed letters that accepted some editorial changes but clearly rejected others. For

example, in response to a query about more details for the section entitled "The Tribal Hunt," Long offered Margaret Whitaker, the state editor with whom he worked most closely, extensive revisions, writing, "You will remember my story was rewritten by Ralph and Mr. Crane in which they inserted the 'thundering herd' went by or something along that line to give it color and pep. I explained, when I was there that the herd was coaxed more than driven into the enclosure as a thundering herd is the same as a stampede among our western cattle."[8] He then provides discussions of the various ways hunters led buffalo into enclosures and new details for some sections of the manuscript. In the letter he also addresses the continuing issue of finding an artist to work on the illustrations: "I will see Mr. Larson [the educational field agent at Fort Peck] about the artist Standing that is referred to in the Washington letter. He is hard to handle."[9]

By the time he was approached to contribute to the Montana Writers' Project, William Standing had gained a national reputation as both an accomplished artist and a trickster. It is perhaps the latter quality that made Long less inclined to recommend Standing for the project. This trickster quality is invoked in the opening lines of his biographical sketch for *Land of Nakoda* where he writes, "In the white men's custom I am William Standing after the first name of my old father, Standing Rattle. My father called me Looks In the Clouds. My own choice is Fire Bear. . . . It makes no difference to me. If people want me to sign a name on pictures in white man's way and buy more that is all right. But I would rather be Fire Bear."[10] Like Long, he was raised at Fort Peck and called the Oswego community home. After attending Haskell Indian School in the early 1920s, he became acquainted with Oscar Brousse Jacobson, the director of the School of Art at the University of Oklahoma. Jacobson brought Standing to Oklahoma, where he trained along with the artists who became known as the Kiowa Five.[11] This experience led to both national and international exhibitions of Standing's work.

Standing was somewhat ambivalent about his success as an "Indian" artist. Commenting on his time at school, he said, "I became more like a white man. I took off my leggings and the barbers cut my braids. Then many years later, when I went to Washington to exhibit paintings, the

white men decided I looked too much like them and gave me horse hair braids to wear with my Indian Clothes."[12] Standing returned to Montana in the early 1930s, where he married and started a family.[13] He worked in a variety of media, including oil and watercolor, but was well known for his pen-and-ink drawings and cartoons. Some cartoons were bawdy depictions of western life that he sold as postcards to tourists, while others offered contemporary critiques of the federal government and its various relief policies. He sold his art locally to hotels and shops, including the Pioneer Store in Oswego, which was for a time run by August Knapp and Knapp's brother-in-law, James Larpenteur Long.[14]

Whatever Long's initial objections were to Standing, he agreed to the partnership and Standing was officially hired by the Montana Federal Art Project to work on the book. Over the course of 1939 and 1940, Standing drew well over 100 illustrations specifically for Long's manuscript (fig. 2). They detail everything from cooking practices to styles of dress to specific scenes from the recited stories. The pen-and-ink images are reminiscent of Standing's previous work, but where his former drawings displayed both humor and cynicism, his work for *Land of Nakoda* demonstrates sincere appreciation for the stories of the "old ones." In his biographical statement, he notes that he went over the drawings with many of the tribal elders to make sure that he had all the elements correct and that they reflected "not the imitation Indian but the real one who hunted humpbacks in good old days."[15] Both Long and Standing worked diligently to represent the tribe in ways that satisfied the demands of the Writers' Project but would be respected by the community.

Revisions continued on the manuscript over the next two years. Kennedy, who had been working in the state office since 1937, became supervisor in 1940 and worked aggressively to bring the project to completion. Over the summer of 1941, editorial reports were exchanged over the final concerns. One was about the title; the state office believed that the working title of "The Assiniboines" was "not lively" enough but liked the subtitle, "First Boy and Fire Bear Tell the Story of Their People." This latter suggestion was rejected by the national office because it was "comparable to titling a book with the name of the author."

Ultimately, the state office decided on *Land of Nakoda: The Story of the Assiniboine Indians*. While seemingly trivial, the debate over the title is reflective of the challenges facing the book throughout its development—how to make it distinctive and interesting to outsiders while not resorting to clichéd stereotypes of Native communities.

This was further demonstrated by the controversy regarding the revisions to the biographical statements for the volume. Long's original statement was more than 25 handwritten pages and detailed his growing up and significant moments of his adult life. This was edited heavily by the state office because of length; however, the edits also muted specific facts, such as his participation in the Catholic Church, that seemed to complicate his Assiniboine heritage.[16] As for Standing's statement, the editors took issue with the fact that he used a vernacular writing style that was linked to "Indian English" and edited his piece significantly. A 1941 report explained the changes: "It seems hardly fair to Standing, however, to let the ungrammatical English stand. . . . See text editing, in which we have tried to make the writing clear and grammatical without destroying its flavor."[17] Standing used this writing style in his correspondence, and it was an important aspect of his own self-presentation.[18] Rather than being seen as "ungrammatical" slang, the vernacular was a way of asserting an identity as a contemporary tribal member. Ultimately, the state and national offices used their editorial power to limit how much each contributor could play with and challenge dominant stereotypes of what it meant to be "Indian" in the early 20th century.

After the final tranche of edits, 1,000 copies of *Land of Nakoda* were printed by the State Publishing Company in Helena, Montana, in early 1942. Kennedy looked for a national distributor, and some positive early reviews provoked interest.[19] But even after the book's publication, Long continued to send detailed letters with corrections and updates. In these letters he asserted that the primary, and most important, readership of the book was the community itself. He asked that the changes be made before a second edition because "a wrong word here and there makes the Indian reader detect the error at once and, from what I have heard, many are going to get the book to keep in memory of the old people who gave the stories for the book."[20] The

Figure 2
Page 2 in *Land of Nakoda: The Story of the Assiniboine Indians,* with William
Standing's illustration *Old time camp crier*

state may have envisioned the book as a way of making the wider US society aware of Assiniboine history, but Long and Standing saw it differently; for them it was a gift, gathered by the community and presented to future generations.

NOTES

1 Michael Kennedy, Publication Report, February 4, 1942, Records of the Work Projects Administration, State Progress Reports and Research Publications, Montana, 1935–44, Box 1808, National Archives at College Park, MD (hereafter NACP).

2 For more on the "Indian Series" and the aborted projects elsewhere, see Mindy J. Morgan, "Constructions and Contestations of the Authoritative Voice: Native American Communities and the Federal Writers' Project, 1935–41," *American Indian Quarterly* 2, nos. 1/2 (Winter/Spring 2005): 56–83.

3 Byron Crane to Henry Alsberg, July 27, 1938, Records of the Work Projects Administration, State Progress Reports and Research Publications, Montana, 1935–44, Box 1808, NACP.

4 For more information about Long and his description of his early life, see Mindy J. Morgan, "Acts of Inscription: Language and Dialogism in the Archive," in *Transforming Ethnohistories: Narrative, Meaning, and Community*, ed. Sebastian Felix Braun (Norman: University of Oklahoma Press, 2013), 181–200.

5 Byron Crane to Henry Alsberg, April 27, 1939, Records of the Work Projects Administration, State Progress Reports and Research Publications, Montana, 1935–44, Box 1809, NACP. Long published two articles in *Indians at Work*: "An Indian Trader Speaks," *Indians at Work* 3, no. 3 (1935): 28; and "Indian Hunting Story," *Indians at Work* 3, no. 19 (1936): 44–45.

6 Byron Crane to Henry Alsberg, June 20, 1939, Records of the Work Projects Administration, State Progress Reports and Research Publications, Montana, 1935–44, Box 1809, NACP. Crane also asked permission to use unpublished sketches originally produced for the Montana Guide Series in the book.

7 James Long to Eleanor Plummer, August 23, 1939, MC 77, Box 17, Montana Historical Society (MHS).

8 James Long to Margaret Whitaker, July 27, 1939, 1, MC 77, Box 17, MHS.

9 James Long to Margaret Whitaker, July 27, 1939, 2, MC 77, Box 17, MHS.

10 William Standing, "The Illustrator," in *Land of Nakoda: The Story of the Assiniboine Indians* (Helena, MT: State Publishing Company, 1942), 281.

11 The Kiowa Five were Spencer Asah, James Auchiah, Jack Hokeah, Stephen Mopope, and Monroe Tsatoke. Lois Smoky, the only woman, was part of the initial group but left before Auchiah joined. Their art was used in many WPA mural projects and was reproduced widely during the era. While Standing trained with these artists under Jacobson, his style differed significantly and was more reminiscent of the western "cowboy" artists he admired.

12 Standing, "The Illustrator," 282.

13 In the 1934 census from Fort Peck, Standing was listed as living with his wife, Nancy, and his young son (born 1933) and daughter (born 1930).

14 See John Ewers, "William Standing (1904–1951): Versatile Assiniboin Artist," *American Indian Art Magazine* 8, no. 4 (1983): 54–63, for a lengthy discussion of Standing and his art, including the relationship to Long. In this article, Ewers also includes examples of the pen-and-ink cartoons that make fun of government relief projects. A further example of Standing's satirical cartoons was published in *Indians at Work* 3, no. 13 (1936): 32.

15 Standing, "The Illustrator," 283.

16 For a detailed description of the editorial changes between Long's handwritten document and the published version, see Morgan, "Acts of Inscription," 190–91.

17 Editorial report, July 30, 1941, 2, MC 77, Box 17, MHS. In the same report, the editors allude to a previous discussion where they debated if the biographical statements should be in the first person, as originally written, or revised to the third person. Ultimately, they decided to keep them in the first person, allowing Long and Standing to describe themselves.

18 Standing uses further examples of the vernacular in a letter to Sid Willis, the owner of the Mint Bar in Great Falls and a patron of both Standing and Charlie Russell, the famous artist of Montana and the mountain West. William Standing to Sid Willis, no date, MC 77, Box 17, MHS. Standing admired Russell, and his style of writing can be seen not as a limitation of his own abilities, but rather as the adoption of a tradition in which artists often used local vernaculars as a means of displaying authenticity to the larger public.

19 The book was reviewed in the *New York Times* on April 4, 1942. After that review, the DC office was notified about the possibility of national distribution. See letter from Merton Yewdale, May 16, 1942, Records of the Work Projects Administration, State Progress Reports and Research Publications, Montana, 1935–44, Box 1808, NACP.

20 James Long to Michael Kennedy, March 23, 1942, 2, MC 77, Box 17, MHS.

Origins of the Artist: A New Look at Minor White's Formative FAP Years

TIFFANY STITH COOPER

n October 1938 the Oregon Federal Art Project (FAP) hired an amateur photographer for the job of photographing the cast-iron-fronted buildings in Portland's downtown waterfront. The area, long damaged by the Willamette River's routine flooding, was slated for destruction to make way for a new highway, and Minor White was the readiest candidate for the job of recording its doomed elegance for posterity (1939; fig. 1). He received the title "junior artist" and was supplied the funds and materials necessary over the next five months to produce a portfolio of 29 images that not only beautifully accomplished the assignment but also proved pivotal to White's ambitions as a photographer. He would ultimately work on the FAP for the next three years in a variety of positions—some of which have only recently come to light, revealing the fuller extent to which the FAP under the Works Progress Administration (WPA) facilitated artists' development and helped shape the formative career of one of America's and the 20th century's finest photographers.

White had only taken up photography in earnest after moving to Oregon from Minnesota in 1937.[1] He acquired a rudimentary knowledge of the medium as a botany major in college, but was determined to master the camera as an instrument of both social and creative achievement. Arriving in Portland, he took a room at the YMCA and promptly became a member of the Oregon Camera Club. Within a few months he began a photography program at the Y, securing the equipment, materials, and darkroom necessary for producing photographs and, just as important, presenting himself as a photographer. When his fellow residents nominated him as their Multnomah County precinct committee person, he attended meetings with camera in hand.[2] Members asked him to make photographs to supply visual resources for upcoming issues to be discussed. It was at these meetings that he first encountered the lawyer Gladys Everett, who then introduced him to the assistant director for the Oregon FAP, Margery Hoffman Smith.[3] As the WPA was to be tasked with the razing of Front Avenue (formerly Front Street), Smith hired White on October 5, 1938, to document the historical interest of its picturesque cobblestone streets and ornate facades prior to demolition.[4]

The Front Avenue portfolio White ultimately produced evinces a burgeoning artistic sensibility and a clear talent for the formal aspects of composition. It inventories buildings that introduced cast-iron construction to Portland and captures the distinct grandeur to which the cast-iron technique aspired. But White also opposed the demolition.[5] So while he was careful to capture all the doorways, windowsills, and details any architectural historian would need

Figure 1
Minor White (1908–1976)
Front Street, Portland, Oregon, 1939 (negative); circa 1970 (print)
Gelatin silver print
11 15/16 × 9 1/4 inches
Portland Art Museum, Portland, Oregon, Museum Purchase: Funds provided by the Photography Council, 2017.35.1

Figure 2
Minor White
The Dodd Building and the Cook Bldg. S.W. Front Ave. at Ankeny St., 1939
From *A Portfolio of Historic Buildings in Portland, Oregon, Federal Art Project, 1939*
Gelatin silver print
13½ × 10½ inches
Courtesy of John Wilson Special Collections, Multnomah County Library

framing, creating a contrast with the facade that is the beginning of a poetic facility.

Toward the end of 1938, the FAP came under close scrutiny of the House Un-American Activities Committee, which claimed that funds were being misused in producing "bad art by second-rate artists" and that there were "communist agents at work in FAP."[6] Based on these findings, the committee decentralized the national arts project based in Washington, DC, in favor of state and regional programs. The western states regional director, Joseph Danysh, an arts writer for the San Francisco *Argonaut*, became more involved in Oregon.[7] In late 1939 Oregon's state director of the FAP, Burt Brown Barker, retired.[8] These political changes coincided with White's work assignment expanding to include both sides of Portland's waterfront (circa 1939; fig. 3). Although no correspondence has been found that discusses exactly why White was asked to shoot amid the east side's docks and granaries, there were two likely objectives. First, he was scouting locations for *Hydro*, an upcoming Bonneville Power Administration film lauding the new Bonneville Dam.[9] But many of the photographs also contain a series of dramatic stylistic shifts that distinguish them from the Front Avenue series, suggesting a second, aesthetic objective: to deliberately move away from the documentarian, narrative approach toward explicitly formalistic artistic compositions. This second objective indicates Danysh's direct influence on White's development from amateur photographer to creative artist.

Danysh ran a gallery with the photographer Ansel Adams in San Francisco from 1933 to 1935. The Adams-Danysh Gallery promoted Group f/64 aesthetics, conceiving of photography as a fine art form marked by using the smallest aperture setting, sharp focus, carefully framed compositions, and an emphasis on individual taste in subject matter; the group broke from pictorialist photography, which emphasized beauty, soft focus, and tonality. In California, Danysh was the only FAP director to establish a Creative Photography Division intended to promote modern art photography.[10] Photographers such as Hy Hirsh, Sonya Noskowiak, Brett Weston, and Edward Weston all had "creative assignments" during Danysh's administration. White's contact with Danysh and the spread of the group's

to identify a particular building, he also created a series of photographs that communicate a real and impending sense of loss. Streets are vacant, windows are blackened, and florid embellishments crumble in neglect and decay. For White, the WPA's provision of time, materials, and subject facilitated a progress in technique that only daily and deliberate practice can effect. *The Dodd Building and the Cook Bldg. S.W. Front Ave. at Ankeny St.* (1939; fig. 2), for example, captures his gradually advancing sophistication with exposure techniques, articulating with equal intensity objects in the bright exterior against the darkened interior space. The impression is that these structures contain elaborate grand staircases, stained-glass windows, and stylish light fixtures throughout. But if we look closely at the edges, we can see that White has included exposed brick walls and unfinished

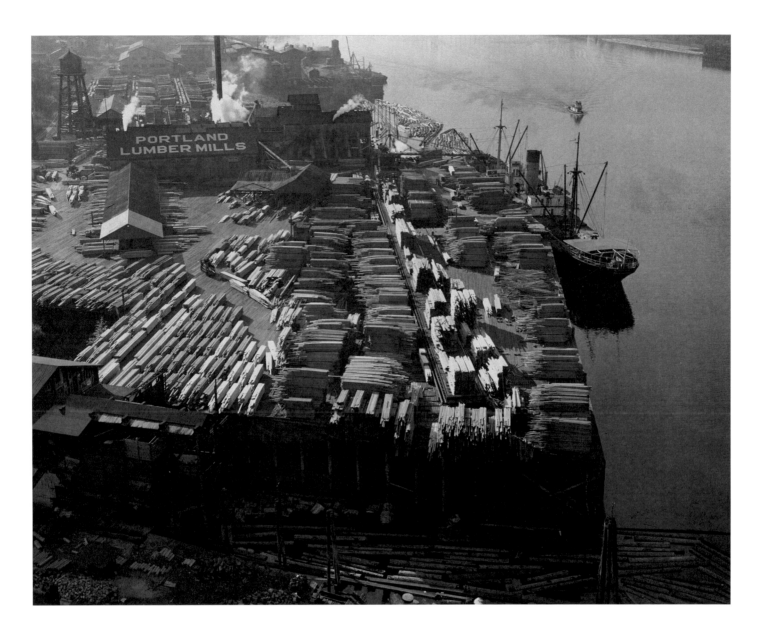

Figure 3
Minor White
Untitled (Portland Lumber Mills), circa 1939
Gelatin silver print
10⅝ × 13⁷⁄₁₆ inches
Portland Art Museum, Portland, Oregon, Courtesy of the Fine Arts Collection,
US General Services Administration, New Deal Art Project, L42.2.20

reaction to pictorialism led White to devote the next eight months to mastering f/64 techniques.[11] He produced about 50 images, all utilizing Group f/64 aesthetics. *The Patch* (circa 1939; fig. 4) is a work from this time, emphasizing textures and tonal ranges among the objects found at the wharves.

By October 1939 White's creative assignment had come to an end. It was thought that he was not rehired by the FAP administration until July 1940, when he became a teacher and manager at the Grande Ronde Valley Art Center in La Grande, Oregon. But in March 2001, 2,500

negatives and 112 hand-colored lantern slides made by the Oregon FAP's Photographic Division were discovered in the Portland Art Museum's storage.[12] Included in the boxes were 200 previously undocumented negatives created by White between February and December 1940.[13]

Reviewing the administration's reports alongside the negatives, it becomes clear that White began working closely with the Photographic Division at least as early as November 1939. He used their supplies and darkroom, and even assisted the FAP's senior photographer, Sam Ventura, with copy-stand work, matting, and photomurals. He photographed both the art produced in Oregon and the activities of the federal art centers. Each state's Photographic Division regularly sent slides to Holger Cahill, the director of the FAP in Washington, DC; these images were then distributed to local and national newspapers and magazines in an effort to

Figure 4
Minor White
The Patch, circa 1939
Gelatin silver print
13¼ × 10¼ inches
Portland Art Museum, Portland, Oregon, Courtesy of the Fine Arts Collection, US General Services Administration, New Deal Art Project, L42.2.22

advocate for the importance of government sponsorship of the arts. The discovered negatives allow us to identify which of these unattributed images were in fact created by White. One of White's assignments was included in one such publicity campaign: "This Work Pays Your Community Week," a 1940 national exhibition of arts, crafts, and textiles to show taxpayers "where the money goes." His focus was on artists at work in their fields of specialty, and the images are rich in local detail. In one, Martina Gangle and Arthur Runquist are shown painting one of the canvases for the Pendleton High School mural (circa 1940; see page 101). In another, Franya Prudhomme poses at her desk while she creates watercolors and stage-set designs for Oregon's Federal Theatre Project (1940; fig. 5).

The negatives also reveal that beginning in April 1940, White traveled to all three Oregon community art centers and taught courses on photography and portraiture. He first taught in the capital city of Salem before heading to the southern Oregon coastal town of Gold Beach. He then traveled across the state to the northeastern town of La Grande. While at each center he photographed daily activities, children's painting classes, theater productions,

Figure 5
Minor White
Untitled (Portrait of Franya Prudhomme), 1940
Nitrate negative
5 × 4 inches
Oregon WPA and SFA Negatives Collection, Anne and James F. Crumpacker
Family Library, Portland Art Museum, WPA 4897

and even his own portraiture courses. The images capture the informal class structure and the centers' somewhat improvised and, in some cases, rustic conditions. Much of the art created in these classes was sold during the FAP's "National Art Week," November 25–December 1, 1940, which gave Americans an opportunity to show their patriotism by purchasing local art. White's photographs of the La Grande auction were published in the May issue of the American Federation of Arts *Magazine of Art*, which was devoted to publicizing the art centers of Oregon.[14]

While White was teaching his six-week course at the Grande Ronde Valley Art Center, the center's director resigned. White was offered and accepted the position for the next year, increasing his monthly salary from $75 to $125.[15] By November his duties included not only directing the center but also conducting a weekly radio show, writing

articles for the local paper, and teaching three to five classes a week. He also began writing a teaching manual, and spent his free time exploring and photographing the area's countryside, farmlands, lakes, canyons, and mountains. It was in La Grande, White wrote, "that the philosophy of photography that I had soaked up from reading books came to fruit. Edward Weston and the f/64 School dominated."[16]

White's photography from this time matures in subtlety and complexity, emphasizing the depth, texture, and patterns of La Grande's environment and the visual rhythms characteristic of Oregon's rich topography (circa 1940; fig. 6). Many images in this portfolio reflect a mood of foreboding, with low dark clouds, animal skulls, and cemetery markers. But the arrangements with lower horizons and interrelated forms draw attention to the formal relationships in a way that presses the representational toward the abstract (see page 131, fig. 29). He would continually circle back to these techniques and themes over the course of his career. Through the La Grande images, White experienced his earliest notoriety. Three of them were selected by the curator Beaumont Newhall for *Image of Freedom* (1941–42), a juried exhibition at the Museum of Modern Art, New York.[17] White's first solo exhibition, *Landscapes of Eastern Oregon*, opened at the Portland Art Museum in 1942, and four of the pieces would then be included in the book *Fair Is Our Land* (1942), edited by Samuel Chamberlain.

White resigned from his art center position in October 1941 and moved to Portland to accept a commission from the Portland Art Museum to photograph two historic mansions. While working on the photographs, he received notice to report for military service. Before he left, the museum's director, Robert Tyler Davis, expressed an interest in hiring White as the photography curator after the war. Although that offer never materialized, Davis did introduce White to his close friends Beaumont and Nancy Newhall in 1945. And it was through his work with the Newhalls that White's status grew from a regional to a nationally known photographer.

From the 1940s to the 1970s Minor White would create photography programs for the Massachusetts Institute of Technology, the Rochester Institute of Technology, and the California School of Fine Arts (now the San Francisco

Art Institute). He was a cofounder and editor of *Aperture* magazine and coauthored the *Zone System Manual* with Ansel Adams.[18] Through his work as artist, author, teacher, administrator, critic, and editor, White's influence on the field has been considerable. It is a contribution that has its origin in the Oregon Federal Art Project and the WPA's direct investment in American arts. Reflecting on his career toward the end of his life, White said that his time as a young man in the WPA had "touched on practically everything I have ever done since."[19] Surveying the more recent information about the extent of White's work in Oregon, we can see more clearly how the WPA—by providing the tools, structure, employment, support, time, and opportunity—effectively facilitated White's determination to transform his inexperience and ambition into a singular and lasting contribution to America's visual arts legacy.

Figure 6
Minor White
Imnaha Canyon (and Sheep Creek Canyons from Five-Mile Point), circa 1940
Gelatin silver print
7⁵⁄₁₆ × 9⁷⁄₁₆ inches
Portland Art Museum, Portland, Oregon, Courtesy of the Fine Arts Collection, US General Services Administration, New Deal Art Project, L42.26.5

NOTES

1 Unless otherwise noted, biographical information is from Peter Bunnell's "Biographical Chronology," in Peter Bunnell, Maria B. Pellerano, and Joseph B. Rauch, *Minor White: The Eye That Shapes* (Princeton: The Art Museum, Princeton University, with Bullfinch Press, 1989), 1–13.

2 Monroe Sweetland, interview by the author, Portland, Oregon, April 24, 2002.

3 Everett, a respected Portland attorney and dynamic leader, was appointed in 1936 by Emerson J. Griffith, the head administrator for Oregon's WPA, as the director for the Division of Women's and Professional Projects. She indicates in a 1978 interview that she worked closely with Griffith and would find the materials and sponsorship to fund not only the Women's and Professional projects but also the art projects. White first encountered Everett at the committee meetings, and provided photographic documentation of housing conditions that helped her form the Housing Authority in Portland. Oral history interview with Gladys Everett [sound recording], March 1978, Oregon Historical Society, Portland; Jesse Mae Short, "Portland Housing Authority Photographs Collection 1918–1939," Related papers in Manuscript 1413, Oregon Historical Society, Portland, Oregon.

4 Minor White, "Memorable Fancies, 1956(?)," TMs (photocopy), Minor White Archive, Princeton University, Princeton, New Jersey.

5 According to the architect John Yeon, White was associated with a small group of artists and architects who banded together to oppose the demolition of Portland's historical district. John Yeon, unpublished interview by Peter Bunnell, September 26, 1985, Peter Bunnell unpublished personal notes, Princeton, New Jersey.

6 Jonathan Harris, *Federal Art and National Culture: The Politics of Identity in New Deal America* (Cambridge, UK: Cambridge University Press, 1995), 122–23.

7 E. J. Griffith to Joseph A. Danysh, March 3, 1937, Burt Brown Barker papers, 1935–1938, reel 2551, Archives of American Art, Smithsonian Institution. This letter indicates that as soon as Danysh was appointed, he wanted all photography assignments to be communicated to him before any assignment was made. In the letter, Griffith denies this request and states that Burt Brown Barker would directly handle all photographic work.

8 "Oregon Art Project Correspondence 1936–38," Friends of Timberline archives, Portland, Oregon.

9 Stephen Kahn, telephone interview by the author, April 22, 2002. Kahn was the first publicity director for the Bonneville Dam. He met White at the Multnomah County committee meetings and hired White as his secretary for the People's Power League. White left after seven months when he received the "creative assignment" with the WPA. Kahn was assigned writers from the Federal Writers' Project and Minor White to make the film *Hydro*. Kahn explained that Parris Emery, the cinematographer, "used Minor White's still photographs to get a feel for what I wanted the film to convey. . . . Unfortunately we did not give him credit in the film. Back then you did not give credit to still photographs."

10 Joseph Danysh, "Adams-Danysh," *Art Digest* 58 (November 1941): 18–19.

11 In all these early images in which White first explored Group f/64 concepts, he used pebbled matte paper supplied by the projects, and not glossy paper as the f/64 photographers preferred. Outside of publications, White did not see f/64 images in person until the exhibition *Pageant of Photography*, December 1940, at the Portland Art Museum. Minor White to Fred Hill, December 1940, Fred Hill's personal letters, La Grande, Oregon.

12 While researching White's Portland years, I came upon a catalogue card in the Portland Art Museum's library that simply read: "Delivery—Forest Service from Washington D.C. 1952." With this clue and the registrar's assistance, I searched the museum's deep storage and eventually found four cardboard boxes, all with the original tape intact, in the basement of Portland's former Masonic Temple. The postmarks on the boxes showed that the negatives were shipped from Washington, DC, to the Oregon Forest Service in October 1952, and span the years 1936 to 1942. A large percentage of the images document the Oregon Art Project: the construction of Timberline Lodge and its artwork, easel and mural paintings produced for the region, and the various art activities and events sponsored by the Art Project at art centers throughout the state. In 2001 the Portland Art Museum received a grant from the Henry Luce Foundation to research, catalogue, and digitally archive these images.

13 White handwrote his first and last name on each of his negative sleeves and gave each of his negatives a number that coincides with the same numbering system found on his "creative assignments."

14 American Federation of Arts, *Magazine of Art* 34 (May 1941).

15 National Personnel Records Center, Civilian Records Facility, "Works Progress Administration Individual Earnings Record—Minor M. White," October 5, 1938–October 28, 1941, National Archives, Saint Louis, Missouri.

16 James Baker Hall, *Minor White: Rites & Passages* (New York: Aperture, 1978), 21.

17 Beaumont Newhall, "Image of Freedom," *Bulletin of the Museum of Modern Art* 9, no. 2 (November 1941): 14–16. The jury consisted of Ansel Adams, Alfred Barr, A. Hyatt Mayor, David McAlpin, Newhall, James Thrall Soby, and Monroe Wheeler. They selected 95 photographs from among the 799 submitted for consideration. The museum acquired all three of White's photographs at $25 apiece. The show included such photographers as Imogen Cunningham, André Kertész, Charles Sheeler, Aaron Siskind, Frederick Sommer, and Brett Weston.

18 Ansel Adams and Fred Archer codeveloped the Zone System, which is a method of managing both the exposure and the development of black-and-white negatives. Many felt that the Zone System was difficult to understand, and White rewrote it into simpler terms.

19 Paul Hill and Tom Cooper, "Camera—Part One: Interview Minor White 1908–1976," *Camera* (English ed.) 56 (January 1977): 38.

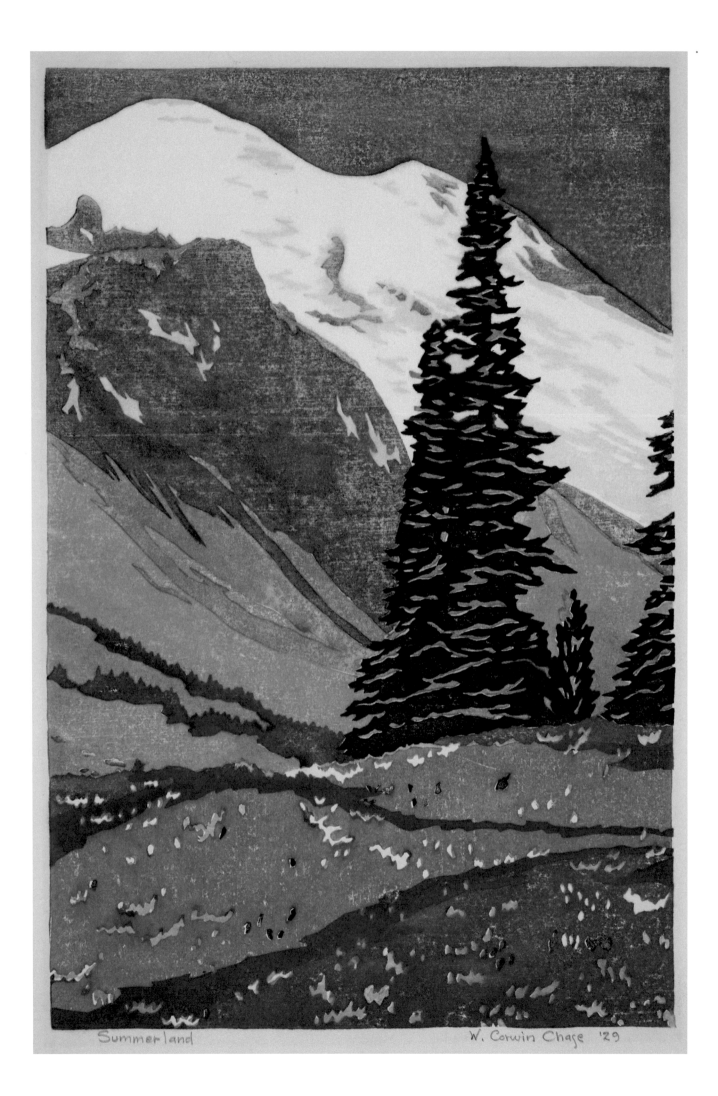

Summerland W. Corwin Chase '29

Printmaking in Washington State and the New Deal Art Projects

DAVID F. MARTIN

The government funding of printmaking activities in Washington State came at an opportune time.

In March 1929 the Northwest Printmakers Society (NWPS) held their first exhibition at Seattle's Henry Art Gallery, just seven months before the Wall Street crash ushered in an era of financial despair in the United States. The group was formed the previous year by 12 charter members, with 10 of them being women artists associated with the University of Washington's School of Art.[1] The organization's crusade for printmaking brought the medium to a wider audience of both practitioners and collectors while also advancing exhibition opportunities within the region. These included the Northwest Printmakers Annual. After the Seattle Art Museum (SAM) opened in 1933, the museum's founder and director, Richard Fuller, immediately began sponsoring the annual exhibition, after its previous association with the Henry Art Gallery.

When the Public Works of Art Project (PWAP) was initiated in December 1933, several regional artists who concentrated specifically in printmaking became employed by the project. Most noteworthy were those who specialized in the creation of color woodblock prints, including the brothers

Waldo S. Chase (submitted six prints) and W. Corwin Chase (submitted five prints) and Elizabeth Colborne (submitted six prints).[2] It is important to note that these artists sometimes used blocks that had been cut in previous years.

In 1934 the Corcoran Gallery of Art in Washington, DC, held its *National Exhibition of Art by the Public Works of Art Project*; included was W. Corwin Chase's color woodcut depicting Mount Rainier titled *Summerland* (1929; fig. 1), although the blocks had been carved several years earlier. Chase had recently married in 1932, and some of the works created on his extended honeymoon in Hawaii were also printed for the PWAP.

After the PWAP came to a close a short five months after it began, it was replaced by other programs, including the Federal Art Project (FAP) in 1935. In Seattle, noted artists such as Fay Chong, Richard Correll, Z. Vanessa Helder, Agatha B. Kirsch, Joseph Knowles Jr., Malcolm Roberts, and Julius Twohy (Two-vy-nah-up) produced paintings and/or prints for the projects. The roster of FAP artists in Seattle reflected the egalitarian goal of bringing art and art education to the entire community. These artists constituted a wide range of ages, backgrounds, and professional accomplishments, with some in the beginning stages of their careers and others fully established.

Kirsch, a renowned landscape, portrait, and mural painter, had been active in the local art scene since 1905. Her only known lithograph, *Artists at Work* (circa 1936),

Figure 1
W. Corwin Chase (1897–1988)
Summerland, 1929
Color woodblock print
12½ × 8⅜ inches
Private collection

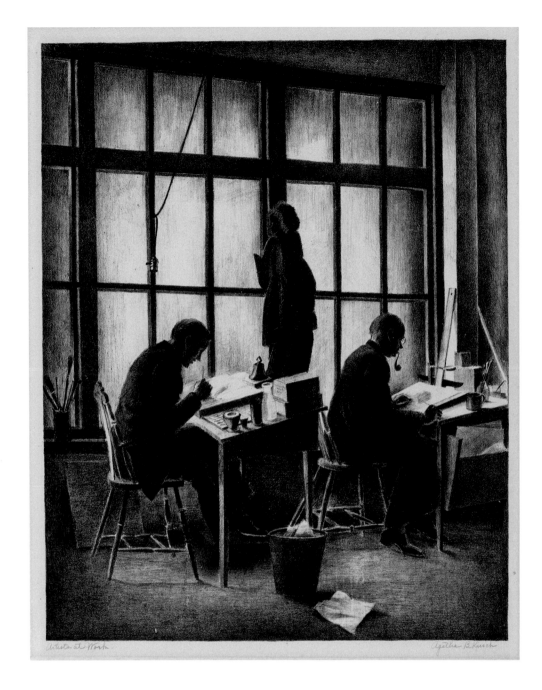

Figure 2
Agatha B. Kirsch (1879–1953)
Artists at Work, circa 1936
Lithograph on paper
16¾ × 13⅜ inches (plate)
Jordan Schnitzer Museum of Art, University of Oregon, Eugene. Allocated by the US Government, Commissioned through the New Deal art projects, WPA56:1.102

depicts her fellow Seattle artists working in their shared studio (fig. 2). The lithograph is so accomplished that it raises the hope of the rediscovery of additional prints created by this talented artist (see also page 147, figs. 47a–b). Women were fairly represented among the FAP artists, as were gay artists such as Roberts, whose partner at the time, Morris Graves, was also a painter on the program, as was Mark Tobey briefly. Adding to the diversity of the roster was Chong, a Chinese American artist who was particularly successful with his linocuts depicting the region's rural and industrial subjects executed within a modernist aesthetic (fig. 3; see also page 149, fig. 50), and Twohy, a Ute artist who created prints in both color and black and white based

on his Native American heritage (fig. 4; see also pages 139, 141, figs. 38, 41).

One of the contributing factors for the flourishing of printmaking under the FAP was the appointment of Robert Bruce Inverarity as head of the program for Washington State. He had success in the printmaking field himself and in 1930 even authored the instructional

Figure 3
Fay Chong (1912–1973)
March Landscape, not dated
Stencil cut on paper
6¼ × 8 inches
Smithsonian American Art Museum, Transfer from DC Public Library,
1967.72.52

booklet *Block Printing and Stenciling* for the Camp Fire Girls
Library of the Seven Crafts.

An offshoot of the FAP was the Graphic Arts Project,
which provided studios in major national cities and was
active in Seattle as well. The project utilized a master print-
maker working with a variety of artists, with materials
and presses readily available. The program emphasized
lithography, block printing, and, later, screen printing.
On a national level, it employed nearly 800 artists in
36 American cities by 1938.[3]

Local access to printing presses for etching and lithog-
raphy was scarce during the Depression years. In Seattle a
lithography press was used at the Cornish School of Allied
Arts (now Cornish College of the Arts), with instruction
provided by Walter O. Reese, and at the University of
Washington, where Helen N. Rhodes, one of the founders of
the NWPS, taught various techniques in the field. However,
most artists not on the FAP or unable to attend schools had
no access to presses and materials. In 1939 the graphic artist
Abe Blashko, too young to qualify for the project, asked
SAM's director to purchase presses for local artists to use.
Fuller agreed, with the proviso that Blashko would teach
his fellow artists how to make prints. Fuller purchased both
an etching press and a lithography press along with plates,

stones, and materials to be used for free by local artists in a
workshop set up in the basement of the museum.[4]

One of the unique techniques advocated by Inverarity
and others on the project was the medium known as lac-
quer airbrush stencil. The prints were made utilizing a sten-
cil that was cut from a design submitted by an artist and
the lacquer paint was sprayed onto the stenciled paper by
airbrush, giving the prints a soft, fluid quality. The stencils
and printing were produced by artisans on the project, pri-
marily Otho Barnes and Donald MacDonald, who worked
with the artists in realizing their designs. Hans Bok, one of
the youngest artists on the project, created prints that were
both traditional and abstract. Roberts, one of the region's
few surrealists (see page 142, fig. 43), was very active in the
FAP program, producing prints, paintings, sculptures,
and even mosaic murals; some of his prints and paintings
of that period have homoerotic subtext.[5] Roberts and
the other artists who created works in this medium were

Figure 4
Julius Twohy (Two-vy-nah-up) (1902–1986)
Tom Toms and Drum, 1939
Lithograph on paper
17⁷⁄₁₆ × 21⅝ inches (sheet)
Henry Art Gallery, University of Washington

included in a show of stencil prints circulated by the FAP's National Exhibition Section, which was accompanied by an instructional pamphlet to inspire children to make their own prints with qualified teachers.[6]

Art instruction was another mission of the FAP. Inverarity recruited several artists from Seattle and was also assigned artists from outside of the state to teach at the Spokane Art Center, one of the country's largest and most successful FAP community art centers. Among the first

shows there was a series of 23 framed photographs illustrating various printmaking processes. This was part of a traveling exhibition curated by the national director of the FAP, Holger Cahill.[7]

One of the most noted regional artists of the period was Helder, who moved to Spokane to teach at the art center in April 1939 after attaining significant success locally and in New York. Helder already had printmaking experience, having produced lithographs for the Seattle project using techniques learned from her instructor George Picken at the Art Students League in New York a few years earlier.[8] Helder's precisionist style and superb drafting skills translated perfectly into the graphic medium (fig. 5).

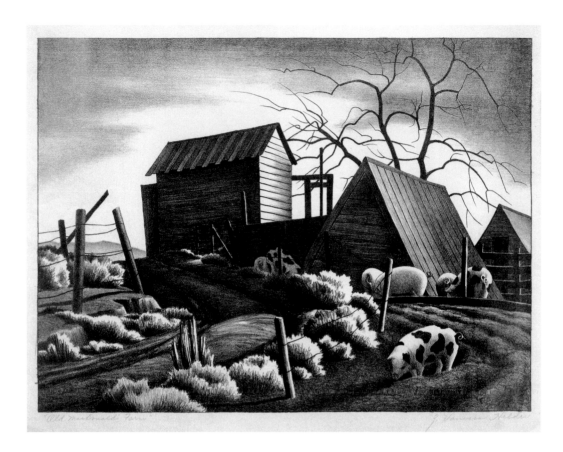

Figure 5
Z. Vanessa Helder (1904–1968)
Old MacDonald's Farm, circa 1939
Lithograph on paper
9½ × 12⅞ inches
Tacoma Art Museum, Gift of David F. Martin and Dominic A. Zambito in honor
of Margaret Bullock, 2013.17.1

One of the younger artists that Helder developed a particularly close friendship with was Robert O. Engard, who studied with her at the Spokane Art Center. Engard had been introduced to lithography when working at the Spokane Lithographing Company, creating fruit-crate labels. He and Helder convinced the owner of the company to donate one of the presses to the art center and to make the stones available at wholesale prices. The owner complied, and Engard became the instructor of lithography at the art center from 1939 to 1941. With Helder's guidance, he developed into a fine watercolorist and lithographer in his own right, often exhibiting his work in national competitions along with her (fig. 6).[9]

A number of lesser-known artists produced prints at the Spokane Art Center, and many of these have survived because of the generosity of Engard's donations to several art institutions in his later years. Joseph Kimmel, known

mostly as a commercial illustrator and cartoonist, produced a masterful work titled *Monroe Street Bridge* (circa 1940; fig. 7), among many others that display a quality that is equal to some of the region's more noted artists.

With printmaking attaining such a high level of importance, an organization called the Inland Empire Art Association commissioned the artist Phil Paradise to execute an original lithograph titled *Black Stallion* in 1941 as the first in a series of at least five limited-edition prints designed for the association's membership.[10] Other art center instructors contributed to the portfolio, including Engard, Helder, James FitzGerald, and Margaret Tomkins. The association had ambitious plans to establish a permanent art collection and building for its activities in addition to its annual support of the Spokane Art Center, but unfortunately, it was never realized.

When the FAP ended in 1943, many of the graphic works produced through the projects were distributed to public institutions and museums across the country. Unfortunately, the major art institutions in Washington State selected only a few prints by regional artists, with most of them disseminated to larger institutions nationwide. Some of these prints held in regional museum

"Grand Coulee Construction 10/15 Robert O. Engard

collections today were acquired later by private donation or purchase.

 Printmaking continued to flourish in Washington State with additional government support of artists through the GI Bill after World War II and the continued success of the NWPS until the Society disbanded in 1971. When the US General Services Administration compiled a national inventory of work from the New Deal art projects in 1999, none of Washington State's museums or art institutions participated. This omission has resulted in the dearth of publications and exhibitions on the subject. Today, however, with more institutions posting their collections online, we are able to locate works formerly thought to have been lost or destroyed. This allows for fresh reassessments and new scholarship. In Washington State, the spirit of collective printmaking activities survives in organizations such as Print Zero Studios and Seattle

Figure 6
Robert O. Engard (1915–2003)
Grand Coulee Construction, circa 1940
Lithograph on paper
11¾ × 9⅛ inches
Tacoma Art Museum, Gift of David F. Martin and Dominic A. Zambito in memory of Philip Henderson, 2013.17.2

Figure 7
Joseph Kimmel (dates unknown)
Monroe Street Bridge, circa 1940
Lithograph on paper
13½ × 10 inches
Jundt Art Museum, Gonzaga University; Museum purchase with funds provided by the College of Arts and Sciences and Doyle Jacklin, 2017.14.5

Print Arts. Like their predecessors in the WPA, regional artists continue to produce works that reflect the spirit and unique culture of the Northwest.

NOTES

1　The charter members of the NWPS were Maud Elmer, Josephine Hanks, Gertrude Harris, Merdeces Hensley, Emily Kirk, Helen Buck Markey, Rose Nyman, Ambrose Patterson, Viola Patterson, Ruth Penington, Helen N. Rhodes, and Kenneth Stryker. Miriam Bauson, "The Northwest Printmakers" (research paper, University of Washington, 1986), 1.

2　Clara Reynolds, art director, Seattle Public Schools, scrapbook of clippings and documents, Works Progress Administration Federal Arts [*sic*] Project, Washington State, Seattle Public Library.

3　Washington Art Project, Spokane Art Center, *Art Horizons*, no. 1 (1939): n.p.

4　Kenneth Callahan, "The Art Museum," *Seattle Daily Times*, April 4, 1941, 13. Also see Scott Martin, "Integrating Style with Substance: An Interview with Abe Blashko," *Raven Chronicles* 3, no. 3 (Spring 1994): 22–27.

5　See David F. Martin, *Territorial Hues: The Color Print and Washington State, 1920–1960* (Edmonds, WA: Cascadia Art Museum, 2017).

6　Washington Art Project, Spokane Art Center, *Art Horizons*, no. 4 (1939–40): n.p.

7　Washington Art Project, Spokane Art Center, *Art Horizons*, no. 1 (1939): n.p.

8　See Margaret E. Bullock and David F. Martin, *Austere Beauty: The Art of Z. Vanessa Helder* (Tacoma: Tacoma Art Museum, 2013).

9　See Bullock and Martin, *Austere Beauty*. Additional information derived from numerous notes made over many conversations between Robert Engard and me from 1990 until his death in 2003.

10　Northwest Museum of Arts and Culture, Spokane, Northwest Art Collection, Works on Paper, https://www2.northwestmuseum.org /exhibits/s-works-on-paper-spokane-art-center-students-paradise .htm. Additional information provided by Paul Manoguerra, director-curator, Jundt Art Museum, Gonzaga University, Spokane.

Room 207

Ruq

Draperies

Ruq

Upholstery

design

Blue Gentian

Bedspread

Alternate

Art and Craft Restoration of Timberline Lodge

SARAH BAKER MUNRO

Among Works Progress Administration (WPA) projects, Timberline Lodge is unique. In addition to being the largest federally funded recreational structure in the national forests or parks, it is filled with WPA-funded artwork, furniture, and textiles. Remarkably, it still operates as a ski lodge with most of its original furnishings and artwork intact, and it is enriched by continuing restoration projects. Margery Hoffman Smith was Timberline Lodge's interior designer in 1937 and 1938, when the Federal Art Project (FAP) in Oregon funded furnishing of the lodge. She was responsible for the creation of an interior that blended styles such as Arts and Crafts with more contemporary art deco features. Decades later, after visiting Timberline Lodge on a crowded day in 1974, Smith declared, "Let them come. Let it wear out. But build up enough feeling in the community for it to make replacements when necessary."[1] By then, she could see that restoration was needed.

The rustic lodge and its furnishings are publicly owned. The US Forest Service in the Mount Hood National Forest administers and manages the lodge and ski area through a permit issued to a private company. In 1955 Richard L. Kohnstamm, a skier and native New Yorker who was employed as a social worker in Portland, formed R.L.K. and Company (RLK), which completed needed maintenance and expanded facilities at the lodge, contributing to its growing popularity. Use of the lodge also surged as the ski industry developed in the 1950s and 1960s. Far more visitors were coming to Timberline than the original builders ever anticipated. By 1975 Kohnstamm realized that making "replacements when necessary" would require community support. He enlisted his friend John A. Mills to organize the nonprofit Friends of Timberline and to serve as its executive director. Mills invited Smith to serve as a member of the distinguished inaugural board of Friends of Timberline, established in 1975 to restore the lodge's original art and furnishings. Restoration began as a joint effort of public, private, and nonprofit interests.

Friends of Timberline's restoration activities were initiated by an Art and Restoration Committee, chaired by Rachael Griffin, who had recently retired as curator at the Portland Art Museum and who was a member of the first board of Friends. Griffin recalled that at the first meeting, held on July 22, 1975, the committee agreed to focus on three objectives: (1) to repair and restore existing works of art, (2) to inventory the art and furnishings of the lodge as a first step toward a catalogue, and (3) to restore and re-create rugs and fabrics using WPA records and photographs.[2] Funds were raised to restore major oil paintings, and the inventory was completed

Figure 1
Blue Gentian guest room scheme, watercolor in the Timberline Lodge room design books, John Wilson Special Collections, Multnomah County Library, Portland, Oregon

and published in a catalogue that came out in 1978, completing the first two objectives. The third objective, the textile project, was undertaken by a federally funded four-year textile workshop.

Textile Restoration and Re-creation Workshop

Most of the original textiles had worn out and needed replacement. A few could be repaired for exhibit, but almost none could be used in furnishing the lodge. Fortunately, during or shortly after completion of the lodge in 1938, workers created books of original patterns and hand-painted designs showing themes and color schemes for the guest room decor (fig. 1).[3] A textile workshop was needed that would provide an environment similar to the one in which the textiles had first been made. The perfect vehicle for such a project was found in the federally enacted Comprehensive Employment and Training Act (CETA).

Adopted in 1973, the act provided funding to train workers for jobs in the public sector or in nonprofit organizations. This program was a jobs-training initiative for many kinds of work, not just art and craft. These programs became so successful across the country that, as the arts writer Arlene Goldbard notes, "there is scarcely a U.S. community artist who was around in the mid-1970s who did not either hold a CETA job or work directly with someone who did. Most community-based groups in the United States dating from that time were launched on their labor-intensive path with CETA support."[4] Others have described it as "the largest government arts funding program in history."[5]

Locally, CETA funding was administered through the City of Portland, Clackamas County, and the Multnomah/ Washington County Consortium. Under CETA the Portland artist, craftsperson, and teacher Marlene Gabel organized a textile workshop to re-create handwoven upholstery and draperies, appliquéd draperies, and hand-hooked rugs for Timberline. She provided her studio in southwest Portland as a workshop and soon three handweavers and seven rug hookers were hired (fig. 2). Among the first CETA workers were Linny Adamson (who replaced Gabel as the director of the CETA project and became curator of the lodge in 1979), Thelma Dull (who

Figure 2
CETA textile workshop rug hookers, weavers, and seamstresses, 1979
Courtesy of Friends of Timberline Archive

Figure 3 (opposite page, top)
Appliquéd draperies for guest rooms, 1979
Courtesy of Friends of Timberline Archive

Figure 4 (opposite page, middle)
Timberline Lodge main lobby with re-created textiles made by the CETA textile workshop: mezzanine appliquéd draperies, main lobby woven draperies, hand-woven upholstery fabric for curved couches, and circular hand-hooked rugs
Courtesy of Friends of Timberline Archive

Figure 5 (opposite page, bottom)
Timberline curator Linny Adamson sitting in model guest room at Timberline Lodge, mid-1980s
Courtesy of Friends of Timberline Archive

had worked under the FAP on the original Timberline textiles), and Annin Barrett (who has continued her involvement with Timberline textile restoration and re-creation). CETA funds were directed toward labor. Only 10 percent of the allocation was allowed for materials, and most of the materials needed were donated by local companies, such as Pendleton Woolen Mills.[6] In addition to Gabel's studio, looms were set up at several other locations, including Wildflower Fibres and the Oregon School of Arts and Crafts (OSAC, later Oregon College of Art and Craft).

The CETA Timberline textile workshop faced the daunting prospect of re-creating all draperies, upholstery, and rugs for the lodge by hand. Although the task was immense, production by the Timberline textile workshop was impressive. Between December 1975 and February 1979, weavers created 860 yards of handwoven fabric for draperies in public areas and upholstery; seamstresses sewed 40 sets of appliquéd drapery panels for the mezzanine and guest

rooms (fig. 3) and 20 appliquéd bedspreads for guest rooms; and rug hookers made 38 hand-hooked rugs of various sizes for use in the main lobby (where 7 round rugs measuring 8 feet in diameter were placed), the mezzanine, and guest rooms.[7] Logos with the year of production were attached to the new creations. Colors were matched as closely as possible to those in the originals. For the main lobby, large panels of draperies were woven in shades of rust, orange, and green (fig. 4). Perhaps more than any other restoration project, the Timberline textile workshop revitalized the face of the interior of the lodge with fresh handmade furnishings for the public areas and guest rooms. After CETA funding ended in 1979, Adamson continued to organize workers to re-create textiles (fig. 5). Fabric dying and rug hooking workshops, for example, took place at various locations, including OSAC and the Multnomah Art Center. Many workers are still creating textiles for the lodge, working in their homes, meeting to pick up and deliver completed projects, and participating in work parties.

Some of the re-created fabrics have suffered from extremes of temperature and humidity. Weavers have relined large drapery panels in the lobby and dining room several times over the last four decades and repleated some to replace worn-out sections. When handmade bedspreads, upholstery, and rugs were damaged or wearing out, replacement was not always feasible. Though some guest rooms are still furnished with re-created handmade bedspreads, upholstery, and rugs, lodge operators eventually abandoned the unique decor in other guest rooms. An exception is that all guest rooms have hand-appliquéd draperies. Where exact replication of the original has not been possible, "in the spirit of the original" is Adamson's motto. In addition, seamstresses adapted original designs to create handmade appliquéd draperies for windows in the 1975 C. S. Price Wing, thus providing handmade furnishings in some of the lodge's newer spaces.

Restoration and Re-creation of Wood, Rawhide, Metal, and Glass Furnishings

Craftspeople have also restored and re-created Timberline furnishings in wood, rawhide, metal, and glass. In 1970, when additional heavy fir dining-room chairs were needed for the lodge, the Forest Service ordered 52 copies from Prison Industries at the federal penitentiary at McNeil Island, Washington. Additional replicas of dining-room chairs have been made since, some by Ray Neufer, the supervisor of the WPA woodshop that had built the original furniture. Original chairs are regularly repaired when legs break or other damage occurs. The fir-backed, iron and rawhide chairs in the lower lobby are almost indestructible, except for the rawhide, which becomes brittle over time. Friends of Timberline member Arthur McArthur volunteered to undertake restoration of these chairs single-handedly. He researched how to prepare leather strips to be pliable enough to weave into seats, how to restore the wood backs, and how to treat rusty metal frames. McArthur restored these chairs at least once and some of them a second or even a third time. Other craftspeople repaired or made new rawhide shades for lamps and parchment coverings for the large globe-shaped light fixtures in the main lobby. Carvers have re-created ram's heads multiple times for decoration outside the front door as well as buffalo and bear heads for log ends at the building's eaves.

Three generations of blacksmiths have created ironwork for the lodge, forming an unbroken chain of craftspeople. O. B. Dawson, the supervisor of the FAP metal shop, became acquainted with Russell Maugans, a commercial pilot who spent his retirement years making handwrought fireplace pokers, lamp stands, gates, and handrails for the lodge (fig. 6). In turn, Maugans introduced Darryl Nelson and the Northwest Blacksmith Association to the lodge. Maugans and Nelson created handwrought handrails in the tradition of FAP ironwork and installed them in stairways, where they are frequently mistaken for originals. For the Rachael Griffin Historic Exhibition Center and Coyote Den, installed in 1986, Maugans, Nelson, and members of the Northwest Blacksmiths created handwrought iron gates similar to the FAP coyote-head gates to the Cascade Dining Room. Individuality was achieved through small details, such as a little frog hidden on the edges of the gates.

In 1977 the WPA artist Virginia Darcé was able to restore the opus sectile glass-mosaic panels depicting Paul Bunyan and Babe the Blue Ox in the Blue Ox Bar that she had designed in 1938. When the largest of the three panels

Figure 6
Blacksmith Russell Maugans working on a hand-forged and hammered
fireplace poker, 1980s
Courtesy of Friends of Timberline Archive

was damaged by water leakage in 2009, the glass artist Gil
Reynolds was enlisted to restore it a second time, painstak-
ingly matching the colors of broken original pieces. In addi-
tion to working with Darcé on the Blue Ox Bar panels in
1938, Pete Ferrarin made the floor compass at the entrance
to the lower lobby. It was restored in 1979 by his son, Mario,
and Raymon Re, who were trained in the same technique.

Timberline was acknowledged as an icon of the WPA
when it was designated as a National Historic Landmark
in December 1977. In 1995 the Forest Service, RLK, and
Friends of Timberline agreed to a mission statement for
the lodge that articulated the tension between its roles as a
museum and as a hotel: "Maintain the artistic, historic and
architectural integrity of Timberline Lodge and its envi-
rons. Balance historic preservation and operational needs
while maintaining a viable mountain resort with a rich
history available to all visitors."[8] The mission statement

became part of the Historic Building Preservation Plan
adopted by the Forest Service in 1999 that divided the lodge
into zones. Those areas designated as historic "exhibit
unique or distinctive qualities, original historic fabric, or
represent exceptional examples of skilled craftsmanship."
Here, the goal "is to maintain and preserve the historic
integrity . . . including design, fabric, association, and feel-
ing."[9] The formal restoration process ensures that projects
preserve the quality and style of original furnishings of the
lodge while satisfying Margery Hoffman Smith's mandate
to "Keep it alive!"

NOTES

1 Beth Fagan, "San Francisco Designer Active in Arts Expansion of
 Oregon," *Oregonian*, November 24, 1974.

2 Rachael Griffin, "Restoration," in *Timberline Lodge*, ed. Rachael Griffin
 and Sarah Munro (Portland: Friends of Timberline, 1978), 48.

3 The books of color schemes are held in the John Wilson Special
 Collections at the Multnomah County Library, Portland, Oregon.

4 Arlene Goldbard, "Historical and Theoretical Underpinnings," in *New
 Creative Community: The Art of Cultural Development* (Oakland, CA: New
 Village Press, 2006), excerpts online at https://arlenegoldbard.com
 /essays/books/newcc/public-service-employment-for-artists/.

5 Lynda Frye Burnham and Steven Durland, "Looking for CETA:
 Tracking the Impact of the 1970s Federal Program That Employed
 Artists," *Public Art Review*, no. 54 (Spring/Summer 2016), https://
 forecastpublicart.org/looking-for-ceta/.

6 Marlene Gabel in "Getting Involved" video project in cooperation
 with the Junior League of Portland, 1978. Other suppliers were the
 Goldsmith Co., Atiyeh Bros Inc., Kendel Knitting Mills, and White Stag.
 Sarah Baker Munro, *Timberline Lodge: The History, Art, and Craft of
 an American Icon* (Portland: Timber Press, 2009), 148.

7 Linda Adamson, "Progress Report," Textile Workshop, Friends of
 Timberline, February 1979.

8 Quoted in Jeff Jaqua, "Timberline Lodge Historic Building Preservation
 Plan, Executive Summary," March 26, 1999, US Forest Service, Zigzag
 Ranger District.

9 Jaqua, "Timberline Lodge Historic Building Preservation Plan." On
 February 26, 1999, the Forest Service, the Advisory Council on Historic
 Preservation, and the Oregon State Historic Preservation Office exe-
 cuted a Programmatic Agreement to implement the Historic Building
 Preservation Plan.

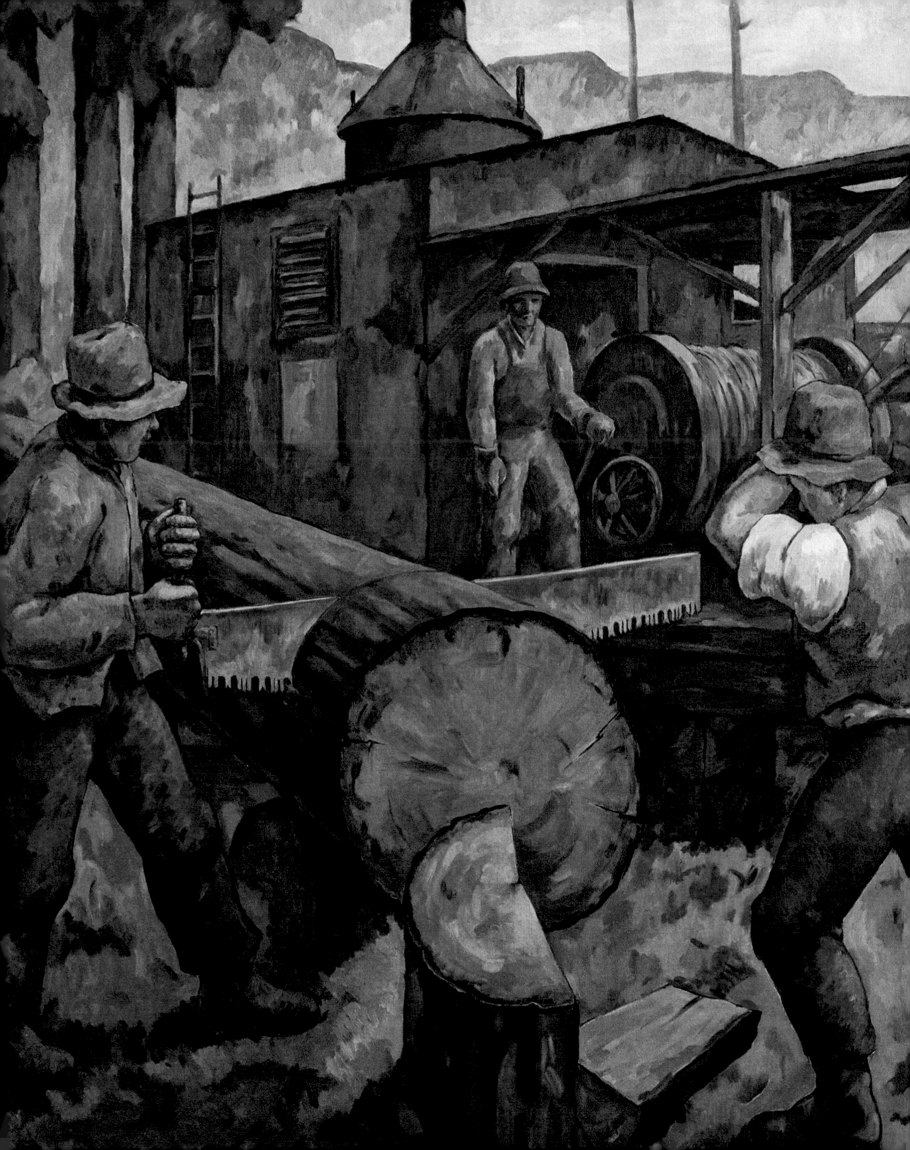

"Excuse me, do you know what happened to the mural that used to be here?"

ROGER VAN OOSTEN

Endings are usually messy. That was especially true for the Works Progress Administration (WPA). Between 1940 and 1943, the WPA came to a gradual close. Projects shut down, offices were shuttered, and outstanding work orders were wrapped up. The WPA had always drawn political ire and struggled to get money allocated to it in the national budget. In the early 1940s Congress simply stopped paying for it. Arguably, a national jobs program wasn't needed anymore. When the country entered World War II in late 1941, unemployment ended nearly overnight. Funds for the WPA ran out in June 1943.

WPA art lived in a nether world in the postwar years. It had been created with public money, so theoretically it belonged to the public. However, no funds had been left to care for it, let alone to create educational programs to put the art in context for future generations. It was owned by everyone and by no one.

The Washington Federal Art Project (FAP) left behind a great deal of impressive work in Seattle. But there was a problem. Having paid for the creation of works of art and distributed many of them to public institutions such as schools, libraries, and museums, the FAP left no rules as to

what those institutions were obligated, or not, to do with the art.

As time went on, the art lost its meaning and started to look old-fashioned. Paintings of men working in the lumber industry, meant to remind Depression-era audiences that heroic labor was noble, looked out of place in the booming postwar years, and virtually heretical as the ecology movement got underway in the 1970s. And art styles changed radically after the war. Many artists who had been supported under the New Deal programs tossed out the constraints of realism and turned to bold, colorful abstraction. FAP paintings looked quaint in comparison. Paintings and murals were often pulled from walls and simply stashed away.

In Seattle, most FAP art was out of public display by 1970. There were few art historians calling for preservation, the government had abdicated all responsibility for the artwork, and the institutions that had possession of the artworks sometimes tried to get rid of them. Many times, they did. Preservation happened by chance, or because of a singularly informed champion. Luckily, Seattle had both good luck and a fair share of champions.

The FAP created hundreds of artworks in Seattle. Most have gone missing or were destroyed or discarded. But there have been survivors.

In 1972 the downtown branch of the Renton Post Office was scheduled to be demolished. On the wall over

Figure 1
Jacob Elshin (1892–1976)
Logging (detail), 1937–38
Oil on canvas
5 × 9 feet
West Seattle High School, Courtesy of Seattle School District

the postmaster's office door was a 1938 mural by Jacob Elshin that celebrated the local mining industry (see page 83, fig. 21). Murals in post offices were paid for not by the FAP but by the US Treasury Department under the Section of Fine Arts, an early precursor to Seattle's 1 Percent for Art ordinance, passed in 1973.

Elshin was one of the region's top muralists during the Great Depression. Born in Russia in 1892, he fled the country in 1917 as the Bolsheviks took power. He immigrated to the United States and settled in Seattle in 1923. He was on the FAP in Seattle, where he painted a mural for West Seattle High School (discussed below). He entered Section of Fine Arts competitions and won two commissions for post office murals, including the one in Renton.

No plans had been made to preserve Elshin's Renton mural. It was set to be demolished along with the building. This was not a tenable situation to the director of the Renton Public Library, Clark Peterson, who wanted the mural for the library. The postmaster agreed to transfer the mural if the library paid to have it removed. The library did more than that. It paid for the mural's restoration and hung it in the library's new Highland Branch. Personal determination had saved a mural in Renton, and Peterson's accomplishment is worthy of praise. But over on the campus of the University of Washington (UW), Barry Witham, the executive director of the School of Drama, saved a building.

In the 1930s the WPA and the Federal Theatre Project (FTP) built two theaters on the UW campus—the Showboat Theater and the Penthouse Theater (fig. 2). By the late 1980s the Showboat was in bad shape. The university wanted it gone; the School of Drama Board wanted it repaired. Witham came up with an elegant solution. He would agree to let the university tear down the Showboat if it provided funds to restore and move the Penthouse Theater to a new location. After initial resistance, the university relented. As Witham described, "The Penthouse Theater was an innovative, landmark design, the first theater designed to produce plays in-the-round. There was some consternation from members of the board, but the deal was the right thing to do."[1] The theater was moved from south campus to a woodland setting in north campus.

Witham wasn't done. The author of a book on the FTP, he fully believed in the merits of federal patronage and felt

Figure 2
Glenn Hughes Penthouse Theater, University of Washington, Seattle, 2008

the preservation of art, artifacts, and buildings from the FTP was essential. He knew from records in the drama department's files that FAP artists had created six scale models of famous theaters, including Shakespeare's Globe Theatre in London. Witham went on a long search for the models and found them in an off-campus warehouse. They were in fair shape, but needed restoration and cleaning. Witham found a sponsor to repair the models, but there was a catch. The agency would only support the restoration if the university would add an educational component. Witham was undaunted, and on May 5–6, 2006, he hosted *WPA: Public Arts in a Time of Crisis*, a two-day symposium on various aspects of federal support of the arts in the 1930s.

My own adventures in finding, restoring, and educating audiences about FAP artworks have been comic, frustrating, and wonderful. For the better part of 30 years, I've given lectures, dug into archives, and searched dark corners to find works of art and artifacts. Although rewarding, it hasn't been easy. Walking up to a museum curator and explaining that such-and-such an artwork was given by the FAP to the museum in 1939 and asking where it is now is a good way to be shown the door. I've been politely dismissed for three decades.

Sometimes, miracles happen. In 2002 I spent a week going through every classroom on the UW campus looking for two sculptures by the FAP artist Irene McHugh. She was said to have created a bust of Shakespeare and a bust of Dante. The campus art administrator told me they were long

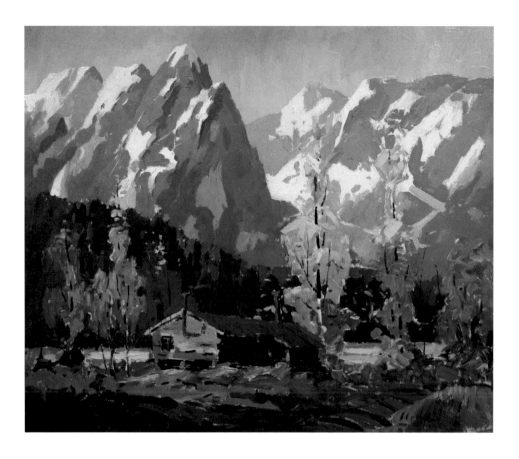

gone, likely thrown away or sold. I searched the School of Drama first, but found nothing. Then I searched the English Department; there was no sculpture in any of the classrooms or common rooms. I stopped by the office to ask if anyone had seen a bust of Dante or Shakespeare around. No, they replied. I was walking out the door when a woman said, "I think there's something like that in the coat closet." I looked and there, at the bottom of the closet, covered in coats, scarves, and hats, was McHugh's bust of Shakespeare.

In 1998 I was at Seattle's Museum of History & Industry, in its former location in Montlake, going through their art collection, which was stored in a room with no windows. On the back wall were large rolling racks with art on them. As I pulled them open to look, the dust fell like snow. On one rack I spotted a painting with a Public Works of Art Project label on it, so we pulled it out and into the light. It was a lovely image of a small cabin near Index, Washington, painted by Eustace Ziegler (fig. 3), a justly

famous master known for his near-impressionistic paintings of the Yukon. More surprising, it had an exhibition tag from the Corcoran Gallery of Art in Washington, DC. The painting had been included in the 1934 *National Exhibition of Art by the Public Works of Art Project*, the first national exhibition of art created under the New Deal. Interestingly, the Ziegler work was painted on two sides; the backside had a painting of Mount McKinley. Oddly, Ziegler had never been on relief rolls. He was famous and successful by 1934. He had donated the painting to the project to show his support for federally funded art.

In 2002 I took a stack of notecards to the Burke Museum in Seattle and met with curator Rebecca Andrews. I explained that several works of FAP art had been given to the museum in the 1930s, when it was known as the Washington State Museum. She expressed doubt that any were still in the collection, but promised to look around. A day later, she called to say that she had actually found several drawings and watercolors, including three drawings by McHugh of an Inuit family (see page 146, fig. 46), and two watercolors by Agatha B. Kirsch of a Native American camp on Coronation Island in Alaska (fig. 4); these were the most beautiful pieces of art I'd ever seen.

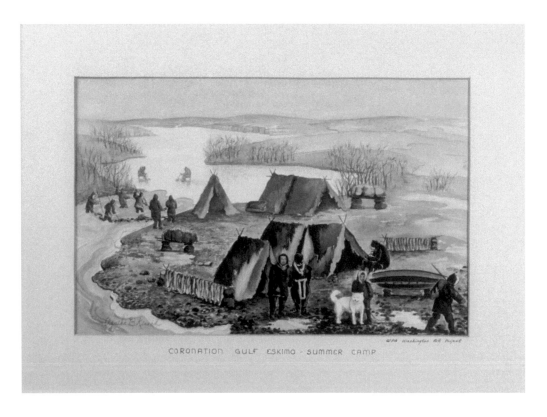

Figure 4
Agatha B. Kirsch (1879–1953)
Coronation Gulf Eskimo Summer Camp, 1939
Watercolor on paper
10¾ × 21¾ inches
Burke Museum of Natural History and Culture, L3559/1

I asked if the museum could find room to temporarily exhibit them. Andrews and Susan Libonati-Barnes, the Education Department head, agreed to exhibit the drawings, watercolors, and several replica artifacts created by FAP artists, if I would write the labels and a give a lecture to put the works in historical context. Just like that, the Burke became the first Seattle museum in 70 years to hold an exhibition of WPA art.

My greatest find was also the strangest. In 2000 I contacted Seattle Public Schools and asked if they knew the whereabouts of Elshin's three-panel mural for West Seattle High School. Eleanor Toews, who was then Seattle Public Schools' archivist, told me the mural was missing, that it had been taken down sometime in the 1950s and was assumed to be gone. In all my years of looking for lost artworks, I have come to the conclusion that people may stuff the art in a corner or take it home or paint over it, but no one throws the art away.

I took Toews up on her offer to go look for the mural and we went out to West Seattle High School, which was due to be renovated in the summer, including the demolition of many areas of the interior. I had an old photograph of the original installation of the mural above the entrance to the theater, but that entrance had been redesigned several times. We continued on room by room, but there didn't seem to be anywhere large enough to hold the three panels. We entered one last room, which looked odd, truncated in some way. Toews suspected that one large room had been split into two. The center divider between the two rooms was several large bookcases and a makeshift wall. We looked at each other and moved over to the bookcases. As we began pushing one away from the wall, we heard a heavy thud. We stretched our heads around the back of the bookcase, and there were the three panels: one showing the early settlers landing at Alki, one showing the settlers bartering with the local Duwamish tribe, and one showing logging activities in West Seattle (figs. 1, 5; see also page 143, fig. 44).

A committee was formed, money to restore the panels was located, and the restoration began. It was agreed to reinstall the mural at West Seattle High School, where it belonged. It was displayed in the school's library. It's displayed there still.

In the 1930s, with the nation in a bone-crushing Depression, a daring president and his equally daring wife created an ambitious set of programs to reinvent

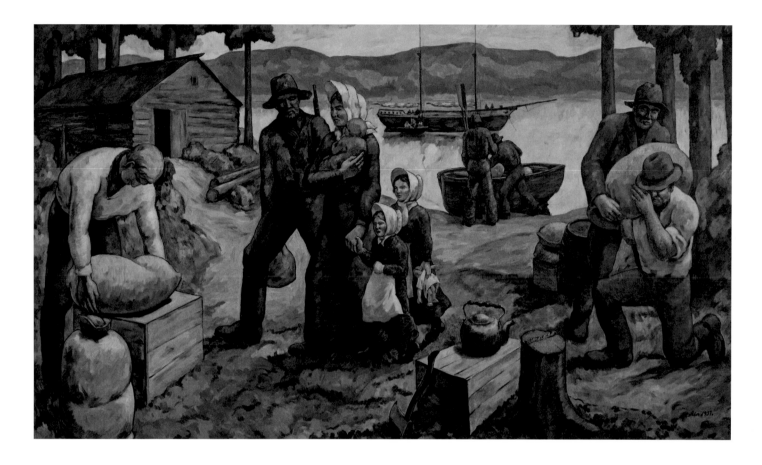

Figure 5
Jacob Elshin
Landing (one from a three-panel mural), 1937–38
Oil on canvas
5 × 9 feet
West Seattle High School, Courtesy of Seattle School District

the country and lift the spirits of its people. Franklin and Eleanor Roosevelt gambled that the people of this country were strong, smart, and passionate enough to build a better country. That included, for a brief time, the belief that art was an important element in American society. Today, the artworks created by the New Deal projects are a visible memory of a government's trust in the talents of its people.

NOTES

I wish to thank Clark Peterson, Barry Witham, and Rebecca Andrews for their help with this essay.

1 Barry Witham, conversation with author, March 27, 2019.

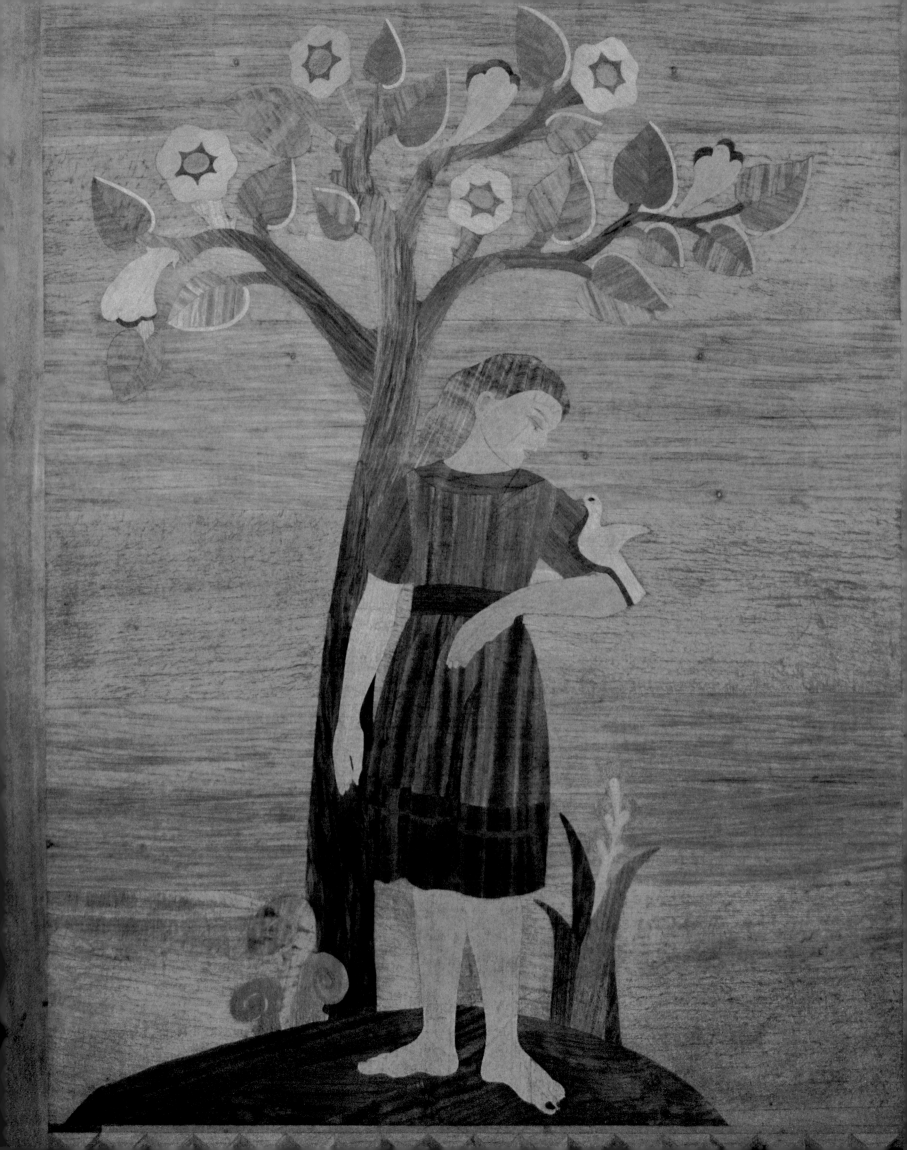

Artists' Materials and Studio Practice in the Conservation of New Deal Artworks in Oregon

NINA OLSSON

When conserving a work of art, an essential initial phase is to perform a detailed examination. This involves the interpretation of a complex overlay of visual evidence of natural aging of the materials, damage, vandalism, and past treatments, and ultimately the identification of the artist's media and studio practices. A well-developed understanding of the materials and methods used is a core part of the art conservation process, which not only guides the treatment choices but also becomes a profile of the piece in terms of technical art history. Beyond the visual appearance of an artwork, the studio practices used by each artist set the historical context, with its specific mixture of available materials, influences, scope, and creative choices.

From a technical perspective, many New Deal artworks were created in the context of historicism and the revival of craft in the arts that dominated the formative years of both the artists themselves and the art project administrators. Most of the artists active in Oregon during the New Deal were trained regionally, yet many continued their studies on the East Coast at places such as the Pratt Institute, the Yale School of Art, and the Art Students League of New York, where they were inculcated in medieval and Renaissance techniques with a special attention to the artisanship of art making. The uninterrupted use of approaches and methods transferred to Federal Art Project (FAP) artists by their mentors in the 1910s and 1920s may be observed in their practices and artworks through the New Deal era and beyond, and reinforces the fundamental character of craftsmanship created under the Works Progress Administration (WPA).

An interesting regional example is the WPA wood marquetry work of Aimee Gorham, who studied at the Pratt Institute in the 1910s, where the decorative arts and fine arts were presented seamlessly on a creative continuum. Gorham combined the Italian Renaissance technique of wood marquetry with the newest, cutting-edge industrial wood products of the era, mechanical presses, and industrial furniture coatings. In 2016 Gorham's 1938 mural *Send Us Forth to Be Builders of a Better World*, designed for the entrance foyer of Chapman Elementary School in Portland, was conserved (fig. 1).[1] To produce the mural, measuring 128 square feet, Gorham used an extensive selection of domestic and exotic figured wood veneers to achieve remarkably varied effects of chroma, grain, and *chatoyance* (or "cat's eye effect," an iridescent or three-dimensional optical effect of select wood grains), which were identified during treatment. Several of the species used, including Orientalwood (Australian walnut),

Figure 1
Aimee Gorham (1883–1974)
Send Us Forth to Be Builders of a Better World (detail), 1938
Wood marquetry
10 feet × 17 feet 5 inches (overall)
Chapman Elementary School, Portland, Oregon
Courtesy of Portland Public Schools

Queensland maple, Indian rosewood, and bubinga, are today considered rare and restricted due to protected status under the Convention on International Trade in Endangered Species of Wild Fauna and Flora. The booming regional furniture manufacturing industry provided Gorham with unique access to these veneers, which were adhered to plywood panels. The plywood substrate, quite novel at the time, provided the structural stability that allowed Gorham to extend the dimensions of her compositions to grand architectural formats, evoking the decoration of paneled studies of the Italian Renaissance. Her use of modern and locally made laminates by the Douglas Fir Plywood Association resulted in panels that have remained quite planar to this day, despite the unstable environmental conditions in which they have been housed.

The Chapman mural had suffered extensive surface damage due to neglect, resulting in delamination of the veneer, scratches, vandalism, and the application of inopportune coatings that obscured the glowing figural effects of the wood grains. Significant deliberate vandalism to the wood veneer was compounded by inadvertent damage to the coatings when tape used to affix posters and announcements to the mural surface was torn away. Staff and teachers confessed to me that they had ceased to recognize the mural as a work of art to be protected. This echoed the recent news of another Gorham panel, titled *Solomon* (1937; see page 126, fig. 22), which had been found facedown on a floor and was being used as a drop cloth.[2] (*Solomon* was rescued and is now safely housed at the Portland Art Museum.) During treatment of *Send Us Forth*, scientific analysis of the coatings determined the use of traditional materials such as shellac and wax, combined with more modern materials such as nitrocellulose.[3]

In the field of painting, both the Yale School of Art and the Art Students League were hotbeds in the dissemination of the various tempera techniques.[4] At Yale, Daniel V. Thompson had been teaching courses in egg tempera painting that were offered while Oregon artist John Ballator attended (1929–34). In 1933 Thompson published his English translation of the 14th-century artist Cennino Cennini's *The Craftsman's Handbook* (*Il Libro dell'Arte*). Cennini's famous primary source text is a detailed manual that codified medieval studio practices in Tuscany at the beginning of the 14th century, and contains recipes and step-by-step descriptions of how to produce an altarpiece. Although the text had already been translated into English by Mary Philadelphia Merrifield in 1844, encouraging Pre-Raphaelite painters in Great Britain, Thompson's translation was a novel source and inspiration for American painters.[5]

At the Art Students League, Kenneth Hayes Miller and Thomas Hart Benton actively experimented with and subsequently taught egg tempera, distemper, and casein techniques as well as mural painting from 1926 on,[6] in the period when several Northwest artists were students, including Erich Lamade (1924–27), Louis Bunce (1927–31), William Givler (1927–31), and Albert C. Runquist (1929–32). Bunce was a student with and friend to Jackson Pollock,[7] who declared that Benton had a profound impact on his formation as an artist.[8] The Oregon art project administrator Margery Hoffman Smith and painters Arthur Runquist and Charlotte Mish also studied at the Art Students League in the early 1920s.

The collaborative nature of many New Deal commissions created opportunities for exchange and knowledge transfer of historic painting techniques, especially among the painters who worked side by side on commissions or in the designated shared studio space in downtown Portland.[9] For example, Martina Gangle's 1938 large diptych titled *Pioneers Sailing by Raft down the Columbia* and *Columbia River Settlement* was painted in egg tempera (fig. 2), a technique she may have learned while working with the Runquists.[10] Among the many examples is the collaborative work of Ballator, Bunce, and Lamade in painting the tempera mural at the Saint Johns Post Office (1935–36; see page 68, figs. 1, 2), and Bunce and Clifford Gleason's work in 1938 on *Alice in Wonderland* and *Arabian Nights*, also painted in egg tempera (fig. 3).[11] It is interesting to note that in Cennini's time, egg tempera was used principally to paint works on panel, while tempera techniques were employed during the WPA for large-format paintings on canvas, probably due to the luminous, transparent, and matte quality that closely approximated the appearance of fresco murals painted with pigments on lime plaster in medieval times. This reveals an interest in utilizing historic techniques without strict adherence to their traditional application. Yet

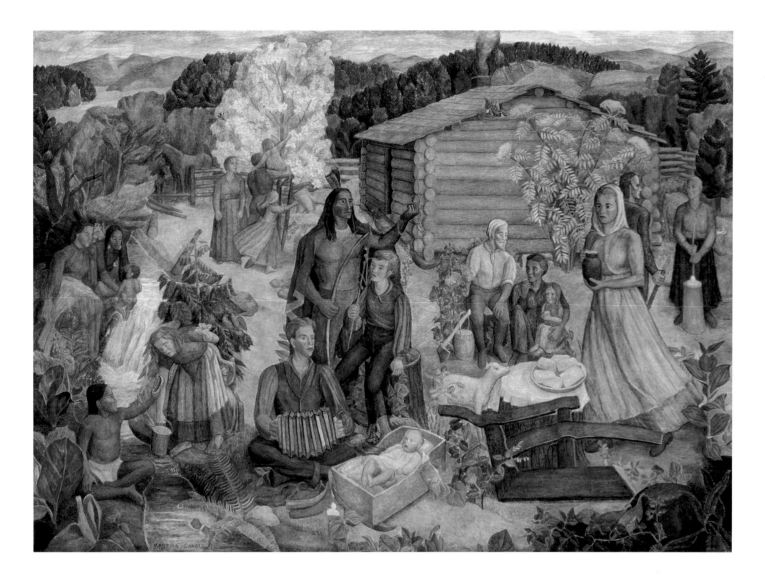

Figure 2
Martina Gangle (1906–1994)
Columbia River Settlement, 1938
Tempera on canvas
9 × 12 feet
Rose City Park School, Portland, Oregon
Courtesy of Portland Public Schools

another factor that may have contributed to the choice of tempera painting techniques was their low cost compared with fine art oil paints; they therefore would have been an economical solution for large mural surfaces.

The conservation of Lamade's *Pageant of Oregon History* (fig. 4) is an ongoing large-scale project to recover a forgotten mural that was essentially lost in plain sight. It was created as an FAP commission between 1939 and 1940 for Portland's Abernethy School. The mural portrays the people and events in Oregon's history, and was designed as a linear, chronological frieze that surrounds the room. Around 1960 Lamade's mural was completely overpainted,

and until 2007 was known exclusively through black-and-white photographs captured by Minor White in 1940, also under the auspices of the WPA. Inspired by those photographs, research and testing was conducted to determine the location and assess the condition of the mural.[12] During the conservation, cross-section sampling and materials analysis identified the use of an oil tempera mixture for the first contoured sketch, then casein paint for the final rendering of the figures.[13] In 2018 the first campaign of cleaning took place, removing six layers of wall paint from the south and southeast walls. The mural miraculously has avoided major damage to the surface, and is surprisingly well conserved, in part a tribute to Lamade's technical mastery of his craft and his choice of casein. The results of the first campaign of cleaning revealed a colorful palette that was impossible to anticipate from White's images, evoking the mural decoration of King Tutankhamun's tomb. Uncovering of the remaining mural surface began in the summer of 2019 and

Figure 3 (opposite page)
Louis Bunce (1907–1983) assisted by Clifford Gleason (1913–1978) and other students
Alice in Wonderland (one from a two-panel mural), 1938
Tempera on canvas
6 × 9 feet approx.
Bush Elementary School, Salem, Oregon
(Relocated in 2005 to North Salem High School)
Courtesy of Salem Public Schools

Figure 4
Erich Lamade (1894–1969)
Pageant of Oregon History (detail), 1939–40
Casein on plaster
54 inches high (continuous frieze)
Abernethy School, Portland, Oregon
Courtesy of Portland Public Schools

will continue in 2020. Beyond the painted surface, the restoration project will recover the architectural context of the room.[14] Lamade wrote his own historically inspired treatise in 1952, titled *The Craft of the Artist: A Simple Text for Fine Arts Painting*, in which he describes the care an artist must take in considering "the relationship that his design will have to its surroundings."[15]

A number of Oregon murals were painted directly on plaster, as Lamade did for *Pageant of Oregon History*, and as Percy Manser did for his 1934 proscenium mural *How Manifold Are Thy Works, The Earth Is Full of Thy Riches*, a commission under the Public Works of Art Project for the auditorium of Hood River Middle School (see page 51, fig. 10).[16] However, the majority of the New Deal murals followed WPA recommendations that artists paint the works off-site on canvas and subsequently marouflage (adhere) the canvas to the plaster wall. Lead white paste was recommended as a durable adhesive for oil paintings on canvas,[17] which Howard Sewall used to mount the murals he painted for Oregon City High School,[18] as did Barry Faulkner for the murals he painted for Oregon's capitol building (fig. 5).[19] Bunce and Gleason used instead animal-hide glue to marouflage their murals at Bush Elementary School in Salem, employing a technique that may have been seen as more compatible with the egg tempera medium. Bunce continued to size the cotton duck he used as a primary support with rabbit-skin glue for his entire career.

A significant drawback to the use of tempera painting was that it resulted in large surfaces that were inherently fragile, unprotected by varnish, and easily subject to damage and vandalism, which threatens their preservation. And for many, the artistic currents were on the cusp of change at the close of the WPA. In fact, a base factor

Figure 5
Barry Faulkner (1881–1966)
The State of Oregon, 1938
Oil on canvas
59¾ × 70¾ inches
Governor's Suite, Oregon State Capitol, Salem

relevant to the fate of New Deal artworks was the popu-
lar rise of modern aesthetics in American culture at the
mid-20th century, which caused some of these works to be
perceived as passé, evocative of poorer times, and therefore
less desirable within a span of just 20 years, perhaps even
by the artists themselves. The overpainting of Lamade's
Pageant of Oregon History is the most striking example of
that change in aesthetic taste, but many other works were
dispersed, allowed to deteriorate irreversibly, vandalized
or even intentionally obscured, discarded, destroyed, and
ultimately lost. Regional researchers have led the way to
raise awareness about the intangible and tangible value of

New Deal cultural heritage distributed in the territory that
is often neglected, misunderstood, and undervalued; they
have played a critical role in identifying works at risk and
creating a groundswell for their preservation.[20]

Although numerous conservation treatments were
initially motivated by extreme conditions of damage or
imminent threat rather than by calm, unpressured support
for their preservation, the scope and technical under-
standing of each conservation effort have grown over time,
building on prior knowledge and successes. Conservators
and conservation scientists untangle the often challeng-
ing technical aspects of the projects, while historians, art
historians, and descendants and students of the artists
disseminate knowledge about the artists and their creative
processes as cultural heritage of great worth to our region.

NOTES

1 For a description of the treatment, see Nina Olsson and S. Radivojevic, "Aimee Spencer Gorham's Wood Marquetry of the Pacific Northwest," in *Postprints of the Wooden Artifacts Group Session and Joint Session of Architecture and Wooden Artifacts*, papers presented at the 45th Annual Meeting of American Institute for Conservation of Historic and Artistic Works (AIC), Chicago, May 28–June 2, 2017 (Washington, DC: AIC, 2017), 87–100.

2 Verbal communication by Bonnie Laing-Malcolmson and Bill Rhoades.

3 Analysis was conducted by Portland State University Regional Laboratory for the Science of Cultural Heritage Conservation.

4 Richard Boyle, Hilton Brown, and Richard Newman, *Milk and Eggs: The American Revival of Tempera Painting, 1930–1950* (Chadds Ford, PA: Brandywine River Museum in association with Washington University Press, 2002).

5 Other such texts were Max Doerner's *The Materials of the Artist and Their Use in Painting with Notes on the Techniques of the Old Masters*, first published in English in 1934, and A. P. Laurie's *The Painter's Methods and Materials*, published in 1926.

6 Lance Mayer and Gay Myers, *American Painters on Technique, 1860–1945* (Los Angeles: J. Paul Getty Museum, 2013), 219–20.

7 Roger Hull, *Louis Bunce: Dialogue with Modernism* (Salem, OR: Hallie Ford Museum of Art, 2017), 10.

8 "Tom Benton did it for me. He gave me the only formal instruction I ever had, he introduced me to Renaissance art. . . . I am damned grateful to Tom." Quoted in Boyle, Brown, and Newman, *Milk and Eggs*, 77–78.

9 Historical photographs show the Runquist brothers, Martina Gangle, Charlotte Mish, and others working in the downtown Portland shared painting studio space: Multnomah County Library Digital Collection, JWpic_000220, https://gallery.multcolib.org/image/painting-studio.

10 Gangle's murals, also known as *The Columbia River Pioneer Migration: The Raft*; *Homesteaders*, were painted in 1938 on-site at Rose City Park School (now Rose City Park Elementary School) (RCP) and hung continuously on the auditorium wall since their creation. In 2007, due to closure of RCP, Portland Public Schools (PPS) contracted for conservation of the paintings, which had fallen into neglected and vandalized condition. Treatment was conducted during the summer of 2007 at RCP. RCP merged with Gregory Heights to become Rose City Heights, but despite the will and desire to move the paintings to the new school, no suitable location was available for the fragile and large-format works. Madison High School was proposed as an alternative site, since the paintings would remain a cultural- heritage asset to the same pool of students. In 2009 PPS installed the paintings in the auditorium of Madison High School, where they hung from 2009 to 2019, which provided protected environmental conditions for the tempera paintings. In the context of the upcoming demolition of Madison High School, PPS will relocate the two Gangle paintings back to Rose City Park Elementary School.

New Deal artworks in schools continually face threats connected to urban growth, changes in demographics, and the evolution of teaching methodologies, which have resulted in the modification of buildings and, in the most striking cases, the closure or demolition of schools. In response to this existential threat to the artwork, several murals have been relocated from their original sites. While the murals themselves were saved, the original architectural contexts were lost, creating questions as to where and how to present these artworks to preserve not only their material but also their core reason for being—to perpetuate their public art or didactic function. A further unresolved problem is that once an artwork is relocated, the historical memory of the original location may elude administrators and prevent reunification of the mural with its intended site even if the original locations are reopened or repurposed. The relocation of Gangle's diptych to RCP will represent a rare opportunity to return the two paintings to their original location.

11 Thanks to a committee formed by Bonnie and Roger Hull, conservation of this diptych was conducted in 2005–6, which included the removal of the threatened murals before the 2005 demolition of Bush Elementary School in Salem, Oregon. The murals are currently in North Salem High School, Salem.

12 Ginny Allen successfully identified the Old Library room within Abernethy, and I conducted testing in 2007.

13 Lamade's technique for the contours recalls that of Thomas Hart Benton, who used a "[w]ater emulsion—egg, water, stand oil and a few drops of copal" for his initial sketches from 1925–26. Mayer and Myers, *American Painters on Technique*, 220. Furthermore, Lamade used a brilliant green underpaint for the rendering of skin tones of the Native figures, despite the opacity of the top skin layer, suggesting that he followed Cennini's description of egg tempera painting technique.

14 The project will use the original blueprints and 1940s photographs to guide the restoration of the architectural surfaces, such as stripping paint from the woodwork, removal of the acoustic tile that partially obscures the wood moldings, replacement of fluorescent fixtures with period-style pendant "schoolhouse" lighting, and replacement of the reduced 1970s aluminum windows with wood sash fenestration.

15 Erich Lamade, *The Craft of the Artist: A Simple Text for Fine Arts Painting* (New York: [Erich Lamade], 1952), 106.

16 Conservation of Manser's mural was conducted in 2007, in the aftermath of extensive water damage to the auditorium from burst water pipes.

17 Raphael Doktor, *Technical Problems of the Artist, Vol. 2: Canvas Adhesives* (New York: Federal Art Project, 1939), 6.

18 For a full description of conservation treatment of the Sewall murals, see Tomas Markevicius and Nina Olsson, "Flexible Thermal Blanket and Low Pressure Envelope System in the Structural Treatment of Large Scale and Traditional Paintings on Canvas," in *The AIC Painting Specialty Group Postprints, Vol. 23*, papers presented at the 38th Annual Meeting of the American Institute for Conservation of Artistic and Historic Works of Art (AIC), Milwaukee, May 11–14, 2010 (Washington, DC: AIC, 2013).

19 Barry Faulkner's *The State of Oregon* (1938) was conserved in 2008 in the emergency response to a fire that breached the exterior wall of the Governor's Suite in the Oregon State Capitol. It should be noted that the Oregon State Capitol's interior painted murals and sculpture were created under the Public Works Administration, independent of the WPA's art project.

20 Among others, I would like to acknowledge Margaret Bullock, Ginny Allen, Sarah Baker Munro, Roger and Bonnie Hull, and Bill Rhoades for their knowledge and opportune interventions.

CONCLUSION:
LOOKING BACK, LOOKING FORWARD

MARGARET E. BULLOCK

Public art is meant to take part in the everyday life of a community. New Deal art in particular was born of the desire to make art accessible to all and to serve as a visual reminder of the histories, the values, the resources, and the talents of people in towns and cities across the nation. Unfortunately, what often happens over time to public artworks is that familiarity can breed invisibility and, particularly in the case of New Deal artworks, neglect and loss. Changing times and tastes also have contributed.

In 2001, when the research for this book began in earnest, the New Deal art projects in the Northwest appeared to have been fairly limited. There had been some exciting rediscoveries and restorations, however, that indicated there was a larger story still to be uncovered if the fragments were reassembled. Eighteen years later, the work of many has revealed the astonishing scope and variety of what took place here. And there is still much to recover and explore about the effects of these projects on the art history of the region and their intersections with larger national developments.

The chapters in this book about the individual New Deal art projects in the Northwest have been deliberately bookended by discussions of the broader contexts for looking at what happened here both historically and from a contemporary perspective. The art projects were not a rarefied experience for a chosen few; rather, they were sprawling and messy and very much intertwined with the attitudes, politics, and cultural events of the 1930s and early 1940s. Although the projects were always at the mercy of congressional politics, they grew out of the shock of sudden widespread poverty and were expected to solve many problems: to provide jobs, maintain skills, support public morale, offer safe channels to protest social ills, and popularize the arts. And they did. The art projects made significant and widespread contributions to the arts in America and left a lasting imprint that is still visible today. Not only were artists employed during a time of need, but their profession was respected as legitimate work. Americans of all types were encouraged to experience art making firsthand and explore their own talents. Opportunities to see original art were legion.

There can be, however, a tendency to surround the New Deal art projects with a rosy nostalgia, and that is now being interrogated. Even as the organizers preached a doctrine of art in aspirational terms that included and reflected all Americans, it is important to acknowledge they often fell short. The projects' designers and often their administrators supported widespread policies of racism and exclusion. For African American artists, opportunities were limited or nonexistent outside a few East Coast cities such as New York and Philadelphia. Art center programs and classes for African Americans were usually segregated or hosted in a fully separate community art center. Although in some ways African American artists had more opportunities

than before the art projects, they were represented in a disproportionately small percentage of the overall activities nationwide. This discrimination was experienced by other ethnic groups as well. On the West Coast, for example, there were many talented and active artists of Asian descent who were the motivating force behind a number of art organizations and clubs in the region, but few of them were employed by the art projects, though their white students and colleagues were.

Artworks in schools, post offices, federal buildings, and other community spaces across the country enshrined violence toward Indigenous peoples or celebrated mythic pioneer histories that ignored or justified the forcible removal of Native tribes to make way for Euro-American settlers. Other forms of discrimination devalued Indigenous artistic aesthetics or conflated them into a single style that was claimed to represent all groups. Few Indigenous artists were hired to work on the art projects, and among those who did, many encountered criticism or pressure to assimilate if their work did not conform to white administrators' or community members' ideals of how "Indian" art should look.

Women fared better in many ways, though they were never completely free of sexist attitudes from colleagues who blocked them from supervisory positions or important assignments. Yet in American society women had long been considered the natural allies of the arts, and countless cultural organizations were founded and run by them. As a result, women were readily employed. There were powerful and influential female administrators throughout the hierarchies of the art projects and other New Deal projects, and in most parts of the country the numbers of women artists hired were substantial.

The New Deal art projects in the Northwest were a microcosm of these currents and conflicts. They participated fully in the cultural benefits and made their own significant contributions to the national story. They equally took part in the negative aspects. The popular, and stubbornly held, belief that the western states were isolated cultural backwaters during this period is belied by the extent of government and community investment in public works and the scope of the art projects. Overall, the aesthetics of the artworks produced in the Northwest conformed to national trends. Regional scenes and images of westward expansion are common, often drawing upon modernist color, composition, and figuration. There are a handful of artists who experimented with alternative styles, but realism of one form or another predominated. Women made up about 30 percent of those hired in the Northwest, but only 12 non-Caucasian artists have been confirmed as employed on the art projects in all four states of Region 16, despite the presence of extensive Indigenous communities and numerous citizens of Asian descent. To date the roster includes only two African American artists working in Region 16.

There are also distinctive features to the Northwest art projects. Most prominent is the embrace of traditional craft materials (wood, ceramic, glass, wrought iron) as artistic media and the willingness to extend the definition of fine art to embrace their creative uses. This has proved to be a lasting characteristic of the arts of this region. The experimental work by Northwest artists, particularly in glass and ceramics, that continued into the 1950s and beyond has been pivotal to the development of contemporary art forms regionally and nationally.

The Northwest's enthusiastic adoption of the community art center concept is also noteworthy. The number of visitors to the region's New Deal art centers and extension galleries was staggering, considering the overall population in the area at that time and its generally scattered distribution. Unpacking the history of the art centers has also revealed their unexpected role as a crossroads and training ground for artists who went on to become nationally prominent, such as Morris Graves, Z. Vanessa Helder, Clyfford Still, and Minor White. Others came to the region as teachers and chose to stay, forging significant regional careers, among them Ruth Egri, Carl Morris, and Hilda Morris. In fact, this migration of artists into the Northwest occurred throughout the art projects at large.

Another discovery was the extent of the work done for military installations in the region and how actively the art projects were involved, from providing art and furnishings for living quarters to producing air maps and propaganda posters, even before the United States entered World War II. Also unanticipated was the enthusiasm with which military bases embraced the projects and welcomed art of all kinds. This symbiosis is a fascinating case study of

the complex relationship between the arts and national defense. One other notable aspect was the active and innovative Graphic Services Division in Washington State, which made a substantial contribution to the national printmaking revival. Above all these impacts and realizations, however, the most outstanding characteristic of the New Deal art projects in the Northwest is their extensive scope and variety.

During the most recent economic recession that began in 2008, large cuts in private, corporate, and government funding for the arts spurred calls for a contemporary New Deal for the arts. Such enthusiasms disregard, however, the complexities of the original art projects and the realities of current government support for the arts, which is buffeted just as constantly by shifting politics and cultural trends as the earlier projects were. Contemporary public art commissions similarly have to navigate a host of restrictions, expectations, and community needs. The hope for a revival of the New Deal art projects in their multifaceted, all-embracing glory seems quixotic.

If they are not a model for the arts in the 21st century, what can the New Deal art projects offer us looking forward? One recommendation is to reengage with the artworks themselves, to make them visible again. They contain a bounty of information on the art history of their regions in the 1930s and early 1940s. In the Northwest it was a highly active and fertile period, but it has been minimally researched and is often overshadowed by the later and more prominent rise of the artists labeled the Northwest Mystics or the Northwest School. A number of New Deal images encapsulate social ills both literal and coded that justify governmental inequities or serve as subtle propaganda. They offer lessons in critical and analytical consumption of imagery that are much needed in our contemporary visually focused society. Ultimately, the success of the New Deal art projects and the calls for their revival argue for the importance of and desire for art in public life. The *why* of the human creative impulse is a mystery, but the expression and the experience of it seem to be as fundamental a need as food and shelter. In the midst of a national crisis, the US government gambled on that belief and added the intangible to the practical, fashioning an unprecedented role for the arts in American society.

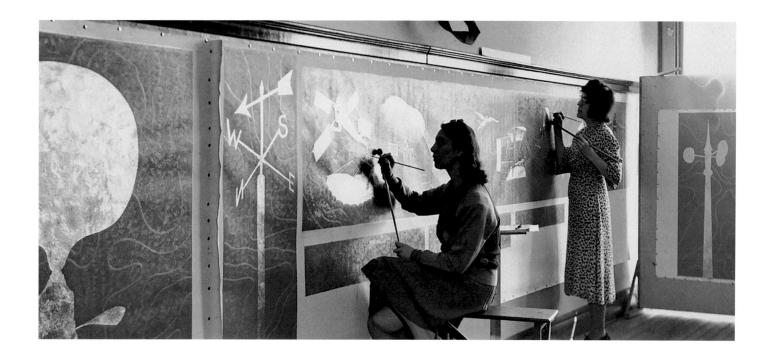

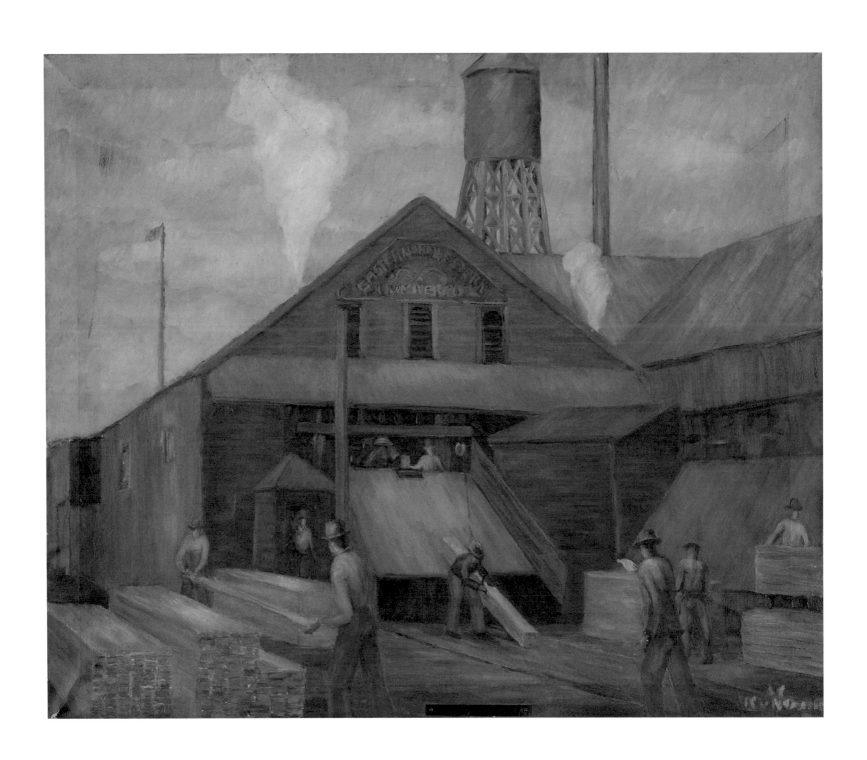

List of Artists Employed by Project and State

The following list identifies the artists employed under the four New Deal art projects in Idaho, Montana, Oregon, and Washington; it does not include those who were employed as office workers, maintenance staff, and the like. The list has been compiled from written evidence consisting primarily of government documents, art project correspondence, labeled art project photographs, artwork labels, and newspaper accounts. If there are alternate spellings of an artist's name in these records, the primary name listed is either from the artist's own correspondence or is the most common usage. If a woman artist was known by both her surname and her husband's last name, she is listed by her surname with a cross reference under her married name. A few women were identified only by their husband's name and no first name has yet been found (for example, Mrs. J. P. O'Hara). This list contains the author's current information as of the publication of this book, but it is highly likely there are other artists who were employed on the art projects in the Northwest who are yet to be discovered.

—Margaret E. Bullock

KEY

The letter codes in brackets after an artist's name identify the media of the works they created on the art projects or the type of projects to which they were assigned, where known. A question mark indicates that the likely media in which an artist was working was inferred based on context or other works by the artist.

a=art center or extension gallery director
c=calligraphy
ce=ceramic
d=drawing
e=etching
f=furniture, soft furnishings
i=illustration

l=lithograph
lct=linocut
m=mural
mo=mosaic
mq=marquetry
o=oil
oth=other
p=painting (medium unidentified)

ph=photography
pr=printmaking (medium unidentified)
ps=pastel
s=sculpture
sk=silkscreen
sn=scene painting
t=teaching

tm=tempera
tx=textile
w=woodworking (decorative)
wc=watercolor
wct=woodcut or wood engraving
wr=wrought iron

PUBLIC WORKS OF ART PROJECT

Idaho

Baumgartner, Victor
Dennis, George W.
Dunn, Alfred
Fowler, Ethel
Hughes, Helen
Joice, Donald [t]
Lommasson, W. I.
Moller, Olaf [m, o]
Newton, Francis W.
Nord, Henry Allen
O'Connell, Charles

Perrine, Eugene
Schroeder, George
Scott, Margaret Mary
Smith, Cecil [o]
Steiniger, Herbert [p, s]
Swift, John T.
Teater, Archie
Westfall, Frances
White, Nell Reid
Wise, Carl

Montana

Clarke, John Louis (Cutapuis)
Donovan, Dorothea
Kittendorfer, Mrs. G. A.
Martineau, Stanley [s]
Peter, George [o]
Shope (a.k.a. Schope), Irvin (a.k.a. Irwin, a.k.a. Shorty) [m]
Wible, William M., Jr. [p]

Oregon

Ackley, Herbert [o, p]
Anderson, Anna M. [o]
Austin, Darrel [m, o]
Austin, Margot—see Helser, Margot
Barchus, Eliza [o]
Barrett, Oliver [s]
Barto, Vivian N. [o]
Becquet, Marion [o]
Bell, Sidney [o]
Bendixon, George [o]

PUBLIC WORKS OF ART PROJECT (CONTINUED)

Biles, Stuart [o]
Bohlman, Herman T. [o]
Bunce, Louis [o]
Carey, Rockwell W. [o]
Clark, Edith [p, ps]
Clark, Florenz (a.k.a. Florence) [wc]
Clough, Arthur [s]
Collins, Bradford [p]
Curl, Martina—see Gangle, Martina
Darcé, Virginia [o]
Dawson, O. B. (a.k.a. Orion B.) [wr]
de Broekert, Jim [s]
de Noyer, Nelva [wc]
Deutschman, Lambert [s]
Dobell, R. H. [ps]
Dougan, Lee L. [p?]
Dowling, Colista [o]
Dunberg, Edna [s]
Ehrman, Hyman M. [s]
Elmer, Clementine [o]
Erikson (a.k.a. Erickson), Dora [o, s, w]
Fabrick, Anton [o]
Feurer, Karl (a.k.a. Carl) [o]
Field, Marian (a.k.a. Marion) [o, wc]
Flaherty, Kathryn [o]
Fraley, Laurence K. [s]
Fulton, Cyrus J. [o]
Gangle (a.k.a. Curl), Martina [o]
Gardner, Neal [s]
Gilbert, Grace J. [c, e]
Gilbert, Louise [o]
Gilmore, W. H. (a.k.a. Wesley H.) [d, wc]
Givler, William H. [o]
Gordon, Charles S. [wc]
Gorham, Aimee (a.k.a. Mrs. A. S.) [d, pr, s, wc]
Gould, Corrinne [wc]
Griffin, Rachael [o]
Hadley, Elizabeth [f]
Harbison, Robert E. [s]
Hayes, William P. [o]
Heaney, Charles E. [wct]
Hedrick, Mary S. [wc]
Helser, Margot (a.k.a. Mrs. Darrel Austin) [o, wc]
Hetrovo, Nicolai S. [wc]
Heywood, Herbert [wc]
Hillman, Fred [s]
Hollister, Maud (a.k.a. Maude) [o]
Hudson, Harlow E. [d, wc]

Hult, Esther [s]
Hussey, T. W. [s?]
Jeffery (a.k.a. Jeffrey), George [o]
Johnson, Jeanette [o]
Johnson, Mabel [wc]
Johnson, Phillip Halley [o]
Keller, Clyde Leon [o]
Kellogg, Anita [d, oth]
King, Will [s]
Lamade, Erich (a.k.a. Eric) [o]
Latta, Henrietta [o]
Lavare (a.k.a. Lavarre), Gabriel [s]
Lawrence, H. Abbott [d]
Leavstrand, Pete [o]
Lewin, Herman C. [w]
Loomis, Birdie (a.k.a. Virdie) [o]
Lynch, Douglas [o]
Lyon, Cathryn [o]
Mackenzie, Catherine de Witt [wc]
Malkasian, Esther [tx]
Manser, Percy [m, o]
Marsh, Harold D. [o]
McClure, Ross [s]
McIlwraith, William F. [e, l]
McKim, C. C. (a.k.a. Charles C.) [o]
Moore, Helen B. [d, wc]
Nelson, Victor L. [ps]
Neylon, Austin [oth]
O'Hara, Mrs. J. P. [o]
Paisley, Leroy [pr]
Patten, Eleanor C. [o]
Pedersen, Conrad [o]
Price, C. S. (a.k.a. Clayton S.) [o]
Pritchard, Louise—see Utter, Louise
Pritchard (a.k.a. Pritchert), Walter [s]
Quigley, Edward B. [o, s]
Rayner, Herbert [s]
Ricen, Stanley [o]
Runquist, Albert C. [o]
Runquist, Arthur [o]
Schubert, Louis [s]
Schubert, Otto C. [s]
Serebrennikov, Marian [d, wc]
Sewall, Edward [o]
Sewell, Alice [o]
Shepard, Olivia [o]
Sherman, Bella Willis (a.k.a. Mrs. Charles W.) [i, tx]
Sibley, Frank [wc]
Sisson, Nellie Stowell (a.k.a. Mrs. Edward O.) [o]

Skinner, Charlotte B. [o]
Smith, Robert [d]
Sonnekes, F. J. [s]
Sorensen (a.k.a. Sorrensen), Rex [s]
Standley, William J. [s]
Stricker, Rosamond (a.k.a. Rosamund) [o]
Sutherland, Jean (a.k.a. Gean) [s]
Thomas, Florence [s]
Trullinger, John [o]
Utter (a.k.a. Pritchard), Louise [s]
van Scoy, Myrtle [o]
van Zandt, Rosalie [o]
Vezzani (a.k.a. Vessani), D. [s]
Voisin, Adrien [s]
von Schmidt, Fritz [wc]
Wade, Murray
Wanker, Maude [o]
Weise (a.k.a. Weiss), Valentine [s]
Wells, Donald L. [s]
Wells, Vesta [o]
Wetterstrom, Margaret [s]
Wilkinson, Jack [o]
Wiseman, Josephine [o]
York, Rhoen [o]

Washington

Abrams (a.k.a. Abrahams), Theodore H. [tx]
Anderson, Guy [o, wc]
Anthony, Margaret [p, pr]
Bakke, Wilhelm (a.k.a. William) [s?]
Barrett, Fernand [p]
Binney, Mabel [oth]
Bishop, Ralph J. [d, wc]
Brown, Ruth Shirley
Bruseth, Alf [i]
Buckler, Bertha B. [p]
Burnley, John E. [oth, p]
Camfferman, Margaret [o]
Camfferman, Peter [m]
Chase, W. Corwin [wc, wct]
Chase, Waldo [wct]
Claussen, Estelle [p, wc]
Cobb, Chester Soule' [o, wc, wct]
Colborne, Elizabeth [l, wct]
Cookson, Stanley [o]
Cooper-Griffith, Fanny [p]
Cope, Irene [o, wc]

Creekmore, Raymond [l]
Curtis, Elizabeth L. [m]
Davis, Fay [oth]
Davis, Leonard [p]
de Mole, Frank [f]
Edmonds, Frank H. [oth, s]
Elshin, Jacob [o]
Enabnit, Merlin G. [wc]
Engel, Vera [l, lct, wct]
Faliduff, W. [l]
Ferguson, William W. [o]
Fery, John [o]
Fields, Earl [o]
Fisken, Jessie [oth, wc]
Fitzgerald, Edmond [o, wc]
FitzGerald, James [d, wc]
Forkner, Edgar [o, wc]
Fritch, Barbara [oth]
Fullerton, Betty [p]
Gebert, Ernst [s]
Gill, Ross [wc]
Gonzalez (a.k.a. Gonzales), Salvador [wc]
Graves, Morris [o, oth]
Grosser, Max F. [s]
Groves, W. B.
Gruble, Adam [wr]
Hamilton, Georgia
Harrison, Theodora [d]
Haupt, Edward J. [m]
Holmes, F. Mason [o]
Houston, James L. [oth]
Jensen, Lloyd E. [w]
Johnson, first name unknown [s]
Kelez, Ivan Marion [s]
Kemp, W. A. [p]
Kielland, Alfred [oth]
Kreps, Ruth M. [l, lct, o, wc, wct]
Lap, E. [wct]
Lembke, Halford [s]
Lemon, David [s, w]
Lindstrom, Charles W. [o]
Marsh, Leon [oth]
Mattison, Leota [m, o, oth]
Meyers, C. W. [w]
Minard, Lois [oth]
Moller, Louise Hinkley [m, oth, wc]
Multner, Ardis [d, f]
Neal, W. F. [w]
Nestor, Barney [o]
Newman, Winifred [o]
Nomura, Kenjiro [o]
Norling, Ernest [d, o, wc]
Olsen, Claude [o]
Patrick, Ransom [wc]

Pearson, Charles [e]
Posey, Gwen [oth]
Rapp, Ebba [o]
Rhodes, Helen [wc]
Rodionoff (a.k.a. Rodinoff),
 Steve [o]
Rollins, Charlotte [l]
Salmon, Lionel E. [o]
Sando, E. M. [oth, s]

Sauers, Grace H. [p]
Schlosser, Weyand [d, oth]
Schweer, Hulda [o]
Sheckels (a.k.a. Sheckles),
 Glenn [o]
Shkurkin, Vladimir. P. [o]
Sonnichsen, Yngvar [o]
Spencer, Duane
Strong, Peggy [o, wc]

Sumbardo, Martha [t]
Sung, Rowena Clement [o]
Tadama, Fokko [o]
Thurman, Winifred [lct, tx]
Tokita, Kamekichi [o]
Ullman, Julius [wc]
Uttendorfer, Mike [wr]
van Dalen, Pieter [m, o]
Varney, Walter E. [s]

Walkinshaw, Jeanie [o]
Warden, T. J. [oth]
Warren, Marajane (a.k.a. Mary
 Jane) [m]
Wehn, James [s]
Wiggins, Myra [o]
Winslow, Elwood L. [p]
Wright, Grace Latimer [f]
Ziegler, Eustace P. [o, wc]

TREASURY RELIEF ART PROJECT

Idaho

NA

Montana

NA

Oregon

Ballator, John [m]
Bunce, Louis [m, o]
Lamade, Erich (a.k.a. Eric)
 [d, m, o, tm, wc]

Washington

Callahan, Kenneth [m, o]
FitzGerald, James [o, wc]
Rich, Hovey [m, p]
Twohy, Julius (Two-vy-nah-up)
 [m, p]

SECTION OF FINE ARTS

Idaho

Fitzgerald, Edmond [m]
Lochrie, Elizabeth Davey [m]
Martin, Fletcher [m]
Standing Soldier, Andrew [m]
Walton, Richard G. [m]

Montana

Beaulaurier, Leo J. [m]
Burkhard, Verona [m]
Hannon, Olga Ross [oth]
Hill, Forrest [m]

Lochrie, Elizabeth Davey [m]
Meloy, Henry [m]
Ralston, J. K. (a.k.a. James K.)
 [m]
Yphantis, George [oth]

Oregon

Ballator, John [m]
Bunce, Louis [m]
Carey, Rockwell [m]
Fitzgerald, Edmond [m]
Grellert, Paul [m]

Lamade, Erich (a.k.a. Eric) [m]
Morris, Carl [m]
Sweet, Frederick [oth]
Vincent, Andrew [m]
Wiley, Lucia [m]
Wilkinson, Jack [m]

Washington

Callahan, Kenneth [m]
Elshin, Jacob [m]
Fitzgerald, Edmond [d, m, o, wc]
Fuller, Richard [oth]

Gassner, Mordi [m]
Haines, Richard [m]
Hart, Lance (a.k.a Lantz) [m]
McCosh, David [m]
McGovern, Donlon P. [s]
Nicholson, Douglas [m]
Norling, Ernest [m]
Patterson, Ambrose [m]
Runquist, Albert C. [m]
Sazevich, Zygmund [s]
Strong, Peggy [m]
Vincent, Andrew [m]

FEDERAL ART PROJECT

Idaho

Bartlett, Ivan [m]
Chase (Miss) [t]
Martin, Fletcher [m, s]

Montana

Beauchamp, John (a.k.a. Jack)
 [a, pr, t]
Brennan, James [i]
Busch, Caroline [t]
Caldwell, Irene [oth, sk, t]
Catenaro, Armand [t]
Giordano, Antonio [t]
Hall, Robert [i, t, wc]
Houle, Elroy [a]
Hughes, Beatrice Howie
Jose, J. [sn]

Jovick, Anton [t, w]
Keenan, Betty [t]
Loney, first name unknown [sn]
Mandelman, Beatrice [t]
Mason, first name unknown [sn]
McDaniels, P. [sn]
McHatton, John J. [a, m?, sn]
Mogus, Dolores [pr]
Parker, Gladys Christie [d?]
Raile, K. [sn]
Redmond, James [a, d, t]
Riley, Beverly [t]
Scott, C. W. [t]
Sharkey, Neil [d, oth, t, w]
Standing, William (Fire Bear) [i]
Stephens, Arnold [t]
Stevens, Frank [a]
Tyler, Earl [oth, sn, w]
Ward, Frank [t]

Oregon

Ahlberg, Florence [l]
Allison (Mr.) [wr]
Anderson (Mr.) [sn]
Ashworth (Miss) [oth]
Austin, Darrel [o]
Austin, Margot—see Helser,
 Margot
Baker, Fred [f]
Ballator, John [m]
Ballinger, Charles [s]
Bashaw, Reynold B. [d, i, oth]
Bates, Clarence E. [s, t]
Behnke (Mr.) [f]
Bell, Anna [t]
Benders (Mr.) [sn, w]
Bendixon, George [m, p]

Benedict, Edward [l, oth, wc]
Berndorf, first name
 unknown [l]
Berry, George [s]
Bitters (Mr.) [w]
Blew, John [p]
Blioch (Mr.) [wr]
Blumenstiel, Helen [t]
Boivine (a.k.a. Boivin) (Mr.)
 [sn, w]
Bowden, Harry [t]
Bunce, Louis [a, m, o, t]
Burri, Fred [wr]
Cappo, Rosa [f]
Carey, Rockwell [l]
Carlson (Mr.) [w]

Clayston (a.k.a. Clogstan), E. Belle [m, p]
Clough, Art H. [s]
Collins, Fred [oth, s]
Cross, Helen [t]
Curl, Martina—see Gangle, Martina
Curry (Mr.) [w]
Danaher, T. [t]
Darcé, Virginia [m, mo, mq, o, oth, t, wc]
Dawson, O. B. (a.k.a. Orion B.) [f, s, wr]
de Broekert, Jim [s]
Dornbush, Adrian J. [ph, t]
Downs (Mr.) [sn, w]
Dryden, Littleton P. [o, sn]
Dull, Thelma [f]
Dunberg, Edna [s]
Dupee (a.k.a. Dupuy), Cherie M. [oth, t]
Ebert, Marjorie [a]
Eckles (Mr.) [wr]
Edmondson, Elizabeth [t]
Erikson (a.k.a. Erickson), Dora [l, o, wc]
Ferrarin, Pete [f, mo]
Fessler, George [wr]
Feurer, Karl (a.k.a. Carl) [l, o, wc]
Field, Marian (a.k.a. Marion) [a]
Fiske, John [m]
Fitch, first name unknown [tx]
Flavelle, Alan [mo, o, p, t]
Foster, Harter [t]
Frasier (Miss) [f]
Fredolph (Mr.) [wr]
Frisk, Edward (a.k.a. Friske, Eduard) [f, wr]
Gallagher, Margaret [ce, f]
Gangle (a.k.a. Curl), Martina [l, m, o, s, t, tm, wc, wct]
Gibbs, Howard [f, m, p]
Gilkey, Gordon [e]
Gingrich, Mae [t]
Gleason, Clifford [m]
Gorham, Aimee [mq]
Graves, Orie [m, o]
Haller, Charles M. [mo, w]
Hardy, Melvin [ce, p?]
Harrison (Mr.) [wr]
Harth, Henry [f, wr]
Heaney, Charles E. [d, o, pr, tm, wct]
Hedgepeth, Claude [f, mo, mq, w]
Helser (a.k.a. Austin), Margot [m, o, wc]

Huston, first name unknown [t]
Ingler, Charla [oth]
Jeffery (a.k.a. Jeffrey), George [l, wc]
Johnson, Phillip Halley (a.k.a. Hallie) [m]
Kee, Bue [ce, s]
Keegan, Melvin [f, mo, s, w]
Keinath, Otto [mq, w]
Kinersly, first name unknown [wr]
Lamade, Erich (a.k.a. Eric) [d, m, o, s, t, tm, wc]
Laman, Thomas [f, mo, s]
Lavare (a.k.a. Lavarre), Gabriel [f, oth, s, sn, t, wr]
Lemery, Charles E. [sn, t]
Lewin, Herman [w]
Loggan (Mr.) [sn, w]
Lynch, Douglas [m]
Manser, Percy [o]
McChesney, Arthur [w]
McClure, Ross [w]
McIntosh (Mr.) [ph]
Miller (Mr.) [mq, sn, w]
Mish, Charlotte [l, m, o, tm]
Morris, Carl [o]
Morrison, George [wr]
Neese (Mr.) [w]
Nelson, Helen [t]
Neufer, Ray [f, oth, w]
Newman, Harold [oth]
Nichols, Violet [t]
Penlock, first name unknown [l]
Peterson, John W. [f, w, wr]
Philpott (Mr.) [sn]
Price, C. S. (a.k.a. Clayton S.) [m, o]
Price, Jack [f, sk]
Pritchard, Louise—see Utter, Louise
Pritchard (a.k.a. Pritchert), Walter [a, oth, s]
Prudhomme, Franya (a.k.a. Frances) [f, o, sn, t, tx]
Purcell, Howard [tm]
Quigley, Edward [m, p, s]
Randall, Byron [t]
Rithaler (a.k.a. Ritthaler), Jake [wr]
Robinson, Jane [a, t]
Runquist, Albert C. [m, tm]
Runquist, Arthur [m, o, tm]
Schmierer, Isabelle [t]
Schubert (Mr.) [s]
Scott, E. R. [m]
Seliger, Jerome [mq]

Sewall, Howard [f, m, mo, o, wc]
Shook, David [oth]
Siegmund (a.k.a. Sigmund), William [wr]
Slobe, Laura [t]
Smith, Margaret [m, s, sn]
Smith, Margery Hoffman [f]
Snodgrass, Ella [d, p]
Sonnekes, first name unknown [sn]
Sorle (a.k.a. Soule), first name unknown
Spratt, Alberti [l]
Spurlin (Miss) [f]
Stewart, first name unknown [f]
Streat, Thelma Johnson [tx]
Sumpter (Mr.) [wr]
Thomas, Florence [d, s]
Thomas (Mr.) [w]
Tschopp, Agnes [t]
Utter (a.k.a. Pritchard), Louise [s]
Val Clear, Charles [a, d, f]
Vanetti, Gertrude [t]
Ventura, Sam [ph]
Vermeers, Arthur [oth]
Voisin, Adrien [s]
von Meier, Fritz [oth]
Wageman (Mr.) [w]
Wagner, Ivan [mq, w]
Walton (Mr.) [wr]
Warner, first name unknown [f]
Wasser, Arthur [a]
Watkins, Isaac [t]
Weise (a.k.a. Weiss), Valentine M. [s]
Wells (Mr.) [p, sn]
Whitcomb, Bess [t]
White, Minor [a, ph, t]
Witt, William [s]
Wood, Elizabeth Hoffman [l, wc]
Zane, Nowland B. [s]
Zussin, Harold [t]

Washington

Abrams, Oliver [oth]
Abrams (a.k.a. Abrahams), Theodore H. [pr, tx]
Adams, Evert [oth]
Allingby, Austin [p]
Anderson, Guy [p, t]
Bamber, Wallace [oth]
Barnes, Otho R. [mo, pr]
Baron, Henry [oth]
Beavers, Harold [t]

Blanc, Marian [s, t]
Bok, Hans (a.k.a. Wayne Woodard) [d, p, pr, wc]
Bowman, Herbert [t]
Bruseth, Alf [oth, wc]
Butler, John [wc?]
Cahill, Stella [oth]
Caley(?), Donald G. [t]
Campbell, Janet [t]
Carpenter, Earl [d, t, wc]
Chong, Fay [lct, wc]
Corbin, Louise [a, t]
Correll, Richard [l, lct, m, mo, oth, pr, s]
Corrigan, John
Cumming, William [d, p]
Cunningham, Paul L. [oth, pr, s]
Davis, John [t]
Deutsch, Hilda (a.k.a. Hilda Morris) [o, s, t, wc]
Donaldson, R. [mo]
Downer, Kenneth [a, p, t]
Egri, Ruth [t]
Elshin, Jacob [m, o, tm, wc]
Engard, Robert O. [p, pr, t]
Erickson, Lou [d, i, t]
Evernden, Frank [t]
FitzGerald, James [a, pr, s, t]
Fleckenstein, Opal [t]
Fletcher, William O. [oth, wc]
Fossek, Clementine [oth, wc]
Fullerton, Betty
Gebert, Ernest
Gilmore, R. M. [oth, w]
Glenn, George R.
Gonzalez, Salvador [wc]
Graves, Morris [d, o, oth, p]
Griffin, Worth [a]
Harper, Betty [t]
Haugland, Augustine [d, lct, m]
Helder, Z. Vanessa [l, m, t, wc]
Holmes, F. Mason [p]
Hurd, R. S.
Hutchins, Sheldon [d, m]
Hutson, O. N. [mo]
Inverarity, Robert Bruce [mo]
Kelez, Ivan M. [s]
Kimmel, Joseph [pr]
Kirsch, Agatha B. [d, l, m, wc]
Knowles, Joseph, Jr. [d, e, pr]
La Barnes, H. [mo]
Lattin, Hazel [t]
Lee, Robert Cranston [wc?]
Lilly, Lulu [t]
Looff, John [oth]
Losey, Blanche Morgan [d, sn, wc]
Lurvey, Lettie [t]

MacDonald, Donald [pr]
Marsh, Leon
Mattison, Leota
Mayumel, Joseph [t]
McHugh, Irene [d, s]
Meyer, Janalene [t]
Michalov, Anne [l, pr, t, wc]
Morris, Carl [a, p]
Morris, Hilda—*see* Deutsch, Hilda
Murphy, Dorothy [oth]
Myers, Lenora [t]
Nelson, Irene [t]
Nosker, Ruth [t]

Oldfield, Otis [pr?]
Olson, Esther
Patrick, Ransom [m, o, sk, wc]
Petric, Lubin [tm]
Prior, Olga [t]
Prouty, Amy [t]
Roberts, first name unknown [m]
Roberts, Malcolm [l, mo, o]
Rutter, Joseph
Sabin, Betsy [a, t]
Sando, E. M. [oth]
Sawyer, Loretta [t]
Shaw, Jack [wc]

Sheckels (a.k.a. Sheckles), Glenn [m]
Sheridan, Bernard [oth]
Short, Frank [oth, w]
Smith, Fabian [t?]
Snyder, E. [mo]
Snyder, Jean [t]
Solman, Joseph [t]
Spohn, first name unknown [m]
St. Clair (Miss)
Stapp, David [i, sk]
Steward, Ella [t]
Stich, Mabel [t]
Stumer, Mildred [s?]

Sumbardo, Martha [t]
Tobey, Mark [p, s]
Tomkins, Margaret [pr, t]
Twohy, Julius (Two-vy-nah-up) [l, m, pr, wc]
Ullman, Julius [o, wc]
van Wyck, William G.
von Phul, Phil
Willas (a.k.a. Willis), Elizabeth [l, m, oth, pr]
Wood, R. V. [a]
Woodard, Wayne—*see* Bok, Hans
Woodward, Lavergne [t]

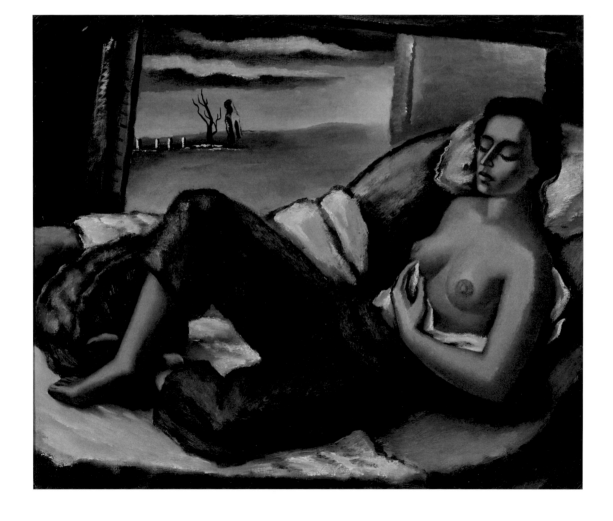

Commissions by State and Project

The following list is a compilation of commissions under the four New Deal art projects in Idaho, Montana, Oregon, and Washington. The list has been compiled from written evidence consisting primarily of government documents, art project correspondence, labeled art project photographs, artwork labels, and newspaper accounts. It does not include individual artworks if no location is associated (for artists of these works, see Appendix 1). It contains the author's current information as of the publication of this book. Where known, artwork type and artist are identified. Because of changing guidelines and funding throughout the projects, some works were commissioned but appear to have never been completed and are labeled as such where known. The whereabouts of works marked as unlocated are currently unknown to the author; much work is still needed to find missing artworks.

—Margaret E. Bullock

KEY

Information is listed in the following order:

Recipient (additional agency or organization information), city or county, artwork type (additional notes, if any) [artist's last name, if known]

An asterisk (*) at the end of an entry indicates the artwork's location is currently unknown to the author.

IDAHO

Public Works of Art Project

Boise Public Library (building now privately owned), Boise, murals in children's reading room [Moller]
Governor's Office, Boise, painting (now at Idaho State Historical Society) [C. Smith]
Latah County, art classes [Joice]
State Normal School (now Lewis-Clark State College), Lewiston, prints*
University of Idaho, Moscow, prints*

Treasury Relief Art Project

No projects known

Section of Fine Arts

Blackfoot Post Office, Blackfoot, mural in main and lockbox lobbies [Standing Soldier]
Buhl Post Office, Buhl, mural in main lobby [Walton]
Burley Post Office, Burley, mural in main lobby [Lochrie]
Kellogg Post Office, Kellogg, mural in main lobby [Martin]
Preston Post Office, Preston, mural in main lobby [Fitzgerald]
Saint Anthony Post Office, Saint Anthony, mural in main lobby [Lochrie]

Federal Art Project

Ada County Courthouse (now University of Idaho Law and Justice Learning Center), Boise, murals throughout building [Bartlett, Martin]
Boundary County Courthouse, Bonners Ferry, sculptural reliefs on facade [Martin]
Idaho State Department of Education, Boise, temporary educational displays*
Latah County, art classes
Lowell School, Boise, mural*
Mackay Library, Mackay, mural*
Park School, Boise, mural*
Saint Anthony Public Schools, Saint Anthony, easels*
Spaulding Centennial Celebration, Lewiston, posters*

MONTANA

Public Works of Art Project

Bozeman Post Office (now US Post Office and Federal Building), Bozeman, painting (now in the Federal Building lobby) [Peter]

Montana State College (now Montana State University), Bozeman, painting [Wible]

State University (now University of Montana), Forestry Building, Missoula, paintings*; mural [Shope]

State University library, Missoula, sculptures [Martineau]*

Treasury Relief Art Project

No projects known

Section of Fine Arts

Billings Post Office (now James F. Battin Federal Building and US Courthouse), Billings, mural in main lobby [Beaulaurier]

Deer Lodge Post Office, Deer Lodge, mural in main lobby [Burkhard]

Dillon Post Office, Dillon, mural in main lobby [Lochrie]

Glasgow Post Office, Glasgow, mural in main lobby [Hill]

Hamilton Post Office, Hamilton, mural in main lobby (lobby is now administrative office and museum) [Meloy]

Sidney Post Office (now Disaster and Emergency Services), Sidney, mural in lobby [Ralston]

Federal Art Project

Colleges and Universities

Montana School of Mines (now Montana Tech), Butte, mural in library*; backdrops for unidentified location [Loney, Mason, McHatton, Tyler]*

State University (now University of Montana), Missoula, illustrations of class materials*

Schools

Butte High School, Butte, signs [Sharkey]*

Girls Central High School, Butte, theater scenery [Jose, McDaniels, Raile]*

Other Government Agencies (Local, State, National)

Great Falls Housing Authority, Great Falls, mural (unclear if completed) [McHatton]*

Montana Federal Writers' Project, Bozeman, sketches [Hall]*; book illustrations [Standing]

Montana Historical Records Survey, Bozeman, book covers [Caldwell]*

Montana State Hospital for the Insane (later Warm Springs State Hospital), Warm Springs, art classes; occupational therapy; picture mounting [Tyler]*; signs [Tyler]*

Montana State Planning Board, Helena, illustrations*

Rocky Boy's Indian Agency, Hill County, Rocky Boy's Reservation, map [Sharkey]*; scrapbook [Sharkey]*

US Forest Service, Missoula, illustrations*; lantern slides*

Various federal Indian reservations, art classes

Various regional hospitals, gallery talks for nurses

WPA Adult Education office, Butte, signs [Jovick]*

WPA Recreation and Education office, Butte, signs [Sharkey]*

Community Organizations

Camp Fire Girls, Butte, book covers [Caldwell]*

Junior League, Butte, stencils [Mogus]*

Wildflower Preservation Society, Butte, signs [Jovick]*

OREGON

Public Works of Art Project

Colleges and Universities

Oregon State College (now Oregon State University), Corvallis, paintings (now at Benton County Historical Society) [Austin, Bunce, F. Clark, Gangle, Lamade, Manser, McKim, Pedersen, E. Sewall, Trullinger]; sculptures (now at Benton County Historical Society) [Gardner, Gorham, Harbison, Hillman]

University of Oregon library, Eugene, sculptures [Dunberg, Gardner]; wood carvings [Clough, de Broekert, McClure]; wrought-iron architectural elements [Dawson]

University of Oregon Medical School (now Oregon Health and Science University), Portland, mural [Austin]

University of Oregon Museum of Art (now Jordan Schnitzer Museum of Art), Eugene, painting [C. S. Price]; prints [McIlwraith]

Schools

Ainsworth School, Portland, print [G. Gilbert]*

Benson High School, Portland, mural*

Couch School, Portland, painting [Van Scoy]*

Eugene High School, Eugene, sculpture [Gardner]*

Hood River Middle School, Hood River, mural [Manser]

Jefferson High School, Portland, sculptures [Voisin]

Oregon Public Schools, various locations, illustrations [Sherman]*

Oregon State School for the Blind, Salem, carvings*; sculptures [Sutherland, Wetterstrom]*

Rose City Park School (now Rose City Park Elementary School), Portland, plaque [O. Schubert]

Washington High School, Portland, relief mural [Vezzani]*

Libraries

Eugene Public Library, sculpture [Dunberg]*

Multnomah County Central Library, Portland, sculpture [L. Schubert, Thomas]; paintings [C. S. Price]

Other Government Agencies (Local, State, National)

Board of County Commissioners, Portland, painting [Wanker]*

Bonneville Dam, Multnomah County, sculpture*

Circuit Court, Portland, drawings [Lawrence]*; paintings [Carey*, Feurer, Flaherty*, Fulton*, Hetrovo*, Lynch*, McKim*, Pedersen*, Shepard*]; print [McIlwraith]*

City Attorney's Office, Portland, painting [Fulton]*

Civilian Conservation Corps, Eugene, drawings [Gilmore, Gorham, Hudson]*

County Clerk's Office, Portland, paintings [Fulton, Lyon]*

Crater Lake National Park, Klamath County, sculptures [Pritchard]*

Customs House, Portland, paintings (one now at Oregon Historical Society) [Fabrick, Gordon*]

Dock Commission, Portland, painting [Carey]*

Doernbecher Memorial Hospital for Children (now Doernbecher Children's Hospital), Portland, paintings [Helser, Van Zandt]*; wall panel [Darcé]*

Eugene Park (a.k.a. Skinner Butte Park), Eugene, birdbath*

Federal Building, Portland, sculpture [Lavare]*

Mayor's Office, Portland, paintings [Griffin, Hetrovo]*

Oregon Historical Society, Portland, paintings [Griffin, Hetrovo]; bookplates [Kellogg]*; print [McIlwraith]*

Oregon State Capitol, Salem, portraits of past governors (possibly destroyed in 1935 fire)*

Oregon State Highway Department, various locations, mileposts [Utter]*

Portland City Hall, Portland, painting [S. Bell]*

Portland Finance Department, Portland, painting [A. Runquist]*

Portland Public Affairs office, Portland, painting [Bohlman]*

Portland Public Auditorium (now Keller Auditorium), Portland, painting work (possibly stage sets)*

Portland Public Utilities, Portland, painting [Givler]*

Portland Public Works, Portland, painting (now at Oregon Historical Society) [Carey]

Portland Zoo (now Oregon Zoo), Portland, sculptural panels [Lavare]*; wood carvings*

Postmaster, Portland, painting [C. S. Price]

Various government offices, Washington, DC, drawings [Gorham, Hudson]*; paintings [Bunce*, Carey*, Fulton*, Givler*, Lamade*, Manser*, McKim*, C. S. Price, Shepard*]; prints [Gorham, Heaney, McIlwraith]*

Veterans' Hospital, Portland, sculpture [Hillman]*

Community Organizations

Portland Art Museum, Portland, paintings [Erikson]; sculpture [Erikson]*

Treasury Relief Art Project

Saint Johns Post Office, Saint Johns, mural in lobby [Ballator, Bunce, Lamade]

Seattle Marine Hospital (now Pacific Tower), Seattle, allocation of paintings [Lamade]*

Treasury Relief Art Project office, Washington, DC, paintings [Bunce, Lamade]*

Section of Fine Arts

Burns Post Office, Burns, mural in lobby (now in Harney County Courthouse) [Wilkinson]

East Portland Station Post Office, Portland, mural in lobby [Grellert]

Eugene Post Office, Eugene, mural in lobby [C. Morris]

Grants Pass Post Office, Grants Pass, mural in lobby [Bunce, Lamade]

Newberg Post Office, Newberg, mural in lobby [Carey]

Ontario Post Office, Ontario, mural in lobby [Fitzgerald]

Saint Johns Post Office, Saint Johns, mural in lobby [Ballator]

Salem Post Office (now State Office Building), Salem, mural in lobby [Vincent]

Tillamook Post Office (now Tillamook City Hall), Tillamook, mural in lobby [Wiley]

Federal Art Project

Colleges and Universities

Linfield College, McMinnville, sculpture [Pritchard]*

Oregon State College (now Oregon State University), Corvallis, entrance gates [Dawson]

Oregon State College Bexell Hall, Corvallis, marquetry [Gorham, Hedgepeth, Keinath, Wagner]

Oregon State College Department of Forestry, Moreland Hall, Corvallis, marquetry (now in Richardson Hall) [Gorham, Hedgepeth, Keinath, Wagner]

Oregon State College library, Kidder Hall, Corvallis, sculptures (now in Richardson Hall) [Weise]; wrought-iron architectural elements [Dawson]

Oregon State College Memorial Union, Corvallis, furnishings [Dawson]; wrought-iron architectural elements [Dawson]

Oregon State College President's Office, Corvallis, furnishings [Dawson]*

Oregon State College Women's Dormitory, Snell Hall, Corvallis, wrought-iron architectural elements [Dawson]

University of Oregon, Eugene, entrance gates [Dawson]; model*; relief maps*; wood architectural elements [Lavare]*

University of Oregon Art Department, Lawrence Hall, Eugene, mural (destroyed) [Johnson]

University of Oregon Chapman Hall, mural [Scott]; wrought-iron architectural elements [Dawson]

University of Oregon Esslinger Hall, Eugene, flower bowls [Pritchard]

University of Oregon gymnasium, Eugene, sculptures [Pritchard]*

University of Oregon Howe Field, Eugene, wrought-iron architectural elements [Dawson]

University of Oregon Journalism building (now Allen Hall), Eugene, sculptures [Pritchard*, Utter]

University of Oregon library, Eugene, furnishings [Dawson]; inscriptions [Zane]; murals [Gangle, A. Runquist, A. C. Runquist]; prints (library) [Gilkey]; sculptures [Bates, Clough, de Broekert, Dunberg, McClure, Utter]; wrought-iron architectural elements [Dawson]

University of Oregon McArthur Court, Eugene, wrought-iron architectural elements [Lavare]

University of Oregon Medical School, Portland, furnishings [M. H. Smith]*; lantern slides [Ashworth, Benedict]*; scientific charts [Ashworth, Benedict]*

University of Oregon Museum of Art (now Jordan Schnitzer Museum of Art), Eugene, paintings [C. Morris, A. Runquist]; prints (allocated from the Washington Art Project) [Chong, Correll, Kirsch, M. Roberts, Twohy]

University of Oregon Museum of Natural History (now Museum of Natural and Cultural History), Eugene, diorama [Shook]; sculptures [Collins]

Schools

Abernethy School, Portland, mural [Lamade]

Ainsworth School, Portland, marquetry [Gorham]

Alameda School (now Alameda Elementary School), Portland, marquetry [Gorham]

Beach School, Portland, mural [C. S. Price]

Benson Polytechnic School, Portland, stage sets [Lemery, M. Smith]

Binnsmead School, Portland, painting [Prudhomme]*

Bush Elementary School, Salem, mural (now at North Salem High School) [Bunce, Gleason]

Chapman School, Portland, wood marquetry (entrance to auditorium) [Gorham]

Corvallis High School, Corvallis, art reproductions [Dupee]*

Franklin High School, Portland, mural [Ballator]; sculpture [Berry, Laman]

Girls' Polytechnic High School, Portland, furnishings [Laman]*

Gold Beach School, Gold Beach, sculpture [Witt]*

Grant High School, Portland, painting [Austin]; stage sets [Lemery, M. Smith]; wooden screens

Gregory Heights School, Portland, marquetry [Gorham]

High School of Commerce (now Cleveland High School), Portland, stage sets [Lemery, M. Smith]*

Highland School (now Dr. Martin Luther King Jr. Elementary School), Portland, paintings [Mish]

Irvington School (now Irvington Elementary School), Portland, furnishings [Neufer]; marquetry (library, nature study center) [Gorham]; mural [Quigley]; paintings [Purcell]*; sculpture [Weise]

Jefferson High School, Portland, carving [M. Smith]; marquetry (auditorium) [Gorham]; mosaic [Flavelle]; paintings [Austin, Bunce]; prints [Ahlberg, Berndorf, Erikson, Feurer, Gangle, Jeffery, Penlock, Spratt, Wood]; wooden screens

Lents School, Portland, allocation of artworks*

Lincoln High School, Portland, marquetry (auditorium) [Gorham]; painting [C. S. Price]

Llewellyn School, Portland, allocation of artworks*

Milwaukie High School (a.k.a. Milwaukie Union High School), Milwaukie, mural in lobby (destroyed during remodel) [Darcé]; painting [Bendixon]*

Mount Angel School District, Mount Angel, weaving equipment*

Mount Tabor School, Portland, allocation of artworks*

Oregon City High School (a.k.a. Oregon City Senior High School) auditorium, murals [H. Sewall]; paintings [Bendixon]

Oregon State School for the Blind, Salem, carvings*; looms*

Oregon State School for the Deaf, Salem, looms*

Pendleton High School (a.k.a. Pendleton Senior High School), mural (now at Umatilla County Historical Society) [Gangle, A. Runquist]

Pendleton Junior High School library, mural (now at Pendleton High School) [C. S. Price]

Peninsula School, Portland, allocation of artworks*

Portland Public Schools, Portland, wooden screens [Neufer]

Riverdale School, Portland, marquetry [Gorham]*

Roosevelt High School library, Portland, mural [M. Smith]

Rose City Park School (now Rose City Park Elementary School), Portland, mural in auditorium [Gangle]; sculpture [Lavare]

School District #1, Portland, furnishings [Neufer]*; sculpture [Lavare, Quigley]*; stage sets [Lavare]*

Shattuck School, Portland, furnishings [Laman, M. H. Smith]*

Washington High School, Portland, sculpture [Lavare]

West Linn High School, West Linn, mural [Bendixon]*

Whitaker School, Portland, drawing stands*; furnishings [M. H. Smith]*

Woodstock School, Portland, allocation of artworks; wooden screens

Libraries

Clackamas County Library, Oregon City, drawing [Heaney]*; posters*; signs*

Corvallis Public Library, Corvallis, art reproductions [Dupee]*

Deschutes County Library, Bend, posters*

Hood River County Library, Hood River, posters*; signs [Darcé]*

Jackson County Library, Medford, posters*; signs [Darcé]*

Josephine County Library, Grants Pass, posters*; signs [Darcé]*

Library Association of Portland, furnishings [Dawson]*; paintings [Feurer]*; prints [Feurer]*; stage sets*

Malheur County Library, Burns, posters*; signs [Darcé]*

Multnomah County Library, Portland, no details known

Oregon City Library, Oregon City, mural (destroyed during remodel) [Darcé]; painting [Darcé]*

Oregon State Library, Salem, bookplate design*; mural [Mish]; paintings [Erikson, Feurer, Jeffery]

Umatilla County Library, Pendleton, posters*; signs [Darcé]*

Wasco County Library, The Dalles, posters*; signs [Darcé]*

Other Government Agencies (Local, State, National)

Board of County Commissioners, Portland, no details known

Bureau of Parks, City of Portland, papier-mâché [Newman]*

Circuit Court, Bend, furnishings [M. H. Smith]*

Circuit Court, Portland, no details known

City Attorney's Office, Portland, no details known

City Hall, Portland, murals [Fiske, Mish]*

City of Silverton, road signs*

County Clerk's Office, Portland, no details known

Crater Lake National Park, Klamath County, no details known

Custom House, Portland, no details known

Dock Commission, Portland, no details known

Doernbecher Memorial Hospital for Children (now Doernbecher Children's Hospital), Portland, mural [Helser]*; paintings [Darcé, Helser]*

Fall Creek Camp (now Fall Creek State Recreation Area), Fall Creek, no details known

Federal Theatre Project, Portland, screens [Prudhomme]*; stage sets [Lemery, Prudhomme]*

Federal Writers' Project, Oregon, illustrations [Bashaw]

Finance Department, Portland City Hall, Portland, mural [Mish]*

Governor's Mansion, Juneau, Alaska, furnishings [Frisk, Gibbs, M. H. Smith]*

Klamath County Infirmary, Klamath Falls, furnishings [Laman, M. H. Smith]*

Klamath County Poor Farm, Klamath Falls, furnishings*

Mayor's Office, Portland, no details known

Office of Public Works, Portland, no details known

Oregon Historical Society, Portland, artwork reproductions*

Oregon State Forestry Department, Salem, carving [Weise]*

Oregon State Highway Commission, Salem, furnishings [Gallagher]*

Oregon State Tuberculosis Hospital, Salem, art classes [Bunce]

Port of Portland, Portland, paintings [Mish]*

Portland Public Auditorium (now Keller Auditorium), Portland, orchestra set*

Silver Falls State Park, Marion County, blueprints*; furnishings [Peterson, M. H. Smith]*; road signs*

Soil Conservation Service, US Department of Agriculture, Spokane, paintings (now at Oregon Historical Society) [Dryden]

Timberline Lodge, US Forest Service, Mount Hood, carvings [Keegan, Lamade, Neufer, F. Thomas, Weise]; ceramics [Kee]*; furnishings [Ferrarin, Harth, Hedgepeth, Neufer]; linoleum murals [Lynch];

marquetry [Gorham]; model; mosaic [Darcé, Ferrarin, Keegan, Laman, H. Sewall]; mural [C. S. Price]; opus sectile [Darcé]; paintings [Austin, Benedict, Erikson, Feurer, Gangle, Heaney, Jeffery, C. S. Price, H. Sewall, Wood]; prints [Carey, Erikson, Feurer, Heaney, Jeffery]; textiles [M. H. Smith]; wrought-iron architectural elements [Dawson]

Tongue Point Naval Air Station, US Navy, Astoria, ceramics [Kee]*; furnishings [Gibbs, Laman, J. Price, H. Sewall, M. H. Smith, Val Clear]*; murals [Gibbs, Graves]*; opus sectile [Darcé]*; paintings [Austin, Darcé, Erikson, Feurer, Flavelle, Graves, Heaney, Jeffery, Lamade, Mish, A. Runquist]*

US Forest Service, Oregon, dioramas [Shook]*; exhibit backdrops*; lantern slides*; paintings [Dryden]*

Various government offices, Washington, DC, furnishings [Frisk, Harth, Laman, M. H. Smith]*; paintings [Helser]*

Veteran's Hospital, Portland, no details known

Works Progress Administration, Oregon, photography [Ventura, White]

Community Organizations

American Red Cross, Portland, paintings [Feurer]*

Hammond House, location unknown, marquetry [Darcé]*

Kiwanis Club Children's Summer Camp, Mount Hood, furnishings [M. H. Smith]*

Montavilla Kiwanis Club, Montavilla, furnishings [M. H. Smith]*

New York World's Fair, New York, drawings [Bashaw]; model [Neufer, Vermeers]; wrought iron [Dawson, Siegmund]

Oregon Historical Society, Portland, no details known

Pacific Livestock Exposition, Portland, model*

Portland Art Association (now Portland Art Museum), Portland, paintings [C. S. Price]

San Francisco World's Fair Commission, San Francisco, drawings [Bashaw]*; furnishings; wrought iron [Siegmund]*

WASHINGTON

Public Works of Art Project

Colleges and Universities

University of Washington, Seattle, geological drawings [Schlosser]*; lantern slides [Fisken, Minard]*; lettering [Houston]*; textiles [T. Abrams]*

University of Washington Art Department, Seattle, murals [Mattison, Warren]*; painting [Newman]*

University of Washington Commons, Seattle, mural [P. Camfferman]*

University of Washington Medicinal Herb Garden, Seattle, entrance markers [Grosser]

University of Washington Oceanography Building, Seattle, mural (now in Ocean Sciences Building) [Curtis]

University of Washington Women's Gymnasium (now Hutchinson Hall), Seattle, mural [Curtis]

Washington State College (now Washington State University), Pullman, mural (mosaic?) [Haupt]*; painting [Shkurkin, Tokita]*; print [Engel]*

Washington State Museum (now Burke Museum), University of Washington, Seattle, diorama [Edmonds]*; drawings [Multner]*; exhibition assistance [Graves, Marsh, Warden]; geological drawings [Houston, Marsh]*; painting? [Burnley]*

Schools

Aberdeen Public Schools, Aberdeen, painting [Fitzgerald]*

Anacortes Public Schools, Anacortes, painting [Fitzgerald]*

Auburn Public Schools, Auburn, painting [Claussen]*

Bellevue High School, Bellevue, sculpture [Lemon]*

Bellingham Normal School, Bellingham, painting [Ziegler]*

Bellingham Public Schools, Bellingham, drawings [Norling]*; painting [Fitzgerald]*; sculpture [Lemon]*

Blaine Public Schools, Blaine, painting [Claussen]*

Bremerton Public Schools, Bremerton, painting [Fitzgerald]*

Centralia Public Schools, Centralia, painting [Fitzgerald]*

Chehalis Public Schools, Chehalis, painting [Enabnit]*

Cheney Normal School, Cheney, painting [Tokita]*

Ellensburg Normal School, Ellensburg, painting [Nomura]*

Ellensburg Public Schools, Ellensburg, painting [Fitzgerald]*

Everett Public Schools, Everett, paintings [Enabnit, Ullman]*

Gault School (now closed), Tacoma, painting [Holmes]*

Grand Mound Reform School (a.k.a. State Training School for Girls), Grand Mound, paintings [Ullman]*

Gray School (now Gray Middle School), Tacoma, painting [Holmes]*

Grover Cleveland High School, Seattle, sculptures [Gebert, Kelez, Lemon]*

Havermale Junior High School, Spokane, painting [Kemp]*

Highland High School, Cowiche, prints [W. C. Chase]*

Highline High School, Burien, paintings [Claussen, Ullman]*

Hoquiam Public Schools, Hoquiam, paintings [Enabnit, Fitzgerald]*

Hutton Trade School, Spokane, painting [Winslow]*

Issaquah Public Schools, Issaquah, painting [Ullman]*; sculpture [Lemon]*

John Rogers High School, Spokane, painting [Kemp]*

Kennewick Public Schools, Kennewick, painting [Gill]*

Kent Public Schools, Kent, painting [Gill]*

Lake City School (now closed), Lake City, painting [Ullman]*

Lewis and Clark High School, Spokane, paintings [Anthony]*

Libby Junior High School, Spokane, painting [Kemp]*

Lincoln High School, Tacoma, paintings [Forkner, Lindstrom]*

Mason School (now Mason Middle School), Tacoma, carving [Bakke]*

McCarver School (now McCarver Elementary School), Tacoma, painting [Strong]*

Monroe Reform School, Monroe, paintings [Gill, Gonzalez, Ullman]*

Mount Vernon Public Schools, Mount Vernon, paintings [Gill, Gonzalez]*

North Central High School, Spokane, painting [Schweer]*

Okanogan Public Schools, Okanogan, painting [Gill]*

Olympia Public Schools, Olympia, painting [Fitzgerald]*

Parkland Academy, Spanaway, painting [Holmes]*

Port Angeles Public Schools, Port Angeles, painting [Shkurkin]*

Port Townsend Public Schools, Port Townsend, painting [Ullman]*

Prosser Public Schools, Prosser, painting [Claussen]*

Pullman Public Schools, Pullman, painting [Enabnit]*

Puyallup Public Schools, Puyallup, painting [Fitzgerald]*

Raymond Public Schools, Raymond, painting [Fitzgerald]*

Renton Public Schools, Renton, paintings [Fitzgerald, Ullman]*

Seattle Public Schools, Seattle, furnishings [de Mole, Multner]*; lantern slides [F. Davis, Fisken]*; paintings [Cookson, Cope, Elshin, Fery, Fisken, Fitzgerald, Forkner, Gonzalez, Kreps, Newman, Norling, Rapp, Rodionoff, Sheckels, Shkurkin, Strong, Tadama,

Ullman, Wiggins, Ziegler]*; prints [W. C. Chase, Cobb, Engel, Kreps, Pearson, Thurman]*; sculptures [Gebert*, Kelez*, Lemon*, Wehn]; textiles [T. Abrams, Thurman]*

Spokane Public Schools, Spokane, textile [Thurman]*

Stadium High School, Tacoma, painting [Ziegler]*

State Normal School, Ellensburg, paintings [Nomura, Tokita]*

Stewart School, Tacoma, painting [Holmes]*; print [Pearson]*

Sumner Public Schools, Sumner, painting [Fitzgerald]*

Tacoma Public Schools, Tacoma, carving [Bakke]*; paintings [Fitzgerald, Lindstrom]*; textile [Thurman]*

Vancouver Public Schools, Vancouver, painting [Fitzgerald]*

Walla Walla Public Schools, Walla Walla, paintings [Fitzgerald, Sauers]*

Washington State School for the Blind, Vancouver, sculpture [Lemon]*

Wenatchee Public Schools, Wenatchee, painting [Fitzgerald]*

Yakima Public Schools, Yakima, painting [Fitzgerald]*

Libraries

Aberdeen Public Library, Aberdeen, painting [Gill]*

Everett Public Library, Everett, paintings [Anderson, Enabnit, Fery, Patrick, Rhodes, Ziegler]*

Olympia Public Library, Olympia, paintings [Shkurkin, Wiggins, Ziegler]*

Puyallup Public Library, Puyallup, prints [W. C. Chase]*

Seattle Public Library, Seattle, paintings [Enabnit, Fisken, Forkner, Moller, Newman*, Sauers*, Sung*, Ziegler]; prints [Engel, Pearson]; sculpture [Kelez]*

Spokane Public Library, Spokane, paintings [Buckler, Winslow]*

Sumner Public Library, Sumner, painting [Gonzalez]

Tacoma Public Library, Tacoma, paintings [Fitzgerald, Sung]*

Washington State Library, Olympia, paintings [Forkner, Wiggins]*

Yakima Public Library, Yakima, painting [Forkner]*

Other Government Agencies (Local, State, National)

Aldercrest Sanatorium, Snohomish, paintings [Fitzgerald, Moller]*

American Guide, Federal Writers' Project, Seattle, illustrations [Bruseth]*

Civilian Conservation Corps, Lake Cushman, drawings (now at Special Collections, Seattle Public Library, and Special Collections, Tacoma Public Library) [Norling]

Civilian Conservation Corps, Orcas Island, drawings (now at Special Collections, Seattle Public Library, and Special Collections, Tacoma Public Library) [Norling]

Firlands Sanatorium Children's Ward, Seattle, mural [Moller]*

Fort George Wright, Spokane, painting [Ferguson]*

Fort Nisqually, Point Defiance Park, Tacoma, decorative map [Bishop]

Harborview Hospital, Seattle, painting [Cookson]*

King County Hospital, Seattle, sculpture [Wehn]*

King County Hospital Unit 2, Georgetown, painting [Elshin]*

King County Juvenile Court, Seattle, painting [Nestor]*

McNeil Island Penitentiary, Washington State Department of Corrections, McNeil Island, paintings [Cookson, Forkner]*

Seattle Marine Hospital (now Pacific Tower), Seattle, furnishings [Wright]*; paintings [Ullman]

Seattle Veterans Hospital, Seattle, painting [Wiggins]*

Snohomish County Hospital, Monroe, painting [Sonnichsen]*

South Park Playfield, Seattle, entrance gates [Gruble, Uttendorfer]*

Spokane City Hall, Spokane, paintings [Anthony, Barrett]*

State Historical Society (now Washington State History Museum), Tacoma, decorative map [Bishop]

Temple of Justice, Olympia, paintings [Nestor, Walkinshaw]*

Various government offices, Washington, DC, drawings [FitzGerald, Norling]*; paintings [Anderson, Claussen, Cobb, Cookson, Elshin, Fields, Fitzgerald, FitzGerald, Forkner, Graves, Nomura, Norling, Olsen, Patrick, Rapp, Tokita, Ullman, Ziegler]*; prints [W. C. Chase, Engel, Kreps]*

Washington Soldiers Home, Orting, paintings [Olsen, Sonnichsen]*

Washington State Capitol, Olympia, decorative map [Bishop]*; painting [Ziegler]*

Washington State Reformatory, Monroe, painting [Ullman]*

Western State Hospital, Steilacoom, painting [Wiggins]*

Community Organizations

American Legion, Seattle, painting [van Dalen]*

Seattle Art Museum, Seattle, illuminations [Harrison]; paintings [Anderson, M. Camfferman, Fields, Graves, Nomura, Rapp, Tokita, Ullman]; sculptures [Lembke, Varney]

Treasury Relief Art Project

Seattle Marine Hospital (now Pacific Tower), Seattle, murals (some panels now at Museum of History & Industry) [Callahan, Rich, Twohy]; paintings (allocated from Oregon TRAP) [Lamade]*

Unidentified location, easel paintings [FitzGerald]*

Section of Fine Arts

Anacortes Post Office, Anacortes, mural in main lobby [Callahan]

Bremerton Post Office, Bremerton, mural in main lobby [Norling]

Camas Post Office, Camas, mural in main lobby [Nicholson]

Centralia Post Office, Centralia, mural in main lobby [Callahan]

Clarkston Post Office, Clarkston, sculpture in main lobby [McGovern]

Colville Post Office, Colville, mural in main lobby [Fitzgerald]

Kelso Post Office, Kelso, mural in main lobby [McCosh]

Kent Post Office, Kent, sculpture in main lobby [Sazevich]

Lynden Post Office, Lynden, mural in main lobby [Gassner]

Mount Vernon Post Office, Mount Vernon, mural in main lobby (now at Skagit Valley College) [Patterson]

Prosser Post Office, Prosser, mural in main lobby [Norling]

Renton Post Office, Renton, mural in main lobby (now in Sunset Multi-Service Center) [Elshin]

Sedro-Woolley Post Office, Sedro-Woolley, mural in main lobby [A. C. Runquist]

Shelton Post Office, Shelton, mural in main lobby [Haines]

Snohomish Post Office, Snohomish, mural in main lobby [Hart]

Toppenish Post Office, Toppenish, mural in main lobby [Vincent]

University Station Post Office, Seattle, mural in main lobby (now storage room) [Elshin]

Wenatchee Post Office (now Wenatchee Valley Museum and Cultural Center), Wenatchee, mural in main lobby [Strong]

Federal Art Project

Colleges and Universities

University of Washington Arboretum, Seattle, sign*

University of Washington Department of Chemistry, Bagley Hall, Seattle, mosaic mural [Barnes, Donaldson, Hutson, Inverarity, La Barnes, E. Snyder]

University of Washington Department of English, Padelford Hall, Seattle, sculptures [McHugh]

University of Washington School of Art, Art Building, Seattle, painting for library [Elshin]*

University of Washington School of Drama, Hutchinson Hall, Seattle, mural for library (now a classroom) [Sheckels]; theater models

Washington State Museum (now Burke Museum), University of Washington, Seattle, anthropological illustrations [Kirsch, McHugh]; artifact cataloguing; artifact replicas; dioramas (now at Washington State History Museum, Tacoma) [Bamber, Cunningham, Sando]; exhibition displays; herbarium portfolios; scientific illustrations (now at Washington State History Museum) [Kirsch]

Western Washington College of Education (now Woodring College of Education, Western Washington University), Bellingham, prints [T. Abrams, Correll, Cunningham, Helder, MacDonald, Twohy]; sculpture [Cunningham] (all works now at Western Gallery, Western Washington University)

Schools

Aberdeen Elementary School, Aberdeen, murals in lobby and auditorium (not completed)

Aberdeen School District, Aberdeen, allocation of artworks*

Alki Elementary School, Seattle, sculpture [Kelez]

Arlington High School, Arlington, murals [Correll]

Arlington School District, Arlington, prints [Correll]*

Bellingham School District, Bellingham, allocation of artworks*

Chehalis School District, Chehalis, allocation of artworks*

Colville School District, Colville, allocation of artworks*

Franklin School, Pullman, sculpture [Correll, Cunningham, McHugh]*

Highline High School, Burien, paintings [Elshin, Patrick, Ullman]*

Hutton School (now Hutton Elementary School), Spokane, art classes

Pullman School District, Pullman, allocation of artworks*

Seattle Public Schools, Seattle, art reproductions*; lantern slides*; museum artifact reproductions*; paintings [Kirsch]*; sculptures [Kelez]

Spokane Public Schools, Spokane, illustrations [Erickson]*

Spokane Vocational School, art classes

Sunnydale School, Burien, allocation of artworks*

Taft School, Tacoma, painting [Holmes]*

West Seattle High School, Seattle, mural in lobby (now in library) [Elshin]

Yakima School District, Yakima, allocation of artworks*

Libraries

Kitsap Regional Library, Bremerton, prints [Correll]*

Seattle Public Libraries, University District Branch, Seattle, linoleum mosaic (may not have been completed)*; poster panels*

Washington State Library, Olympia, mosaic? [Correll]*; paintings [Bok, Gonzalez]*

Other Government Organizations (Local, State, National)

13th Naval District, US Navy, Bremerton, posters*

Adult Education Division, Works Progress Administration, Seattle, art classes [Bowman, Lattin, Lilly, Lurvey, Mayumel, Myers, Nelson, Prouty, Sawyer, J. Snyder, Steward, Stich, Sumbardo, Woodward]

City of Seattle, air raid armbands*; blackout maps*

City of Seattle Light Department, flood control model [Sheridan]*; models of Diablo Dam and Skagit Power Development*; murals [Sheckels, Spohn, Roberts]*

Cushman Indian Hospital (destroyed), Puyallup Reservation, murals for dining hall [Haugland, Twohy]; textile designs [Twohy]*

Federal Theatre Project, Seattle, posters*; set designs (some now at University of Washington Special Collections) [Losey]

Felts Field, Spokane, drinking fountains*; stone marker*

Fort Lewis, US Department of Defense, Tacoma, extension gallery; murals (may not have been completed)*; pilot training maps*

Kiwanis Home for Children, Spokane, art classes

Mount Baker Tunnel, Washington State Highway Department, Seattle, sculptures at east entrance [FitzGerald, Wehn (for Toll Bridge Authority)]

Mount Rainier National Park, US National Park Service, Longmire, map*; relief model*; unidentified artworks [Stapp]*

Mount Spokane State Park ski lodge, Washington State Parks Department, decorations*; textiles [Twohy]*

National Emergency Council, Seattle, models of Bonneville Dam, Columbia Gorge, Grand Coulee Dam (all commissioned, unclear if completed)*

Negro Repertory Theater, Federal Theatre Project, Seattle, set designs (some now at University of Washington Special Collections) [Losey]; stage sets*

Point Defiance Zoo (now Point Defiance Zoo and Aquarium), Tacoma, mural for waiting room (unclear if completed) [Correll]*

Public Lands and Social Security Building, Olympia, map murals [Helder, Hutchins, Kirsch, Willas]*

Sand Point Naval Air Station Academy Officer's Quarters, US Navy, Seattle, mural [Helder, Kirsch]*

Sand Point Naval Air Station Officers Club, US Navy, Seattle, map mural [Patrick]*

Spokane Children's Home, Spokane, art classes

State Capitol Building, Olympia, map mural*

Surplus Commodity Depot, Food Stamp Department, Seattle, sketches*

US Army Corp of Engineers War Department, Seattle, models (Cape Flattery, Annette Island Landing Field)*

Washington Children's Home, Spokane, art classes

Washington State Department of Health, Seattle, painting [Elshin]*; posters [Stapp]*; poster display [Correll, Cunningham]*

Washington State Department of Public Instruction, Olympia, art classes

Washington State Highway Department, various locations, highway markers*

Woodland Park Zoo, Seattle, background paintings for animal houses and Monkey Island*

Community Organizations

Spokane Art Association, Spokane, exhibitions

Archival Resources Consulted

The records of the federal art projects in the Northwest are mostly scattered and fragmentary. The sole large cache is located in the National Archives, College Park, Maryland, part of the massive collection of documents from the New Deal projects, which are only broadly catalogued. The list of resources below is designed to assist researchers in finding original documents from the region's federal art projects. It reflects the sources accessed by the author during her research. For varied bibliographic references on the Northwest New Deal art projects and specific citations from materials below, see the endnotes in each essay.

—Margaret E. Bullock

Archives of American Art, Smithsonian Institution, Washington, DC

Papers, Burt Brown Barker, Holger Cahill, Robert Bruce Inverarity; Oregon FAP records; oral history interviews, artists and administrators [all projects, all four states]

Butte–Silver Bow Public Archives, Butte, Montana

Butte Art Association records; regional newspapers [FAP, Montana]

Friends of Timberline Archive, Portland, Oregon

Papers, Burt Brown Barker; general files, Timberline Lodge; photographic negatives, Oregon WPA [FAP, Oregon]

Montana Historical Society, Helena, Montana

WPA records, Montana [FAP, Montana]

Multnomah County Library, Special Collections, Portland, Oregon

List of WPA project locations; photographs, Oregon Art Project activities (print and online) [FAP, Oregon]

National Archives and Records Administration, College Park, Maryland

Record Group 69: Records of the Work Projects Administration
(includes information on all four states unless otherwise noted)

Entry 801, Boxes 19, 20, 21 [FAP, Idaho, Montana, Oregon]
Entry 1021, Boxes 2, 9, 15 [FAP]
Entry 1023, Boxes 18, 22, 27, 28, 33, 42, 47 [FAP, particularly Montana]
Entry 1024, Box 57 [FAP, Washington]
Entry PC 37, 11, Boxes 438–441, 447, 451, 452, 457, 458 [FAP]
Entry PC 37, 12-14, Boxes 1174, 1175 [FAP, Idaho]
Entry PC 37, 12-28, Boxes 1806–1808 [FAP, Montana]
Entry PC 37, 12-40, Boxes 2372, 2374–2376 [FAP, Oregon]
Entry PC 37, 12-52, Boxes 2740–2743 [FAP, Washington]

Record Group 121: Records of the Public Buildings Service
(includes information on all four states unless otherwise noted)

A1, Entry 1, Boxes 1–8 [PWAP]
A1, Entry 2, Box 6 [PWAP]
PI-110, Entry 106, Boxes 1, 3, 4 [PWAP]
PI-110, Entry 108, Boxes 1–4 [PWAP]
PI-110, Entry 112, Boxes 1, 4 [PWAP]
PI-110, Entry 115, Boxes 1, 2 [PWAP]
PI-110, Entry 116, Boxes 1–6 [PWAP]
PI-110, Entry 118, Boxes 1–3 [TRAP, Oregon, Washington]
PI-110, Entry 119, Boxes 25, 27 [TRAP, Oregon, Washington]
PI-110, Entry 126, Boxes 1–4 [Section]
PI-110, Entry 128, Box 1 [Section]
PI-110, Entry 129, Box 1 [Section]
PI-110, Entry 133, Boxes 19, 60, 89, 111, 112 [Section]
PI-110, Entry 135, Boxes 1, 2 [Section]
PI-110, Entry 142, Boxes 2, 3 [Section, Oregon, Washington]

Still Pictures Branch
(includes images from all four states)

RG69, Series AG [FAP]
RG69, Series AS [FAP]
RG121, Series CMS [Section]
RG121, Series GA [Section]
RG121, Series MS [Section]

Northwest Museum of Arts and Culture, Spokane, Washington

Papers, Spokane Art Center [FAP, Washington]

Oregon Historical Society Library, Portland, Oregon

Papers, Margery Hoffman Smith; interview, Gladys Everett [FAP, Oregon]

Oregon State University Special Collections, Corvallis, Oregon

Documents and photographs, federal art projects on campus [PWAP and FAP, Oregon]

Portland Art Museum, Anne and James F. Crumpacker Family Library, Portland, Oregon

Photographs, Oregon WPA (digitized); newspaper scrapbooks [FAP, Oregon]

Seattle Public Library Special Collections, Seattle, Washington

Newsletters, Spokane Art Center; scrapbook, art in Seattle Public Schools [PWAP and FAP, Washington]

University of Oregon Libraries, Division of Special Collections & University Archives, Eugene, Oregon

Art on campus; biographical information, Burt Brown Barker [PWAP and FAP, Oregon]

University of Washington Special Collections, Seattle, Washington

Records and photographs, federal art projects [PWAP and FAP, Washington]

Washington State History Museum, Tacoma, Washington

Photographs, WPA [FAP, Washington]

BLANCHE 1938

ACKNOWLEDGMENTS

This book is dedicated to Francis V. O'Connor, pioneering scholar on the New Deal art projects, for blazing the trail and encouraging me in my first few steps on it some 18 years ago, and to Rock Hushka, Tacoma Art Museum's director of Northwest special projects, for alternately coaxing and prodding me to finish the last uphill miles.

Between those two points I have been helped by a host of mentors, colleagues, and friends, all of whom I acknowledge below. Several have been particularly pivotal to this project, including Ginny Allen, Tiffany Stith Cooper, Dan Everhart, Mark Humpal, David F. Martin, David Milholland, Sarah Baker Munro, and Nina Olsson. I extend my sincere thanks to my coauthors, who have brought to this book varied viewpoints and careful new assessments of the art of the New Deal in the Northwest: Roger Hull, Mindy J. Morgan, Sharon Ann Musher, Philip Stevens, and Roger van Oosten, along with Cooper, Martin, Munro, and Olsson, who are named above.

The book has benefited at every stage from the expertise and careful attention of Zoe Donnell, Tacoma Art Museum's exhibitions and publications manager; Michelle Piranio, editor; Phil Kovacevich, designer; and the staff of TAM's curatorial department, notably head registrar Jessica Wilks and Faith Brower, Haub Curator of Western American Art. I would also like to thank executive director David Setford for his unwavering support of this large and time-consuming project.

If I have missed anyone, please know that your part was not less memorable, only that my memory is less reliable.

—Margaret E. Bullock
 Interim Chief Curator, Curator of Collections
 and Special Exhibitions

Linny Adamson, Timberline Lodge, USDA Forest Service
Roger Admiral, College of Forestry, Oregon State University
Ginny and Bill Allen
Rebecca Andrews, Burke Museum, University of Washington
Antonella Antonini, Western Gallery, Western Washington University
Rebecca Baker, Special Collections, University of Washington Libraries
Skye Bassett, Boise Art Museum
Stephen Dow Beckham, Lewis and Clark College
Johanna Bjork, Lewis-Clark State College Library
Randy Black, Friends of Timberline
Brian Booth
Sue Bruns, School of Drama, University of Washington
Jim Carmin, Multnomah County Library
Lily Chumley
Jack Cleaver, formerly Oregon Historical Society
Tiffany Stith Cooper
Ellen Crain, Butte–Silver Bow Public Archives
William Creech, National Archives and Records Administration, DC
Anne Crouchley, Portland Art Museum
M. C. Cuthill, formerly Oregon Historical Society Research Library
Emily-Jane Dawson, Multnomah County Library
David de Lorenzo, Knight Library, University of Oregon
Daniel Delahaye, US Postal Service Facilities Headquarters
Jacqueline Dirks, Reed College
Carol Egan, formerly Portland Public Schools
Ann Eichelberg, formerly Portland Art Museum
Jimmy Emerson
Brent Emmons, Hood River Middle School
Pam Endzweig, Museum of Natural and Cultural History, University of Oregon
Richard Engeman, formerly Oregon Historical Society
Kathy Erickson, Fine Arts Collection, General Services Administration

Dan Everhart, Idaho State Historic Preservation Office

Kathy Flynn, National New Deal Preservation Association

Larry Fong, formerly Jordan Schnitzer Museum of Art, University of Oregon

Mary Gallagher, Benton County Historical Society and Museum

Roberta Gebhardt, Montana Historical Society

James Gregory, Department of History, University of Washington

Kristin Halunen, Museum of History & Industry

Kate Hampton, Montana State Historic Preservation Office

Andrew Harbison, Special Collections, Seattle Public Library

Dave Hegeman, State Library of Oregon

John Herman

Melody Holmes, Heritage Station Museum

David Horowitz, Portland State University

Carolyn Howe

Mark Humpal, Mark Humpal Fine Art

Mary Iverson, Skagit Valley College

Jeff Jaqua, USDA Forest Service

Ed Jaramillo, Skagit Valley College

Kerry Jeffrey, US Postal Service

Brian Johnson, formerly Stanley Parr Archives and Records Center, City of Portland

Elizabeth Josias, Point Defiance Zoo and Aquarium

Evan Kalish

Susan Karren, National Archives and Records Administration, Seattle

Trisha Kauffman, Museum of People's Art

Rick Keil, School of Oceanography, University of Washington

Jody Klevit

Diana Knight, Department of Chemistry, University of Washington

Jessie Kotarski, City of Renton

Tony Kurtz, Western Libraries: Heritage Resources, Western Washington University

Michael Maire Lange, The Bancroft Library, University of California, Berkeley

Karl LeClair, Boise City Department of Arts and History

Lois Leonard

Douglas Lynch

John Lyons, Portland Public Schools

David F. Martin, Cascadia Art Museum

Marsha Matthews, formerly Oregon Historical Society

Lauren Mellon, Seattle Art Museum

David Milholland, Oregon Cultural Heritage Commission

Lynette Miller, Washington State History Research Center

Gene Morris, National Archives and Records Administration, College Park

Michael Munk

Sarah Baker Munro

Elizabeth Nielsen, Oregon State University Library

John Olbrantz, Hallie Ford Museum of Art

Nina Olsson

Michael Parsons

Ilona Perry, Northwest Room/Special Collections, Tacoma Public Library

Larry Len Petersen

Ann Poulson, Henry Art Gallery, University of Washington

Kasey Rahn, W. A. Franke College of Forestry and Conservation, University of Montana

Prudence Roberts, formerly Portland Art Museum

Roger H. D. Rowley, Prichard Art Gallery, University of Idaho

Debra Royer, formerly Anne and James F. Crumpacker Family Library, Portland Art Museum

Roger Saydack

Susan Seyl, formerly Oregon Historical Society Research Library

Elisabeth Smith, Seattle Art Museum

Michael Sullivan, Artifacts Consulting, Inc.

Kent Sumner, Oregon State University

John Suydam, formerly Pierce Library, Eastern Oregon University

Amy Thompson, Special Collections and Archives, University of Idaho Library

Su Tipple, School of Oceanography, University of Washington

Dana Turvey, The Clarke Gallery

Roger van Oosten

Carroll van West

Melanie Wachholder, Wenatchee Valley Museum and Cultural Center

Sarah Wiecks, formerly Oregon Health Sciences University

Dallen Wordekemper, US Postal Service

Nicole Yasuhara, Oregon Historical Society

CONTRIBUTORS

MARGARET E. BULLOCK is interim chief curator and curator of collections and special exhibitions, Tacoma Art Museum. She holds an MA in anthropology from Washington State University and an MA in art history from the University of Oregon. Prior to joining the Tacoma Art Museum in 2007, she was curator at the Harwood Museum of Art in Taos, New Mexico; associate curator of American art at the Portland Art Museum, Oregon; and a research fellow in American art at the Montgomery Museum of Fine Arts, Alabama. She has curated exhibitions and written articles and books on American and European fine and decorative arts. Her specialty is late 19th- and early 20th-century American art with a particular focus on the art of the Pacific Northwest.

TIFFANY STITH COOPER holds a BA in art history from the University of California, Santa Barbara, and an MA in art history from the University of Oregon. Her research focuses on the American photographer Minor White and his early years spent in Portland, Oregon. An abridged account of her thesis, "Form to Light: Minor White in Oregon 1937–1942," was published in a special issue of *Calapooya: A Literary Review* devoted to White (2004). She is the assistant director of programming and booking at Portland'5 Centers for the Arts.

ROGER HULL is professor emeritus of art history and senior faculty curator, Hallie Ford Museum of Art, at Willamette University, Salem, Oregon. He is a distinguished scholar on Pacific Northwest regional art of the 20th century. He holds an MA and a PhD from Northwestern University. He has written eleven monographs on significant Northwest artists of the early to middle 20th century, including Louis Bunce, Charles

Heaney, George Johanson, and Lucinda Parker, among others. His articles on American and Northwest art have appeared in *Sculpture Magazine*, *American Art Review*, *History of Photography*, and *Oregon Humanities*. He received the Oregon Governor's Art Award in 1999 for his work on the Northwest's art history.

DAVID F. MARTIN is curator at the Cascadia Art Museum, Edmonds, Washington, and an independent arts researcher and widely published author who has documented the art history of Seattle and the Pacific Northwest since 1986, as well as of western New York State since 1981. He is a leading authority on early Washington State art and artists, particularly women, artists of Asian descent, and LGBTQ artists. Martin served for three years as regional president of the Northwest Chapter of the National Museum of Women in the Arts, Washington, DC. He is the author of numerous award-winning books and catalogues, and contributes essays and catalogue entries for national and international publications on painting, printmaking, and photography.

MINDY J. MORGAN is associate professor of anthropology and affiliated faculty of the American Indian and Indigenous Studies Program, Michigan State University. Her book *"The Bearer of This Letter": Language Ideologies, Literacy Practices, and the Fort Belknap Indian Community* (2009) examines how literacy functioned as both a cultural practice and a cultural symbol for the Assiniboine and Gros Ventre communities of the Fort Belknap Reservation during the late 19th and 20th centuries. Morgan served as curriculum coordinator for a collaborative Nakoda language project at Fort Belknap College, which led her to investigate tribal members' participation in the Montana

Federal Writers' Project in the late 1930s and early 1940s. She is currently working on a new project regarding the periodical *Indians At Work*, published by the Office of Indian Affairs between 1933 and 1945.

SARAH BAKER MUNRO has a BA from Pitzer College and an MA in folklore from the University of California, Berkeley. She has been active with Friends of Timberline in Portland, Oregon, since 1975 and is a past president of the board. As historian of Timberline Lodge, she coauthored the 1978 catalogue on the lodge and has revised and updated the guidebook through several editions. In 2004, with the Labor Arts Forum, she helped organize a symposium on New Deal art in Oregon. She is the author of *Timberline Lodge: The History, Art, and Craft of an American Icon* (2009) and has curated exhibitions celebrating the 75th anniversary of the New Deal at the Oregon Historical Society and Timberline Lodge. From 2012 to 2018 she served as the director of the Hoover-Minthorn House Museum in Newberg, Oregon, boyhood home of President Herbert Hoover.

SHARON ANN MUSHER is associate professor of history at Stockton University, New Jersey. She holds a PhD in history from Columbia University and an MPhil in economic and social history from Oxford University. She is the author of *Democratic Art: The New Deal's Influence on American Culture* (2015), which traces a range of aesthetic visions that flourished during the 1930s to outline the successes, shortcomings, and lessons of the golden age of government funding for the arts. She has also written about 1930s cultural issues for *The Oxford Handbook of the African American Slave Narrative* (2014) and *Interpreting American History: The New Deal and the Great Depression* (2014). Her current book project, *Promised Lands: Hadassah Kaplan, Zionism, and the Making of American Jewish Women*, uses her grandmother's archive to explore the emerging special relationship between American Jewish women and Palestine/Israel in the early 20th century.

NINA OLSSON is a researcher and conservator of paintings in private practice in Portland, Oregon. She earned her BS in art history and studio art from the University

of Wisconsin, Madison, in 1987. In 1990 she completed a painting conservation program at the Istituto per l'Arte e il Restauro–Palazzo Spinelli, Florence, Italy, and taught painting conservation there as well as courses in the history of art restoration for the University of Michigan and Wisconsin Joint International Studies Program. From 2011 to 2014 she held a research position at the University of Florence Department of Industrial Engineering. Olsson has presented and published internationally on research topics that range from conservation treatments of Italian 15th-century to American 21st-century works of art to the development of new technologies and conservation treatment methods. Over the past two decades she has spearheaded multiple restoration projects of Federal Art Project murals in Oregon public schools.

PHILIP STEVENS is assistant professor of anthropology and director of American Indian studies, University of Idaho, and a regent at San Carlos Apache College. He is an enrolled member of the San Carlos Apache tribe. He earned an MA and a PhD in language, reading, and culture from the University of Arizona, and a BA in English literature from Saint Anselm College, New Hampshire. Through his teaching and research, he has become an expert in the machinations of Western educational facilities within reservation schools. His research interests are in the field of Apache mathematics, pedagogical disconnects between dominant cultures and Indian communities, educational "raiding," and the cultural values imparted through the educational process. He has participated in national workshops of the American Educational Research Association and American Anthropological Association on topics in decolonization, cultural responsiveness in Indigenous education, and methodologies on Indigenous educational sovereignty and social justice, most recently in the *Journal of Critical Thought and Praxis*.

ROGER VAN OOSTEN is an art historian and author who frequently writes about and lectures on the New Deal art projects. He has curated art exhibitions at the Burke Museum and the Museum of History & Industry

in Seattle. He also has organized and participated in the restoration of public murals in Duarte, Monterey, and Los Angeles, California; Sebring, Florida; and Seattle, and frequently serves as a consultant on mural preservation projects. His mural restoration efforts have been covered in the *Seattle Times* and *ArtsPatron Magazine*, and on *KING-TV*. Van Oosten is a partner at Action Mary, a public relations firm in Seattle. He graduated from Boston University in 1985 with a degree in journalism. He is currently writing a book about the Public Works of Art Project.

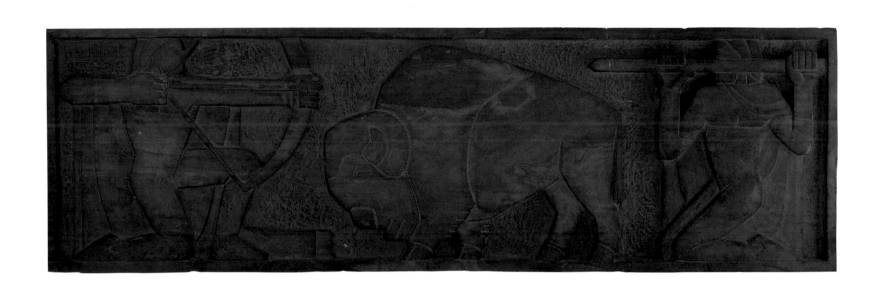

PHOTOGRAPHY CREDITS

Tacoma Art Museum gratefully acknowledges the work of the photographers whose images of artwork are reproduced in this publication.

All photo material is provided courtesy of the lender, in addition to the following as listed below.

PAGES 6, 188: Photo © Tacoma Art Museum, photo by Richard Nicol

PAGES 10–11, 126 (fig. 21), 130 (fig. 28): Photo © Oregon State University, photo by Hannah O'Leary

PAGES 14, 55 (fig. 15), 60: Photo © Seattle Art Museum, photo by Elizabeth Mann

PAGES 21, 22, 24, 45, 70, 72, 78 (fig. 14), 162, 165 (fig. 3), 166, 167, 237: Photo © Dan Everhart

PAGES 23 (fig. 6), 68 (figs. 1, 2), 74, 75, 85 (fig. 24): Photo © Jimmy S. Everson, DVM

PAGE 26: JIM WILSON / The New York Times / Redux

PAGES 28, 31, 120, 121 (figs. 15, 16): Friends of Timberline © Aaron Johanson

PAGE 34: Oregon Festival of American Music © Kent Peterson

PAGE 35: Courtesy of the Anacortes Museum

PAGES 36 and back cover, 58, 83 (figs. 20, 21), 88, 110, 138, 143, 151, 168, 172, 196, 201, 231: Photo © Tacoma Art Museum, photo by Terry Rishel

PAGES 38, 73 (figs. 7, 8): Photo © Carroll van West montanahistoricland-scape.com

PAGE 43: © The Oregonian and Barcroft Studios

PAGE 46 (fig. 3): Courtesy of the Montana Museum of Art and Culture

PAGE 46 (fig. 4): Courtesy of newspapers.com

PAGES 51, 76, 80, 89 (fig. 29), 113, 114 (figs. 7, 8), 129: Photo © Tacoma Art Museum, photo by Dale Peterson

PAGES 52 (figs. 12, 13), 115 (fig. 9), 116 (fig. 11 and detail): Courtesy of Special Collections and University Archives, Knight Library, University of Oregon

PAGES 77 (figs. 12, 13), 82, 84, 85 (fig. 23), 86, 87 (figs. 26, 27), 89 (fig. 30), 90, 133, 238: Photo © Tacoma Art Museum

PAGE 78 (fig. 15): Photo © Mark Humpal

PAGE 79: Photo © Kasi M. Belcher

PAGE 81: Photo © Debbi Reeves

PAGE 91: Photo © Evan Kalish

PAGES 96, 142 (fig. 42): Courtesy of Western Washington University, © Rod del Pozo

PAGE 119: Photo by Conkling Inc., Courtesy of Friends of Timberline Archive

PAGE 122: Courtesy of Oregon Health and Science University, Portland

PAGES 125, 205, 206: Photo © Loren Nelson

PAGE 130 (fig. 27): Courtesy of Oregon Federal Art Project 1935–1943, John Wilson Special Collections, Multnomah County Library, Portland, Oregon

PAGE 132 (fig. 30): Courtesy of the Umatilla County Historical Society

PAGE 176: Photo © Tiffany Stith Cooper

PAGES 182, 187: Photo © David F. Martin

PAGE 190: Friends of Timberline

PAGE 198: Photo © Joe Mabel

PAGES 202, 207, 208: Photo © Nina Olsson

New Deal Art in the Northwest: The WPA and Beyond is published in conjunction with the exhibition *Forgotten Stories: Northwest Public Art of the 1930s*, organized by the Tacoma Art Museum and on view from February 22 through August 16, 2020. The exhibition is also presented at the Hallie Ford Museum of Art at Willamette University from September 20 through December 20, 2020.

This publication is made possible by the Henry Luce Foundation.

Both the publication and the exhibition have been thoughtfully supported by associate sponsors Matthew and Kimberly Bergman.

The exhibition is generously supported in part by ArtsFund and Tacoma Arts Commission.

HENRY LUCE FOUNDATION

ARTSFUND

Tacoma Arts Commission

Tacoma Art Museum
1701 Pacific Avenue
Tacoma, WA 98402
tacomaartmuseum.org

Distributed by University of Washington Press
uwapress.uw.edu

Publisher's Cataloging-In-Publication Data
(Prepared by The Donohue Group, Inc.)

Names: Bullock, Margaret E., editor. | Tacoma Art Museum, issuing body, host institution.
Title: New Deal art in the Northwest : the WPA and beyond / Margaret E. Bullock.
Description: Tacoma, Washington : Tacoma Art Museum, [2020] | "Published in conjunction with the exhibition Forgotten Stories: Northwest Public Art of the 1930s, organized by the Tacoma Art Museum and on view from February 22 through August 16, 2020"--Copyright page. | Includes bibliographical references.
Identifiers: ISBN 9780924335488
Subjects: LCSH: Public art--Northwest, Pacific--History--20th century--Exhibitions. | New Deal, 1933-1939--In art--Exhibitions. | Northwest, Pacific--Economic conditions--20th century--In art--Exhibitions. | United States. Works Progress Administration--Exhibitions. | LCGFT: Exhibition catalogs. | Essays.
Classification: LCC N8836.N56 N49 2020 | DDC 709.795--dc23

ISBN: 978-0-924335-48-8

Designer: Phil Kovacevich
Editor: Michelle Piranio
Project Manager: Zoe Donnell
Proofreader: Carrie Wicks
Print and color management: iocolor, LLC, Seattle
Printed and bound in China

Image Captions

Unless otherwise noted, dimensions for all works in this publication are provided as height by width by depth and reflect image size for works on paper.

FRONT COVER: Virginia Darcé (1910–1985), *The Market*, 1938, tempera on board, 22½ × 30½ inches, Portland Art Museum, Portland, Oregon, Courtesy of the Fine Arts Collection, US General Services Administration, New Deal Art Project, L45.3.2

BACK COVER: Ambrose Patterson (1877–1966), *Local Pursuits* (detail), 1936–38, oil on canvas, 5 feet 3 inches × 11 feet, Mount Vernon, Washington, Post Office, now Collection of Skagit Valley College, Courtesy of United States Postal Service. © 2019 USPS

INTERIOR IMAGES:

PAGE 2: President Franklin Delano Roosevelt's motorcade in front of Timberline Lodge (detail), September 28, 1937, Courtesy of Friends of Timberline Archive; PAGE 6: Jacob Elshin (1892–1976), *Old Mill* (detail), 1934, oil on canvas, 29 × 38 inches, Tacoma Art Museum, Loan from the Fine Arts Collection, US General Services Administration, Public Works of Art Project, 1933–1934, with gratitude to Mark Humpal, T2013-49-1; PAGES 10–11: Aimee Gorham, *The Forests* (detail), 1938, wood marquetry, 11 × 15 feet, Moreland Hall, Oregon State College (now in Richardson Hall); PAGES 16–17: Peggy Strong (1912–1956), *The Saga of Wenatchee* (detail), 1939–40, oil on canvas, 6 feet 6 inches × 18 feet, Wenatchee, Washington, Post Office, Courtesy of United States Postal Service. © 2019 USPS; PAGES 160–61: Forrest Hill (1909–death date unknown), *Montana's Progress* (detail), 1941–42, oil on canvas, 6 feet 6 inches × 15 feet 10 inches, Glasgow, Montana, Post Office, Courtesy of United States Postal Service. © 2019 USPS; PAGE 210: Cecil Smith (1910–1984), *Twenty Mule Team*, 1934, oil on canvas, 25 × 48 inches, Idaho State Museum; PAGE 213: Z. Vanessa Helder and Agatha B. Kirsch painting the mural *The History of Flight* for the Sand Point Naval Air Station Academy Officers Quarters (detail), circa 1940, Robert Bruce Inverarity papers, circa 1840s–1997, Archives of American Art, Smithsonian Institution; PAGE 214: Albert C. Runquist (1894–1971), *Sawmill*, 1933–34, oil on canvas, 30 × 36 inches, Oregon Historical Society Museum, 90-133; PAGE 219: Carl Morris (1911–1993), *Woman Resting*, 1939, oil on canvas, 36 × 43 inches, Jordan Schnitzer Museum of Art, Eugene, Allocated by the US Government Commissioned through the New Deal art projects, WPA56:1.276; PAGE 220: Thelma Johnson Streat (1911–1959), *Monstro the Whale*, 1940, wool, 8½ × 11¼ inches, Portland Art Museum, Portland, Oregon, Courtesy of the Fine Arts Collection, US General Services Administration, New Deal Art Project, L42.32.1; PAGE 228: Herman Lewin (active 20th century), Untitled (floral motif), 1933–34, wood, 28 × 22 inches, Portland Art Museum, Portland, Oregon, Courtesy of the Fine Arts Collection, US General Services Administration, New Deal Art Project, L34.21.2; PAGE 231: Blanche Morgan Losey (1912–1981), set design for *One Third of a Nation*, 1938, pencil on paper, 8½ × 11 inches (sheet), private collection; PAGE 234: Artists at work at the Oregon FAP headquarters, Portland, courtesy of Oregon WPA and SFA Negatives Collection, Anne and James F. Crumpacker Family Library, Portland Art Museum, WPA 5401; PAGE 237: Ivan Bartlett (1908–1976) assisted by other FAP artists, detail from an untitled 18-panel mural cycle to a design by Fletcher Martin (1904–1979), 1939–40, oil on canvas, 8 × 9 feet approx., University of Idaho Law and Justice Learning Center (formerly the Ada County Courthouse), Boise; PAGE 238: Edna Dunberg (1912–1936), *A Relief in Stone*, 1934, sandstone, 12 × 34 × 2½ inches, Design Library, Lawrence Hall, University of Oregon, Eugene

Copyright Permissions

Every effort has been made to identify and acknowledge copyright holders for the artworks reproduced in this publication. Tacoma Art Museum would be grateful for further information concerning any artist for whom we have been unable to locate a rights holder. Any errors or omissions will be corrected in subsequent editions.

PAGE 141: © Correll Studios